Catalogue of The Newark Museum

TIBETAN COLLECTION

Volume III: Sculpture and Painting

Valrae Reynold

Amy Heller

Janet Gyatso

The Newark Museum
Newark, New Jersey
1986

This publication has been supported by grants from:
The National Endowment for the Arts
The J. Paul Getty Trust
The Andrew W. Mellon Foundation
The Asian Cultural Council
Contributions to the Eleanor Olson Memorial Fund

© 1971, 1986 by The Newark Museum.
Published 1971. Second Edition 1986.
The Newark Museum
49 Washington Street
P.O. Box 540
Newark, New Jersey 07101

Designed by Frank Pietrucha/Graphic Design
Drawings and map by Bruce Pritchard
Photography by Armen Shamlian, Armen Photographers
Type set by Elizabeth Typesetting Company, New Jersey
Printing by Compton Press Inc., New Jersey

Library of Congress Cataloging in Publication Data

Newark Museum.
 Catalogue of the Newark Museum Tibetan collection.

 Vol. 3 by Valrae Reynolds, Amy Heller, and Janet Gyatso.
 Rev. ed. of: Catalogue of the Tibetan collection and other Lamaist articles in the Newark Museum, 1st ed. 1950–71.
 Includes bibliographies and index.
 Contents: v. 1. Introduction— —v. 3 Sculpture and painting.
 1. Art, Tibetan—Catalogs. 2. Art, Buddhist—Tibet—Catalogs. 3. Art—New Jersey—Newark—Catalogs. 4. Tibet (China)—Civilization—Catalogs. 5. Newark Museum—Catalogs. I. Reynolds, Valrae. II. Heller, Amy. III. Gyatso, Janet. IV. Title.
 N7346.T5N48 1983 709′.51′5074014932 83-17293
 ISBN 0-932828-15-9 (pbk. : v. 3)

COVER
The Wheel of Existence
P40

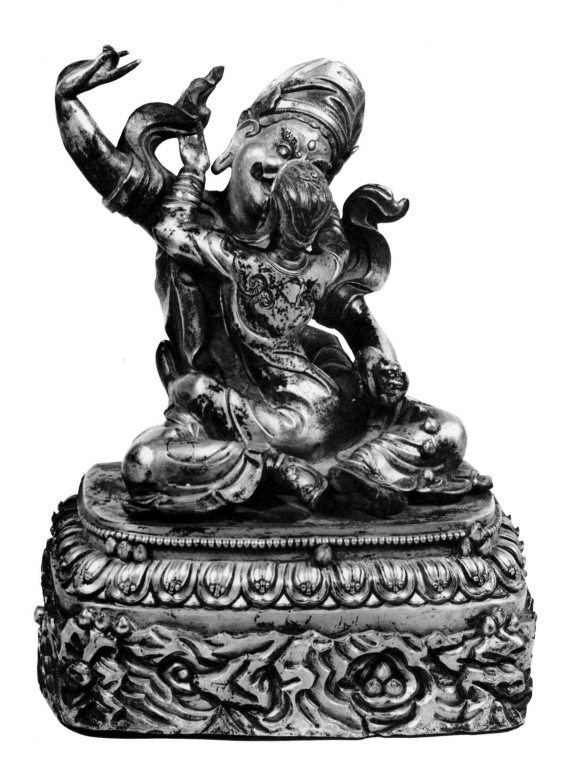

FRONTISPIECE

Jambhala and Consort
S38

FOREWORD

The Newark Museum's Tibetan collection is regarded as one of the foremost holdings of such material in the world. Political events of the last twenty-seven years have caused the disruption of traditional Tibetan culture, making the Museum's collection even more valuable as a record of a civilization now vastly altered. The unique nature of the collection is that this record is so complete. It includes objects of everyday life as well as painting, sculpture and ritual material. The Newark Museum is proud that it has not only amassed this collection but that it also has consistently supported related research and publication.

The first edition of the five-volume *Catalogue of The Newark Museum Tibetan Collection*, produced between 1950 and 1971, was written by then curator Eleanor Olson, to whom we owe a great debt for her pioneering work and devotion to Tibetan scholarship. The publication of the revised edition of Volume III is evidence of the Museum's continued commitment to this great assembly of art and ethnography.

Valrae Reynolds, Curator of the Oriental Collections, has supervised all aspects of this volume and written much of the text. I applaud her dedication to excellence and care in bringing this new edition to press. Scholars Amy Heller and Janet Gyatso have provided valuable assistance over the last three years in researching many aspects of the collection as well as writing extensive segments of the text.

The Museum is indebted to the contributors to the Eleanor Olson Memorial Fund, to the Andrew W. Mellon Foundation which provided funds for research, and to the National Endowment for the Arts, the J. Paul Getty Trust and the Asian Cultural Council for the generous contributions which have enabled this new edition to be published.

Samuel C. Miller
Director

CONTENTS

EDITOR'S ACKNOWLEDGEMENTS

Eleanor Olson's pioneering work on Tibetan art and ethnography resulted in the five-volume *Catalogue of The Newark Museum Tibetan Collection*, published between 1950 and 1971. Volume III, revised edition, has been reorganized and rewritten. Those readers familiar with Eleanor Olson's original work will notice that the sections on writing and printing equipment, books, seals and documents are absent. Except for manuscript illustrations, which are to be found in the present edition under painting, and book covers, which in turn can be found under sculpture, books and manuscripts will be examined in the forthcoming revised edition of Volume V. However, the current authors are indebted to Eleanor Olson's original research and lyrical writing style for many of the entries.

Amy Heller, a doctoral candidate in Tibetan history and art at the Ecole Pratique des Hautes Etudes, Paris, has assisted from this project's inception; helping to select objects and elucidating upon historic, iconographic and stylistic problems. Janet Gyatso, a professor at the Institute for Advanced Studies of World Religions and the State University of New York at Stony Brook, has assisted Amy Heller in the major Tibetan translation chores, corrected the Sanskrit and Tibetan terminology and given advice on many aspects of the catalogue, as well as providing the essay, "The Image as Presence."

Nima Dorjee and Tsepon Shakabpa have helped with additional translations of Tibetan inscriptions and given invaluable assistance in identification and historical documentation. Ian Alsop has been most generous in translating Nepalese inscriptions, as well as sharing his views concerning Nepalo-Tibetan cross influences. John Huntington has been unfailingly generous in his advice on dating and provenance, especially in regard to Pala-influenced material. David Snellgrove, Gilles Béguin, Heather Karmay-Stoddard, Anne-Marie Blondeau, Ariane Macdonald-Spanien, Yoshiro Imaeda, Françoise Pommaret-Imaeda, Pratapaditya Pal and Robert E. Fisher reviewed early drafts of the catalogue and made many useful suggestions. Wladimir Zwalf, Alex Wayman, Elliot Sperling and Tenzin N. Tethong have given their moral support to this project since its beginning. I would also like to thank Richard S. Lanier, Director of the Asian Cultural Council, and Deborah Marrow, Program Officer at the J. Paul Getty Trust for their encouragement and guidance. Jack and Muriel Zimmerman and John and Berthe Ford have been unstinting in their enthusiasm, as well as allowing Mrs. Heller, Dr. Gyatso and myself to explore comparative pieces in their collections.

Ruth Barnet has cheerfully typed many manuscript drafts and Bruce Pritchard has supplied fine maps and drawings. The complex task of editing the catalogue has been ably handled by Patricia Warner. Mary Sue Sweeney has provided advice at every stage in the development of this project. Director Samuel C. Miller has given his enthusiastic support to the research and publication from its first conception and ensured its successful completion.

Valrae Reynolds
Curator of Oriental Collections

EXPLANATORY NOTES

The catalogue entries are divided into sculpture (S) and painting (P) and arranged in chronological and, to some extent, geographical order. Essays on historical and religious contexts and the technical processes used for Tibetan sculpture and painting provide a framework for the individual entries. The historical essay, in particular, presents many of the problems and theories involved in dating and assigning provenances for Tibetan art. The charts of deities and historical figures, body marks, poses, hand gestures and attributes are guides to locate specific images and forms in the entries.

The entries were selected from a much larger body of the Museum's holdings, in order to represent historical, iconographic and technical developments in Tibet and related cultures. Buddhist material which exemplifies the kind of sculpture or painting likely to have been carried to, or to have acted as models for, Tibetan forms, is included from India, Kashmir, Nepal and China. The entries necessarily reflect the strengths and lacunae of The Newark Museum's collection. The objects collected by Dr. Albert L. Shelton in Kham (Eastern Tibet) between 1905 and 1920 (and acquired as the Crane Collection in 1911 and the Shelton Collection in 1920, see Volume I, pages 54 to 58) are important because of their known provenance (not proof, however, of known site of manufacture). Examples from the Crane/Shelton Collections have thus been included which, although not of the highest artistic standards, are invaluable in documenting stylistic diversity within a given area of Tibet.

Phonetic spelling has been used for Tibetan and Sanskrit words. A table at the back of the catalogue provides both phonetic and transliterated spelling for these words. The modern Chinese system (*Pin Yin*) has been used for Chinese spelling.

Many of the objects have been published previously in Newark Museum catalogues and articles. Citations for previous publications are given, however, only for significant independent scholarly works. Comparative material has been drawn extensively from the books of Pratapaditya Pal, Ulrich von Schroeder and Giuseppi Tucci. These and other frequently cited works are abbreviated in the footnotes. A table of abbreviations precedes the selected bibliography.

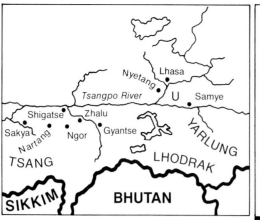

Detail: Central and Southern Tibet

Nyetang
Lhasa
Tsangpo River
U
Samye
YARLUNG
Shigatse
Zhalu
Sakya
Ngor
Gyantse
LHODRAK
Nartang
TSANG
SIKKIM
BHUTAN

Khotan
XINJIANG

Kunlun Mountains

LADAKH

Karakorum

Leh

Mountains

CHANGTHANG

Indus River

Dharm-
sala

NGARI
GUGE
Gartok
TOH

T
I
B

Sutlej
River
Tsaparang

▲ Mt. Kailasa
Manasarowar Lake

Himalayas

N E P A L

Delhi

Ganges River

Kathmandu

I N D I A

TIBET AND AREAS
OF INFLUENCE

━━━ Political borders (prior to 1959)

General area inhabited by
Tibetans (20th century)

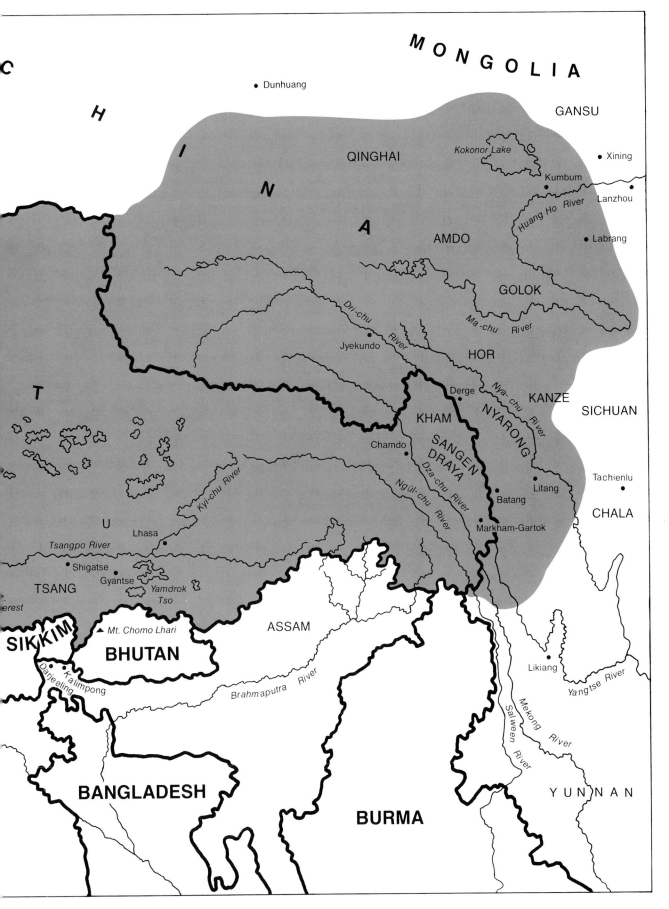

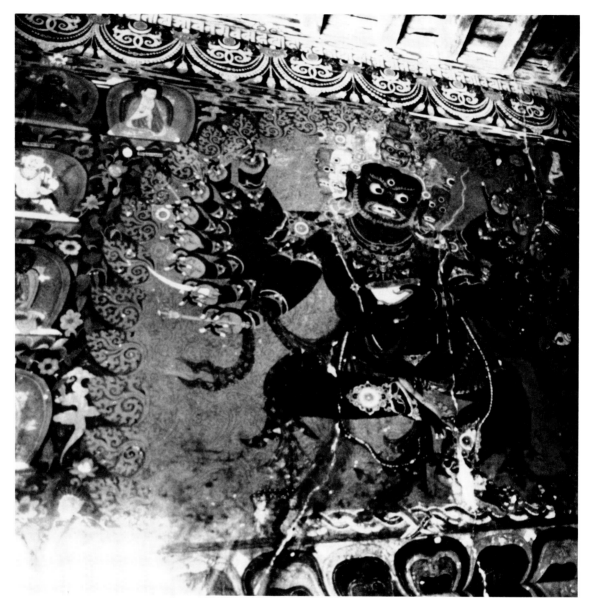

FIGURE 1

Wrathful deity, wall painting in the
Palkhor Chöde Kumbum

Gyantse, Southern Tibet, 1982

Photograph courtesy of Tamara
Wasserman Hill

I. HISTORICAL BACKGROUND

Grimacing, multi-headed deities dance in clouds of fire above cosmic oceans; a serene buddha in joyous meditation smiles from his rainbow throne; such are the themes evoked by Tibetan artists in profuse, stylized settings and a palette of vibrant colors. Since the seventh century, A.D., the Tibetans have been developing a fantastic world of forms, in paintings and in sculpture, ordered by the symbolic language of gestures, attributes and proportions which express the varied metaphysical concepts central to Buddhism.

Inspired by the arts of Central Asia and China, as well as of India and the Kashmiri and Nepalese schools, Tibetan work displays the complex interaction of these external influences—which Tibetan artists progressively fused into expressive and distinctive styles of their own. The process was infinitely gradual, since Tibetan religious conservatism emphasized iconographic accuracy and consistency rather than aesthetic innovation. The styles of earlier schools were held in such esteem that, in some cases, replicas were made even centuries later. These factors, together with the anonymity preferred by Tibetan artists, the very few dated images and, above all, the fact that these paintings and sculptures must now be considered as examples isolated from the context of the country where they were produced—and which remains largely inaccessible today—all conjoin to obscure the study of Tibetan art history. It is to be hoped that when, and if, access is made possible to the sanctuaries remaining in Tibet, we will obtain the evidence needed to better determine the various styles and schools of Tibetan art.

However, we must remember that even if a given sculpture or painting is rendered in the style of a certain region or school, it may never be possible to give a definitive date or provenance for most individual works. Styles intermingled and were diffused throughout Tibet and beyond its borders; artists traveled widely; icons, tankas or manuscripts were sent as presents to far away recipients. In an attempt to trace the progression and persistence of the multifarious products of Tibetan art, the following essay explores some of the better known monuments and the artistic and historical evidence* in relation to The Newark Museum's collection. Since many Tibetan images, whether sculpted or painted, follow iconographic traditions set down in the earliest centuries of Buddhism, the first section deals with the antecedents in India and the regions surrounding Tibet.

1. Artistic developments prior to the seventh century

There is scant literary evidence concerning the making and use of images representing the historic Buddha, Shakyamuni, during his lifetime (ca. 563-483 B.C.) and in the five centuries following his nirvana. The earliest surviving anthropomorphic portrayals of buddhas and bodhisattvas date from the first centuries of the Christian era when a non-perishable medium, stone, came into common use for sculpture. It seems apparent that the first representation of Buddhist

* For general discussions of Tibetan history, the development of the Buddhist religion in India and Tibet, and the indigenous religion of Tibet, please consult Volume I, pp.15-26 and 29-42.

images in monolithic stone form appeared after a long doctrinal development and, perhaps, after a lengthy period of image making in perishable materials.[1] First-to-third century stone sculptural remains from the Ganges-Jumna Valley (whose artistic center was Mathura) show that artists were producing images of male and female earth spirits and super heroes, such as historical kings, as well as anthropomorphic deity forms of Buddha, Shiva (for Hindus) and Mahavira Jina (for Jains).

To differentiate the Buddha's special nature from earth spirits, super heroes, Hindu and Jain deities, artists placed well established elements from Shakyamuni's life story or from Buddhist doctrine on the "superhuman" body form: a monk's shaven head and draped religious robe, or Wheel of Dharma on palms of hands or soles of feet. The two favored poses for these early sculptures are frontal standing and seated meditation positions (page 40). References to Shakyamuni's early princely life are expressed in the distended ear lobes (which once held heavy rings) and in the top knot, a vestige of the long hair cut and pulled up upon renouncing the world. This top knot, the *ushnisha,* is also conceived as a kind of "wisdom bump", a superman sign necessary to all buddha representations, as was the *urna,* the circular mark between the brows, sometimes portrayed as a curled hair "beauty spot." Hand gestures *(mudras)* include the raised, open palm of fearlessness, *abhaya,* and teaching, *dharmachakra* (pages 40 and 41). Bodhisattvas are shown in the elaborate garments and jewelry of royal figures combined with the specific body marks appropriate to their position as potential buddhas. Two of the most prominent bodhisattvas, Maitreya and Avalokiteshvara, can be identified in the earliest stone images by their attributes, the vase and lotus, respectively.

A second stylistic trend from the first three centuries A.D., developed in Gandhara, the northwest region (now Pakistan and Afghanistan) formerly subject to Persian and Hellenistic influences and, like the Ganges-Jumna region, under the rule of the Kushan empire. Symbolic objects, such as stupas (S9-1), an interest in the biography of Shakyamuni, and the depiction of superhuman buddhas and bodhisattvas proliferated in Gandhara as in the Kushan-held regions of northern central India, but the Gandharan artists followed artistic models from the Asian-Hellenic tradition. Although robed in the elaborate drapery and bearing the classic features and wavy hair of the Mediterranean, the Gandharan Buddhist images have the same marks, poses and hand gestures as seen in the Mathuran examples (figure 2).

While these coexisting styles were developing, the expansion of Buddhism began following the east-west trade axis through Central Asia, first to the northwestern frontiers of India and eventually east to China. As it traveled, the mixture of Gandharan and Mathuran Buddhist styles evolved into new forms, influenced by the local populations whose physiognomy and costumes were reflected to a degree in the icons. This paralleled the doctrinal accommodation to local beliefs and deities which made Buddhism such a success as it spread throughout Asia.

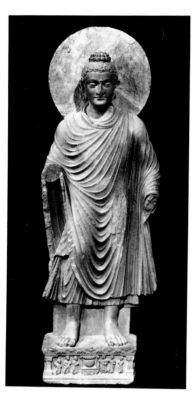

FIGURE 2

Standing Buddha

Schist stone, h. 54″ (137.2 cm); Pakistan, Gandharan period, circa 2nd-3rd centuries A.D.

Purchase 1983 The Members' Fund and Special Funds 82.184

1. See Snellgrove, *Image of the Buddha,* pp. 13-124, and John C. Huntington, "The Origin of the Buddha Image: Early Image Traditions and the Concept of Buddhadar Śanapunyā," *Studies in Buddhist Art of South Asia* (Delhi, 1985), pp. 25-58, for fuller discussions of the development of Buddhist art to the seventh century and the problems in interpreting the extant material.

The breakup of the Kushan empire in approximately the third century A.D., led to a diffusion of styles in Gandharan and Central Asian art, but the primary influence upon Buddhist imagery remained India proper. From the fourth to sixth centuries the Gupta dynasty, based in the Ganges Valley, ruled an extensive empire in India. During the Gupta reign earlier philosophic developments in Buddhism were realized in the sophistication of sculpture and painting from this period. A belief in the plurality of buddhas and bodhisattvas over infinite space and time, and the ideal of a savior deity who is committed to the collective salvation of all sentient beings are two of the prominent features of the Mahayana form of Buddhism, which was predominate in Northern India by this time. These beliefs led to the increased appearance of buddha figures in groups symbolic of the cosmic order, and of a multiplicity of bodhisattvas and goddesses, signifying the bliss and compassion of the enlightened state. Gupta stone and metal sculpture (and the surviving examples of fifth-century Buddhist painting in the caves at Ajanta and Bagh) shows that artists learned to convey the abstract concepts of Mahayana Buddhism in plastic form, where the body's physicality is fully under the control of the transcendent wisdom and calm of the inner being. Heavy-lidded eyes in deep meditation in a graceful, oval face; a lithe body of plant-like smoothness revealed through gossamer robes, and a now-codified series of auspicious marks, gestures and poses defined the Indian Buddhist ideal.

This ideal form reached Gandhara, the Himalayas, Central Asia and China in the fourth to the seventh centuries. Although vestiges of Hellenic and contemporary Western Asiatic influences can still be discerned in Gandharan art (and to a lesser degree in Indian art), they are primarily of a decorative nature, as in the Persian-style robes and flying ribbons seen in bodhisattva figures. The small Himalayan Valley kingdoms absorbed Guptan styles either directly, as in the case of Nepal, or mixed with the Gandharan traditions, as in the case of Kashmir. In Central Asia and China, there was a penchant for depicting the Buddha on a gigantic scale (as at fifth-to-sixth-century Bamiyan in Afghanistan and fifth-century Yun'gang in northern China) or in uncounted numbers (as in the fifth-to-tenth-century "Thousand Buddha" caves at Dunhuang, northwest China), as extensions of the supramundane and infinite nature concepts of Bud-dhahood.[2] The complex mixture of political, religious and stylistic elements in Central Asian imagery at this time, has yielded the extraordinary range of art found at oasis sites. The predominantly Gandharan-derived sculpture and painting from the early sites gives way gradually to the Chinese-dominant art of the later sites.

Buddhism had reached China by the first century A.D. From the fifth to the eighth centuries, under the aegis of the Northern Wei, then the Sui and Tang rulers of China, massive Buddhist monuments were created, the best known of which are the Yun'gang, Longmen and Dunhuang caves containing stone and clay statuary and extensive painting schemes. The artwork at these sites expressed the doctrines and the iconography of Mahayana Buddhism as carried from Gupta India by pilgrims and missionaries. These Chinese artistic remains

2. These concepts had developed in India proper: the gigantic (S. *Brhad*) Buddha appears to relate especially to the cult of Vairochana. See AAI, p. 206.

show, however, a heterogeneous blend of Indic styles with numerous Central Asian and indigenous features. A small, seventh-to-eighth-century Chinese bronze buddha (figure 3) shows the synthesis of the Guptan idealized body with a Chinese face and the heavy, symmetrically folded robes of Gandharan-inspired Central Asia. By the seventh century, Buddhism had thus penetrated all those areas of Asia which would figure in the development of Tibetan culture.

2. Artistic developments within Tibet, seventh to ninth centuries

The introduction of Buddhism and Buddhist art into Tibet was part of a multifaceted interaction—economic, cultural and political—between Tibet's royal government and the cultures of India, Nepal, Central Asia and China.[3] Historic records of Tibet were known by the early seventh century, contemporary with the gradual political unification of Central Tibet and the extension of Tibetan territory by military conquests and matrimonial alliances. From 634 to 850, the armies of the Tibetan emperors (tsenpos[4]) intermittently conquered and occupied portions of the northern trade routes, and pressed constantly against the Chinese frontier, from Gansu in the north to Yunnan in the south, bringing Tibet in contact with the Indo-Hellenic cultures of Central Asia and the Confucian, Taoist and Buddhist traditions of China. During this same period, and with fluctuating success, Tibet controlled or exacted tribute from Nepal and portions of northeastern and northwestern India.

Tsenpo Songtsen Gampo (reigned ca. 630-650) married Chinese and Nepalese princesses, who are credited with the introduction of Buddhist images into Lhasa, the royal capital, where they were enshrined in specially constructed temples. Contemporary accounts[5] indicate that the Tibetan official commitment to Buddhism in the seventh to the ninth centuries was tempered, however, by internal opposition and the heterogeneous nature of Tibetan civilization.

Since there is scarce physical evidence remaining from this period of the Tibetan empire, our understanding is hampered. What has survived conveys a picture of a complex culture, which combined influences from many areas of Asia. Tibetan tradition speaks of the four-sided borders of Tibet: to the east, China (land of divination and calculation); to the south, India (land of religion); to the west, Persia/Byzantium (land of wealth, jewels and trade), and to the north, Turks and Uighurs (land of horses, weapons and war).[6]

Recent archeological work has confirmed human habitation in the two "heartlands" of the Central Tibetan plateau, the Lhasa and Yarlung Valleys, from at least the neolithic period (2,000-1,500 B.C.).[7] From the

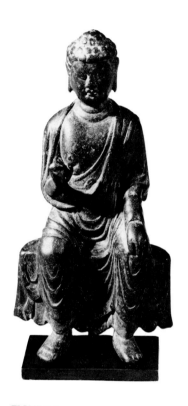

FIGURE 3

Seated Buddha

Bronze, h. 8" (20.3 cm); China, 7th-8th centuries

Purchase 1980 Anonymous Fund 80.322

3. Stein, *Tibetan Civilization*, pp. 56-70, and Snellgrove and Richardson, *Cultural History*, pp. 23-94, are especially useful for discussions of problems in the study of this period.

4. Regarding *tsenpo*, see Elliot Sperling, "A Captivity in Ninth Century Tibet," *The Tibetan Journal*, vol. IV, no. 4 (1979), pp. 23, 29-30; the Chinese term *tsan-p'u* used to translate *tsenpo* is the equivalent of "emperor" rather than "king."

5. These include the Chinese Annals and other historical records; the Chinese and Tibetan documents recovered from Dunhuang; Indian and Nepalese edicts and chronicles; and Tibetan pillar inscriptions.

6. Stein, *Tibetan Civilization*, p. 39.

7. *Wen Wu*, pp. 20-31; neolithic is not defined here but stone implements similar to those excavated in these two Central Tibetan grave sites are also found throughout the Himalayas; compare the examples in Michael Aris, *Bhutan, the Early History of a Himalayan Kingdom* (Warminster, England: Aris & Phillips Ltd., 1979), pp. XVIII-XXIII and pl. 1.

earliest, seventh-century written accounts, we learn of massive stone castles guarding agricultural settlements in these valleys, and vast, disciplined armies commanded by astute generals. Chinese records emphasize the fine armor, horses and fortresses of the Tibetans. There are numerous ruins of castles and guard towers from this era, which suggest that the Tibetan architectural heritage stems from the arid lands of Western Asia. There, as in Tibet, packed earthen dwellings and stone block fortresses were practical and durable. This architectural tradition continued into modern times with the fortress model adapted for use as temple and monastery, or palace and farmhouse.

Perhaps the most interesting physical remains from the seventh to the ninth century period are the stone pillars (T. *doring*), which record the deeds, treaties and religious edicts of the *tsenpos* and other officials.[8] Although there is a prehistoric tradition of monoliths in Tibet, the earliest inscribed pillar is at Zhol, Lhasa, dating from circa 764. This tapering, four-sided column records a minister's service to the *tsenpo*, victories over the Chinese and rewards received, in a script already definitively Tibetan in its assured and elegant style. This script had been in use during the reign of Songtsen Gampo, a century earlier. The letters are apparently modeled on the Northern Gupta script in use in Kashmir, but adapted to the very different linguistic form of spoken Tibetan.[9] It is interesting that the Tibetan court chose the written language of India, when its exposure to the rich, literary traditions of China was more extensive.[10] The pillars may be likened to the monumental columns or memorial tablets, in use among Tibet's neighbors to the west, south and east. The Tibetan form often blends the tall, imperial columns, typical of Western Asia and India, with the rectangular shape and animal-form bases of Chinese memorial tablets. Chinese influence is most obvious in the recently excavated base of the pillar ascribed to *Tsenpo* Sadnaleg (reigned 793-815) in Yarlung (figure 4), and that of the 822 Sino-Tibetan treaty pillar in front of the Jokhang in Lhasa, both of which have tortoise forms.[11] The incised or relief decoration on Tibetan bases and columns also reflects their eclecticism mixing Buddhist emblems, Chinese dragons, and Indic celestial beings. The capitals of pillars are abbreviated canopies or "tiled" roofs, with conch shell, jewel, lotus, or sun/moon finials.[12] The capitals thus resemble actual Tibetan architectural forms, for sloping roofs and finials adorn all sacred structures from the seventh to the twentieth centuries.

The other major corpus of extant remains from the dynastic period are the Buddhist temples and monasteries established by the *tsenpos* and

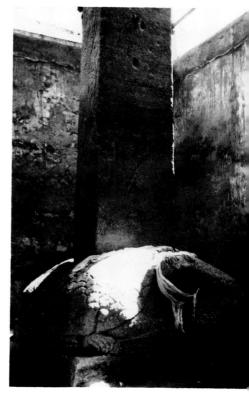

FIGURE 4

Tortoise base of the pillar ascribed to *Tsenpo* Sadnaleg (793-815)

Yarlung, Central Tibet, 1985

Photograph courtesy of Tamara Wasserman Hill

8. The Tibetan name means "long stone" and is applied, as well, to numerous Tibetan prehistoric monoliths; see Tucci, *Transhimalaya*, pp. 50-52, fig. 38. For a complete review of the inscribed pillars and their historical significance, see H.E. Richardson, *A Corpus of Early Tibetan Inscriptions* (England: Royal Asiatic Society, 1985).

9. There are many problems with the time span and personages involved in this traditional account, particularly the short time allowed between Songtsen Gampo's reign (634-650) and the appearance of a completely developed written language in the Dunhuang documents of 655; see Stein, *Tibetan Civilization*, p. 59 and Snellgrove and Richardson, *Cultural History*, pp. 74-77.

10. Stein, *Tibetan Civilization*, p. 58 and Sperling, "A Captivity...," for Sino-Tibetan relations in the ninth century.

11. *Wen Wu*, pp. 73-78; see also Richardson, *Corpus of Inscriptions*, p. 155 and pl. 15 for a third tortoise-base pillar at gTsang-grong.

12. The Gupta Indian style celestial beings can best be seen in *Wen Wu*, p. 74. Richardson, *Corpus of Inscriptions*, pls. 1, 4, 5, 6, 9, 11, 12 and 13 provides a survey of decorative detail, bases and canopies on Tibetan columns.

their queens, in collaboration with religious advisors. Later sources stress the significance of these monuments, which are the most concrete evidence of the "First Diffusion" of Buddhism under the "Great Religious Kings", and there is independent corroboration of the foundation of many of the structures in contemporary edicts and documents. The problem for the art historian is *in situ* verification of those parts of these ancient and holy buildings, which might date from the imperial period. During Songtsen Gampo's reign, the Jokhang and the Ramoche temples were founded in Lhasa to house, respectively, the images of Akshobhya Buddha brought to Tibet by the Nepalese consort and that of Shakyamuni brought by the Chinese consort. The Chinese and Nepalese images were interchanged between the two temples during the reign of the next *tsenpo*,[13] and the continued embellishment and sanctity of the images has prevented modern investigation of their style and age. However, the wooden columns and beams around the main sanctuary in the Jokhang, carved in the style of Gupta India, may date from the seventh century.[14] Meanwhile, the Ramoche temple remains in a state of disrepair.[15] Also in Lhasa, are life-size clay images of Songtsen Gampo, his two foreign wives and his ministers. These are displayed in the Potala, the seventeenth-century palace built on the site of an earlier fortress (see Volume I, cover and illustration, pp. 36-37). Similar images of the *tsenpo* and the two wives are in the Jokhang. Overpainting and cloth covers prevent a clear analysis of these portraits.[16]

The other major location of imperial foundations is the Yarlung Valley and the adjacent area just north of the Tsangpo River. Samye (P43), the monastery founded by *Tsenpo* Trisong Detsen (reigned 755-ca. 797-98), lies midway between Lhasa and Yarlung. Later renovations and additions have altered this structure supposedly modeled after Indian monastic complexes in Bihar. An inscribed pillar and a bronze bell on the site are of unquestioned eighth-century date, but the architecture itself has not been subject to close historic analysis. A temple in the vicinity of Samye, however, has been investigated recently by the Chinese; called Drakmar Keru and founded by Tride Tsugtsen (reigned 704-755), it was the birthplace of his son, Trisong Detsen. Although the building was expanded in the eleventh and sixteenth centuries, an eighth-century chapel is still intact. Of interest here are polychromed clay images of eight bodhisattvas and two donors (portraits of Tride Tsugtsen and his Chinese wife), each ten feet high, with inscribed wooden "soul poles" (see page 31), and birch bark manuscripts visible in the damaged backs of the heads. The style of the images is related to that of the imperial portraits in Lhasa; the garment type is close to those on Buddhist figures in Sui and Tang China.[17]

13. Shakabpa, *Tibet,* pp. 25-27.

14. The worn condition of the carving make it difficult to assess whether Nepalese carvers, working in a post-Guptan manner, executed this work as is traditionally believed; Henss, *Tibet,* pp. 66-68, plan p. 71. Nepalese antecedents can be seen in Licchaivi period carvings in the Kathmandu Valley; see Slusser, *Nepal,* pls. 310-12, and Pal, *Art Nepal I,* fig. 160-65.

15. Henss, *Tibet,* photos, p. 84.

16. See Deng Ruiling et al., *Potala Palace,* figs. 60, 61, 62 and 64, and Henss, *Tibet,* fig. 31 for the Potala images; see Henss, fig 15 and Ngapo Ngawang Jigmei et al., *Tibet,* fig. 170, for the Jokhang images.

17. *Wen Wu,* pp. 65-72.

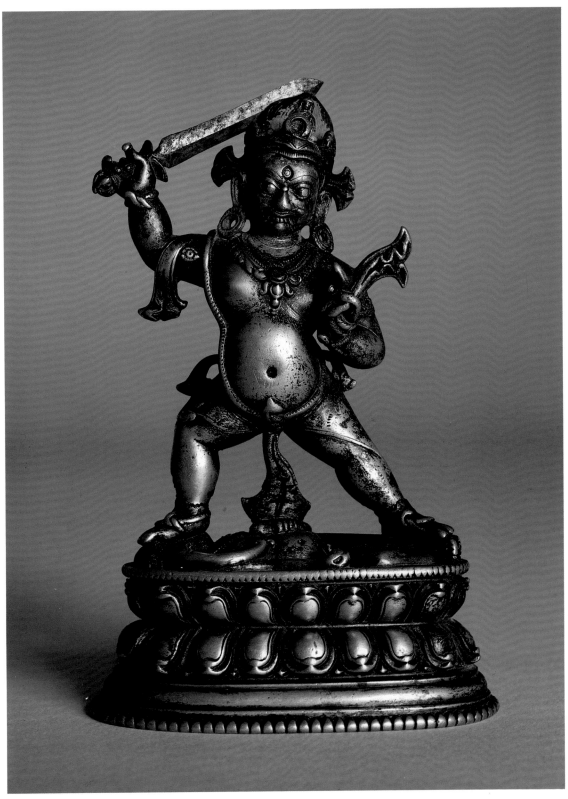

PLATE 1
Vighnantaka
S11

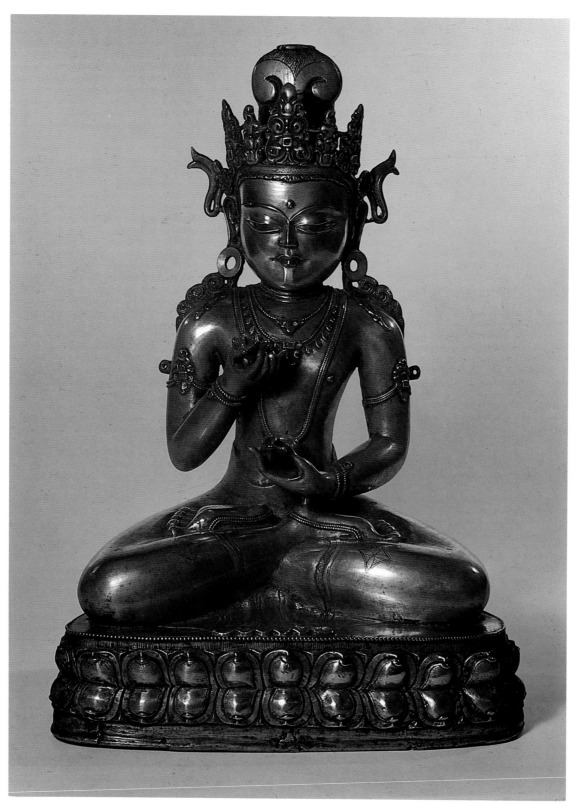

PLATE 2
Vajrasattva
S25

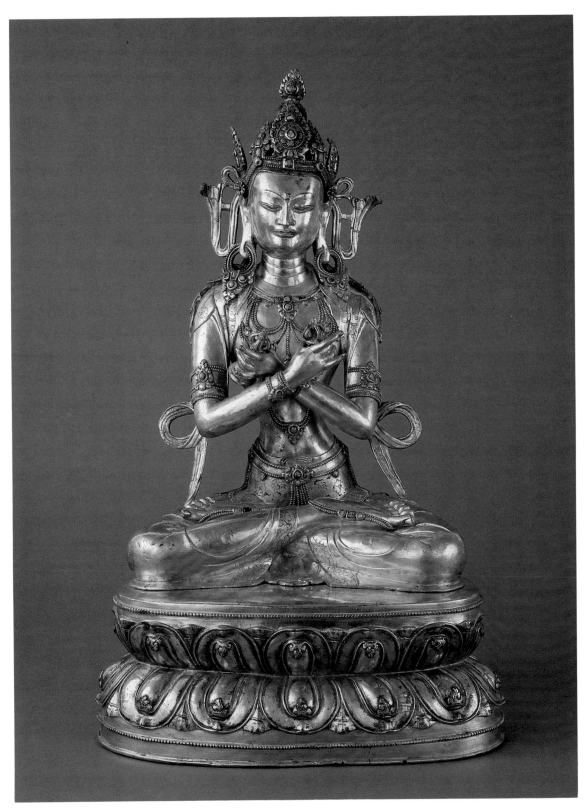

PLATE 3
Vajradhara
S28

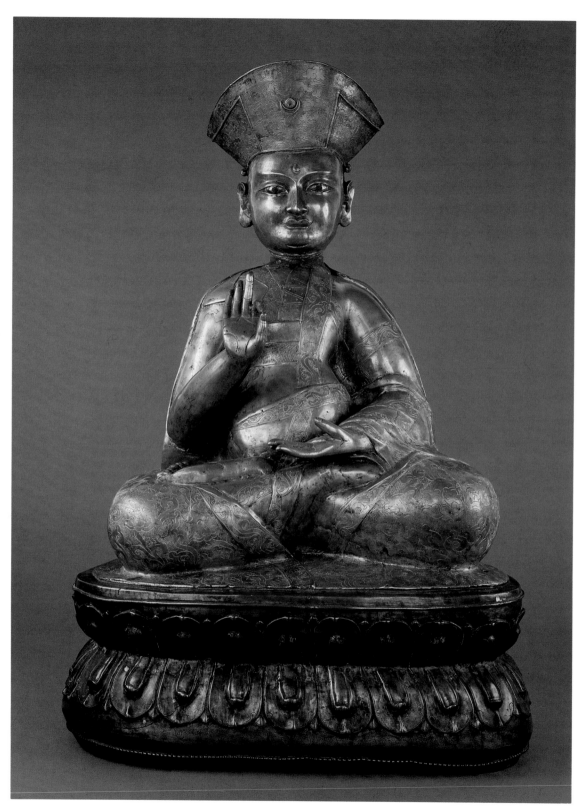

PLATE 4
Lama Gyawa Gotsangpa
S30

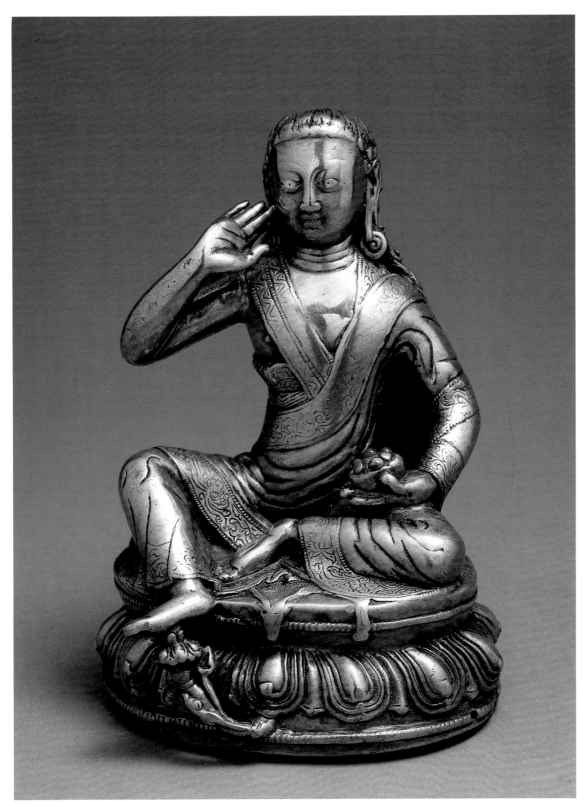

PLATE 5
Milarepa
S32

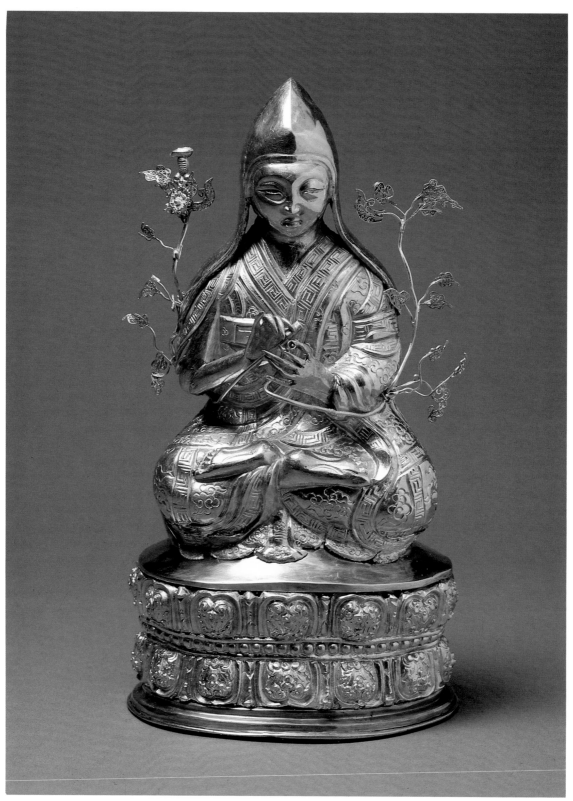

PLATE 6
Tsongkhapa
S41

PLATE 7
Illustrated volumes of the *Prajnaparamita*
P3

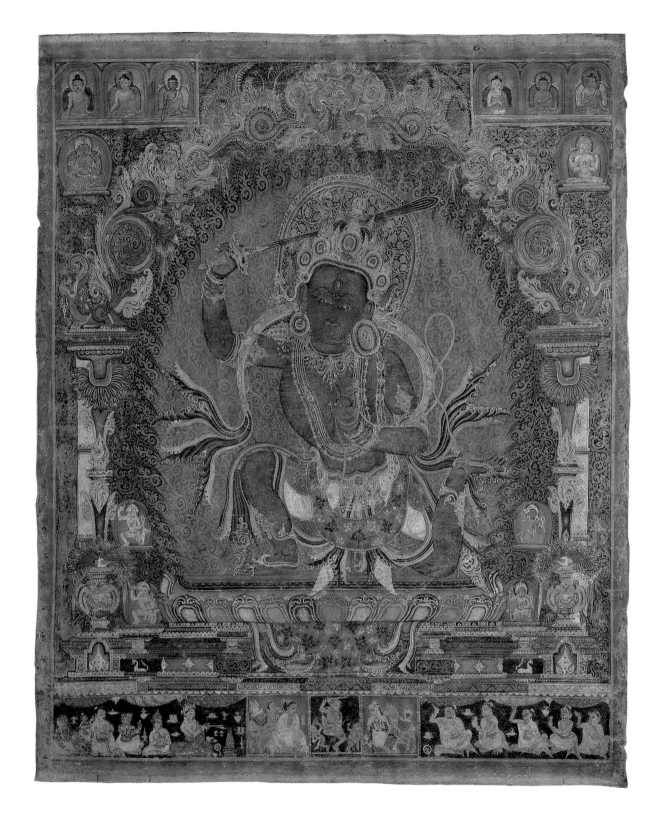

PLATE 8
Chandamaharoshana
P5

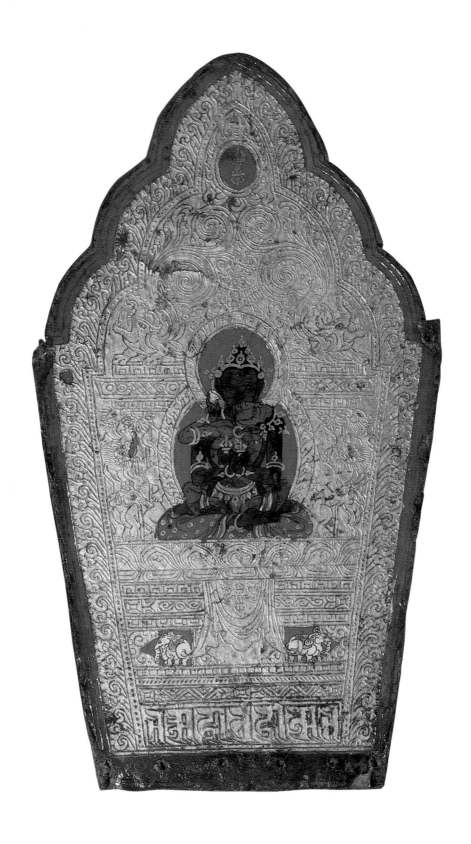

PLATE 9
Crown (detail)
P6

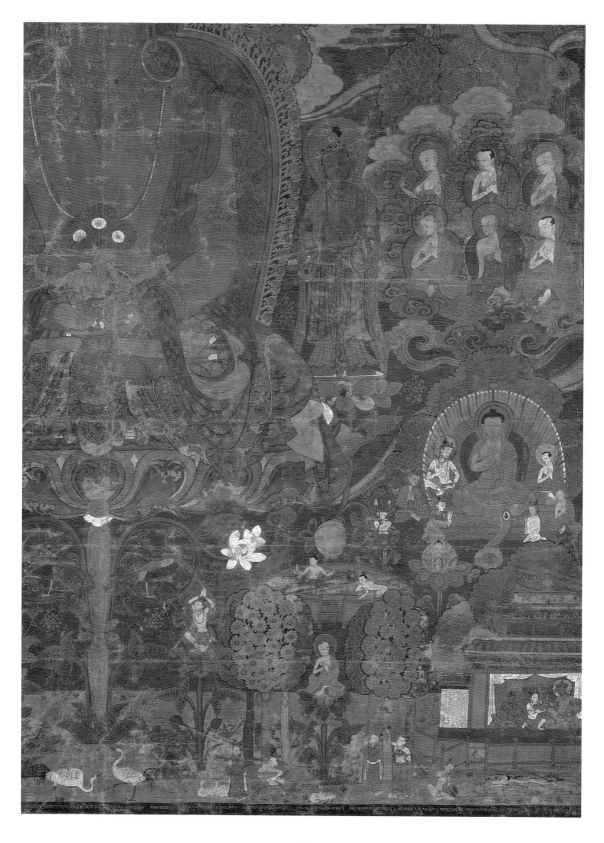

PLATE 10
Paradise of Amitayus (detail)
P7

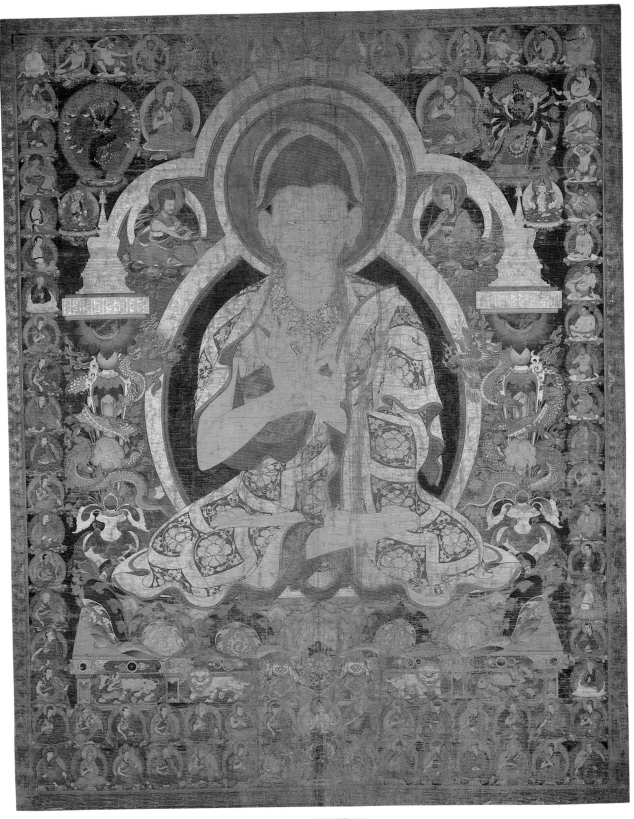

PLATE 11
Portrait of Sonam Gyatso
P12

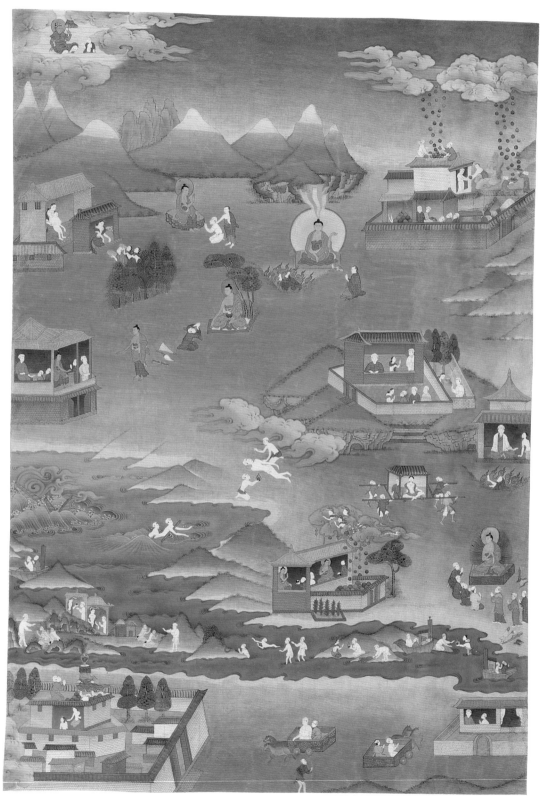

PLATE 12
Scenes from the *Bodhisattva Avadanakalpalata*
P13

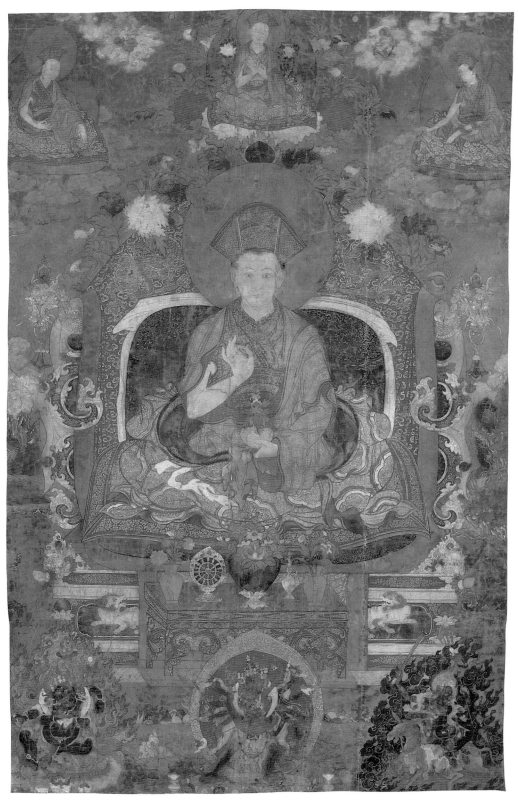

PLATE 13
Portrait of a Drukpa Lama
P16

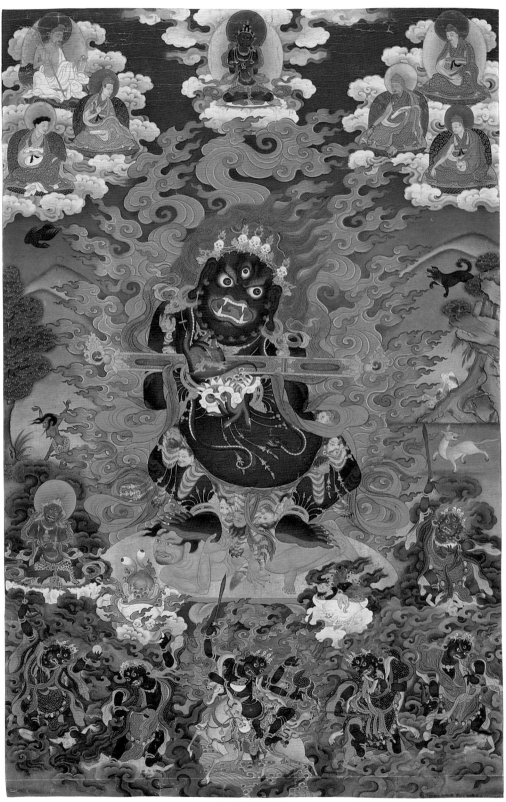

PLATE 14
Mahakala as "Lord of the Tent"
P27A

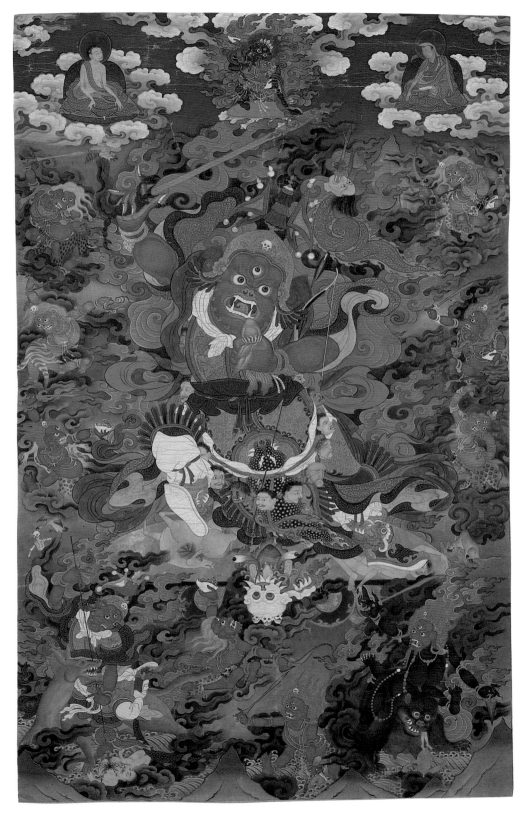

PLATE 15
Begtse
P27B

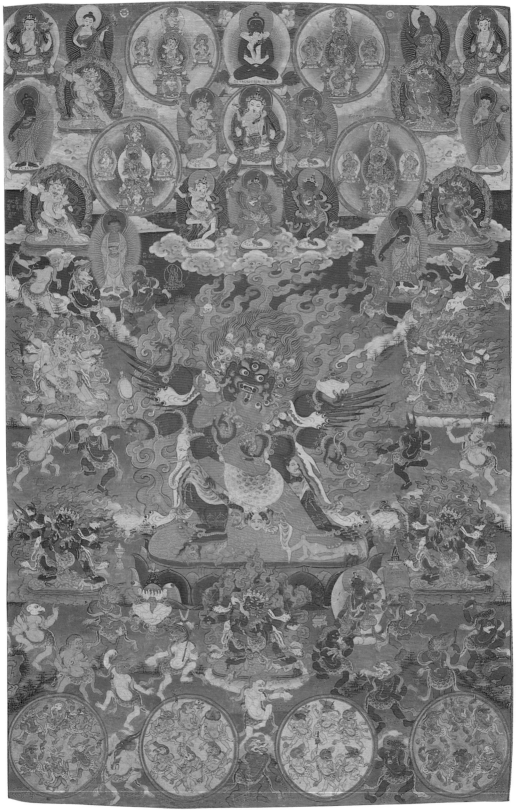

PLATE 16
Mandala of the Fierce and Tranquil Deities
P25

Traditional accounts of the "First Diffusion" period, contemporary edicts, chronicles and records, and the few certain physical remains from the seventh to the ninth centuries all attest to a rich cultural milieu, at least on the level of the imperial court. Supported by indigenous traditions as well as drawing upon the varied influences of the ancient civilizations at the "four borders", an artistic mix was created that was already recognizably Tibetan. A period of political upheaval and religious realignment culminated in the downfall of the imperial dynasty in the mid-ninth century. The royal tombs at Yarlung and the main Buddhist temples and monasteries established by the court were abandoned, while control of the frontier in Central Asia and China was lost. But even if, in the course of the strife, monasteries were destroyed and monks dispersed, Buddhism was by then too firmly entrenched in Tibet to disappear. Small groups of disciples clustered around individual masters in hermitages throughout Tibet, continuing the transmission of the teachings. These groups, deprived of the protection of a centralized government which could ensure their subsistence and cohesion, integrated local non-Buddhist deities and practices into their teachings. The iconography and names of these deities became incorporated into Tibetan liturgy in the eleventh century, when Buddhism again flourished in Tibet.[18]

3. Artistic influences reaching Tibet, and internal developments of the tenth to fourteenth centuries

When historic records resume in the mid-tenth century, a resurgence of Buddhism is attested in both Eastern and Western Tibet. Descendants of the Tibetan royal line had moved west to Guge, near Kashmir and northwestern India, and monks fleeing the persecution and strife in Central Tibet had moved east to Amdo and Kham. The kingdom of Guge, drawing upon the Buddhist heritage of India, made a significant impact on the religion and art of Western Tibet, while the remnants of monastic groups from Central Tibet found, in Northeastern and Eastern Tibet, support for Buddhist doctrines in their fellow refugee monks from Khotan (fleeing Muslim persecution) and in the adjacent Xixia (Minyak) and Uighur states. Although in opposition to each other, the kingdoms which formed in the regions now covered by the Chinese states of Qinghai, Gansu (including the important site of Dunhuang) and Sichuan gave support to Buddhism and provided new mixtures of Sino-Tibetan and Central Asian cultures after the disintegration of the centralized Chinese and Tibetan empires. The Tangut state of Xixia which, from 982 to 1227, ranged over the areas of northwestern China once ruled by the Tibetan empire, was an important cultural link between the emerging Central Tibetan Buddhist communities and the northwestern Chinese frontier.[19]

In Western Tibet, seeking to restore the orthodox Buddhist tradition, the Guge king, Yeshe Ö, sent students to the great monastic centers in northeastern India and Kashmir. The outstanding student was Rinchen Zangpo (958-1055), who returned from his final trip to Kashmir with many Buddhist texts and a large retinue of artists.

18. See Snellgrove and Richardson, *Cultural History,* pp. 95-110, and A.M. Blondeau, "Le Tibet, Aperçu Historique et Geographique," *Essais,* p. 15, regarding possible Nyingma and Bon developments during this ninth to eleventh century period. See also P26-29, 31,33,34.
19. Stein, *Tibetan Civilization,* pp. 70-71.

Kashmiri monasteries excelled in the study of the class of texts called *Yoga-Tantra* ("Rites of Yoga"), which emphasize the five-fold nature of Buddhahood, symbolized by five buddhas and attendant bodhisattvas with Vairochana at the center. These tantric liturgies and related meditative practices could be carried out in a monastic setting. Outside the monasteries, individual masters who sought additional techniques or powers (*siddhi*) while using the *Yoga-Tantras* were known as *mahasiddhas* (see page 39). The study of the *Kalachakra Tantra* (S5) may have originated in northwestern India or in Kashmir, since Kashmiri masters apparently played a major role in introducing this liturgy, as well as those of the *Yoga-Tantras*, to Tibet. The form of Buddhism utilizing these texts is called Vajrayana ("The Adamantine Way") or Mantrayana ("The Way of Spells").[20]

Artistically, Kashmir had preserved the ideals of Gandhara and Western Asia, refined by the artistic developments of Guptan art, in a cultural phase that reached its height in the eighth century. When Tibetans went to study in Kashmir in the eleventh century, the distinctive Kashmiri sculpture and painting featured pinched waists, exaggerated musculature, large eyes under arching brows and elaborate, festooned crowns (S2-3). Kashmiri stylistic influence is noticeable as late as the twelfth century in the Western Himalayas (S4-6), but the areas of its political and cultural prominence were by then diminished. At this time the renewed growth of Buddhism in Western Tibet created new opportunities for Kashmiri artists and religious masters in need of patronage.

The artists accompanying Rinchen Zangpo were quickly put to work decorating the temples and monasteries he founded in Western Tibet, with the support of Guge rulers. These temples vividly document the conventions of Vairochana-cycle mandalas and the buddha pentad used to illustrate the liturgies of the *Yoga-Tantra* texts.[21]

To complement the efforts of the Kashmiri masters, the Guge rulers looked to the eastern Indian monastic universities in what is now Bihar, Bengal and Orissa. The Bihar-based, Pala dynasty (ca. 750-ca. 1150), had inherited the cultural legacy of the Guptas and maintained the last great Buddhist civilization in India. The influence of non-celibate yogic and contemplative techniques, which had absorbed Hindu beliefs and deities, can readily be discerned in the "Supreme Yoga" *tantras* particularly esteemed in Pala India. The primary manifestations of these rituals appear as semi-wrathful deities, e.g., Heruka, Hevajra, Samvara, etcetera. In monastic practice of these *tantras*, the yogic sexual union was reinterpreted for its "implicit meaning". For the monks, the whole process became one of mental visualization in which the posture of sexual embrace embodied the enlightened mind's union of wisdom and compassion.[22] Few Indian examples of "Supreme Yoga" tantric images in this posture are extant, but the *yab-yum* ("Father-Mother") pose became prevalent in Tibet.[23] The debt owed by Tibet to the art as well as the liturgies of Pala India is

20. Snellgrove, "Buddhism in North India and the Western Himalayas," *Silk Route,* p. 78.
21. Ibid. pp. 65-77.
22. Ibid. pp. 77-78.
23. The union of semi-wrathful forms with female consorts is more commonly shown in a side-by-side posture in Northeastern Indian art; see fig. 5. See AAI, fig. 18.14 for an example of an excavated Pala image in sexual embrace.

considerable. Elements of the Pala artistic tradition, such as Indian costumes and physiognomy, tiered hairstyles, ovoid haloes, and jewelry motifs, were transmitted to Tibet through manuscripts (P1), images (figure 5),[24] paintings, and by artists, pilgrims (Tibet to India), and missionaries (India to Tibet).

The most prominent Indian sage invited to Tibet was Atisha (982-1054) (S40). Born into a noble family in Bengal, he had studied and taught at the universities of Bodhgaya, Odantapuri and Vikramashila. Not only was Atisha eminently knowledgeable in both tantric texts and the philosophical "Perfection of Wisdom" literature, according to his biography, he was accomplished in the arts of calligraphy, carving, bronze casting and drawing, as well. After a brief stay in the Guge kingdom, where he was highly acclaimed and influenced Rinchen Zangpo, Atisha traveled to Central Tibet in about 1045, where he discovered the early monasteries in various states of disarray. He also found, however, a core group of disciples, some of whom had traveled from Eastern Tibet to meet him. There, in Kham and Amdo, various currents of Buddhist teachings had been preserved in the aftermath of the fall of the Central Tibetan dynasty.

Atisha's presence in Central Tibet inaugurated an era of intense religious activity, the "Second Diffusion of Buddhism," evidenced by numerous translations from Sanskrit to Tibetan, the restoration of early temples, and the foundation of monasteries throughout Tibet. Tibetans traveled to Bihar and Nepal to study with yogins and monks, who passed on the fruits of their individual mystic experiences. Due to increasing Muslim pressure across northern India, Pala and Kashmiri masters fled to Tibet, where their skills were much appreciated. Within a century, from about 1050 to 1150, three major schools of Tibetan Buddhism were created: Kadampa, centered around Atisha; Sakyapa descended from Drogmi, who studied with yogins first in Nepal then in India; and Kagyupa, whose lineage stemmed from Marpa, who had also studied with Indian yogins. Those who practiced the texts as translated during the "First Diffusion" period are called Nyingmapa, literally "the Ancient Ones," in reference to these three later schools. Each school, and eventually its sub-schools, is distinguished by the study of particular texts and the deities mentioned therein, but students traveled from master to master to learn new texts and mystic techniques regardless of dogmatic rivalry. Thus, they were exposed to a plurality of doctrines, techniques and related icons.

It is clear that direct Pala influence, as imported by Atisha and other Indian masters, was the primary artistic antecedent for Tibet during this period. In sculpture and painting the Pala style flourished, from approximately the mid-eleventh to the mid-thirteenth centuries, across a vast region extending from Ladakh in the Western Himalayas to Chinese Central Asia. Several examples of Tibetan work in The Newark Museum clearly show Pala influence: S7-11 and P2-3. Of these, the chorten (S9-C), drawings (P2) and manuscript illustrations (P3) have been radio-carbon dated to between the eleventh and thirteenth centuries. Other datable materials in this style are woodblock prints, textiles and paintings recovered at the Xixia settlement of Kharakhoto.[25] The Kharakhoto paintings and illustrated Buddhist texts

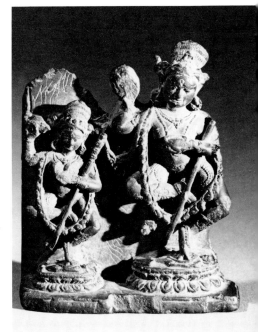

FIGURE 5

Heruka and consort
Chlorite stone, h. 3⅛" (7.9 cm); Eastern India, 11th-12th centuries
Purchase 1986 the Members' Fund 86.44

24. Pala metal images can be seen in photographs of the altar at Sakya monastery in Southern Tibet, von. S., p. 464.

25. *Sino-Tibet*, pp. 20, 35-42, and DDH, pp. 76-85.

include chortens, bodhisattvas and monks similar in form, pose and adornment to those of the Newark dated drawings and manuscripts (P2-3).[26] All of this material must have been executed prior to the devastation of Kharakhoto by Genghis Khan in 1226. The Pala style is also to be found at Dunhuang, both in wall and scroll paintings. These were executed, most probably, during the Xixia occupation of 1036 to 1227.[27] The Kharakhoto and Dunhuang materials (which are now corroborated by the dated Newark Museum chorten, drawings and manuscript illustrations) have helped to date a significant group of tankas now in Western collections.[28]

Tibetan sculpture based on Pala prototypes has survived in great numbers and is more difficult to date. The discussions for entries S7-11 give the range of geographical locations, metal types and techniques for small portable metal images in the Pala style. Current investigation of the vast amount of *in situ* material is lacking. A final problem with regard to the Tibetan Pala artifacts is just how late artists continued to work in this style. Direct contact with India ceased abruptly with the devastation of all Buddhist institutions by the Muslin invasions during the last years of the twelfth century. Tibetan and refugee Indian artisans probably continued to rely on the established Indian ideal into the early thirteenth century but, in Central and Southern Tibet, a new reliance upon Nepal for artistic inspiration is apparent a few decades later. We must turn to China for firmly dated evidence of the new style.

The Mongols, who founded the Yuan dynasty in China (1279-1368), are known to have been in contact with Tibetan monks shortly before Genghis Khan's conquest of Xixia in 1226-27.[29] Following a Mongol threat to Tibet's northern borders, the most prominent Sakya lama, Sakya Pandita (P14), was summoned in 1244 to the Mongol camp in Kokonor. There, in addition to giving religious instruction, he interceded as political negotiator to sway the Mongol invasion of Tibet. Consequently, the Sakya order was assigned political control over Central and Southern Tibet. In 1253, Kublai Khan became the patron of Sakya and appointed Phagpa, Sakya Pandita's nephew, as his preceptor. Sakya lamas continued to occupy this prestigious post until the fall of the Yuan dynasty in 1368.[30]

Sakya artistic relations with Nepal were well established by the mid-thirteenth century, due to Sakya dominion in Tsang, Southern Tibet, where there was close contact with the Kathmandu Valley, across the Himalayas. The Sakya monks particularly esteemed the work of Nepalese artists, whom they engaged for architectural, sculptural and

26. *Sino-Tibet,* pls. 16-22, DDH, pl. 22-31, 33.

27. For wall paintings see Dunhuang Research Institute, *Dunhuang Mogao Caves,* vol. 5 (Japan, 1982), pls. 154-57 (cave 465); for scrolls see Roderick Whitfield, *The Art of Central Asia, The Stein Collection in the British Museum* (Japan, 1982), pls. 15, 16 and fig. 39, and pl. 53, figs. 98, 99 and 100; dates are disputed but probably fall under Xixia occupation.

28. Pal in TP, pp. 29-45, has given the most recent and succinct discussion of these tankas, identifying them as "Kadampa" after one of the main schools of Tibetan Buddhism flourishing in this time period. The link between Pala painting and this group of tankas was first identified by John C. Huntington, "The Styles and Stylistic Sources of Tibetan Painting," (Ph.D. diss., UCLA, 1968), pp. 14-29, 44-65.

29. *Sino-Tibet,* p. 42.

30. See Herbert Franke, "Tibetans in Yuan China," *China Under Mongol Rule,* ed., John D. Langlois, Jr. (Princeton University Press, 1981), pp. 296-328, for a full account of the relationships between Mongol rulers and Sakya hierarchs.

painting projects in Tsang. The Nepalese had developed a distinctive metal casting and forging tradition (S14-18), and a painting style unique to themselves (P4-6).[31] In about 1261-62, it is known that eighty Nepalese artists were working in Tibet to build a golden chorten under Yuan and Sakya patronage. At the request of Phagpa, upon completion of this project, the head artist, a young member of the Nepalese royal family, Aniko (1245-1306), was invited to Kublai Khan's court in China. Aniko's fame and importance in China, where he worked until his death, are well attested in the Yuan chronicles.[32] Although no documented examples of Aniko's work have survived, there are some extant sculptures and woodblock prints in a striking Nepalo-Tibetan style which are dated during Aniko's life span.

An interesting group of Nepalo-Tibetan stone relief sculptures were carved in a cave complex at Feilai Feng, in southeastern China, with Chinese inscriptions dating from 1282 to 1292. Notable among these are a heavy-bodied Kubera (Jambhala), naked, except for floral or jeweled garlands and a leaf-form crown, and an equally corpulent Vajrapani, who lunges in *alidha* pose and grasps a *vajra* in his raised right hand.[33] The round, popping eyes, jeweled disk earrings, swirling scarves, "flaming" hair and squat bodies of these figures are elements familiar in the fourteenth-to-sixteenth-century Nepalo-Tibetan repertoire (see P5, S20,21,23), and it is surprising to find them in Southern China at so early a date. A recently published portable stone image of Mahakala in an even more ornate and exaggerated Nepalo-Tibetan style has a Tibetan inscription dated 1292, which mentions Phagpa lama and Kublai Khan, thus connecting the work directly to Aniko's chief patrons.[34] The transition from the Pala-influenced style of earlier centuries to the Nepalese late thirteenth-to-fifteenth-century style can be observed in several woodblock-printed editions of the Buddhist canon. The *Tangut* (Xixia) *Tripitaka*, printed in Hangzhou in 1302, and the Chinese *Jishazang*, printed on the island of Jisha near the same city in 1306 to 1315, have frontispiece illustrations of round-faced buddhas, bodhisattvas and monks, seated on elaborate thrones, with complex nimbuses and *prabhamandalas* similar to those of P4, 5 and S17. These prominent figures reflect the new idiom, while the massed attendants are in mixed Chinese and Nepalese styles, and at least one illustration has semi-wrathful, protector figures similar to the Feilai Feng Vajrapani.[35]

That Yuan China should have produced numerous examples of Nepalo-Tibetan esoteric art is not surprising in view of the unique and

31. Nepalese artists were almost exclusively Newars, the ancient Buddhist ethnic group based in the Kathmandu Valley. Because of the sustained contact between Tibet and Nepal, earlier Newari influence can be detected, for instance, in the seventh-century Jokhang at Lhasa, and the image of Maitreya, S7.

32. See Erberto Lo Bue, "The Newar Artists of the Nepal Valley. An historical account of their activities in neighboring areas with particular reference to Tibet-I," *Oriental Art* (Autumn, 1985), p. 265, nn. 60-70 and *Sino-Tibet*, pp. 21-23.

33. Richard Edwards, "Pu-Tai-Maitreya and a Reintroduction to Hangchou's Fei-lai-feng," *Ars Orientalis* XIV (1984), pp. 5-50, figs. 38-41; note also fig. 44, a very damaged image of the Mahasiddha Virupa, particularly associated with the Sakya lineage.

34. Heather Stoddard, "A Stone Sculpture of mGur mGon-po, Mahākāla of the Tent, dated 1292," *Oriental Art* (Autumn, 1985), pp. 260, 278-82.

35. *Sino-Tibet*, pp. 42-53, figs. 23-30; the prime patron of these printed books was Guanzhuba, a Tangut with a Tibetan education; a manuscript from Dunhuang records his vow to provide a wide dissemination of the texts. The illustration with the wrathful figures is in the Gest Library, Princeton ("Sakyamuni on *vajra* throne preaching to Sitatapatra").

powerful position held by Tibetan clerics in the administration of all Buddhist affairs.[36] The last Mongol emperor, Xundi (1333-1367), commissioned the finest surviving Nepalo-Tibetan monument in China, the Juyong Guan, northwest of Beijing. This gateway, which originally supported three chortens, was completed in 1343-45 under the supervision of a Tibetan Sakya lama and consecrated by the imperial preceptor, another Sakya monk.[37] The front facade has a magnificent relief in the form of a *prabhamandala*, identical in form and decoration to a gilt copper nimbus of Nepalese workmanship, S17. Examples of Nepalese-style sculpture and painting are extremely prevalent in Southern and Central Tibet but, as most lack dates, they are ascribed stylistically to a broad, fourteenth-to-seventeenth-century time span. In light of the dated Chinese material under discussion, perhaps some of the Tibetan pieces are, in fact, earlier.

The Sakya order retained official Yuan patronage in the fourteenth century, but its power in Tibet gradually diminished due to the rise of the Phamo Drupa based in Central Tibet, who established secular rule from 1358. The Phamo Drupa actively encouraged Tibetan nationalism by measures such as reviving Tibetan civil celebrations according to the ancient imperial tradition, abolishing Mongol titles of authority and replacing them with Tibetan ones, and reinstating the code of laws of the *tsenpos*. The relationship with Yuan China had already crumbled due to the waning of Mongol power.[38]

4. The formation and spread of Tibetan styles, fifteenth to twentieth centuries

From the seventh to fourteenth centuries, the history of Tibetan art had largely been that of imported forms. Chinese, Central Asian, Pala Indian, Kashmiri and Nepalese artists and their work were the formative influences while Tibetans served as patrons, interpreters, conduits and apprentices. Traditional Tibetan art-historical documents corroborate the physical evidence of this. The scholars Taranatha, writing in the seventeenth century in Tsang, and Kongtrul, writing in the nineteenth century in Kham, state that until the fifteenth century Tibetan art was dependent on the Beri or Nepalese style. According to both Tibetan authors, the Beri and the Khache (Kashmiri) styles were made up of several elements of which Central Indian and Pala influences are evident.[39] In the fifteenth century, according to Kongtrul, the first indigenous painting school was established in Tibet, the Menri. E. Gene Smith's commentary to *Kongtrul's Encyclopaedia* states:

> Sman-bla Don-grub of Sman-than in Lho-brag [in Southeastern Tibet] founded the Menri School during the first half of the fifteenth century. The significant characteristic of this school seems to have been the incorporation of Chinese

36. See Franke, "Tibetans in Yuan China," pp. 296-328, for a discussion of the powers held by the Bureau of Buddhist and Tibetan Affairs.

37. *Sino-Tibet*, pp. 25-26, and J. M. Addis, *Chinese Ceramics from Datable Tombs and Some Other Dated Material* (London and New York: Sotheby Parke Bernet, 1978), no. 29.

38. Shakabpa, *Tibet*, pp. 73-82; Snellgrove and Richardson, *Cultural History*, pp. 152-55.

39. Tāranātha of Jo-nan (b. 1585), wrote *History of Indian Buddhism*, circa 1608; see TPS, pp. 147-48, 271-76. For Kongtrul, see E. Gene Smith's commentary on the text in *Kongtrul's Encyclopaedia*, p. 42, n. 72.

influences of the Mongol period although Sman-bla Don-grub is credited as well with certain technological innovations such as the use of new pigments. The Chinese pieces which influenced Sman-bla the most seem to have been the Yuan dynasty temple banners, especially the elegant embroideries that came to Tibet in a steady flow as religious offerings to the great lamas from the first half of the thirteenth century. During this period Gtsan [Tsang] was the center of Tibetan art and culture. It is significant that it was here that the Menri School flourished rather than in Lho-brag where Sman-bla began to paint.[40]

The literary description of the Menri style's incorporation of Chinese elements into Tibetan art, is paralleled by the major paintings and sculptures done in Tsang during the fifteenth century.[41] This mature Tibetan style is fully displayed in the decoration of the monumental Palkhor Chöde Kumbum and the adjacent Tsuglakhang in Gyantse, commissioned through Sakya patronage and consecrated in 1427 (figure 1). The Kumbum, a multi-storied chorten, contains seventy-six chapels, while the Tsuglakhang has two stories of rooms, but each are richly decorated with wall paintings and over life-size clay and metal statues. The decoration of certain chapels continued throughout the fifteenth century; the names of over thirty Tibetan artists who worked on this monument have survived.[42] The mural paintings and statues show the flourishing of a sophisticated, integrated style, the Chinese content recognizable as open space, portraiture, drapery and cloud conventions while the deities' scroll and jewelry forms and idealized foliage betray their Indian and Nepalese heritage. Although a hybrid style, the sculpture and painting of the Kumbum, and related monuments in Tsang, display an assured mastery of curving lines delineating poised, animated figures and brilliant color juxtapositions. New and wholly Tibetan are the lively, elegant portraits of monks, *mahasiddhas* and subsidiary figures in the Gyantse Kumbum and Tsuglakhang. The lovely, expressive outlining and particularly graceful poses of these figures is seen also in small-scale work, such as the Paradise of Amitayus (P7) and the manuscript folios (P8).

On the peripheries of Tibet, some dated work shows the regional extension of the mature Tibetan (Menri?) style. These include a Nepalese artist's notebook of 1435, bearing inscriptions in both Newari and Tibetan, which contains sketches showing sensitive portraits of monks, Chinese decorative motifs and Nepalese patterns.[43] A similar assurance is seen in a group of metal sculptures cast in China under the patronage of the Yongle (1403-24) and Xuande (1426-35) emperors. These early Ming emperors reestablished the *chöyon* ("priest-patron") relationship with Tibetan lamas, particularly the Karmapa hierarchs, which had fallen into disuse with the end of Mongol rule.[44] As in the

40. *Kongtrul's Encyclopaedia*, pp. 42-43.
41. See TPS, pp. 179-85, 186-89 for a discussion of several monuments.
42. TPS, p. 705, n. 933, and Tucci, *Indo-Tibetica* IV/I, p. 19.
43. John Lowry, "A Fifteenth Century Sketchbook (Preliminary Study)," *Essais . . .*, pp. 83-117.
44. Elliot Sperling, "The 5th Karma-pa and Some Aspects of the Relationship Between Tibet and the Early Ming," *Tibetan Studies, in Honour of Hugh Richardson*, eds., Michael Aris and Aung San Suu Kyi (Warminster, England: Aris and Phillips Ltd., 1979), pp. 280-89; *Sino-Tibet*, pp. 72-97.

thirteenth to fourteenth centuries, Nepalese and Tibetans served as officials and artisans in the government workshops in Beijing where these images were most probably made. Work bearing the mark of the Yongle reign shows great stylistic coherence, harmoniously blending Nepalese and Chinese idioms with fine attention to detail and the highest quality gilding and casting. A large group of related images (see S22,23), though lacking inscriptions, seems clearly to be the product of the same workshops. These sculptures were being cast when the embellishment of the Gyantse Kumbum was already underway. Of particular interest is the similarity of drapery and jewelry between the sculpture and wall paintings in Gyantse, and the Yongle and Xuande images. This style of ornamentation can also be found in fifteenth and sixteenth century metal, wood and bone objects from Tibet (see S24-29, 34-36).

The propagation of this mature Tibetan style in fifteenth-century China can best be traced through the series of woodblock-printed, illustrated Buddhist texts, commissioned in Beijing between 1410 and 1431. The illustrations give the full range of iconographic types, from peaceful seated Buddhas to wrathful animated protectors, with ornamented lotus petal bases, flaming or scroll nimbuses, and swaying beaded jewelry which are all elements of the style.[45] The earliest painted tankas with Chinese dates are a group commissioned for the Huguo Si temple in Beijing, between 1477 and 1516. The repertoire of decorative forms from the early fifteenth century is retained in these late fifteenth- to early sixteenth-century examples, although a certain dense crowding and ornate fussiness has begun to compromise the power and energy of the painting.[46]

Fifteenth-to-sixteenth-century art in Western Tibet and Ladakh shows the persistence of Kashmiri styles in the broad faces with elongated eyes, arched brows and rhythmically indented stomach muscles.[47] Kashmiri elements in portable sculpture, which is otherwise in the mature Tibetan idiom, may be seen in the Vajrasattva and Vajradhara images, S25,29, and the book cover, S27. In the case of the portrait, S30, the inscription mentioning a Ladakhi monastery makes the provenance certain, but the idiosyncratic characterization renders stylistic considerations risky. The proliferation of portrait images associated with the Kagyupa School (S30,32,33) may be a matter of sectarian rather than regional or chronological style. The over-painting on walls and sculpture in most of the monasteries throughout Tibet, carried out from the seventeenth to nineteenth centuries (and the destruction in the mid-twentieth century), have made assessment of any art remaining at these sites difficult.

45. For the 1410 illustrations (and reprints of the seventeenth and eighteenth centuries) see Imaeda, "Kanjur et Tanjur Tibetains," *Essais*, pp. 23-51, and *Sino-Tibet*, pp. 55-71, 85, 104-11.

46. The dating, provenance and stylistic sources are discussed in a series of articles in *Oriental Art*: J. Lowry, "Tibet, Nepal or China? An Early Group of Dated *Tangkas*," (Autumn, 1973), pp. 306-15; David Kidd, "Tibetan Painting in China, New Light on a Puzzling Group of Dated Tangkas," (Spring, 1975), pp. 56-60; Kidd, "Tibetan Painting in China, Author's Postscript," (Summer, 1975), pp. 158-60, and H. E. Richardson, "Tibetan Painting in China, a Postscript," (Summer, 1975), pp. 161-62.

47. J. C. Huntington, "Gu-ge bris: a Stylistic Amalgam," *Aspects of Indian Art*, ed., Pratapaditya Pal (Leiden: F.J. Brill, 1972), pp. 105-17 and pl. LVI-LXI.

Tibetan sources, such as Kongtrul, state that the second great school of Tibetan painting was founded in the middle sixteenth century. This school, the Khyenri, is associated especially with the tantric cycles in the mandalas of the Sakya sect, and its salient feature is a Chinese sense of depth and treatment of backgrounds.[48] As in the case of the Menri school, we do not have a firm connection between descriptions of this school and any actual paintings. In fact, the predominantly Nepalese style and the conspicuous *lack* of Chinese influence in Sakya mandalas of the sixteenth to seventeenth centuries only add to the confusion. Chinese elements, such as conventionalized clouds and patterned silk garments, had entered Tibetan painting by the fourteenth to fifteenth centuries (as seen in the Tsang monuments discussed on page 23). These are primarily of a decorative nature, however, and seem to derive from imported textiles. A suggestion of spatial depth and an interest in landscape does enter into Tibetan painting, in isolated instances, at least by this time. This can be seen most prominently in two forms of subject matter: portraits of great monks or ascetics, and narrative scenes from the lives of the Buddha. Examples in The Newark Museum are comparatively later in date (see P14-16, 24 for portraits and P13 for narrative scenes) but reflect conventions probably first brought to Tibet during the period of Mongol influence. Intriguing but undated Tibetan *arhat* portraits, which show strong Chinese influences, have been known for some time. On the basis of comparison to Yuan and early Ming Buddhist painting, these tankas are ascribed to the fourteenth to sixteenth centuries.[49] Tibetan *arhat* paintings of individualized monks in spacious, dramatic landscapes of craggy rocks and flowering trees continue through the nineteenth century, never losing their Chinese essence but showing a uniquely Tibetan exaggerated characterization and heightened color.

It is at the end of the sixteenth century when we next encounter a group of firmly dated Tibetan paintings, a set depicting the previous lives of the Buddha which was in the collection of the Chinese emperor Wanli (1573-1612).[50] The interwoven bands of landscape settings for the episodes in these tankas have by now assumed a completely Tibetan character, with snowcapped mountains, gentle green hills and groups of domesticated trees around walled pavilions. Such Tibetan-style settings can be seen as well in a painting in The Newark Museum, P13. The coloration, organization of space and figural types in Newark's painting suggest, however, prototypes other than Chinese. The turbans and robes of the merchants and kings are obviously copied from Indian Mughal painting, as are the softly graduated transitions from pale green to golden buff in the background. The influence of Mughal painting in Tibet has been little explored but contact with India via Kashmir, as well as by way of Nepal, was certainly possible in the early seventeenth century, when the finest Mughal book illustrations were being produced. The moody and sensitive "staring" faces in P13 are especially evocative of late sixteenth-to-early-seventeenth-century Mughal portraiture (although profile or three-quarter rather than full-face poses were the Indian norm).

48. *Kongtrul's Encyclopaedia*, p. 44; Smith's n. 75 mentions that the identity of the founder of the school and its location are not certain.

49. TP., pls. 56-60, pp. 121-28.

50. Pal, *Art of Tibet*, no. 15 and TP., pl. 61.

Tibetan literary sources list two major schools of painting which developed in the second half of the sixteenth to seventeenth centuries. The Karma Gadri school is associated with Chinese Ming painting and flourished, mainly in Kham, during the eighteenth to twentieth centuries.[51] The Menri sarma, or "new" Menri school, was founded by an artist from Tsang, Chöying Gyatso (flourished 1620-65), who worked on mural paintings under the patronage of the 1st Panchen Lama (P15). With the establishment, in 1642, of a centralized government at Lhasa under the Gelugpa order, Chöying Gyatso worked for the Great 5th Dalai Lama, and the Menri sarma school moved its base to the capital.[52] From the second half of the seventeenth to the twentieth centuries, Menri sarma with its mixture of "old" Menri, Nepalese and Chinese forms, and its innovative "stylized realism", became synonymous with a Central Tibetan mode of painting. The school's work enjoyed vast influence in the eighteenth century through several series of woodcut prints based on painted tankas (P14,15,18). In paintings associated with these prints one may note Chinese-derived conventions, such as sharply faceted rocks and waterfalls, and naturalistically rendered trees and flowers. The large-scale portraits which dominate these tankas are, although idealized, lively in pose and expression.

Seventeenth-to-nineteenth-century sculpture reflects the same broadening of stylistic possibilities as seen in painting, but the spatial and decorative features are necessarily limited by the medium. Portraits such as S39,40 and 41, and pacific deities such as S42, 43 and 46 are depicted in elaborate, Chinese-style garments, and draped thrones. However, even sculpture which is created in China, for instance, the Amitayus with Qianlong inscription, S42, betrays a resurgence of Nepalese influence. Compare the draped throne bases with their scrolling *dorje* "legs" in S42, to those in the inscribed Nepalese Sukhavati Lokeshvara and consort, S45. A certain, Nepalese-derived sweetness and youth in the facial type can also be seen in eighteenth and nineteenth century Sino-Tibetan sculpture (S41,42 and 46). According to the biography of the 7th Dalai Lama (1708-57) in 1744, six Nepalese artists, accompanied by Nepalese and Tibetan monks and doctors, were sent from Lhasa to Beijing upon the request of the Qianlong emperor (1736-95) to assist in the building as well as the staffing of Ganden Shin Chah Ling monastery.[53] The influence of such entourages may explain the particular importance of Nepalese style in eighteenth-century imperial Chinese Buddhist art, as in S42. The continued presence of Nepalese artists, particularly metal workers, is confirmed in the chronicles of the Dalai Lamas and other officials. Important commissions of large-scale sculpture and roof ornamentation were often given to Newari artists between the seventeenth and twentieth centuries.[54] Even in the comparative backwater of Dagyab, in Kham, the biographies of the local Lama officials record six separate commissions to Nepalese artists between 1676 and 1735.[55]

51. *Kongtrul's Encyclopaedia*, pp. 44-46 and nn. 77-80.

52. Ibid., pp. 46-47 and n. 82.

53. Biography of the 7th Dalai Lama, woodblock print edition, translation by Nima Dorjee.

54. E. F. Lo Bue, "The Artists of the Nepal Valley - II," *Oriental Art* (Winter 1985/86), pp. 409-20.

55. Biographies of the Dagyab sKyabs mGon, woodblock print editions, translation courtesy of Nima Dorjee.

It is in painting that the Tibetan artists of the eighteenth to twentieth centuries show special brilliance and innovation. When the dictates of the iconography required an abstract organizational scheme, painters could make use of the mandala, the cosmic grid of circles and squares. In the Nepalese example, P11, the concentric rings and central square "sanctuary", with its four entrances, are survivals of a long-standing Indian tradition. Variants of this classic mandala form can be seen in the more abstract diagrams, P38,39, and in the linear depiction, P37. This Vasudhara mandala in which a gold line on a dark blue ground is used alone, is an example of a popular format in the eighteenth to twentieth centuries. The gold line can be used against dark blue or black (P32), or red (P35), "nagtang" or "tsaltang", respectively, or be a black line on gold or orange (P31), "sertang".

The *nagtang* form is used to particularly dramatic effect in tankas of wrathful deities such as Vaishravana and the Nine Dralha Brothers, P29, and Guru Dragpoche, P30. In these, the black background serves as a dark void out of which the diaphanous bodies of the fierce protectors loom as in a nightmare vision. It is in the iconographic forms of the wrathful gods that late Tibetan painting and sculpture is most inventive and forceful. In sculpture, such as the seventeenth-century Vajrapani, S37, and Jambhala and consort, S38, the powerful attitude of the bodies and fascinating menace in the faces, are perceived through the enrichment of surface and setting. In paintings, one can see the same repertoire of central iconic figure in an idealized landscape (although often the scene is of mayhem rather than para-dise, as is appropriate for the wrathful gods), surrounded by subsidi-ary emanations, as in the depiction of saints and pacific deities. The wild exuberance of the central figure(s), however, in these "demonic" paintings is of special interest. The winged Samantabadra and consort of P25, the fearsome, blue-bodied Lhamo on her mule in P26, and the varied wrathful forms in the two sets of protectors, P27,28, are all finely painted with a remarkable balance between energetic movement and exquisitely detailed line and color.

As can be gathered from this discussion, eighteenth-to-twentieth-century Tibetan painting and sculpture exhibits a confusing diversity of subject matter and style. Opinions as to region and date are risky, when there is no information contained in the work to guide us (such as an inscription or a recognizable portrait) or no known provenance. Nepalese and Chinese influence is diffused over the entire geograph-ical region affected by Tibetan culture, and the artistic production of all areas and sectarian groups was dominated by the "mainstream" Gelugpa school. Artists seem to fit their formats, color schemes and decorative embellishments to suit particular themes and subjects (e.g., lama portraits, mandalas, fierce divinities). Hopefully, as we learn more of the work of particular artists or ateliers and have access to the evidence of *in situ* paintings and sculpture, we will be able to better understand the great heritage of Tibetan art from the last three hundred years. The scarcer remains from the previous one thousand years of Tibetan culture similarly elude our full understanding, but we can at least be certain that a body of complex and profound artwork exists to be explored.

II. THE PHYSICAL SETTING AND
THE COMMISSIONING OF RELIGIOUS ART

Tibetan sculpture and painting are for the most part religious in character. Primarily, they express an understanding of and belief in Buddhism,[1] both in its general Mahayana and its more specific Vajrayana forms. One can sense in these works the profound feeling, the complexity of religious faith, and the love of beauty which form the Tibetan aesthetic. The sculpture and paintings can be viewed in terms of surface color and form, but for Tibetans these qualities cannot be separated from their function as sacred representations of deities, saints and teachers. The reverence for sacred images springs from the ancient Tibetan view of spiritual forces in the world, supported by the Mahayana and Vajrayana Buddhist beliefs introduced into Tibet by its Asian neighbors.

Tibetans are wont to make pilgrimages to sacred sites; to grottoes or the residences of holy men or to places associated with great events or specific deities. While traveling, the devout will circumambulate the sacred monuments which crown mountain passes, or will lay a stone

FIGURE 6

Clay images set out to dry before use as consecration items

Jokhang Temple, Lhasa, 1983

Photograph courtesy of Nima and Elizabeth Dorjee

1. The art of the indigenous Tibetan religion, Bon (see Volume I, pp. 31-36), has borrowed much from Buddhism; for protective deities which show indigenous influences, see P26, 31, 33 and 34.

or prayer flag on the pile of rocks at a particular spot associated with the locality's protective spirit. Tumuli of stone inscribed with sacred Buddhist prayers consecrate pilgrimage routes, while gigantic carvings, paintings of prayers or representations of deities inspire and protect the lone traveler. In the hillsides, large stone images may be carved in relief at locations tradition associates with historic visits by religious sages, or by the early Tibetan kings or their wives. There are, also, images of buddhas and bodhisattvas at certain sites, which are believed not to be the work of human artisans but to have miraculously appeared.

Similarly, temples and monastic complexes are constructed at places where eminent lamas have taught, or had mystic visions. It is common in temples to find wall paintings and tankas portraying figures historically connected with the site, or narrative paintings showing Buddhist legends or even circumstances surrounding the building's construction. Many of these icons serve a didactic purpose as well, because the lay population can learn from paintings of edifying legends of the Buddha and of the miracles and glories of the holy people associated with the temples. In villages and towns, itinerant storytellers illustrate their tales by portable paintings, narrating the exploits of traditional heroes or scenes of Buddhist paradise. Examples of these narrative works in The Newark Museum collection are the Wheel of Existence (P40), the Avadanakalpalata Scenes (P13), and the biographical series of Tsongkhapa (P19).

Each private home, humble or wealthy, has a suitably adorned altar for daily offerings. Usually there is a painted or sculpted image of Shakyamuni Buddha, perhaps accompanied by Avalokiteshvara, considered Tibet's patron protector, along with bowls for offerings of water, butter lamps, incense burners and a vase for flowers. Women sometimes donate precious gems from their jewelry to adorn the images. A local monk or lama is occasionally invited to the home altar to perform rites for festive celebrations, healing or rituals associated with a death in the family. A lay person would also have small icons of metal or clay to wear.[2] Both smaller personal and larger family altar icons are commissioned from local artists in much the same way as work for monasteries and temples. Depending on the wealth and social position of the individual or family, the work would probably be modest in comparison.

The devoted also come to temples and monasteries throughout the year to attend festivals and make donations. It is typical to find a large image as the center of the principal sanctuary, where it can be worshiped by circumambulation, touching and meditation. Tibetan society supports the monastic community by financial or material donations to sustain the operation of the monastery and the life of the monks, and to assist in the construction or renovation of chapels and artworks. The monks themselves will sponsor the creation of artwork for the monasteries. Recent reconstruction of chapels in the Jokhang, in Lhasa, and of entire temple complexes at Ganden monastery, demonstrate the collaborative efforts of lay and skilled workers contributing time and material to build complex assemblages of architectural, sculptural and painted schemes under the direction of religious leaders.

2. Regarding these small icons (*tsa-tsa; tokde*), see p. 48 and S13.

III. IMAGE AS PRESENCE: THE PLACE OF ART IN TIBETAN RELIGIOUS THINKING

BY JANET GYATSO

In the Tibetan religious context, a work of art that is a Buddhist image *(kudra)* is not merely a symbolic representation of an ultimate Buddhist truth. Nor is it simply an icon, a rendering of the ideal form of a member of the Buddhist pantheon. It is both of those things, but to the extent that it embodies the form of the Buddha or deity, the image also conveys the presence of that Buddha in its own right.

The canonical sources for the various forms of the Buddha interpret stance, body color, facial expression, hairstyle, number and positions of limbs, clothing, ornaments and accoutrements, as manifestations of certain principles of enlightenment. In some ways these elements function as mediating symbols, referring to the ultimately formless, indeterminate nature of the enlightenment experience itself. The sword in the hand of Manjushri shows his severance of emotional attachment; Vajrayogini's three eyes indicate her omniscient vision of past, present and future; the green hue of Tara's skin color expresses her wisdom-as-efficacious-action. There are also measurement grids for the bodily proportions appropriate to each genre of Buddhist deity. However, the referential function of these iconographic prescriptives is secondary. Ultimately, what is being referred to, or symbolized, is the ground of enlightenment; and that is not something which exists prior to, or independent of, its concrete appearance in the world. In accordance with the tenets of Mahayana Buddhism, nirvana is never separate from the vow to appear in the world to benefit all beings. In this important sense, Tibetan Buddhist aesthetics of form, color and design are based in enlightenment—the shape of the Buddha's body *is* the act of Buddhahood. The image, partaking in and enacting the proportions, colors and attitudes of an aspect of nirvana, becomes an instantiation of that aspect itself. The very perception of those attributes is thought to remind, or put the viewer in mind, of his or her own inherent enlightenment. Thus is the image always more than a substitute for the presence of the Buddha or deity; it radiates its own presence, which for the religious perceiver is the same as that of the Buddha.

The canons for the Buddha/deity's iconography are used primarily for performing visualization meditation *(sadhana)*. The key concept here is that the practitioner is not ultimately different from the Buddha. It is only through deluded thinking that such a duality is conceived. Visualization is seen as a technique to reinvoke the presence of the "actual" Buddha *(jnanasattva)* in the practitioner's own body and experience *(samayasattva)*. In this sense, the practitioner's body is analogous to the material statue or painting: it becomes a support, or receptacle, for embodiment *(kuten)* in which the living experience of enlightenment is activated.

Thus does the monk or lay aspirant imagine that he or she has become the Buddha—physically, verbally or mentally. Moreover, the entire world is visualized as being the Pure Land, the realm of the Buddha, and all of its contents as expressions of that Buddha. When the practitioner of *sadhana* meets with an image of the Buddha in the real

world, it serves specifically as a reminder of one's endeavor to indentify the mundane world with that of the Buddha. For this practice, the painting or statue serves as a model and aid in the development of the ability to visualize. Gazing at the image is recommended as a way of improving the clarity of the mental image produced during the meditation period.

Although the sacred presence of a Buddhist image is already accomplished merely by the fulfillment of iconographical requirements, presence is further invoked in a variety of ritual settings. The spirit of a painting or statue is especially important for initiation ceremonies (abhishekha, T. wang), in which students are formally introduced to the Buddha/deity and its sadhana. The appropriate image, in a prominent position on the altar, is the focus of the rite. During the initiation, the actual Buddha/deity is invited to enter the image and reside there throughout the ceremony. The lama visualizes that the image is the real Avalokiteshvara, or Tara, or Amitabha, and at several points explicitly asks the students to share this imaginative projection. This ritualized visualizing of presence then valorizes the disciple's ceremonial meeting with the Buddha/deity-as-physical-image.

A similar sort of invocation is performed regularly for the images of the central buddhas and protective deities of a monastery or sect. In monastic institutions, it is the responsibility of the monks to propitiate these deities daily. Music, offerings and prayers of praise ensure the continued presence and blessings of the deity in the institution.

In many ways the very history of the image is a factor in its vivification: in what rituals the image has been employed, what monasteries have kept it, and especially what lamas have been in contact with it. The effects of having the visualized presence of the Buddha projected onto the image are cumulative. This begins with the very first ritual involving the image, the consecration ceremony, which is performed immediately after its construction (see pages 56-59). Here, the image is animated for religious use by a lama, who imagines and projects the spirit of the actual Buddha/deity onto the work of art. Symbolic of this animation is the inscription of the mantric syllables "Om ah hum" on the back of paintings, just at the spots where the corresponding psychic centers (chakra) of the deities depicted on the other side occur. For statues, this is further enacted physically by the depositing of sacred relics, mantras and texts inside the statue's body. In particular, relics imbue the statue with their own presence as physical traces of another embodiment of nirvana. A "soul pole" (sog shing) is also implanted inside statues, providing a central "nerve channel." Thus, in the case of statues, not only is its outer form that of the Buddha, but its inner, hidden contents physically repeat the pattern of Buddhahood. Later, the fact that the image was consecrated in these ways is kept in mind by the religious viewer, and this knowledge enhances and enriches one's perception of the image.

When the image comes to be involved in rituals, and is the object of meditative concentration by accomplished practitioners, its religious value increases in the eyes of the community. And when an image is said actually to have come to life—to have spoken to a meditator or to have performed some action (of which there are many stories in Tibet)—it is seen as having a powerfully numinous presence.

There is, further, the factor of the painting or statue's physical being as such. The spiritual presence of a religious image is enhanced by the material out of which it is made. Precious substances, for Tibetans, are concrete analogies of spiritual value (just as despised substances are synonymous with what is repellent in the world). It is for this reason that statues are encrusted with jewels, and paint pigments mixed with crushed gems and rare medicines. Rosary beads are made from seeds, bones or stones that are chosen to correspond, in some way, to the type of visualization practice for which the beads will be used. Similarly, the power of the symbolic form of a ritual thunderbolt (vajra) or dagger (kila) becomes that much more real and awesome when it is made of the treasured meteorite metal (namchag). Again, votive images are thought to commemorate the deceased that much more effectively when their material includes the cremation ashes.

Because, for these reasons, the religious work of art embodies sacred presence, it possesses for Tibetans the ability to "grant blessings" (chin-lap). This is disseminated in a variety of ways: most physically, it occurs in the contact between the devotee's body (usually at the top of the head) and the image. The meeting of bodies is seen as a concrete instantiation of a shared moment in time and space, an intersection of history. There is also the idea that physical contact transmits spiritual value. The transmission of the blessing can be effected by the lama, who touches the aspirant's head with the image, or by the aspirant alone, who can simply lift the image to his or her own head.

Physical contact with an image is particularly significant during the initiation ritual. Here, the lama's placing of the image on the head of the student becomes a symbolic enactment of the student's right to meditatively assume the form of the Buddha, a right which is granted just in that moment of ritual touching. The contact has other meanings as well. It symbolizes the student's link with the lineage of practitioners who have meditated on that same Buddha in the past. It also signifies the student's awe and respect for the Buddha, if for no other reason than because the contact occurs with the student physically subordinate to the image. Again, when a lama places the weighty vajra on the head of the aspirant, exerting a gentle pressure, it reminds the student, by analogy, of the gravity of the tantric vows taken during the initiation and of the heavy consequences if those vows are broken.

Not only does the image physically grant blessings to a person, it also imparts an auspicious cast to its environment. The presence of a holy image renders its immediate surroundings a sacred space. On the large scale, the placement of images and their temples in the landscape relates to ancient ideas about the spiritual nature of Tibet's geography. Some myths conceive of the topography as a dismembered demon. In an important story connected to the establishment of Buddhism in Tibet, primitive Tibet-as-prone-demoness was subdued by the erection of temples and images at key points on the demoness's body; those structures functioned to pin down the country-demoness, civilizing her by means of the new Buddhist presence.

The long-range perspective of sacred topography might also explain the construction of colossal Buddhist statues, often of the future Buddha Maitreya, at various spots in Tibet. Such monuments mark the country as a realm of Buddhism, and function both to herald the coming enlightenment, and to gather and focus meditative attention.

The powerful effect of a Buddhist image on its location continued to be a prime motivation for the building of such structures in Tibet. One of the principal projects of the fifteenth-century saint-engineer, Tang-tong Gyalpo, was the erection of stupas and temples at key points (*metsa*) in Tibet, in order to tame unruly forces.

The presence of a particularly holy image makes that place the site of pilgrimage. The Jowo Rinpoche image in the Jokhang is an outstanding example; pilgrims prostrate their way there from hundreds of miles away. The climax of their journey will often be a trance experience in the image's presence. In Tibetan biographical literature, there are numerous stories of adepts who have received messages from the Jowo and other images.

Monasteries or villages possessing an important image will take great care in its protection and maintenance; its loss or damage would be thought to have grave consequences for the welfare of the local inhabitants, as if the very life force of the area were threatened. It is usually the monastic community or a lay lama who is responsible for such an image's physical upkeep. On special occasions, they will also display the image in processions or make it accessible to the public.

On a smaller scale, installing Buddhist art into a room or building is thought to affect that place in a similarly positive manner. A sacred image is often the first thing to be placed in a new house, even before personal belongings. By keeping the image there, the ongoing presence of that deity is maintained in the home. The effect, in the tantric imagination, is that the entire house becomes the abode of the deity.

The conviction that a deep interaction occurs between images and their surroundings is reflected in the Tibetan predilection to construct structures to enclose images. Clearly, this is not only to protect the art work; statues and holy objects sometimes have a surprising number of multiple cases and wrappings that far exceed the practical need for shielding or padding. Rather, there is the widespread conviction that images require a seat, a domicile. When possible, statues will have a metal box (*ga'u*) in which they can be kept. For larger images, the temple or shrine room in its totality is the image's seat. In addition, small structures may be built on the roof of a house or monastery to contain images of the protector of that building (*gonkhang*). Other "houses" on rooflines are just solid shapes that simply provide a symbolic structure for the presence of the protector (*tenkhang*).

The image inside the house will be installed on an altar, located in a protected and physically high spot in the building, preferably on the top floor. The altar table itself is usually a complex structure of various levels, which allows the images to be placed on the upper levels. On the lower levels are arranged offerings and the symbolic seven cups of water. The water cups are filled every day and emptied the same evening. Other offerings, such as flowers, candles and incense, are common. Personal effects or significant objects may also be put near the image, in order to attract the image's blessing.

Behaviour towards an image is the same as it would be if the living Buddha or diety were present. A large part of the protocol concerns bodily position, directionality, and the hierarchy of bodily parts. Profound significance is attached to the parallel that is thought to obtain between top and bottom in the physical sense, and high and

low in the sense of spiritual value. An example of this attitude is the widely observed rule that only a person's head or hand should be pointed towards an image; never the feet. When approaching the image, devotees convey deference by assuming a slightly bent posture, with the palms of the hands held together near the middle of the chest, in the symbolic gesture of reverence. The more elaborate bodily expression of respect is the full prostration, practiced upon entering a temple or altar room, or at the beginning of a meditation or ritual session. Three prostrations are standard, but Tibetans will also perform them for protracted periods as a means of purification. The common sight of Tibetans prostrating on smooth wooden boards outside of the Jokhang Temple, even to this day in Lhasa, is an instance of this practice.

The devotee can draw near to the image after prostrations, for the purpose of "receiving the image's blessings," as well as to see and appreciate the work of art at close range. Again, the deferential posture is assumed while approaching. One may seek physical contact by bowing the head and touching the top of one's crown to the lower portion of the image, or to the edge of the table where the image is displayed. When remaining in the artwork's presence, the religious Tibetan sits crosslegged on a level that is below that of the object. In a less structured situation than a ritual or sermon, but one that nevertheless puts the devotee in prolonged proximity to the image, there is further protocol. Smoking, arguing, or any sort of action deemed negative in Buddhism is considered inappropriate in the image's presence.

The same expression of respect through physical positioning is observed when moving a religious art object. The image is always held head up. It is carried by a part of the bearer's body that is auspicious—in the hands, or perched on the head or shoulder, but never under the arm. If it falls, it is immediately picked up and touched to the carrier's head.

When images are borne in procession, the bearers will sometimes be seen to have a cloth or mask covering their mouth. This is to prevent the impure breath of the bearer from intruding into the pure atmosphere radiated by the image. Such a procession is usually preceded by incense carriers, who prepare the air through which the image will pass with auspicious scents. More elaborate parades are accompanied by music, thought to please the Buddha/deity. Special vehicles carry the holy presence, and umbrellas and other standards add further pomp and awesome splendor, announcing the approach of a living Buddhist truth: the same measures that are taken when a living lama passes in procession. An image is packed with much care when it is to be transported for a long distance. In addition to wrapping and protecting the object, efforts are made to ensure that the image will remain head up while in transit. The container holding the object is never set on the ground, but rather is placed in a position of honour, upon its own seat or a high shelf in the vehicle.

When an image is to be disposed of, this is done with cognizance of its spiritual significance. Paintings, as well as texts or illustrated pages or religious writing, or even doodles of a Buddha figure, are not thrown into a trash can. Rather they are interred in chortens or hollow places in images, or are burnt solemnly. If the image was particularly revered,

even a small piece of it will be treasured. Damaged metal or clay images will be kept in storerooms, treasuries, or used to consecrate other statues. The older relics link the new image with the history of the previous, and revive it with the same spiritual presence. This occurred recently in a small village in Eastern Tibet when fragments of a destroyed metal image were saved and used to consecrate the new image, see figure 15.

In general, the treatment of images as though they were actual, living buddhas or deities is not limited to the credulous or uneducated. On the contrary, the most highly literate Buddhist scholar or accomplished yogin will maintain this reverential attitude. For the religiously sophisticated, this attitude is informed by an understanding of the psychological and aesthetic impact of the viewing of images. It is precisely the theoretical knowledge of tantric Buddhism that allows full appreciation of the work of art—a consciously devised tool to evoke intimations of the sacred, and of enlightenment.

IV. ICONOGRAPHY

The deities depicted in Tibetan sculpture typically conform to iconographic standards developed over the 2,500-year history of the Buddhist religion. The pantheon is thus extremely large and varied. The chart below refers to deities and historical figures represented in this catalogue.

One of the most common ways of classifying the wide variety of buddha images is the three modes of embodiment, the three *kaya*. *Dharmakaya* is the ultimate state of enlightenment: *dharma* literally means "law" or "truth"; *kaya* literally means "body." *Dharmakaya* is described as unlimited, unborn, unlocalized and formless, but it is sometimes represented as a nude, unadorned buddha. This is especially prevalent in Nyingmapa tankas; note, for example, the Samantabhadra *yab-yum* at the center top of P25. The *nirmanakaya* ("Body of Emanation") is the form assumed for human perception. The historic Buddha Shakyamuni is considered to be a *nirmanakaya*, whose role is to allow the omniscience of *dharmakaya* to appear directly in our world, in a human body, subject to birth and to death. The reason for the great veneration accorded to a living lama, is that he, in his physical body, is also representing *nirmanakaya*. *Nirmanakaya* in Tibetan is *tulku:* "reincarnated lama." Hence, the practice of portraying the religious masters in sculpture and painting developed in Tibet where the *nirmanakaya* concept not only refers to the historic buddhas, but is embodied in a multitude of living or historic religious masters, also. This is illustrated in the portraits, such as P12 and P14. When the Buddha principle is manifest at the intermediary level, between the mundane human perspective and that of the ultimate abstract truth, it assumes the aspect called *sambhogakaya* ("Body of Enjoyment"). The *sambhogakaya* may appear in diverse forms as buddhas, bodhisattvas or *yidams* (meditational deities), all representing various aspects of the character, qualities, attributes and powers of enlightenment. Avalokiteshvara, for instance, whether having one head and two arms, or eleven heads and one thousand arms, is the *sambhogakaya* manifestation of compassion and altruism. Peaceful or wrathful protective deities are often described as *sambhogakaya*. Good examples are the sculptures S10, 16, 23, 36 and paintings P5 and 27. The forms of images found in particular monasteries reflect the specific deities favored by individual lineages.

Chart of Deities and Historical Figures Depicted in the Catalogue

Note: Names are alphabetized within groupings. Phoneticized Sanskrit and Tibetan names are given, followed by the meaning of the name and references to sculpture (S) and painting (P) entries in which the deities or figures can be found. Please refer to the table on pp. 206-208 for transliterated spellings.

BUDDHAS AND ADIBUDDHAS ("PRIMORDIAL" BUDDHAS)

S. Akshobhya; T. Mikyopa "Imperturbable"	Fig. 22A, P6
S. Amitabha; T. Öpagme "Infinite Light"	P2, P4A, P7
S. Amitayus; T. Tsepagme "Infinite Life"	Figs. 13E, 22D, S42, P7, P35, P36
S. Amoghasiddhi; T. Donyo Drupa "Infallible Power"	P4B
S. Maitreya; T. Champa "Loving One" (Buddha of the Future)	S7
S. Prajnaparamita; T. Sherab ki Parol tu Chinpa "Perfection of Wisdom"	P9
S. Ratnasambhava; T. Rinchen Chungden "Jewelled Source"	P6
S. Samantabhadra; T. Kuntu Zangpo "All Goodness"	P25, P30
S. Shakyamuni; T. Shakya Tupa "Sage of the Sakyas" (Buddha of the Present World Cycle)	Figs. 13G, 14, 19A-B, 21A, P2, P21
S. Vajradhara; T. Dorje Chang "Wielder of the Thunderbolt"	S28, S29
S. Vajrasattva; T. Dorje Sempa "Diamond Being"	S3, S25

BODHISATTVAS ("ENLIGHTENMENT BEINGS")

S. Avalokiteshvara; T. Chenrezig "With Pitying Look" (Embodiment of Compassion)	Figs. 10B, 13A, P1A
(Padmapani form)	S16
(Sukhavati Lokeshvara form)	S45, P41
S. Manjushri; T. Jampal "Pleasing Splendor" (Embodiment of Wisdom)	S2, S4

37

S. Tara:	Fig. 12,
White = S. Sitatara; T. Drolma Karpo "White Savioress"	S14, S15
Green = S. Shyamatara; T. Drolma Jangu "Green Savioress"	P23
S. Vajrapani; T. Chana Dorje "Bearer of the Thunderbolt"	Fig. 10A, S6, S13, S20, S37
S. Vasudhara; T. Norgyunma "Patroness of Wealth"	P37

OTHER MEDITATIONAL DEITIES (T. *YIDAM*) AND GUARDIANS (S. *DHARMAPALA*; T. *CHOEKYONG*)

T. Begtse "Hidden Shirt of Mail"	P27B, P28C
S. Chandamaharoshana; T. Miyowa A form of S. Achala "Immovable"	P5
S. *Dakini*; T. *Kadro* "Sky Goer", cloud fairies who assist mankind in their spiritual pursuit	S35A,C
S. Guyasamaja; T. Pal Sangwa Dupa "Union of Mystery"	Fig. 22C
S. *Heruka* Buddhas	Fig. 5, S35B
S. Jambhala; T. Dzambhala "God of Wealth" (also manifests as S. Kubera and S. Vaishravana; T. Namto Seh)	Figs. 7B, 9, 13D, S8, S38, P29
S. Kalachakra; T. Pal Duki Korlo "Wheel of Time"	S5
S. *Lokapala*; T. *Jigten Kyong* "Guardians of the Cardinal Points" (north = Vaishravana, see also Jambhala)	P20, P21 P29
S. Mahakala; T. Gonpo "The Great Black One"	S1(?), S23, S36, P27A, P28D
T. Pehar	P33, P34
S. Samvara; T. Demchog "Best Happiness" (also known as Chakrasamvara)	S21, P11
T. Setab "He Who Wears Armor"	P31
S. Shri Devi; T. Palden Lhamo "Glorious Goddess", Protectress of the Dalai Lamas	P26, P28A
S. Vajrakila; T. Dorje Phurpa "Diamond (unalterable) Dagger"	S12

S. Vajravarahi; T. Dorje Pagmo "Diamond Sow" (appears as a *dakini*)	Fig. 10A-B, S18, S21, S34
S. Vighnantaka; T. Gegtar Ched "Destroyer of Obstacles"	Fig. 7A, S11
S. Yama; T. Shinje "Lord of Death"	P40
S. Yamantaka; T. Sinje Shed "Conqueror of Death" (also known as S. Bhairava or Vajrabhairava)	Fig. 22F, P28B

HISTORICAL OR SEMI-HISTORICAL BEINGS

S. *Arhats;* T. *Drachompa* Indian adepts who reached enlightenment; commonly in a group of sixteen with their religious supporters: Hva-Sang and Dharmatala (dressed as ascetics or monks)	P24
Atisha (982-1054), the Indian monk who came to Tibet in 1042	S40
The lineage of the Dalai Lamas "Ocean of Wisdom-Honored Teacher", the emanations of Avalokiteshvara	Fig. 22E, P42
Gampopa (1079-1153), disciple of Milarepa	S33B(?)
The lineage of the Gelugpa Lamas	S39, P20
The lineage of the Kagyupa Lamas	S30, P16
S. *Mahasiddhas,* "Great Perfect Ones", Indian yogins, often in a group of eighty-four	Fig. 7C, P12
Milarepa (1040-1123) "Cotton Clad", a mystic and poet especially revered by the Kagyupas	S32, S33A(?)
Padmasambhava; T. Pema Chungneh "The Lotus Born" or T. Guru Rinpoche "Precious Teacher," an Indian mystic and magician who introduced tantric Buddhism to Tibet	Fig. 13B, S31, P17, P22B
Wrathful form: T. Guru Dragpoche	P30
The lineage of the Panchen Lamas "Great Scholar", the emanations of Amitabha	P14, P15
The lineage of the Sakyapa Lamas	P12, P14, P22A
The Kings of Shambhala, a semi-mythical Buddhist Kingdom in Central Asia	P18
Tsongkhapa (1357-1419), founder of the Gelugpa school	S39(?), S41, P19, P20

V. BODY MARKS, POSES (ASANAS) AND HAND GESTURES (MUDRAS)

The phoneticized form of Sanskrit and Tibetan terms is used. Please refer to the table on pp. 206-208 for transliterated spellings.

1. Auspicious marks on the head of a buddha:
 S. *ushnisha*; T. *tsugtor* (top knot or bump on head)
 short "snail" curls or wavy hair
 S. *urna*: T. *dzopu* (circular mark between the brows)
 distended earlobes

2. Flexed standing pose:
 S. *abhanga* (light flexing) varies to *tribhanga* (exaggerated "triple" flexing)

3. Lunging to the right:
 S. *alidha*; T. *yehpeh kyang* (the opposite variation, lunging to the left: S. *pratyalidha*; T. *yonpeh kyang*)

4. Combative kneeling pose:
 S. *achalasana*; T. *miyoweh zug*

5. Dancing pose:
 S. *ardhaparyanka*; T. *gartub*

6. Seated in "royal ease":
 S. *maharajalilasana*; T. *gyalpo rolpa*

7. Seated, relaxed:
 S. *lalitasana*; T. *yeh rol*

8. Seated, legs pendent:
 S. *bhadrasana*; T. *zangpo dugdang*

9. Seated in meditation:
 S. *vajraparyanka, padmaparyanka,* or *dhyanasana*; T. *dorje kyildrung*

40

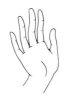
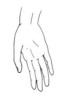
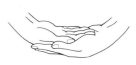

10. Protection or blessing of fearlessness:
 S. *abhaya*; T. *jigme* (upraised or outstretched)

11. Gift-bestowing:
 S. *varada*; T. *chog chin*

12. Meditation:
 S. *dhyana* or *samadhi*;
 T. *samden* or *tingedzin*

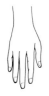

13. Earth-witnessing:
 S. *bhumisparsha*; T. *sanon*

14. Teaching:
 S. *dharmachakra*; T. *chokyi korlo*

15. Reverence:
 S. *anjali*; T. *talmo jar*

16. Argumentation:
 S. *vitarka*; T. *tokpa*

17. Gesture of the indestructable *Hum* syllable: S. *vajrahumkara* or of triumph over the three worlds: S. *trailokyavijayamudra*

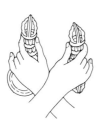
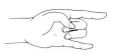
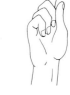

18. Gesture of embracing the *prajna* (wisdom):
 S. *prajnalinganabhinaya*

19. Mesmerizing:
 S. *karana*

20. Threatening:
 S. *tarjani*; T. *dzubmo*

Note:

T. *yab-yum* ("father-mother") is the term for deities embracing their female partners.

Halo is used to describe the radiant light around the head of a deity or saint.

Nimbus is used to describe the radiant light around the body of a deity or saint.

S. *Prabhamandala* ("circle of light") is used to describe the elaborate throne arch around the body of a deity or saint.

ATTRIBUTES

These objects are held by (or displayed in front of) deities and religious figures. For more general symbols, see Volume I, pp. 67-68.

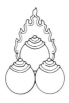

1. "Three jewels":
 S. *tri ratna;* T. *konchog sum*

2. Chopper:
 S. *kartrika;* T. *triguk*

3. Mirror:
 T. *melong*

4. Vajra bell:
 S. *ghanta;* T. *drilbu*

5. Prayer beads:
 S. *malla;* T. *trengwa*

6. Conch shell:
 S. *shankha;* T. *dung*

7. Flaming pearls or jewels:
 S. *chintamani;* T. *yizhin norbu*

8. Vase of ambrosia:
 S. *kalasha;* T. *bumpa*

9. Dagger or "peg":
 S. *kila;* T. *phurpa*

10. Thunderbolt or "diamond" sceptor:
 S. *vajra;* T. *dorje*

11. Begging bowl:
 S. *patra*

12. Arrow:
 S. *shara* or *bana;* T. *da*

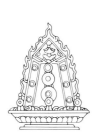

13. Mongoose:
 S. *nakula;* T. *ne'ule*

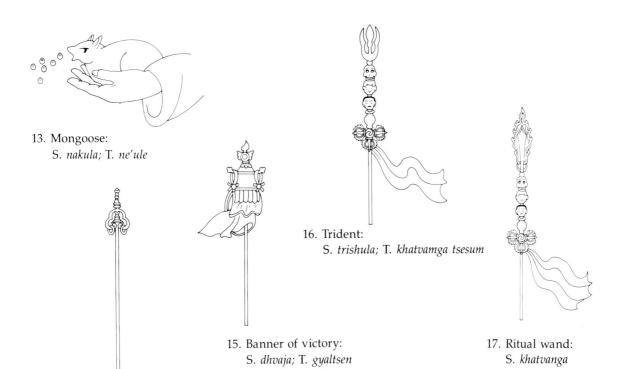

16. Trident:
 S. *trishula;* T. *khatvamga tsesum*

17. Ritual wand:
 S. *khatvanga*

15. Banner of victory:
 S. *dhvaja;* T. *gyaltsen*

14. Alarm staff:
 S. *khakkhara;* T. *kharsil*

20. Skull cup:
 S. *kapala;* T. *todpa*

21. Noose:
 S. *pasha;* T. *zhag*

18. Wheel of the Law:
 S. *dharmachakra;* T. *chökor*

19. Book, scriptures:
 S. *poti, pustaka;* T. *pecha*

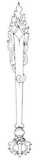

22. Butter offerings:
 T. *torma*

23. Fly-whisk:
 S. *chamara;* T. *ngayab*

24. Sword:
 S. *khadga;* T. *raltri*

25. Skull drum:
 S. *damaru*

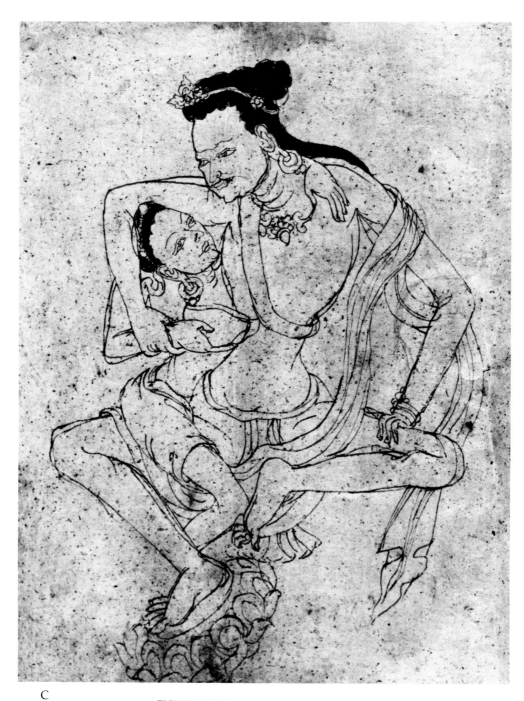

C

FIGURE 7 A-C

Sketchbook

Thin buff paper, bound in blue cloth, 7 7/8″ × 7½″ (20.1 × 19.1 cm) (folded); Nepal, 18th-19th centuries

Anonymous gift 1982 82.235

The five sheets are folded in half to form ten folios, one side of each sheet tinted yellow. Shown are a form of Vighnantaka (A); Jambhala (B), and a *mahasiddha* clutching a woman who offers him a skull cup (C).

VI. SCULPTURE: SELECTION, FABRICATION, FINISHING AND CONSECRATION

Once a decision has been made to commission an image, the person—whether he be a layman, monk, yogin or part of a group (such as a family, a village or a monastic society)—must next approach a worthy artist or artists. Religious advisors, who will have already helped to select the appropriate form of deity, may continue to consult with the artist or atelier to ensure the correctness of the image and will, in any case, be called in to officiate at the consecration. The artist will have recourse to the patron or religious advisors' visualization (whether in a new form or one codified in the *sadhanas*) in oral or written descriptions. Sketchbooks are also quite common. Extant sketchbooks have been found to contain rough sketches and jottings (figures 7-9), as well as finished drawings with accurate proportions and measurements (figure 10). Existing sculptures can also serve as models. Multiple editions of some images are proof of the existence of reusable molds or matrixes as early as the eleventh century (see S4 and 7). The most common, smaller Tibetan sculptures are fabricated in metal, either cast or hammered. Larger images, intended for main assembly halls or chapels in monasteries and temples, can be made of hammered metal but are usually of clay. Outdoor images in the living rock are carved at auspicious locations. Wood and precious materials, such as bone and ivory, are used as well. Each of these materials, and the method of fabrication into a religious image are discussed below.

Some of the most important religious works in Tibet were commissioned by major patrons, such as royal families or monastic officials, as part of elaborate projects which involved the erection and decoration of an entire building. In this case, a large team of architects, sculptors, painters, craftsmen and artisans, working together with religious

A

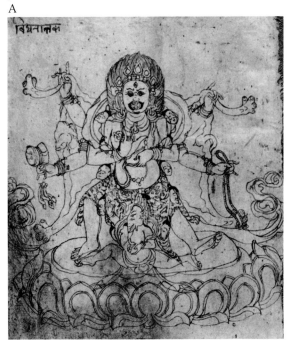

B

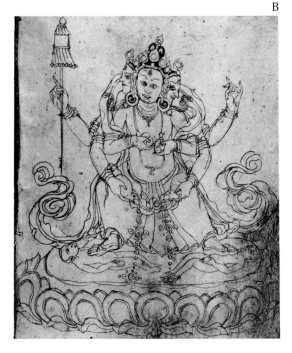

FIGURE 8

Sketchbook

Heavy, yellow-dyed buff paper, 7¼"
× 3⅛" (18.5 × 8.0 cm) (folded);
Nepal, 19th century

Anonymous gift 1982 82.262

The accordian-folded book has black
or red ink on charcoal line sketches,
set vertically across each double
page. The sketch shown is of a
seated buddha with an elaborate
throne and *prabhamandala*.

FIGURE 9

Sketchbook

Medium yellow-tinted paper, 10⅜"
× 4⅜" (26.4 × 11.2 cm) (folded);
Nepal, 19th century(?)

Anonymous gift 1982 82.240

The accordian-folded, incomplete
book of sixteen folios contains black
ink drawings, placed vertically to
the folds with Tibetan inscriptions.
The sketch shown is of Jambhala on
a lion.

advisors, would be involved and the project could take several years.
Biographies of important lamas or political figures and monastic
histories relate the background of these grand schemes. Most of the
sculpture now outside Tibet, however, is of more modest size and
intention and may have involved one patron, a religious advisor and
an artist. The latter might be a monk but a professional layman is more
usual. In any case, certain spiritual preparations are necessary before
embarking on the work. Scriptures might be read, offerings made and
the workplace and tools blessed by a lama. It is important also for a
harmonious relationship to exist between artist, patron and religious
advisor. The artist might be subject to certain abstinences (from meat,
alcohol, onion or garlic) while creating an image. If the subject of the
commission is a tantric deity there are additional precautions, and the
artist must be initiated into the appropriate mandala of the deity.
Certain sacred ingredients may be required, such as earth or water
from a holy site, relics of a lama, or pieces of precious materials, like
gold, coral or herbs. If the image is to be made of clay, these ingredients
are mixed into the clay; if metal, they are mixed with paint and applied
to the inside of the statue after fabrication. Lay artists in Tibet are
generally born into the profession, coming from families of image-
makers *(lhazo),* where they might be raised as apprentices until they
gain master status. It is not unknown, however, for an outsider of
talent and ambition to join a family as an apprentice.[1]

1. Dagyab, "The Professional Artist and His Preparation", pp. 27-28.

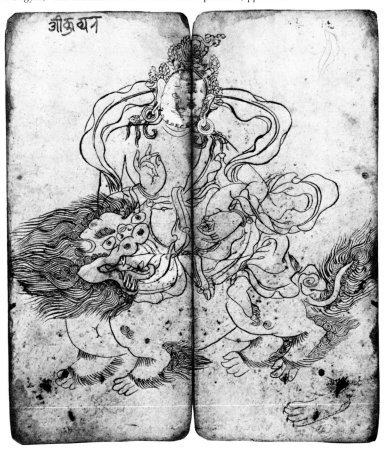

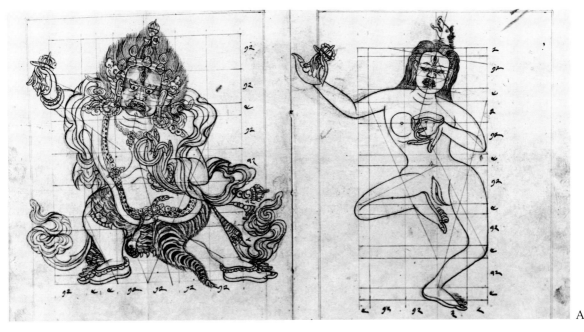

A

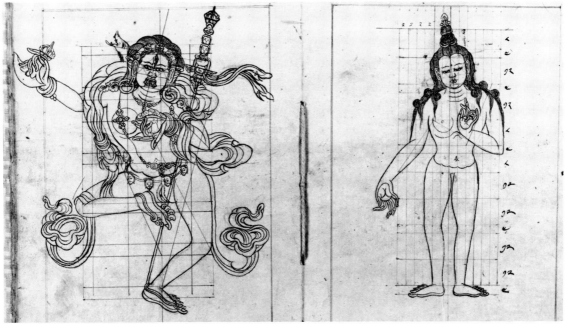

B

FIGURE 10 A-B

Drawing book

Heavy buff paper, bound Western style with center cotton cord; paper covers, finished with silk damask, 11⅛″ × 8¾″ (28.3 × 22.3 cm); Nepal, 19th century(?)

Purchase 1977 Mr. C. Suydam Cutting Bequest Fund 77.276

Notations on the inside front and back covers, give various dates and the information that this is Dinabahadur Lama's *Thigape* (T. "drawing book"). There are drawings of Buddhist deities on both sides of each half sheet, eighteen drawings in all. The work is executed in a fine, precise black line over faint charcoal; the grid for each figure is drawn in charcoal, red ink, or orange ink lines. Twelve drawings have Tibetan numbered grid notations. The folios shown depict clothed Vajrapani (A, left); unadorned Vajravarahi (A, right); adorned Vajravarahi (B, left) and unclothed Avalokiteshvara (B, right).

1. Clay

For sculpture in this medium, a smooth, fine clay is necessary, kneaded together with a one-third proportion of paper pulp for lightness and pliability. For three-dimensional images (see figure 12) the material is worked as a hollow shell from the bottom up. The drying process is controlled by charcoal fires and wet cloths, and the main tool used is a pencil-like stick with a cross-hatched surface at one end and a plain surface at the other. Details, like jewelry, are formed separately in wooden molds and applied to the body (see figure 11). Small, flat, clay images, known as *tsa-tsa* (see figures 13 and 22), are formed in molds, and these are usually made at monasteries. The cast clay images, mixed with paper and/or sacred substances, are then used in amulets or for consecrations. The statues, and frequently the *tsa-tsa*, are finished with polychrome and gilding (see figure 12). Materials for consecration are inserted into the hollow center through the open base or through a special opening at the back; the openings are then sealed following the ceremony.[2] Sculptures made out of butter and/or grain are a technically related form, and are usually small, low-relief, ritual offering pieces (see Volume II). Three-dimensional, butter images were made, however, for important festivals, at the conclusion of which they were ritually destroyed. The butter or grain is colored before it is worked. Two-dimensional grain "paintings" are discussed on page 125.

2. Dagyab, "Clay Sculpture", pp. 46-47.

FIGURE 11

Artist working on clay crown for clay Tara image (see figure 12)

Jokhang Temple, Lhasa, 1983

Photograph courtesy of Nima and Elizabeth Dorjee

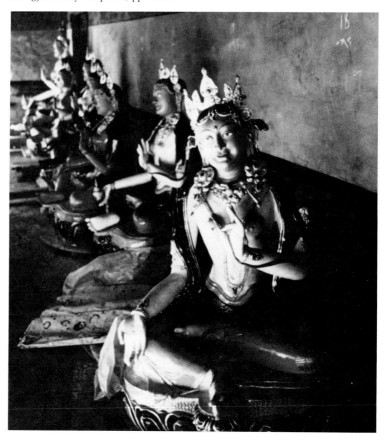

FIGURE 12

Newly fashioned, painted and adorned clay Tara images, approximately 2 feet high

Jokhang Temple, Lhasa, 1983

Photograph courtesy of Nima and Elizabeth Dorjee

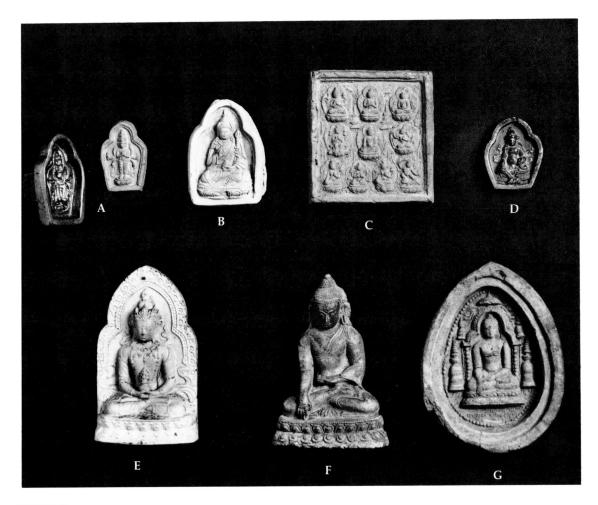

FIGURE 13

Tsa-tsa (top row, left to right):

A. Mold, cast brass, h. 2¼″ (5.7 cm)

Shown with modern clay casting: eleven-headed, eight-armed Avalokiteshvara.

Purchase 1936 Holton Collection. Acquired in Amdo area, circa 1920 36.326

B. Light buff clay (and paper?), shrine shape, h. 2½″ (6.4 cm) Padmasambhava.

Gift of Leo LeBon, 1982. Obtained at Rongpuk, a Nyingmapa monastery in Southern Tibet, 1981 82.207 F-1

C. Light reddish-brown clay, rectangle, h. 3⅜″ (8.6 cm). Assembly of ten deities in three rows; chortens flank upper center deity; tree and rock landscape fills the background.

Gift of Schuyler Cammann, 1959. Obtained in Inner Mongolia, circa 1943-44. 59.108

D. Buff clay, shrine shape, h. 1⅞″ (4.8 cm)

Jambhala, finely painted in colors and gold.

Gift of Valrae Reynolds 1981 Acquired in Lhasa, 1981. 81.373

(Bottom row, left to right):

E. Cast and fired white porcelain, shrine shape, h. 4½″ (11.5 cm) Amitayus, with dots of lacquer and gold leaf. The back has a five-line Tibetan inscription with traces of red paint or lacquer. The porcelain material indicates Chinese manufacture.

Gift of Mrs. M. W. Bryan in memory of Frances G. Wickes 1968. Provenance unknown. 68.84

F. Light reddish-brown clay, h. 4¼″ (10.8 cm)

A three-dimensional image of the Buddha cast in a two-piece mold. Once part of the consecration contents of an image, figure 21A, B.

Purchase 1920 Shelton Collection. Obtained in Batang, Eastern Tibet 20.455D

G. Reddish-brown clay, egg-shaped, h. 4¾″ (12.1 cm)

Shakyamuni Buddha in a shrine with an umbrella canopy; two large, and two small, stupas at the sides. An inscripted Buddhist Creed is below; the back has a scratched-in, four-line Burmese inscription. Pala style; twelfth to thirteenth centuries.

Gift of Schuyler Cammann 1959. Obtained at Pagan, Burma, 1938. 59.107

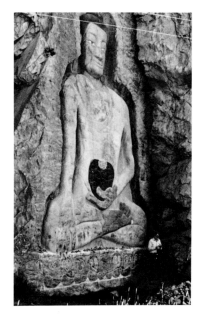

FIGURE 14

Painted carving of Shakyamuni Buddha on cliff face on the road leading from the southwest into Lhasa, 1981.

Photograph courtesy of Valrae Reynolds

A

FIGURE 15A–B

Local artists working on a hammered brass image of Maitreya at Dagyab, Eastern Tibet, 1983

Photographs courtesy of Nima and Elizabeth Dorjee

2. Rock

Tibet abounds with rock outcropping and boulders suitable for carving. The location of a rock—near a sacred area, building, mountain pass, or the like—is usually viewed as auspicious. The form is first drawn on the surface of the rock, and then chiselled to obtain a low-relief image. Carvings are frequently polychromed and require regular maintenance to combat weathering (see figure 14). Portable stones or slates with carved relief mantras or images are placed in piles, adjacent to auspicious areas.[3] The commissioning and execution of such portable stones is more in the nature of ritual practice and is discussed in Volume II.

3. Hammered metal

This method is technically straightforward and may predate the casting of metal. Soft, malleable metals, such as copper, gold and silver, are best suited to this process but brass (see page 51) is also used. The simplicity of the technique allows local artisans to construct images (especially large-scale ones) and architectural adornments, without the resources of a fully equipped workshop. The metal is first heated to a liquid consistency, then cooled and formed into flat sheets with hammers. The sheets are reheated as necessary to facilitate the work. The metal must not be allowed to overheat, and care must be taken to achieve a uniformly smooth sheet. Once the sheets are ready they are cut (paper patterns may be used) and formed by heating and hammering, into the desired shape. For large objects, the sheets are worked in sections which are then joined by dovetailing or soldering (see figures 15 A-B and S43). Small and basically flat pieces (see S15 and 17), especially those with elaborate detail, can be hammered over molds, usually from the reverse[4], using fine chisels and punches. Hammered surfaces are finished identically to cast surfaces, with incising (see page 53), gilding, painting and the insetting of jewels (see page 55).

3. Dagyab, "Stone Carving", pp. 57-58.

4. Dagyab, "Metal Sculpture", pp. 47-48; see also Ian Alsop, "Repoussé in Nepal," *Orientations* (July, 1986), pp. 14-27, for a survey of Newari work in hammered metal.

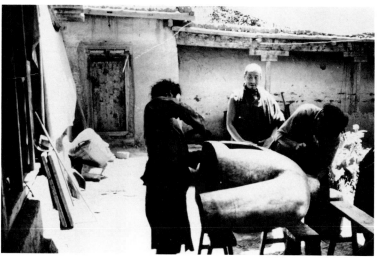

B

4. Cast metal

Metal casting by the lost-wax process has been the technique most frequently used for Tibetan (and Indian, Himalayan and Chinese) images from ancient times. Single and piece molds of various sizes are also employed, especially for small, flat images (see S13 and 20); in either case, the two most popular metals are pure or nearly pure copper and the copper-zinc alloy, brass. Metal testing over the last five years has established that the copper-tin alloy, bronze, was not in use in Tibet or the Himalayas and only partially used in India and China.[5] Three objects in the present catalogue have been subjected to analysis; they are: S5, 9-C and 12. For all other metal entries, the term "copper" is used to describe work where the surface appearance conforms to the 88-to-99 percent copper content range of tested pieces, and the term "brass" to describe works where the surface appearance conforms to the 80-to-85 percent copper, 10-to-20 percent zinc content range of tested pieces.[6] An almost pure copper content, necessarily low in lead, is customary in the Himalayas and Tibet for images to be gilded (see page 54). A high copper content metal is the material favored by the Newari sculptors of the Kathmandu Valley. Silver and gold are used in Tibet and adjacent areas when a particularly precious image is sought.

A. Molds

Reusable molds are made by surrounding an original image (of metal or wood) or a model (of wax or clay) with fine, wet sand or mud. For a simple, thin (solid) image, with an unfinished back (see S13 and 20), the mold is made in a single piece, but usually molds are constructed

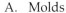

5. Oddy and Zwalf, *Metallurgy*, pp. 1-67.

6. Testing of S5 and 12 is courtesy of Chandra Reedy and Pieter Myers, Los Angeles County Museum of Art and University of California at Los Angeles. Testing of S9C was done by W. T. Chase, I. V. Bene, and L. Zycherman, Freer Gallery of Art, and Harold Westley, Conservation-Analytical Laboratory, Smithsonian Institution (*Artibus Asiae*, vol. XLII, 2/3, 1980, pp. 211-14). Extensive testing of Himalayan and Tibetan metal sculpture is published in von S.; and in G. Béguin and J. Liszak-Hours, "Objets himâlayens en métal du musée Guimet; étude en laboratoire," *Annales Du Laboratoire de Recherche des Musées de France*, Paris, 1982, pp. 28-82, as well as in Oddy and Zwalf, *Metallurgy*.

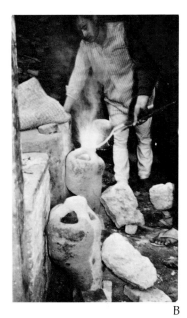

B

FIGURE 16A–C

Newari artists at Patan, Nepal, fashioning metal images in the lost-wax process, circa 1965

Photographs courtesy of Dorothy Shepherd Payer

A. Working wax over a charcoal fire

B. Pouring molten metal into clay molds

C. Cooling molds in water

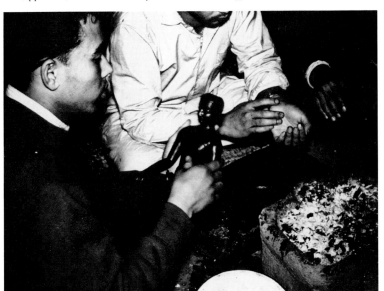

A

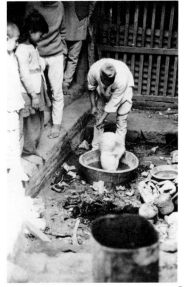

C

in two pieces, each supported by a wooden frame or box. The original image or model is carefully positioned in the two-piece mold so that adjoining side seams will be least visible. After the sand or mud has taken the impression and been hardened by heating or sun-drying, the mold is carefully cut open and the original is removed. After further hardening, molded pieces are securely joined and a conical opening is made into the hollow impression. Molten metal is then poured from a crucible through the opening into the hollow interior. Since solid-cast images must allow for a space to receive consecrated materials, a plug of sand or mud is laid in the back of the mold to create a recess when the molten metal is poured. After the deposit of consecration materials this recess will be sealed with a metal plaque.[7]

7. Dagyab, "Metal Casting", pp. 50-51.

FIGURE 17

Wax models used by Newari artists at Patan, Nepal, circa 1965

Gift of Dorothy Shepherd Payer 1977. 77.438

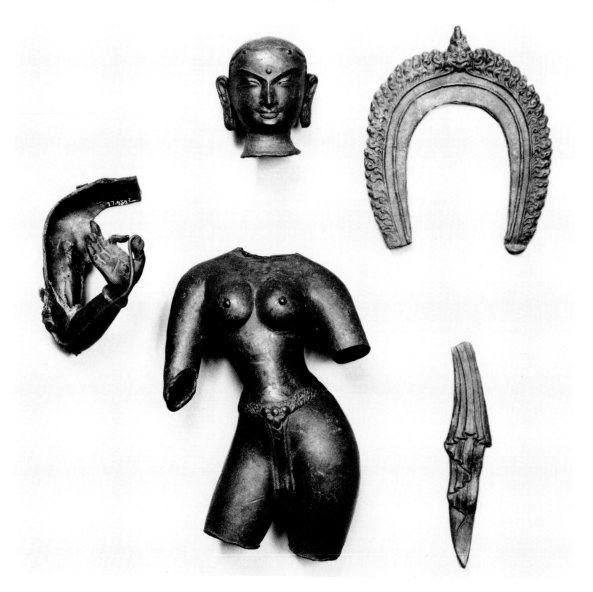

B. The lost-wax process

This difficult technique was practiced by skilled artisans, who form a special caste. Preeminent among these are the Newars of the Kathmandu Valley and their descendents, who have lived and worked in Tibet for hundreds of years and would travel to their patrons or to monasteries to fulfill special commissions. For this process, a model is first fashioned from beeswax. The wax, which has been mixed with various stabilizing agents, is heated and manipulated with the hands and/or carving tools (figures 16A and 17). The artist uses either solid wax, yielding a solid, metal image, or hollow wax to be formed over a clay core or sectioned to accommodate a clay core when assembled. The thickness of a hollow wax shell depends on the strength of the metal to be cast (soft copper requires thicker walls; hard brass, thinner). The Newari artists working today (and the same is presumed of the past) make use of hard, reusable wax or clay matrices for forming details, such as crowns, hands, garments, lotus petals and so on, rather than tackling these elements freehand. Matrices are employed also for casting multiple editions of images; the hard mold forming the "negative" impression of an image, against which the soft wax is pressed to form the "positive" model. Once the wax model is completed, then follows the complex task of assembling the core (if the image is to be hollow); the chaplets (to hold the core in position); the funnels (through which to pour the metal) and the outer clay coating. This very fine coating must be applied directly to the wax to ensure the replication of all intricate details. Additional clay layers, increasingly coarse, are then applied. Each layer is carefully dried, which may take from several weeks to months, depending on the size of the casting and weather conditions. When the clay husk is ready, the wax is melted out or "lost" (in actuality, it is caught in a receptacle for reuse), leaving a cavity with the exact impression of the wax model captured in the clay. The clay is heated to facilitate the even distribution of the molten metal (copper, brass, silver or gold), which is poured into the mold via the prepared funnel (figure 16B). The success of the casting depends on the liquid metal quickly, and uniformly, filling all air spaces left by the wax. After the mold is filled it is cooled with water and broken open to reveal the finished cast (figures 16C and 18). Hence the molds cannot be reused.[8]

C. Incising

Whether cast by way of clay or sand molds or by the lost-wax process, or fabricated by hammering, metal images are then subject to cleaning, polishing and the careful incising of details. If cast, all supports, rough edges and errors are chiseled off, hammered smooth or repaired. Fine details, such as patterning of garments and texturing of hair, are added by incising with sharp tools.

5. Wood, bone and ivory

Images and ritual objects carved from wood and precious materials such as bone and ivory are frequently found in Tibet and the

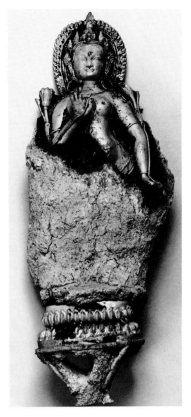

FIGURE 18

Cast brass image, still partially attached to straw and clay mold with funnels used for pouring, by Newari artists at Patan, Nepal, circa 1965.

Gift of Dorothy Shepherd Payer 1977. 77.438

8. E. Lo Bue, "Casting of Devotional Images in the Himalayas: History, Tradition and Modern Techniques," *Metallurgy*, eds., Oddy and Zwalf, pp. 69-78; and von S., pp. 34-38, 43-45.

Himalayas. Woods suitable for carving are a scarce commodity in Tibet and are used sparingly for architectural ornament, domestic paraphernalia and sacred objects. Human bone is used for ritual purposes, although animal bone may be substituted. Elephant tusk or tooth is imported from India or, via China, from Africa. The examples of three-dimensional wooden sculpture included in the catalogue, S33, show influences similar to those in metal images, as do the relief carvings on wooden book covers, S26 and 27. Bone and ivory carving (S19, 35 and 36) is a closely related craft; indeed, the technical similarity of these materials and the use of them in tandem (ivory inlay in wooden book covers; ivory images in wooden shrines) or in similar objects (e.g., ivory and wooden forms of similar images, as in S19) suggests that the same artisans may have utilized all three materials. Tibetan histories and biographies mention the tradition of woodblock carving for printed books, a technique learned originally from the Chinese and documented in Tibet from at least the ninth century.[9] The carved wooden covers (S26 and 27) which protected woodblock printed or manuscript editions of books are obviously a related craft, although it is uncertain whether these were done by the monks themselves, as was clearly the case for the printing blocks, or by professional lay artists. Tibetan sources also mention the carving of "miniature deities," out of turquoise, coral, shell, plum and apricot pits.[10] In all instances, the technique is reductive, like stone carving, and necessitates the cutting down from a larger, original block to form the image.

6. Finishing: gilding; jewel and metal inlay, and painting

Tibetan, Himalayan and Sino-Tibetan images are often adorned in some fashion before they are considered suitable for consecration and use.

A. Fire gilding

Frequently, metal images are fire gilded; a mercury-bonding process that has been in use in India, the Near East and the Mediterranean areas since approximately the third century A.D. In fire gilding, a brilliant, warm, metallic gold surface is firmly adhered to the base metal (which must have a low—less than five percent—lead content for the bonding to be successful). The Tibetan method, similar to earlier Asian techniques, is to melt and pound gold into thin sheets which are then cut into strips and mixed in a proportion of one part gold to four parts mercury. Ground glass (which keeps the gold from adhering to the mixing vessel) and water are added until the mixture resembles paste. Then the metal image is coated with a layer of mercury on all areas intended to receive the gold, while a "strong yellow paint"—to operate as a "resist"—is applied to adjacent areas not meant for gilding. When the mercury has dried, the object is rubbed and then the gold paste (with the ground glass filtered out) evenly applied. The object is turned slowly over a low fire and rubbed with cotton, causing the mercury to evaporate and bonding the pure gold to the image. As a final step, the image is gently polished by rubbing with the side of a

9. See Eliot Sperling, "A Captivity in Ninth Century Tibet," *The Tibetan Journal*, vol. IV, no. 4 (1979), pp. 23, 32-33 for mention of woodblocks used for printing by Tibetans in 820-21 A.D. and Dagyab, "Wood Carving", pp. 58-59, for twentieth century woodblocks.
10. Dagyab, p. 59.

metal needle.[11] For metal sculpture entries, "gilt" implies fire gilding.

B. Inlaid metal

In Tibet and adjacent areas, ungilded metal images may be enhanced with inlays of different colored metals. Again, this is a process with a long history in Southern Asia, and is seen in India from the fifth century A.D. onward. Gold, silver and copper are encountered most frequently. These materials are soft enough to be easily shaped and applied, and their yellow, white and red color contrasts suitably with the color of brass. The eye, lip, jewelry or garment areas to be decorated are cast or carved with undercut depressions or grooves and the metal inlay beaten in. Surface details may be added by chasing.[12]

C. Inlaid and applied jewelry

Fire gilt, inlaid, and plain metal images, as well as clay, wood, bone and ivory sculptures may all be adorned with jewelry (figures 12 and 19B); this predilection for jeweled surfaces goes at least as far back as seventh-century India. If the gems are inlaid, the recesses are cast, hammered or carved and the jewelry is attached, usually with pitch or resin. Typically, this type of adornment is confined to crowns, *urnas*, garments or necklaces. Tibetans will also adorn important images with gem-set gold, silver or gilded copper jewelry and silken garments, dressing the sculpture in the manner of a celestial king or queen (figure 19B). The process is ceremonial and thus may take place gradually over long periods of time, as an image acquires offerings and donations. In order of preference, the favored Tibetan stones are turquoise, coral, amber, lapis lazuli, pearls and jade; and translucent stones, such as rubies and emeralds; as well as colored glass, plastic or crystal imitations of these stones. Indian and Nepalese patrons prefer precious stones, favoring rubies, emeralds and rock crystal.[13]

D. Cold gilding and painting

Sculpture, of any material, in Tibet may be completely or partially cold gilded and/or polychrome painted as the final, finishing process which will often take place at the time of consecration. The face, hair and hands are the important areas for this. The term "cold gold" is used to differentiate this fragile painting technique from the more durable fire-gilding method. Powdered gold, mixed with size as a binding medium, is applied like a paint (see page 132). Additional color may be used to paint the hair blue, red or black, as appropriate, and to enhance facial features in a naturalistic way.[14] The pigments and techniques are similar to those for painting on cloth (see pages 131-133). Gold and colored pigments are easily worn away or damaged, and require frequent reapplication. Thus, it is difficult to determine the antiquity of this practice or its geographical spread. Gold leaf, attached by burnishing or adhesives, is another decorative technique applied to clay and wood objects, usually in conjunction with polychrome painting (see S26).

11. Dagyab, "The Gilding Process", pp. 48-49, and Oddy et al., "Gilding Himalayan Images: History, Tradition and Modern Techniques," *Metallurgy*, eds., Oddy and Zwalf, pp. 87-100.
12. von S., p. 41.
13. von S., p. 41.
14. Oddy et al., "Gilding Images," p. 100; Jackson, p. 87; and Dagyab, p. 45.

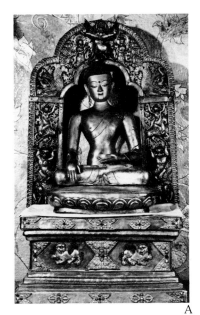

A

B

FIGURE 19A–B

Image of Shakyamuni Buddha, gilt and painted brass, h. 3' 11" (119.38 cm) with gilt copper and wooden throne, and *prabhamandala*.

Shown plain, A, and adorned with gem-set, gilt copper jewelry and brocade ornaments, B.

Tibet, (image) 15th-17th centuries, (ornaments) 18th-19th centuries. Collection of Ivory Freidus

7. Consecration

Blessing and "empowering" ritual objects and icons is a Buddhist tradition of long standing, seen in one form or another in all countries where the religion is practiced. Tibet seems, however, to have carried this custom to a unique, devotional level. Consecration in India can be attested to in some surviving objects, notably in the stupa reliquary form. For example, the Gandharan stone stupa, S9-1 has a cavity inside the *anda* expressly for consecration items. Gold, silver, precious and semi-precious stones, coins and manuscripts are typical consecration items from early stupas such as these. Small, cast images, which have been excavated in India, have no consecrated items contained within them. The "blessing" of some early sculpture may be detected, however, as on the back of Pala metal images, for instance, relief "buttons" bear an incised Buddhist Creed. On Pala stone images the Creed is commonly seen carved around the nimbuses. This practice of inscribing the creed appears on paintings, as well; early Tibetan copies of Pala paintings have the creed written on the back, as in P2. Evidence of consecration in early Nepalese and Tibetan metal sculpture is inconclusive, since surviving examples with consecrations may represent later rituals; also, the original consecration contents may have been lost over the course of time. Investigation is hampered further by the desire not to disturb the spiritual content of images by opening sealed bases and backs. The study of sculpture through x-ray photography and the careful opening and testing of selected objects (as in the chorten S9-C), may help eventually to understand the antiquity and traditions of consecration in Tibet and adjacent areas.[15] It is quite clear, however, that filling images, as well as stupas, has been standard practice in Tibet for several centuries. The interiors of hollow cast and hammered metal and clay sculptures are completely filled with consecration items, as are hollow recesses left (usually in the upper backs) in solid-cast metal sculptures and stone, wood, bone and ivory images. The location of such recesses and state of consecration items are noted in each entry.

The Tibetan term for the consecration ceremony is *rabne*, during which, according to Loden Sherap Dagyab in *Tibetan Religious Art*, "religious articles or writings are permanently associated with the new work of art in order to make it a focus of spiritual blessings."[16] Dagyab goes on to give a concise description of the nature of a Tibetan consecration:

> In the case of a statue, the inside is not left empty but is filled with holy articles—*gzuns-gžug. gzuns-gžug* is normally composed of some of the following articles: *chos-sku'i rin-bsrel* (sacred writings); *sku-bal-gyi rin-bsrel* (physical relics of holy men); *yuns-'bru lta-bu'i rin-bsrel* (meaning "relics which are like grains of mustard seeds"). The sacred writings are mostly mantras taken from the holy texts and there are many passages which are specifically prescribed as being appropriate for lodging in different parts of a statue.... The physical relics of departed holy men may consist of such things as their nails, teeth, hair and so on, or some personal item which

FIGURE 20

Wooden "Soul Sticks," painted red with gold lettering, tied to a chapel pillar and ready to be used as the central post (one each) inside images for consecration, Lhasa, 1983.

Photograph courtesy of Nima and Elizabeth Dorjee

15. Chandra L. Reedy, "A Buddha within a Buddha," *Arts of Asia* (March-April 1986), pp. 94-101.

16. Dagyab, p. 32.

belonged to the holy man such as a piece of clothing or other article that has been in close contact with the holy person during his life. Bone relics or the embalmed bodies of holy men are also sometimes used. Holy images, scriptures and *mchod-rten* [chortens] are also commonly placed inside large statues [figures 6, 21 and 27]....Certain medicinal plants or other articles considered to possess purifying effects...may also be used.

However, these contents cannot just be placed inside the statue in a haphazard fashion. A special ceremony—*gzuns-'bul-gyi cho-ga*—in accordance with the religious rites and rituals laid down in the holy texts, must be performed and it is during this consecration ceremony that the *gzuns-gžug* should be lodged in the appropriate place. In the case of larger statues a stick, preferably of sandalwood and of about the same size as the statue, is usually inserted in the center of the statue at the same time, along with the sacred contents. The stick is called *srog-śin* (literally "life-stick") [or "soul pole", see page 31 and figures 20 and 21B].

For those statues which have a base, such as the lotus cushion seat, there is a cover, called *žabs-bkag* or *žabs-sdom,* which is made to fit the bottom of the statue exactly [figure 21]. In the case of clay statues this bottom cover is usually made of wood, though it can also be made of gold, silver, bronze or brass. After the cover has been firmly secured to the base of the statue two "crossed" *rdo-rje* or *vajra (rdo-rje rgya-gram)* are usually engraved on the outside surface. Secure sealing ensures that no outside agents, such as insects, rodents and the like, can get at or damage the contents and also serves to keep the inside water-tight. Statues without a lotus cushion seat have openings in the back. The covers and sealing process are similar to those already described.

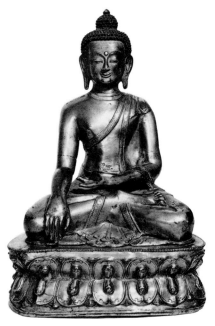

FIGURE 21A–B

A. Image of Shakyamuni Buddha, gilt copper, h. 20¼" (51.4 cm) 19th century

Purchase 1920 Shelton Collection. Obtained in Batang, Eastern Tibet 20.455

B. Contents from inside the image (note "Soul Stick" at center left).

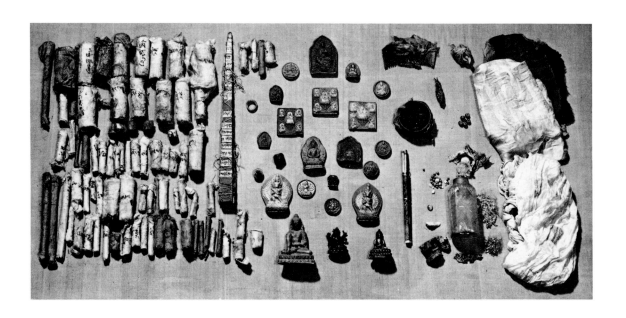

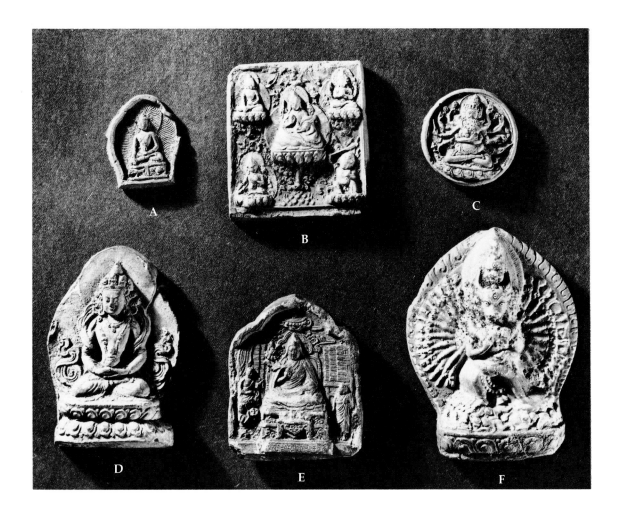

FIGURE 22

Tsa-tsa - Contents of opened image of Shakyamuni Buddha (figure 21A) (Top row, left to right):

A. Dark reddish-brown clay, shrine shape, h. 1⅜″ (3.5 cm) Akshobhya Buddha on an elephant throne. 20.455I

B. Reddish-brown clay, rectangle, h. 2⅜″ (6.6 cm) A Gelugpa Lama holding a vase; lotus stems from the hands supporting flowers with a sword (right) and a book (left); Shakyamuni and Avalokiteshvara, upper left and right; Tara and Mahakala, lower left and right; Tibetan inscription at bottom, effaced; painted gold and red. 20.455K₃

C. Light reddish-brown clay, round, h. 1½″ (3.8 cm) Guhyasamaja *yab-yum*. 20.455H₁

(Bottom row, left to right):

D. Light brown clay, h. 3″ (7.6 cm) Amitayus. 20.455N

E. Dark reddish-brown clay, shrine shape, h. 2⅜″ (6.6 cm) Enthroned 7th Dalai Lama at center; the left hand holds a book (effaced), the right hand holds a lotus; the throne is in Chinese style; Tibetan style books are stacked to the sides behind two monks. A third kneeling figure at lower left offers jewels. A Tibetan inscription runs at the bottom. 20.455L

F. Light reddish-brown clay, h. 3⅜″ (8.6 cm) Yamantaka *yab-yum*, painted gold with black, red and white details. 20.455M₂

Unless there is a genuine necessity to repair the statues—as a result of some natural catastrophe for instance, or accidental serious damage—these sacred contents should not be tampered with. When such a replacement of the old sacred contents with new ones does become necessary, it, too, is performed in strict conformity to the rites and rituals laid down for this purpose.[17]

8. Ritual practices which affect the physical appearance of images

Once created and consecrated, the sculpture of Tibet is used for meditation, worship and inspiration. Certain practices can alter the physical condition of objects over the course of time and this should be considered when assessing the appearance of an image. Accidental damage from burial, fire, falls or blows does, of course, occur and is noted, when it is suspected, in entries. Purposeful earth burial of ritual objects has not been practiced in Tibet since the fall of the empire in the middle of the ninth century. The entombment of objects in chortens, large images and shrines tends to ensure the preservation rather than the deterioration of sculpture, manuscripts and paintings. Indeed, the remarkably pristine condition of some early objects that have come out of Tibet is perhaps due to this practice.

A. Lustration

The worship of ritual objects among both Hindus and Buddhists in India and the Himalayas involves lustration: the pouring on or over, or daubing of sacred liquids and pastes. Over time, these substances can eat or wear away the surface of the object. Lustration has an ancient history in Southern Asia, as is confirmed by the texts and by the condition of extant objects. The accidental accumulation of grease from butter lamps and incense at Tibetan altars is often apparent on the sculpture, but the nature of these substances and the generally dry climate of the country seems to leave the object relatively unharmed. The accumulation of grease on painting is quite another matter (see page 135). Entries which appear to have been affected by lustration are S5, 6, 16, 17 and 21.

B. Rubbing

Ritual touching of sacred objects is also an ancient custom in Southern Asia. Small, personal icons and amulets appear to be especially subject to much handling, but accessible areas of larger images installed on temple altars are also touched and, over the course of years, literally worn down. Tibetans honoring and seeking to acquire blessings from an important image, generally touch their head to it (see page 34). The wear from this practice is mitigated, in the case of major shrines, by creating a special "head-touching" recess in the base.

Entries which appear to have been affected by rubbing are S2, 3, 4, 5, 6, 8, 11, 12, 13, 32, 35 and 36.

17. Dagyab, pp. 32-33.

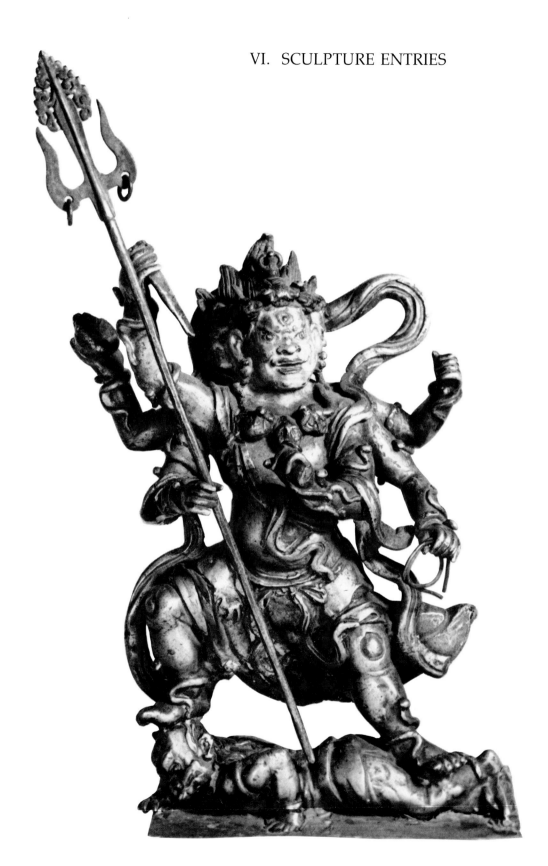

S1

GUARDIAN DEITY

Cast brass with painted details, h. (with wood pedestal) 11¼" (28.5 cm)
Eastern Tibet(?), 9th-12th centuries(?)
Purchase 1920 Shelton Collection 20.451

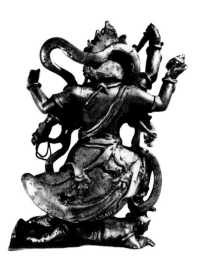

This vigorous though crude image is solid cast in one piece (except as noted below), and has an olive-tan surface patina with blackish encrustations in recesses. The heavy muscled body of the deity steps to the right, both feet planted on a prone demon which struggles to rise, digging its hands into the rectangular wood base.[1] The demon underfoot has a beak-like face, claw hands, raised vertebrae along the back, folded cloth at the hips, and bands at arms, wrists and crossed ankles. The six-armed deity wears a swirling drape across the hips, and over this an animal (tiger?) skin tied with a sash. Another sash swirls behind the hair and over the shoulders and arms, while still another crosses the chest from the right shoulder to the left side of the waist. Snakes encircle ankles, wrists and all six arms. The rough casting and extensive overpainting on the faces and hair[2] make the neck and head areas difficult to discern, but the necklace the god is wearing appears to be three severed heads entwined with snakes. Tufts of flaming hair adorned with snake-and-skull crowns rise above each of the three, grimacing faces. Snakes are also at the deity's ears. A *vajra* (front prong broken off), on a lotus bud, is placed above the center face. Three of the god's six hands hold, respectively, a skull cup, a dagger blade and a noose.[3] The other three hands were cast empty, but were intended to hold implements; the gold and silver damascened and red painted iron trident now in the center right hand, and the iron noose now in the center left hand are no doubt later replacements.

This striking image has been a source of speculation as to its iconography, age and place of manufacture. Fierce multi-armed guardians in menacing poses, wearing swirling scarves similar to Newark's image, are found in Central Asian art where a blending of Chinese and Indic tantric sources is evident. Mahakala is one of the most important of these guardians, having developed in India from a fusion of ferocious Hindu and Buddhist deities. By the time of surviving written iconographies in the twelfth century,[4] several forms of Mahakala are listed, featuring multiple heads and arms; skulls, severed heads, snake and tiger-skin ornaments; flaming hair and heavy bodies. This guardian deity, however, follows a prototype which traveled from India across Central Asia at an earlier period, appearing in the Far East by the eighth century. The gnarled nose and brow, which gives the image such an emphatic expression, are conventions found on *lokapala, dharmapala* and Mahakala forms from several sites in Chinese Central Asia, dating from the eighth to tenth centuries.[5] Guardians with semi-nude and muscled bodies, adorned with swirling scarves, skulls, animal-skin loin cloths and vigorously striding to one side, are frequently seen at the gateways to mandalas or protecting Buddhist icons at the same Central Asian sites. Bird or animal-headed demons or attendants are often associated with these deities.[6]

A specific identification may never be possible for Newark's image. Nevertheless, the presence of paint on the faces and hair; the Eastern

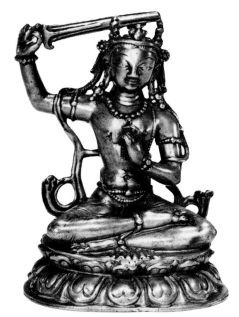

Tibetan style of the (replacement) trident; the fragments of silk and sealed wax on the middle right arm, and the fact that the figure was found in Kham, all point to Tibetan ownership at least in the years immediately preceding its purchase by Shelton. The exuberance of the casting and the patina of the metal are closer to sculpture associated with Tibetan manufacture (although of later date), than to the elegant gilt bronzes of the Tang period in northern China or of twelfth century Yunnan. The "Long Roll of Buddhist Images" scroll from Yunnan of around 1180, and the carvings of protector deities at the Dazu cave site in Sichuan of the twelfth-to-thirteenth centuries, however, do attest to the survival of Central Asian style tantric imagery, close to the Tibetan border, as late as the thirteenth century.[7]

Previously published: Pal, *Art of Tibet*, 1969, pl. 65; DDH, no. 62, and von S., no. 143B.

1. The trampled figure is firmly embedded in the wood, with traces of pitch along joints; the wood may have once been clad in metal.

2. The three faces are painted a golden tan, with black and red used for details of eyes, mouths and hair.

3. The handle is missing from the dagger; the break, level with the thumb and forefinger, appears old.

4. See Bhattacharyya, pp. 344-46.

5. Compare a fragment of a banner painting from Murtuk, Turfan, ninth century, the Metropolitan Museum of Art, *Along the Ancient Silk Routes, Central Asian Art from the West Berlin State Museums* (New York: Metropolitan Museum of Art, 1982), no. 141; and a fragment of a banner painting from Dunhuang, ninth century, *Silk Route*, pl. 60.

6. Compare the guardians at the lower left and right of a wooden shrine from Central Asia, eighth century, Pal, *Bronzes of Kashmir*, no. 102; and of a banner painting, and the Bodhisattva Ucchusma in a painting on paper, both from Dunhuang, ninth century, *Buddhism*, nos. 320 and 321.

7. A lengthy discussion of Newark's image and related Chinese art is in Sheila Coffin Bills, "A Chronological Study of Sino-Tibetan Metal Sculpture (1260-1450)," (Ph.D. diss. Case Western Reserve University, 1983), pp. 109-32, figs. 63-72.

S2

MANJUSHRI

Cast brass, lips inlaid copper, h. 4½″ (11.5 cm)

Kashmir, 10th-11th centuries

Eleanor Olson Bequest 1982 82.70 From the Heeramaneck Collection

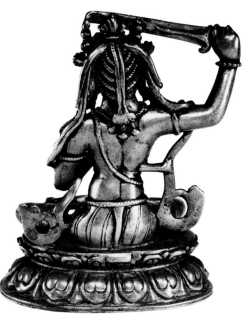

This small, yet powerful, image is cast in one piece in the golden yellow brass typical of Kashmir.[1] The underside of the base is hollow, the figure is solid. The surface has the olive-tan patina common to Kashmiri and Western Tibetan brass images. Wear from rubbing is apparent on the face (the copper inlay on the lips is almost completely gone) and legs; traces of orange paste from worshiping rituals are to be seen in incised areas. There is an old break on the left wrist; a rectangular plug at the back of the lotus base is perhaps the original attachment for a nimbus. The double row of lotus petals continues fully around the base, which is oval in cross-section. This is the Arapachana form of Manjushri, identified by the meditation pose, the small, palm-leaf-style book held at his chest and the sword (handle and tip broken off) raised over his head. This form is seen in tenth-to-twelfth-century images from both eastern India and Kashmir.[2] The princely ornaments include a striped lower garment; beads at waist, chest, neck, legs and arms; a swirling scarf ending in a complete circle

at each hip; a crown with three jeweled, upright sections; side rosettes, ribbons, and braided locks of hair. The beaded style of ornament, the broad, curving, facial features and the articulation of the stomach and chest muscles are characteristic of Kashmiri work. The double-lobed interior of each lotus petal forming the base is found on a large group of Kashmiri metal images, tentatively dated to the tenth to eleventh centuries.[3]

Previously published: Pal, *Bronzes of Kashmir*, no. 53 and von S., no 19H (note that the Pan Asian Collection provenance is incorrect).

1. See von S., p. 50 for analyses of Kashmir images.
2. Compare von S., no. 73A, for a Tibetan copy of an eastern Indian original; no. 20D for another Kashmiri example.
3. See von S., nos. 19A, C, E, F, G; 20A.

S3

VAJRASATTVA

Cast brass, h. 8¾" (22.3 cm)
Kashmir, 10th-11th centuries
Purchase 1984 Willard W. Kelsey Bequest Fund 84.130

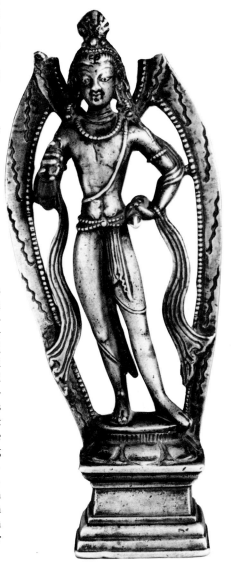

This image is similar to a rather large group of Kashmiri sculptures dated tentatively to the tenth to eleventh centuries. It is solid cast[1] in a golden yellow brass, now exhibiting the characteristic Kashmiri olive-tan surface patina. The head and body nimbus, with incised wavy lines and relief beading,[2] the stepped pedestal, flattened lotus petal base, and alert stance are all indicative of this group of Kashmiri figures.[3] The fan of hair, forming a top knot behind the jeweled and beaded diadem, recalls headdresses on earlier (seventh-to-eighth-century) images from the Swat Valley, Afghanistan.[4] The image is clothed in princely garments and ornamented with beaded chains at ears, neck, hips and arms. Both the flowing scarf, encircling the shoulders and falling in curves from the arms, and the sash hanging from the hip girdle are rendered with semi-naturalistic, incised lines. The deity is identified by the five-pronged *vajra*, held in his right hand, and the matching bell at his left hip. This is a rare, early standing form of Vajrasattva ("Vajra-Being"), who had begun to figure prominently in Indian Vajrayana philosophic developments and first appears in painting and sculpture from eastern and northern India, Kashmir and Western Tibet in the eighth to eleventh centuries.[5]

1. The back of the pedestal (with a shrine-shaped opening), nimbus and figure are flat except for the simple modeling of the deity's buttocks, sacred thread and three-part cascade of rows of hair locks (from crown to shoulders).
2. See von S., nos. 19D and 20D, for two types of complete nimbuses.
3. von S., nos. 19A-D, 20E, 21E-G; for related images found in Tibetan monasteries, see pp. 103, 106, 110.
4. Compare von S., nos. 6C, 7C, 10E.
5. For the more common seated form of Vajrasattva, see von S., nos. 18D, 20B (Kashmir), 72E (a Tibetan copy after an eastern Indian original); and Snellgrove and Skorupski, *Ladakh I*, pp. 60-61 (Alchi, Sum-Tsek, mandala no. 4).

S4

MANJUSHRI

Cast copper, h. 3⅛" (8.0 cm)
Western Himalayas, 11th century
Gift of Mr. and Mrs. Jack Zimmerman 1973 73.127

This small image is solid cast in a dark metal which appears to be pure copper; the single lotus petal base has a dome-shaped interior recess, elliptical in cross-section. The back of the image is roughly formed, with a plug remaining behind the head for the attachment of a halo. There is warping of the petals in front and the face has been much worn. The deity is identified by the sword raised in his right hand. A book, the other symbol of Manjushri, may once have rested on the lotus bud which curves up to the left shoulder. The articulation of the chest and stomach, the broad, rounded form of the lotus petals, the curving scarves, the crown of three triangles, the beaded ornaments and the braided hair are all Kashmiri-derived elements.[1] Kashmir held political control of the Western Himalayas from the early eighth to the early tenth centuries; Hindu images from this period found throughout Himachal Pradesh, show strong Kashmiri influence. It is surmised that Buddhist images were cast by Himalayan sculptors under the patronage of Western Tibetan Buddhists beginning in the tenth century[2]; the use of pure copper here may reflect Nepalese influence. Newark's piece is almost identical to one in the Baader Collection, which still retains its flame-shaped halo.[3] The existence of these two castings proves that reusable matrices must have been employed in such sculptures.[4]

1. Compare S2 and von S., no. 20D.

2. M. Postel, A. Neven and K. Mankodi, *Antiquities of Himachal* (Bombay: Project for Indian Cultural Studies, vol. I, 1985), pp. 99-104; von S., pp. 137-43, nos. 28C-F; compare, also, S5.

3. Staatlichen Museums für Völkerkunde, *Der Weg Zum Dach der Welt* (München: Staatlichen Museums für Völkerkunde, 1983), pp. 324, 331 (upper left).

4. See von S., pp. 43-45, regarding matrices and nos. 30A, C, D, E, 31D, F, as examples of multiple castings; see also S7.

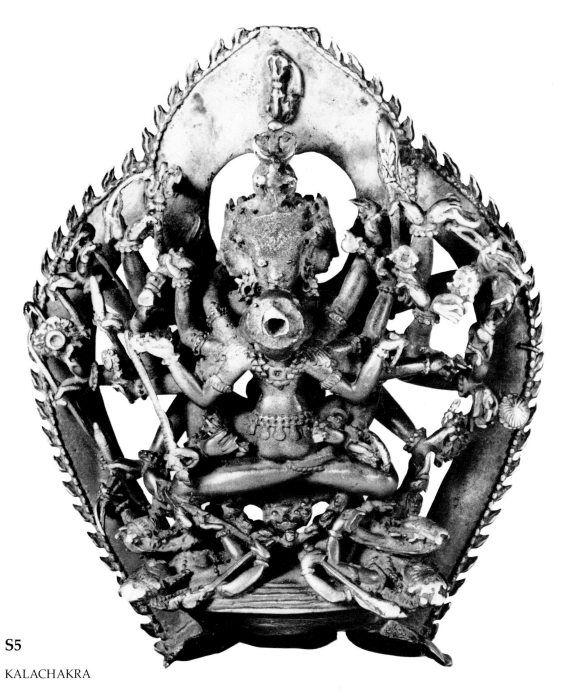

S5

KALACHAKRA

Cast brass, inlaid silver eyes, h. 8½" (21.7 cm)

Western Himalayas, 11th century

Purchase 1976 The Members' Fund, The Membership Endowment Fund, The Bedminster Fund, Inc., The Mary Livingston Griggs and Mary Griggs Burke Foundation, Samuel C. Miller and Dr. Andrew Sporer Funds 76.27

This extraordinary image was cast in one piece in a golden yellow brass,[1] now showing a dark brown patina on areas undisturbed by rubbing or cleaning. The figures of Kalachakra and partner, with their multiple arms, and the four prostrate figures underneath proved too

heavy for the hollow, spreading, lotus petal base and ridged, elliptical pedestal, resulting long ago in the loss of the front and side petals and in numerous cracks and holes in the back. Kalachakra's front and back faces, and all four faces of his partner have inlaid silver eyes. Worship practices have severely worn away the frontal head of the god, giving the bulging silver right eye and vestigial silver slit of the left eye a distorted appearance. Thus, the original lively quality of the faces, with their wide open eyes and indented pupils, can now be seen only on the two side faces of the partner and the rear face of Kalachakra.

Kalachakra, "The Wheel of Time", is the principal deity of the *Kalachakra Tantra*, believed to have originated in northwestern India in the tenth century at a time of growing pressure from Islam on the western borders.[2] As described in the *Nispannayogavali*,

> God Kālacakra dances in Alīdha attitude...He is blue in colour. He wears tiger skin and has twelve eyes and four faces.... [In the] twelve hands on each side...are held the Vajra, the sword, the Triśūla and the Kartri...the Fire, the arrow, the Vajra and the Ankuśa...the discus, the knife, the rod, and the axe...the Vajra-marked bell, the plate, the Khatvānga with the gaping mouth, and the Kapāla full of blood...the bow, the noose, the jewel and the lotus...the mirror, the Vajra, the chain and the severed head of Brahmā.[3]

The image conforms to most of these requirements except, notably, that it is in seated rather than standing position. The innovative and unique use of bifurcation at the wrists, has allowed the sculptor to show all required twenty-four hands and implements without the further crowding and confusion that twenty-four arms would have caused. Kalachakra and partner are adorned in jewels and wear five-leaf crowns over each face. Kalachakra also wears crossed *vajras* in front of his piled hair (below a crescent moon/sun emblem), a tiger skin covering and a rope of human heads encircling his body. The joined halo and nimbus has an outer edge of flames and a *vajra* at its apex. The quality of the casting, the graceful positioning of hands and heads on complex forms, the penchant for seated deities, and the shape of nimbus and base place the Museum's image stylistically with a group of brass images from Himachal Pradesh, dating from the tenth to eleventh centuries. These western Himalayan workshops produced both Hindu and Buddist images, and were under the influence of Kashmiri artists.[4] It is probable that Hindu as well as Buddhist traditions have been drawn upon to create this unusual image. All later surviving examples of Kalachakra, painted or sculpted, are of the standing form.

Previously published: Pal, *Bronzes of Kashmir*, no. 65, von S., no. 27E, and *Silk Route*, pl. 99.

X-ray photograph, courtesy of Chandra Reedy and Pieter Meyers, Los Angeles County Museum of Art and UCLA.

1. Metal composition: 77.3% copper, 14.9% zinc, .77% tin, 5.7% lead and .79% iron; analysis done by Chandra Reedy and Pieter Meyers, Los Angeles County Museum of Art and UCLA, 1982-5.
2. Bhattacharyya, pp. 186-87; Snellgrove, "Buddhism in North India...," *Silk Route*, p. 78.
3. Bhattacharyya, pp. 186-88; the *Nispannayogavali* was composed by the Buddhist author and mystic Mahapandita Abhayakara Gupta who flourished circa 1084-1130 A.D., in northeastern India. See pp. 42-43 for attributes.
4. See von S., pp. 135-43, for a discussion of the historical and artistic setting for these sculptures, and nos. 26 and 27A-G for related examples.

S6

VAJRAPANI (?)

Cast brass with silver inlaid eyes, copper inlaid mouth, h. 13¾″ (35.0 cm)

Western Himalayas, 11th-13th centuries

Purchase 1983 The Members' Fund and C. Suydam Cutting Bequest Fund 83.373

The solid cast figure stands, stiffly erect, on an unusually shaped, double-lotus pedestal, which is hollow and circular in cross-section.[1] The pedestal is so stylized that the lotus petals resemble the ribbed, bulbous surface of a melon. The metal has a pale, golden yellow color with a brown patina; the face, chest and girdle area show extensive wear from rubbing. The image wears princely ornaments and gives the gesture of blessing with upraised right hand and argument with lowered left hand (thumb and finger joined). A *vajra* lies on the pedestal in front of the figure's feet, leading to a tentative identification as Vajrapani.[2] There is a disc at the center of the forehead and a circular plaque at the center of the chest with a Tibetan letter inscribed on it, which is now too worn to read. The extremely elongated, rigid and simplified form of the body, the prominent upturned lips and crescent-shaped eyes, and the long, curved ears flanked by straight, flaring ribbons suggest a Himachal Pradesh artist working for a Western Tibetan patron. As the "Second Diffusion" of Buddhism spread through the kingdoms of Guge, Ladakh, Zangskar and Purang in the tenth to eleventh centuries, the local rulers, monks and pious lay folk seeking images for rituals and worship, turned to Kashmir and Himachal Pradesh, areas with established artistic traditions (albeit Hindu, as well as Buddhist) on the trade routes between India and Tibet. The image shown here resembles Hindu examples from Himachal as well as contemporary Tibetan pieces.[3] The rough casting, the rigidity of stance and the odd iconographic form suggest a provincial milieu with reference to both artist and patron, in contrast to the sophistication and craftsmanship of Kalachakra, S5. The movement away from the classical elements of Kashmiri art to more folksy types, as seen here, occurred in the eleventh to thirteenth centuries in the Western Himalayas.

1. The image was at some time broken at both ankles, just below the solid ankle bangles, and repaired with silver-beaded collars, wrapping the breaks, and with pins inserted from the legs to the base.

2. Vajrapani, "Holder of the Vajra," is more commonly depicted *holding* the implement— see, for example, an eighth-to-tenth-century fragment from Dunhuang, *Silk Route*, pls. 62-63; and S37.

3. M. Postel, A.Neven and K. Mankodi, *Antiquities of Himachal* (Bombay: Project for Indian Cultural Studies, vol. I, 1985), figs. 175-76, 179, 181, 297-98 and 303-4 (all eleventh to early thirteenth centuries); von S., nos. 31G (obtained in Southern Tibet), 32A, B (attributed to Western Tibet).

S7

MAITREYA

Cast brass, h. 6" (15.3 cm)
Tibet, 11th-12th centuries
Gift of Mr. and Mrs. Jack Zimmerman 1973 73.128

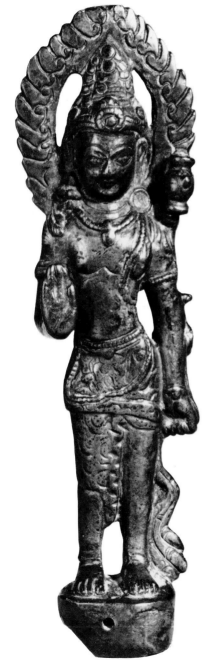

The shallow (½-inch deep) form, rough casting, and dark, silvery black patina of this piece place it among a large group of castings, tentatively attributed to eleventh-to-twelfth-century Tibet.[1] This example is solid cast and quite flat in profile, except for the outstretched right hand. The back is only sketchily finished; the fragmentary base has an interior recess.[2] Faint traces of painted gold remain on the face. The identification of Maitreya, the future Buddha, is based on the water pot perched on the lotus vine at the left shoulder and the antelope skin draped over the left chest. This bodhisattva form of Maitreya is an emanation of the spiritual "father", Maitreya as a Buddha, who appears in the headdress in the form of a stupa, here clumsily depicted as part of the circular incisions of the hair locks. This particular image is similar to two obtained by Tucci in Western Tibet; indeed they may be cast from the same matrix.[3] Although these dark metal pieces have previously been attributed to Western Tibet because of the provenance of Tucci's examples, other figures in this style were obtained by Tucci in Southern Tibet[4] and Pal has recently discussed the evidence of Nepalese influence and the possible location of a workshop in western Nepal or Southern Tibet.[5] It is likely that this group is a provincial Tibetan rendering following a mixed Pala and Nepalese style. The outstretched right hand, the constricted pedestal, the floral decoration on the dhoti, the horizontal sash across the legs, the lotus stem and symbol along the left side and the *tribhanga* pose, all can be seen in many tenth-century images found at Kurkihar, Gaya District, Bihar.[6] The piled headdress, stiff legs, undulating drapery and ornaments, and even the water pot are exhibited in an extraordinary silver image, attributed to twelfth-century Bengal, which had been taken to Tibet, as is obvious from the gold paint on the face and the turquoise inlay.[7] The shape and scroll design of the halo, in particular, and the general aspects of pose and garment of the Newark Maitreya can also be seen in Nepalese images of the ninth to tenth centuries.[8] The size and portability of these Tibetan images make their geographical "findspots" basically irrelevant.

1. See von S., nos. 30A-I, 31A-H, 32A-G, for several examples; tests done on two of these pieces, at the British Museum, show a range of 65-77% copper, 14-30% zinc, Oddy and Zwalf, *Metallurgy*, pp. 27-28, inventory no. 42 (von S., no. 32F) and 63 (von S., no. 30A).

2. Compare bases on von S., nos. 31D, F, for original form of a single, downward facing row of lotus petals below the plain, oval base. Two holes have been drilled in the Newark piece (front and back) evidently to attach a replacement base, now gone.

3. Tucci, *Transhimalaya*, nos. 145-46 (also reproduced in von S., 31D, F); unfortunately measurements are not provided, which would make an exact comparison possible.

4. Tucci, *Transhimalaya*, no. 152 (from Gon dKar rdson, Tsang) and Tucci, *Indo-Tibetica*, IV, pt. III, fig. 13 (from Samada, Southern Tibet) (reproduced in von S., nos. 31B and G).

5. *LA Tibet*, nos. S8 and 12.

6. Compare von S., nos. 64C-D, F-G, 65C.

7. Pal, *Sensuous Immortals*, no. 59 (also reproduced in von S., no. 71F).

8. Compare von S., nos. 78B,D, 80F, 81C,E,F,G.

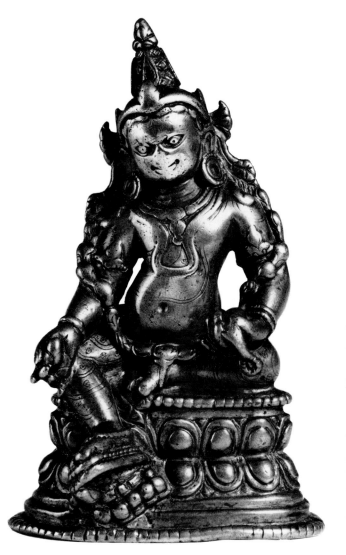

S8

JAMBHALA

Cast brass with painted details, h. 4⅞" (12.4 cm)
Tibet, 12th-13th centuries
Gift of Mr. and Mrs. Jack Zimmerman 1973 73.125

Hollow cast in a pale golden brass, the image shows extensive wear from rubbing on the face and torso. The double lotus petal base, which continues completely around and is triangular in cross-section, is sealed with a plain copper plate, thus the consecration contents are presumably intact (although the image is very lightweight). The corpulent, yet robust, figure of Jambhala is fully modeled, with finely indicated drapery and jewelry front and back. The deity is identified by the characteristic *lalitasana* pose and heavy belly, and by the lemon and the mongoose spitting jewels held in the right and left hands, respectively. In style, the image is in the twelfth-century Pala idiom: pose, incised patterns of the dhoti, florets and curved ribbons to each side of the headdress, pearl edges on the double lotus petal base and separate, lotus-shaped support for the pendent foot.[1] The sealed base, use of gold paint on the face and neck (of which only traces remain) and the blue paint on the hair, indicate certain ownership in Tibet, and the golden metal seems characteristic of twelfth-to-thirteenth-century Tibetan castings based on Pala models.[2]

1. Compare von S., nos. 69C, D, 71A.
2. See von S., nos. 69A, E, G, 73E, H, for probable Tibetan copies of Pala originals.

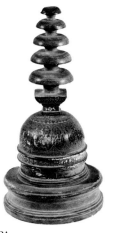

1. STUPA

Schist stone, h. 12¼" (20.4 cm); Swat Valley (Pakistan), 2nd century A.D. Purchase 1980 The Members' Fund 80.323

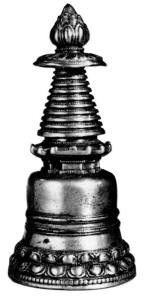

A. CHORTEN

Cast brass, h. 4⅞" (12.5 cm) Tibet, 12th century or later Purchase 1920 Shelton Collection 20.391

Hollow cast in three sections which are welded together; base plate and contents are missing; traces of palm leaf or bark manuscript, with black writing and shiny black residue, cling to the inner sides of the lotus base. A small circle is incised on the *harmika* on one side; small, low relief circles are on each of the ornaments on all four sides. Patina: light golden brown.

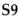

S9

KADAMPA CHORTENS

The transmittal of the concept of chortens (S. stupa) and their role as sacred reliquaries are of great interest in tracing Indo-Tibetan interrelations. The earliest surviving stupas are the remains of first century B.C., architectural structures at Bharhut and Sanchi in India. Their original form is depicted in the narrative reliefs on the gateways and pillar railings of the same period from Bharhut, Sanchi and Amaravati, showing the stupa as a symbol for the death and nirvana of the Buddha.[1] In the reliefs, the stupa form is close to that of the second-century miniature stone example from Swat (in present day Pakistan), see S9-1: a hemisphere *(anda)* on a circular base, surmounted by a stepped rectangle *(harmika)* and a tapering spire of umbrellas; the hemisphere and base are often embellished with festoons and architectural detailing. The persistence of the architectural as well as the symbolic form of stupa, is well documented for both monumental and miniature stupas in all countries which embraced Buddhism.

Northeastern Indian stupas of the eighth to tenth centuries retain the *anda-harmika*-spire form established earlier, although with a variety of sub-bases. Atisha (982-1054) is traditionally credited with bringing the "Kadampa chorten" from northeastern India to Tibet in 1042. The Kadampa sect founded by Atisha's disciples, which was predominant in Central and Southern Tibet between the mid-eleventh to thirteenth centuries, has lent its name to this form of chorten. If we take the Atisha-"Kadampa chorten" tradition as fact, then we would expect these chortens to directly reflect eleventh-century Pala style, since Atisha came from Vikramashila in Bihar, one of the centers of Pala Buddhism. Portraits of Atisha himself, all later in date than the period of Kadampa florescence, are commonly shown with a chorten resting on a lotus flower at his side. The chortens shown with Atisha have the bell-shaped *anda* and the sun/moon/flame finial of "Kadampa" examples, but the spire tends to be straighter and more slender and there is a single row of lotus petals on the base.[2] The supposed tomb-chorten of Atisha, at Nyetang, south of Lhasa, follows a different style, with the *anda* constricted to a stepped base and an arched opening to contain an image. However, brass "Kadampa chortens" are on display in the altar room at Nyetang.[3]

Although no documented metal stupas from northeast India are identical to "Kadampa chortens", stone and metal images from this area, dating from the eighth to twelfth centuries, display various elements that are similar. Stupas decorating stone carvings of this period have a bell-shaped *anda* with ambulatory rings, cruciform *harmika* with secondary corners, and a conical spire. Many have stacked circular bases but some have double lotus petal bases. Stupas, umbrellas, ribbons and bud-flame finials appear at the apex of nimbuses on numerous Pala bronzes.[4] The double, non-aligned rows of lotus petals, which are ubiquitous to "Kadampa chortens", occur as bases in the majority of Pala images. The type of petals (double, with upturned tip and an underrow between each) with beading at bottom and sometimes top, most similar to "Kadampa chorten" lotus bases, are seen frequently in tenth-to-eleventh-century Pala and Pala-style images.

The Tibetan "Kadampa chorten" is known in two specific forms, both are found throughout Tibet and always adhere to a rigid canon of shape and proportion:

1. A circular base, slightly inward-sloping, decorated with a double row of lotus petals, non-aligned, the top row slightly smaller than the bottom and flanked by beaded borders (atrophied or non-existent on the top, in some examples).

2. A bell-shaped *anda*, height approximately equal to the base diameter; the sides encircled at mid-height by a pair of raised rings, and the shoulders curving to a flat summit.

3. A stepped cruciform *harmika* with secondary corners, creating twelve corners in total; low-relief small beading on the edges of the lower (recessed) walls; jeweled ornaments set in the molding along the top of walls, three to each of the four main walls and one to each subsidiary corner. This unit, with its sloping "roof", can be construed as an architectural statement.

4. A conical spire modeled as stacked discs (ten to thirteen in number), each with drilled or beaded decoration on the upper surface.

5. An umbrella decorated with elongated lotus petals on the upper surface.

6. A lotus bud finial with two alternating rows of petals and a pointed tip (in chorten B there is also a flame on top of the main bud).

The elaborate, festooned type of "Kadampa chorten" (C and D) has ribbons curving out from two sides of the lotus bud finial; a moon/sun/flame on top of the bud; funneled pendants hanging from the edges of the umbrella, and a row of narrow petals decorating the connection between the "roof" of the *harmika* and the base of the spire.[5]

A handful of barley grains, found in chorten C, have provided a radio-carbon dating of 1230 A.D.[6] The question remains of how to date other chortens which follow the same form. The extraordinary number of extant Kadampa-type chortens found across a large geographic area complicates their evaluation. Examples have been found in Ladakh and Central and Eastern Tibet, with a substantial number, of no specific provenance, present in Western collections.[7]

Assuming that Atisha did indeed bring this form of miniature chorten with him from India and, possibly, artists capable of fabricating them, this form's close association with the great monk may have inspired its special veneration by monks of the Kadampa order and the laymen supporting the order. Thus "Kadampa chortens" would have been popular as a sacred object to commission. Northeastern Indian Buddhist institutions lasted for 150 years after Atisha's death, thus it is possible that Indian-made stupa/chortens could have been carried (as were innumerable images) to all sections of Tibet where Kadampa monasteries and temples were established. Whether Indian or Tibetan-made, "Kadampa chortens" were to be found in Tibet wherever the sect that venerated Atisha spread.

It is feasible to suppose that production of "Kadampa chortens" ceased after the sect was absorbed and superseded by others, such as the Sakya sect in the mid-thirteenth century. The prestige of Atisha was upheld, however, even as the fortunes of the order associated with him waned. Their chortens maintained a sacred position well into the

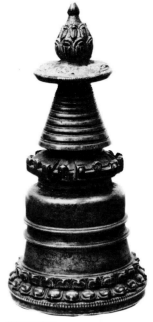

B. CHORTEN

Cast brass, h. 7⅝" (19.4 cm)
Tibet, 12th century or later
Gift 1911 Crane Collection 11.682
Hollow cast in sections which are welded together; the entire upper section is a badly cast later replacement; gold paint remains in the recesses of the lotus bud finial and *harmika*; turquoise glass chips are set in three ornaments to one side of the *harmika* with incised rosettes on other ornaments. The base is sealed with a plain brass plate; the contents are presumed intact. A fragment of red and yellow silk cloth is tied to the *harmika* with four strands of twisted wool cord; remaining black wax on the knot is impressed with a round seal mark. Patina: dark brown.

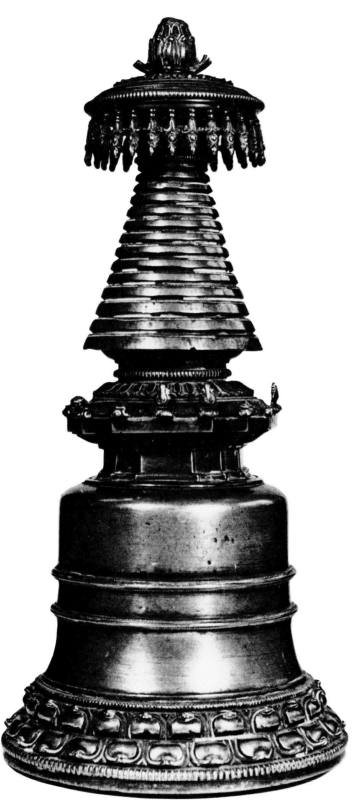

C. CHORTEN

Cast brass, h. 13½″ (34.3 cm)
Tibet, dated circa 1230
Purchase 1981 W. Clark Symington
Bequest Fund 81.23
Hollow cast in sections which are
welded together. The base is sealed
with plain copper plate; all contents
have been emptied and recorded.
Patina: golden brown. Metallurgical
analysis: 70.5-76.32% copper;
1.36-2.86% lead; trace amounts of
tin; 20.41-25.40% zinc (Hatt,
"Tibetan Reliquary," pp. 211-14).

twentieth century, were kept in good repair and even perhaps copied. By the period of dominance by the Gelugpa sect and their adoption of Atisha as part of their lineage, the association of the saint with a chorten was institutionalized in a different way: by portraits in which the reliquary—in a slightly altered form—is one of two, flanking attributes, as in S40.

Shelton's notes on the origins of the 1911 and 1920 collections state that chorten B was from the "Living Buddha" of Batang (probably the Jö Lama, but possibly meaning the Abbot of the Batang Monastery, the "Ba Lama"), and that chortens A and D were "obtained from the Jü [Jö] Lama." The Jö Lama (Volume I, photos, pages 38 and 55) was an incarnate but non-cloistered Lama from Atuntse (Jö), near Batang. Shelton acquired a number of things from this man, who was a close friend from about 1908 until 1922. It is not clear where or how the Jö Lama himself came to possess or act as an agent for religious articles, except that the chaotic circumstance prevailing in Kham from 1905 to 1918, and the destruction of monasteries and palaces, obviously rendered many sacred and princely objects homeless (Volume I, pages 56-58). Chorten A arrived at the Museum empty in 1920. The base plate of chorten D does not fit inside the original grooves at the bottom, evidence that at some time it was removed and resealed; it has remained sealed since its arrival at the Museum in 1920.

Chorten C and all its contents were published by the prior owner, Robert T. Hatt.[8] Hatt based his attribution of Western Tibet for this chorten on the two drawings found inside (P2), giving considerable and useful comparisons with known thirteenth-century paintings and drawings. Subsequent scholarship, however, has now placed the focus on this "Kadampa" style in Central and Southern, rather than Western Tibet.[9] Barley grains enclosed in chorten C were radio-carbon dated to A.D. 1230 (plus or minus sixty-five years). Other contents, such as the drawings and paper manuscripts are consistent with the thirteenth century date; the circa eighth-to-ninth-centuries birch bark manuscripts were presumably old at the time of enclosure. Pertinent aspects of the contents will be discussed separately, where appropriate (e.g., manuscripts in Volume V, forthcoming).

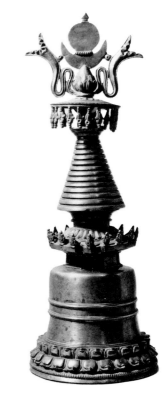

D. CHORTEN

Cast brass, h. 22¼" (56.5 cm)
Tibet, 12th century or later
Purchase 1920 Shelton Collection 20.424

Hollow cast in sections which are crudely pinned and welded together by later repairs; entire top section, from the vertical collar under the umbrella to the finial, is a later replacement, crudely cast. The base is resealed with a copper plate, incised with crossed *dorjes* with "whirling" center; contents are probably disturbed. Patina: golden brown.

1. See vol. I, pp. 68-69, for a discussion of the meaning of the stupa. For Indian forms, see AAI, pp. 61-74, and figs. 5.6 and 5.8, and Snellgrove, *Image*, figs. 11, 12, 13.

2. See S40 and a portrait of Atisha in a wall painting at Nyetang monastery, where he died, Henss, *Tibet*, p. 130.

3. Henss, *Tibet*, p. 130 (date of extant tomb-chorten uncertain) and von S., p. 465.

4. For stupa forms accompanying Pala stone images, see AAI, figs. 18.5, 18.8, 18.10, 18.12. For stupas on a Pala-style clay image, see fig. 13G. For stupas, umbrellas, ribbons and finials on bronze nimbuses, see von S., nos. 53D, 55C, D, F, 56A–C, G, 58A–D, F, 61B–D, 62E–G, 63A–I, 64A–G and 67A–D.

5. Robert T. Hatt, "A Thirteenth Century Tibetan Reliquary; an Iconographic and Physical Analysis," *Artibus Asiae*, XLII, 2/3 (1980), pp. 193-95.

6. Ibid., pp. 175-76.

7. For Ladakh, see Snellgrove and Skorupski, *Ladakh* I, fig. 128; for Central Tibet, see Tucci, *Transhimalaya*, fig. 88; chortens S9A, B, D, were obtained in Eastern Tibet. Hatt, "Tibetan Reliquary," pp. 194-95, gives a partial listing of other "Kadampa chortens."

8. Hatt, "Tibetan Reliquary," pp. 175-220.

9. Pratapaditya Pal, "Off the Silk Route and on the Diamond Path?" *Art International* XXVI/2 (April-May-June, 1983), pp. 55-59; and *LA Tibet*, pp. 115-16, 134-35.

S10

BODHISATTVA

Cast copper alloy with silver and gold inlay, h. 6¾" (17.0 cm)
Tibet, 12th century or later
Purchase 1979 The Members' Fund 79.442

This intricately worked image is cast in one piece in an alloy whose reddish-gold color suggests a high percentage of copper. This reddish tone sets off the silver and gold inlay of floral and striped patterning in the deity's dhoti, the floral and lozenge design of the sash across the chest, and the diapered meditation band secured around the left knee. Silver has been used to form the double beaded sacred thread, which runs from the left shoulder to loop at the pelvis and returns up the back. The inlay work is carried fully around; indeed the image is as exquisite from the back as from the front. The double lotus petal base is hollow. In recessed areas there is a dark brown residue, and red paint traces are visible in the hair locks. The lack of specific symbols and the presence of the meditation strap and lotus indicate a possible identification to any number of bodhisattvas.[1]

The image is unmistakably in the Pala style and several elements correspond closely to twelfth-century Bihar pieces: the teaching hand pose; thick, curving *utpala*-type lotus plants; base of double-layered lotus petals arranged in two rows under a beaded edge; piled, coiled locks of hair with jewel finial, and the unusual pendent left leg. Undoubtedly, the artisan had access to an actual Pala example. An image of Maitreya, found at Fatehpur, near Bodhgaya, which exhibits all of these features is the kind of small sculpture that could easily have been carried to Tibet in the twelfth century and kept in a place of honor; to be copied by local artists in succeeding centuries.[2] An ornate style of metal casting with extensive inlay and even gilding, attributed to the late phase of Pala art, may have been especially attractive to Tibetan patrons and pilgrims visiting Buddhist centers at Bihar. One such image, found at Kurkihar, has many similarities to The Newark Museum piece: a patterned cloth band across the chest with a swirl at the left shoulder, a striped and floral patterned dhoti, thick, curving, lotus plants, a pendent leg pose and piled hair.[3]

Unusual elements in the Newark image make the place of manufacture and date difficult to determine. The band which holds the leg in position for meditation is known in earlier Indian sculpture, both Hindu and Buddhist. A Padmapani image of later date is remarkably close to the Newark piece, even to details such as the double-beaded, sacred thread, the flat curls across the forehead, and patterned meditation band ending in a bow and sash at the knee. The Padmapani has a close affinity to Pala styles but the image represents Padma Wangyal, and is dated 1571.[4] The tenderly featured face of the Newark sculpture is uncommon and decidedly unlike the sharply defined, strong features of Pala images. Here, broad, smoothed brows, eyes, nose, mouth and the downward cast of the head, resemble Nepalese casts of the eleventh to thirteenth centuries.[5] That this may be a copy of a Pala image with a worn face can also be considered, as well as the even more remote possibility of an Orissan prototype. Although the mass of Tibetan sculpture which follows Pala style cannot be firmly

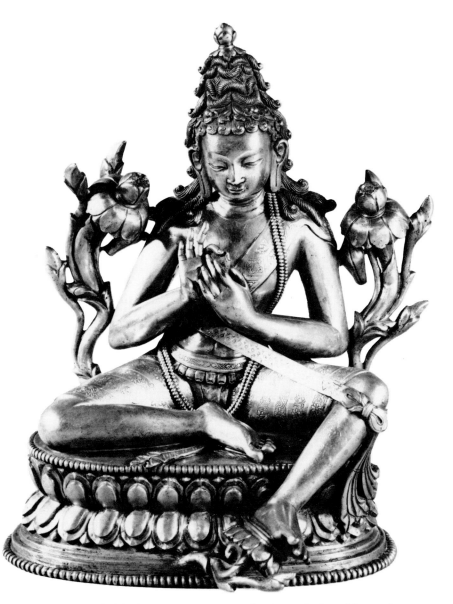

dated, it is probable that most was executed prior to the late thirteenth century, when Nepalese influence became pronounced.

1. The pose and *mudra* is often used for Manjushri and Maitreya; the syncretic forms using Shiva's attributes, such as the headdress and meditation strap here, include the Lokeshvara ("Lord of the World") and Lokanatha aspects of Avalokiteshvara. See Snellgrove, *Buddhist Himalaya*, p. 63, for Lokeshvara; and Marie-Therèse de Mallmann, *Introduction a L'étude d'Avalokiteshvara* (Paris, 1948), pp. 111, 114, for Sri Potalaka Lokanatha.

2. von S., no. 71C, note the hand pose, pendent left leg and thick lotus plants; the same image is discussed by Susan L. Huntington, "Some Bronzes from Fatehpur, Gaya," *Oriental Art* (Summer, 1979), pp. 240-47, figs. 4-5. For Pala images on the altar at Sakya Monastery in Southern Tibet, see von S., p. 464.

3. von S., p. 240 and no. 71A, also published in Pramod Chandra, *The Sculpture of India: 3000 B.C.–1300 A.D.* (Washington, D.C.: The National Gallery of Art, 1985), no. 62.

4. von S., no. 133B; the image was first published by Pratapaditya Pal, *Arts of Asia* (November-December, 1975), pp. 32-35, fig. 3. A partial reading of the inscription by Yoshiro Imaeda indicates that it is an image of Padma Wangyal (1487-1542), represented in a divine form as Avalokiteshvara, and dated to the iron-female-sheep year (1571).

5. Compare von S., nos. 84B, D, and 90F.

S11

VIGHNANTAKA

Cast brass with silver, copper and iron inlay, 5¼" h. (13.4 cm)
Tibet, 12th century(?)
Gift of Judith and Gerson Leiber 1985 85.404
See color plate 1

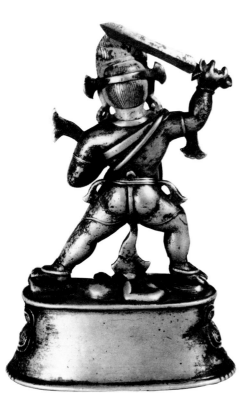

The solid figure and hollow base are cast in one piece of golden yellow brass (with black patina where not rubbed or cleaned). The extraordinarily fine casting depicts the heavy-bellied deity in *alidha* pose, with a sword (forged iron blade attached to the brass *dorje* handle) in his raised right hand, and a *dorje*-noose in his left hand. Both hands give the *karana* gesture. His bulging eyes are formed of silver and copper; the third eye, knotted brow, fangs, "flame" whiskers, and large nose are carefully wrought. He wears a three-leaf crown (center leaf missing its inlay) and a patterned brow-band, with side flourishes behind the ears and a smooth band behind the head; the striated hair is pulled up to a flaming top-knot, tied with a serpent and with a seated buddha at center. The figure is adorned with earrings, a floral necklace with center dark stone inlay, leaf-decorated arm bands, and snakes—with carefully delineated heads and bodies—at his neck, wrists, torso and feet. A tiger skin loin cloth and scarves wrap the hips and hang between the legs, while another scarf encircles his arms.

The elongated, oval, double-lotus base has beading at the top and bottom edges and a beveled band below; all decorative work stops at the sides, leaving the back plain. Underfoot the supine form of the elephant-headed Ganesha holds a boss, or fruit, in the left hand and a conch in the right. He wears a necklace similar to Vighnantaka's and is strongly modeled, with grimacing face. The hollow, blackened, base interior is empty and shows recessed casting for Ganesha's form on top. There is wear on the belly, the snake head at the groin, Ganesha's trunk and right hand, Vighnantaka's raised left finger, and on the central petals and beading of the lotus base. Traces of paint remain: red in the hair, blue on the sashes of the crown, green on the snake in the hair and gold on the buddha in the top knot.

This is an interpretation in true Pala style of the Buddhist deity who conquers Ganesha, the Hindu god who defeats obstacles. The concept is related to that of Yamantaka in its desire to show Buddhist superiority over Hindu deities.[1] The body form, stance, and weapons of both deities are related. Although excavated Pala-period metal examples of Vighnantaka are lacking, similar semi-wrathful gods do appear in Pala sculpture and manuscript illustrations (see P1), and are frequently seen in Tibetan painting and sculpture done in the Pala style.[2] Aspects of that style are seen here, especially in the crown, sashes, lotus pedestal, facial type and ornaments.

1. See Bhattacharyya, pp. 180-81, for the 1163 *Sadhanamala* invocation for Vighnantaka. Ian Alsop, "Five Dated Nepalese Metal Sculptures," *Artibus Asiae* XLV 2/3 (1984), pp. 209-11, fig. 2, cites the eleventh-to-twelfth-century *Nispannayogavali* invocation, and a dated 1297 Nepalese example of Vighnantaka. For Western Himalayan and Tibetan forms of Vighnantaka, see von S., nos. 27F, 36A, 37B and 40G.
2. For related excavated Pala images, see von S., nos. 62A and 69C; *LA Tibet* no. S22, shows a Tibetan image of Vajrapani which exhibits many of the same Pala features as the Newark piece.

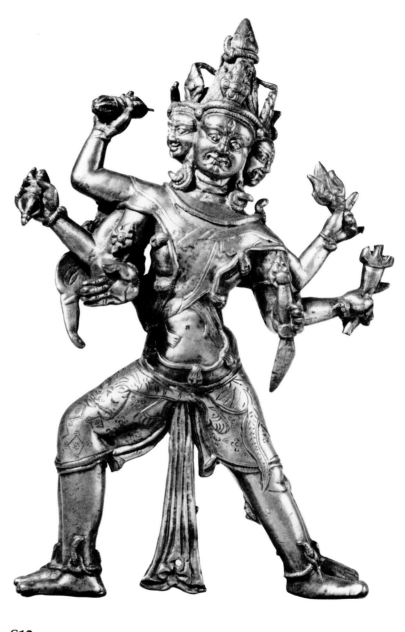

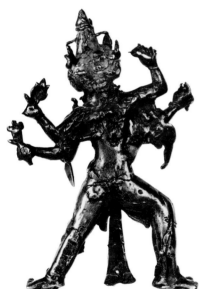

S12

DORJE PHURPA

Cast brass, h. 10¾" (27.3 cm)

Southern or Western Tibet, 12th century (?)

Gift of Mr. and Mrs. Jack Zimmerman in honor of Eleanor Olson 1970
70.27

This heavy, hollow cast[1] image has a golden brown patina on the front;
the back is completely unfinished, showing patches and gouges, with

areas of black residue. Iron chaplets are evident on the legs and chest, and a large, irregular patch of lead repairs a casting flaw in the neck. Traces of red paint remain in incised areas of the elephant skin the god is wearing and on the multiple arms and weapons; orange paint remains on the hair, quite thoroughly covering the back; faint traces of white paint can be seen on the two side faces. There is no base; a hole drilled through the center of the drapery hanging between the legs may once have fastened the body to the base. In the six hands are (right, top to bottom): a nine-prong *dorje,* a five-prong *dorje,* and an open palm; (left, top to bottom): a lotus? (stem broken off), a trident (top and bottom broken off) and a *phurpa.* The central and left faces have curved fangs; all three faces have a third eye, knotted brow, bulging eyes, bulbous nose and cleft chin. The headdress over the faces features a quatrefoil crown, piled hair with lotus bud finial and a coiled snake. Additional snakes adorn the ears, shoulder, (six) wrists and (four) ankles. Quatrefoils decorate the front arms; a chain of heads hangs around the torso; elephant and human skins are tied at the chest and a tiger skin is tied across the hips over a patterned loin cloth.

Dorje Phurpa (S. Vajrakila) is the personification of the "obstacle-removing force" more commonly seen in the ritual implement *phurpa* (the triangular-bladed device in the deity's lower left hand), and is particularly important in the Nyingmapa tradition.[2] The Newark Museum's image, and one very similar in the Los Angeles County Museum,[3] are the earliest known Tibetan sculptures of this deity. Both lack a female partner seen in the later, more numerous, examples. The Los Angeles image has a partial base, showing two *rudras* (forms of Shiva) trampled under Dorje Phurpa's four feet. There are slight differences between the two statues but the basic rendering, especially the "hour-glass" torso, the unfinished back, and the method of attaching additional arms and legs, is similar. This form of Dorje Phurpa may represent an early sculptural adaptation of imported Indic concepts.[4] Pala and Kashmiri semi-wrathful forms, Samvara, Vajrapani and Yama, for instance, had been developed between approximately the eighth to twelfth centuries and these are comparable in stance and attributes to Dorje Phurpa.[5] The color of the metal and crudity of the cast, in both the Newark and Los Angeles pieces, are similar to images attributed to both Southern and Western Tibet. The blend of Pala and Kashmiri styles indicate a time period when each were well known in Tibet, but prior to the influx of Nepalese artisans.

Previously published: DDH, fig. 199; *Silk Route,* pl. 98.

1. See x-ray photograph; metal composition: 87.0% copper, 11.1% zinc, .09% tin, .71% lead and .08% iron, analysis done by Chandra Reedy and Pieter Mayers, Los Angeles County Museum of Art and UCLA, 1982-85.

2. See Huntington, *The Phur-pa,* pp. 13-14, figs. 6-7.

3. *LA Tibet,* no. S21.

4. Manuscripts discussing the deity Phurpa were found at Dunhuang and it is certain that the cult was known in Tibet by the eighth century, R.A. Stein, "A propos des documents anciens relatifs au Phur-bu (Kila)," *Proceedings of the Csoma de Körös Memorial Symposium* (Budapest, 1978). A Pala-style Nyingmapa painting, of perhaps the twelfth to thirteenth centuries, includes an eight-armed form of Dorje Phurpa (identified by inscription as "rDo-rje gShon-nu," an alternative name for Vajrakila), accompanied by a consort on his left knee (?), see TPS, lower left corner, pl. 1.

5. For Pala prototypes, see von S., nos. 59B and 66D; for Kashmiri prototypes, nos. 19G and 20F.

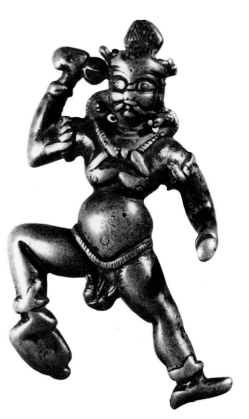

S13

VAJRAPANI

Cast brass, h. 4⅛" (10.5 cm)
Western Tibet (?), 12th century or earlier
Anonymous gift 1984 84.381

The extremely worn condition of this cast makes dating and identification problematic, but does connect it to a class of small, fondled metal objects unique to Tibet called *tokde*: "stone fallen from the sky".[1] *Tokde* are used as amulets, and are always small enough to fit easily in the hand or to wear; thus they are effaced from constant handling. Like *tokde*, this image is thin (three-quarters of an inch at its thickest part) and has an unfinished, recessed back, suggesting a single mold casting. The dark golden brown patina of the brass and the exaggerated chest and stomach are similar to tenth-to-twelfth-century images attributed to Western Tibet.[2] The worn face, hands and attire of this figure have, in common with other early Tibetan fierce forms, the nine-prong *dorje* in the raised right hand, snake ornaments, skull crown, upraised hairdo, tiger skin loin cloth, exaggerated stance, bulging eyes and fangs. Several of these features can also be seen in the Dorje Phurpa, S12, which exhibits more distinctly Pala-derived elements.

1. Tucci, *Transhimalaya*, pp. 34-39, figs. 1-32.
2. Compare von S., nos. 32E and 33A.

S14

TARA

Cast copper with traces of gilt, h. 8⅛" (20.7 cm)
Nepal, 11th century
Purchase 1970 The Members' Fund 70.2

The figure of the goddess is fully modeled with fine, incised detailing on the garment, both back and front. The crown is held by a flat band which passes around the back of the head; the hair has incised waved bands, and is caught in two large chignons at the sides, with three curls flowing down behind the rosette (left), and disk (right) earrings and onto each shoulder. The hollow, shallow, spreading single-lotus base has a flat back, perhaps to accommodate attachment to a larger grouping.[1] This image has been previously published as either Devi ("goddess") or Tara and stylistically dated to the ninth through

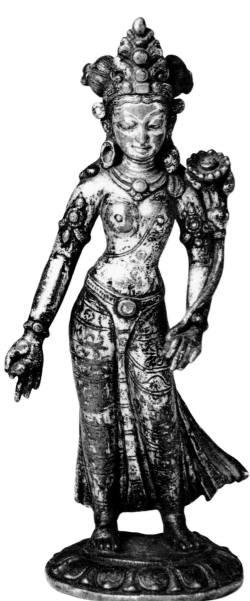

eleventh centuries. The restrained elegance of the figure, and the attention to drapery and jeweled ornamentation exemplified by the goddess are seen in other sculptures attributed to the tenth to thirteenth centuries.[2] The few known dated eleventh-century Nepalese examples are not without similarities to Newark's Tara: a lingam of 1045, whose faces have the same sweeping brows and aquiline noses, and a Vasudhara of 1081, whose garments and face are comparable.[3]

The antecedents for this type of goddess are clearly Indian: the combed striations and double-chignon hair style, jeweled diadem, mismatched earrings, leaf-like armlets and floral patterned diaphanous garment held with an elaborate jeweled belt, can be found on Guptan and post-Guptan sculpture across northern India. The demure expression and youthful body type, typical of Nepalese sculptures of the eleventh to thirteenth centuries, contrasts, however, with the more forceful and mature female ideal seen in Indian art.[4] This is further emphasized by the soft copper metal and warm gold surface preferred in Nepal. The identification of Tara here seems justified; the Buddhist "savioress" is the primary female bodhisattva worshiped by Vajrayana Buddhists. Nepalese images of Tara are frequently shown, as here, bearing the lotus in her left hand and extending the right in *varada mudra*.

Previously published: Pal, *Art Nepal I*, pl. 226; DDH, no. 91; von S., no. 86H.

1. This base was probably set originally into a rectangular plinth common on early Nepalese castings; see von S., no. 90D. A nimbus may have attached to the missing base.
2. Compare von S., nos. 81F, 82B, 88B and 92C-H.
3. See von S., nos. 83F and 85F, for the lingam and 1081 Vasudhara.
4. See, for example, metal images of Tara from Nalanda, seventh to eighth centuries, von S., nos. 49A, B, H, 50C, F.

S15

TARA WITH THRONE AND PRABHAMANDALA

Assembled gilt copper, cast and hammered; silver wire and jewel inlay with traces of paint; h. (goddess only) 14¾" (37.5 cm), (throne) 5½" (14.0 cm), (*prabhamandala*) 21¼" (54.0 cm); total 28" (71.1 cm)

Goddess: Nepal, 10th-12th centuries; throne and *prabhamandala*:Tibet, 15th century or later

Purchase 1920 Shelton Collection 20.453

This large and complex image has been the subject of conflicting opinion for some time. It was obtained by Shelton in Kham, but his notes give no particular provenance. The figure of the goddess is clearly in the style of Nepal, but where and when were the figure, throne and *prabhamandala* made and assembled? The goddess is cast in one piece, and her great weight suggests a "solid" casting.[1] She wears a striped, lower garment which, like a dhoti, is wrapped horizontally around her hips and legs, with an unusual "tail" hanging, vertically, in the back. The garment is fastened by a wide hip belt and a buckle,

set with a blue glass bead and turquoise and glass chips. An undulating pleat hangs from belt to hem line. Each stripe of the garment is fitted with a central groove, set with fine beaded silver wires. A separate sash swoops from the left shoulder across the chest, under the right arm and across the back, to loop at the left shoulder and swing down behind on the left side. The sash has a striped pattern across the center of the hanging section. There are traces, much worn, of similar patterning on the hem to the left and right of the lower legs. Heavy bands with a cross-hatched surface and jeweled buckles clasp her feet. Spiral bands, ending in upright leaves inset with turquoise glass chips, encircle her upper arms and additional bands are at her wrists. A small, beaded necklace, lying close to her throat, has a central rosette set with turquoise glass chips. The large earrings are mismatched: a long smooth tube is in the left ear and a thick, up-curving floral form with turquoise glass chips is in the right. Her hair, marked with striations, is pulled up to a top knot with two side loops and two cascades down behind the ears, ending in curls at the shoulders. The crown curves down to frame her face, with grooves set with silver beaded wire (mostly missing on the right side) fastening in the back with a striped band; the tall, central "leaf" is set with chips of turquoise and clear red glass and the two smaller side leaves have turquoise glass chips. Her feet are cast onto a small oval disk which is riveted down into the base. Heavy gilding covers all surfaces except the silver wire inlay and hair. Traces of pink paint are on the face and neck. The empty hands give gestures of blessing and gift-bestowing.

In the image of Tara, one can see Nepalese characteristics of a very early sort. The exaggerated swelling hips and belly, upper arm ornaments, the lower garment with heavy belt, the arrangement of the body sash, the necklace close to the throat and the crown type are found on goddess figures of the seventh to tenth centuries.[2] Mismatched earrings are also seen in the eleventh-century Nepalese Tara, S14, and eleventh-to-twelfth-century Tibetan Maitreya, S7. A stone stele of Laksmi in the National Museum, Kathmandu, tenth to eleventh centuries, has exactly the same earring combination of tube and rosette.[3] Precedents for silver wire are found in Pala sculpture[4] and in Tibetan images in the Pala style (S10), but not in Nepalese castings. Similar grooves are cast onto Nepalese images, however, to receive strands of seed pearls. The oval base attached to the feet is common to early Nepalese images. Originally, the figure would have been set onto a small lotus pedestal; two thick vertical lugs are cast on the bottom of Tara's oval base for this purpose.

The reticulated throne base is constructed of hammered sheets of gilt copper. Separately hammered gilt copper ornaments (dorje with foliage, two lions, two caryatids on the front, elephants with jewels on each side) have been riveted to the recessed section. A lion-like "face of glory" is part of the relief decoration at the center of the scroll border (above the dorje). Joints and seams appear on the flat, ungilded back. A thin copper sheet, slightly recessed and decorated with an incised double dorje, is attached by eleven brads to the bottom of the throne. The back of the throne has two roughly devised loops at center back to receive a tab at the bottom of the prabhamandala. The weight of the goddess has caused the base to partially depress, so that the image now leans backward.

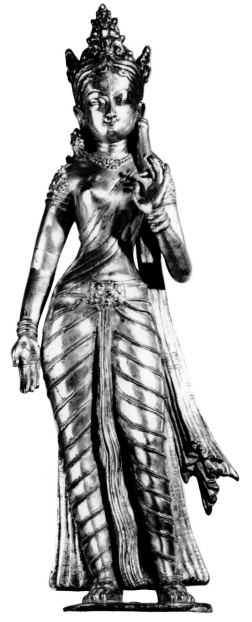

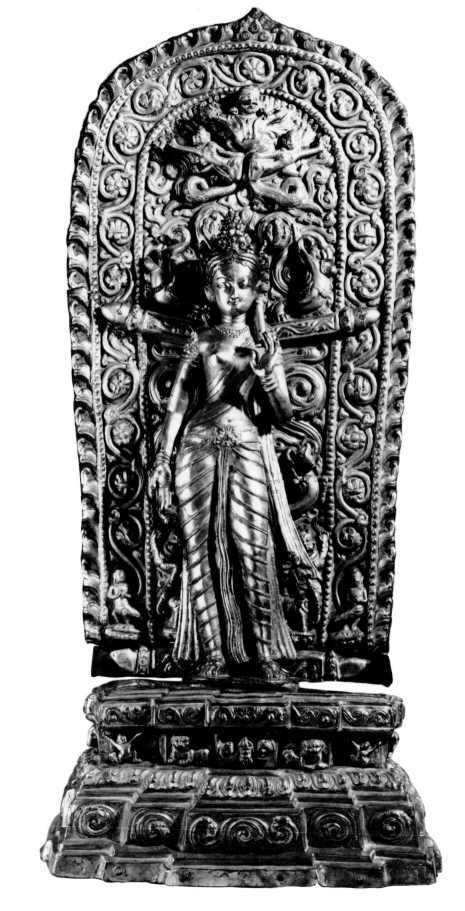

The *prabhamandala* is also constructed from a sheet of gilt copper, with both shallow and deep hammered designs. The central concave vertical panel (behind the goddess) ends in two horizontal bars with a wave-like scroll design and beaded knob ends (to the sides of the goddess's neck). A similar bar is at the base (at the goddess's feet). There is a narrow recessed oval halo, with beaded and scroll edges, behind the goddess's head. Flanking the center are (from bottom to top) elephants on lotus pedestals; lions with "waving" paws; leaping, antelope-like creatures with praying and haloed figures on their backs; thick, scrolling vines; (above bars) *makaras* with front feet, horns, gaping mouths and curly "tails"; a *garuda* with *naga* creatures and a peacock-like, spread tail at the apex and curvilinear vines in the background. Separately formed horns on the *makaras* and snake earrings on the *garuda* are attached with tabs. An outer rim of vines rises from a base of bird creatures on lotus platforms to enclose flowers, leaves and banners. Outside this is a flame rim with a three-jewel apex. Matte gilding covers all the relief surfaces and red paint all the recessed surfaces. The rough copper back has a thick black patina; a copper tab, reinforced with a horizontal copper plate at the bottom, secures the *prabhamandala* to the base.

There is a clear relationship between this *prabhamandala* and those made in Nepal (compare S17) with regard to the decorative elements, mythical creatures and beasts, as well as in technique. Such *prabhamandalas,* with Indian antecedents, were popular in Tibet, as well as in Nepal, by the twelfth century, and they continued to be made until the twentieth century.[5] Most work of this nature is attributed to Newari craftsmen in Tibet, but the *prabhamandala* and the throne added to this Tara, undoubtedly by the same craftsman, have a coarseness and exuberance more associated with "Tibetan taste."

In conclusion, it is proposed that the Tara image, so similar to the early Nepalese type of stately and voluptuous goddess figure, is between tenth to twelfth centuries in date. The technique and materials are definitely indicative of Nepalese work. The base and *prabhamandala* are later, perhaps fifteenth-century additions, and seem more Tibetan in type. Accepting the supposition that a replacement base and *prabhamandala* were fashioned in Tibet for a large and fine imported image, it can also be argued that the image was regilded (which would explain the worn patterning on the garments, faint third eye on forehead and marks on palms; all covered with brilliant gilding), and silver wire placed in the grooves originally holding pearls, at the same time. Certainly the turquoise and glass inlay and the painted face are Tibetan work. Such "enthronement" and embellishment of an honored image are entirely in keeping with Tibetan practice.

Previously published: Stella Kramisch, *The Art of Nepal* (New York: The Asia Society, 1964), no. 39; Pal, *Art Nepal I*, pl. 233; DDH, no. 126.

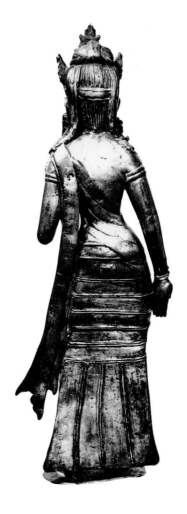

1. There is a rectangular plate or plug on the buttocks.
2. Compare von S., nos. 75E, G, 76F, 78C, 80B and 81F.
3. Pal, *Art Nepal I*, pl. 227; see also pl. 159 for the unusual, single cylinder earring on a seventh-to-eighth-century stone relief figure in the Kathmandu Valley. For Indian antecedents, see Frederick M. Asher, *The Art of Eastern India, 300-800* (Minneapolis: University of Minnesota Press, 1980), p. 86, pls. 186 and 191.
4. See von S., nos. 62A and 71A.
5. See Tucci, *Transhimalaya*, pl. 156; and von S., pp. 404, 408, 413, 415 and 419.

S16

PADMAPANI

Cast gilt copper with jewel inlay and traces of paint; brass base; h. 10⅞"
(27.6 cm)

Nepal, 14th century

Anonymous Gift 1981 81.392

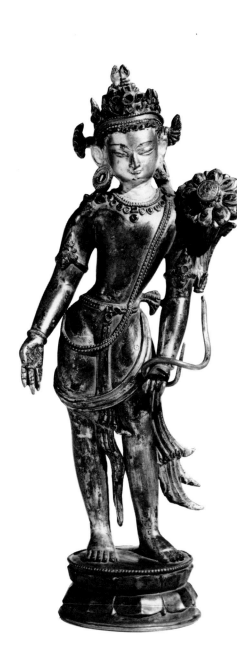

This image exhibits the stance, ornaments and attributes of the
peaceful bodhisattva form favored by Newari artists from the sixth to
the seventeenth centuries.[1] The god stands with his weight on the
right leg, hip thrust out, right hand in the gesture of gift bestowing
and left holding the stem[2] of a large lotus flower, which perches on his
left shoulder. His hair is dressed in ropes of braids, piled on top of his
head, and topped with a flame-shaped gem; additional locks fall down
behind both ears and end in curls at the shoulders. Tight curls form
under the crown, which circles the forehead and is secured to a band
behind the head with volutes above each ear. The crown supports a
prominent central jeweled leaf and four flanking subsidiary leaves.
Large disk earrings, leaf-form armlets, a jeweled belt, a necklace, a
beaded sacred thread and bracelets complete the ornaments. Ruby,
sapphire, and emerald chips are set into the headdress, necklace and
belt.[3] The circular swathe of the drapery across the thighs, echoing that
of the sacred thread, and the busy convolutions of the sashes between
and to the left of the legs came into use in the fourteenth century.[4] The
entire figure, crown and lotus, were once covered in gilding; now only
traces remain except on the face where it is solid. Painted gold remains
in recesses on the face, neck, earrings, and gems in the headdress; blue
paint remains on the hair. The figure is fully modeled in the round
although there is less detail on the back; the incised rosettes on the
front drapery, for instance, are not carried around to the back. The
present brass lotus pedestal (hollow and round in cross-section) is a
replacement. Since the gold and blue paint on the head are proof of
Tibetan ownership, it is probable that the base is Tibetan. The
translucent gemstones, however, indicate that the image was orig-
inally worshiped in Nepal.

1. See, for example, von S., nos. 78B, D, 80A, C, 83G, 86C, E and 99A; Pal, *Art Nepal I,* pls.
8, 13, 46, 187-88 and 197. Compare also S14.

2. The stem of the lotus, separately fashioned and attached, has become detached from the
flower.

3. Recesses in armlets and headdress indicate where additional gems were originally set.

4. Replacing the earlier straight diagonal swathe of drapery across the thighs, compare: von
S., nos. 90F, G (thirteenth century) to those of nos. 94B, F (fourteenth century); and *Art
Nepal I,* pls. 187-94 (ninth to thirteenth centuries) to those of pls. 195-96 (fourteenth
century).

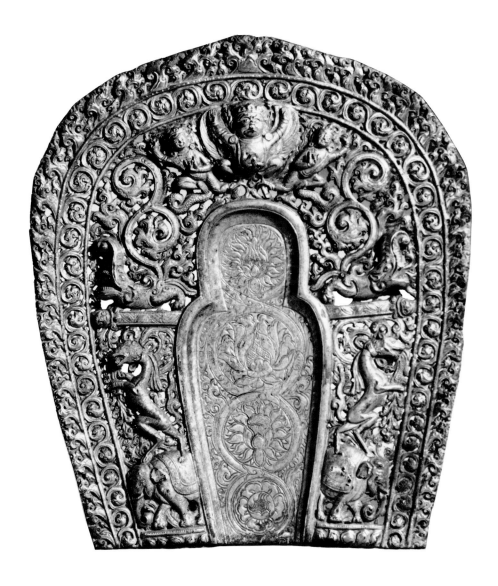

S17

PRABHAMANDALA

Hammered gilt copper, h. 12⅛" (30.8 cm)

Nepal, 14th century

Golden Anniversary Gift of a Group of Present and Past Staff Members
1959 59.346

The thin sheet of copper has been hammered with dense low-relief decorations; the bodies of the two *makaras* at middle sides and a *garuda* with *nagas* at the apex are in high relief. The leaf-scroll background and *rinceau* and flame borders are cut with openwork pattern. The front surface is gilded; powdery green corrosion appears in sections (especially on the right side) where the gold has worn off; a pink residue of ritual pastes once covered much of the gold. The back, ungilded, is completely covered with green corrosion. Remains of iron posts, which originally supported the *prabhamandala* and secured it to a base,

are pinned on at middle and bottom, left and right. The recessed central tri-lobed area, corresponding to the head and body halo of the standing image, which once stood before the nimbus,[1] is incised in low relief with four scrolling loops (of different sizes) enclosing lotus blossoms. This style of *prabhamandala* had become the standard form for Nepalese architectural gateways, paintings and sculpture by the fourteenth century. Antecedents are found in India, where the various elements of lobed halo recess, looping vines, and protecting auspicious beasts are to be seen in ninth-to-tenth-century Pala stone and metal images, and in tenth-century Kashmiri castings.[2] Numerous Nepalese examples range from the sixth to the seventeenth centuries in date.[3] The gilt and copper material and the finesse of the technique used on Newark's *prabhamandala* are characteristic of Nepalese craftsmanship.

Recent scholarship has pointed out the direct relationship between the Newark *prabhamandala* and a dated, imperial gateway in northern China.[4] The Yuan emperor, Xundi (Toghan Temur, reigned 1333-67), ordered the gateway built as a ceremonial entrance in a pass north of Beijing; the complex was conceived as a Buddhist monument surmounted by three white stone pagodas in Tibetan style. The monument was completed in 1345; the pagodas were demolished in about 1400 but the arched gateway beneath has survived. The entire decorative scheme reflects Nepalo-Tibetan origins, but of immediate comparison to Newark's *prabhamandala* are the carvings on the gateway: *garuda* treading on the feet of two fleeing *nagas, makaras* and scrolling foliage, and elephants with rampant, horned beasts on their backs. Along the inner edge of the gateway arch are panels of floral motifs enclosed in vine tendrils, very similar to the recessed central area of the Newark piece. An almost identical *prabhamandala*, in the collection of the Seattle Art Museum, is certainly from the same workshop and time, and the similarity in size suggests both were done as part of a set.[5]

The extraordinarily close comparison of the form and components of the two metal *prabhamandalas* to those of the mid-fourteenth-century Yuan gateway suggest that both derived from a repertoire available to Nepalese artists, and to Chinese craftsmen using Nepalese models, by the early fourteenth century. A possible vehicle for the transmittal of these Nepalese models into China are the several editions of the Buddhist canon, printed in China between 1302 and 1410. These editions contain images seated before *prabhamandalas* featuring many of the decorative elements of Newark's gilt copper example.[6]

1. Compare S15.

2. For Pala throne elements, lions and elephants, see von S., no. 56E; for a Kashmiri *prabhamandala,* see p. 105. These derive from a common earlier Indic tradition; for Gupta period architectural remains, see Slusser, *Nepal,* pls. 321, 328.

3. For architectural sections, see Pal, *Art Nepal I,* pls. 156-57; for use in painting, see P5 and a tanka, dated 1367, in Pal, *Nepal Gods Young,* no. 43.

4. Sheila Coffin Bills, "A Chronological Study of Sino-Tibetan Metal Sculpture (1260-1450)," (Ph.D. diss., Case Western Reserve University, 1983), p. 35-45. See also *Sino-Tibet,* p. 114; and J. M. Addis, *Chinese Ceramics from Datable Tombs and Some Other Dated Material* (London and New York: Sotheby Parke Bernet, 1978), pp. 159-60.

5. Henry Trubner et al., *Asiatic Art in the Seattle Art Museum* (Seattle: Seattle Art Museum, 1973), no. 53.

6. See pp. 21-22 and *Sino-Tibet,* pp. 41-70.

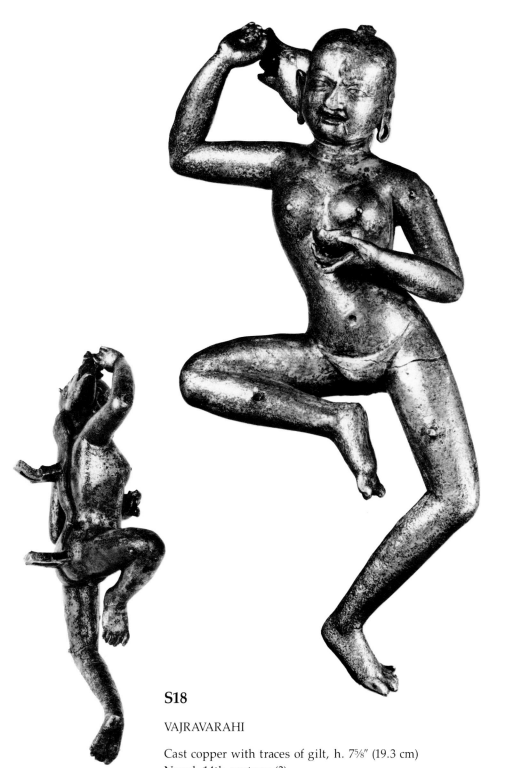

S18

VAJRAVARAHI

Cast copper with traces of gilt, h. 7⅝″ (19.3 cm)
Nepal, 14th century (?)
Purchase 1978 Anonymous Fund 78.125 From the Collection of
George P. Bickford

This image has suffered considerable damage and losses which obscure the original grace and power of her dancing form. The youthful body has been sensitively and carefully modeled in a surprisingly naturalistic manner. The concepts of such *dakini*-beings "dancing in the sky" and "clothed in air," have been translated literally by the artist so that the full weight of the figure (which is considerable for its size) is borne by the two heavy rectangular brackets cast to her mid-back and buttocks, thus supporting the figure completely in the air. Notice that the toes of the lower, right leg are curled and would not have supported any weight.[1] Unlike other *dakini* or Vajravarahi images, this example is completely nude; she was originally, of course, "clothed" in bone and jewel ornaments, separately cast or hammered in metal and floating around her body and head. This use of separately fashioned ornaments can be seen in the silver Vajravarahi, S34. Prongs, for attachment of the original ornaments onto this Nepalese example, are at two places on the top of the head (flanking the broken-off knob where a headdress/finial was once cast), and on the left shoulder, the buttocks, and both legs (front and back). The large loops in the distended ears would have borne earrings; the odd curve of her hair at the back must have been formed to receive adornment, and the sweeping incision under the belly would have been the position for a belt. Perhaps, at the same time that the image suffered the loss of its ornaments, it was burnt in a fire and dropped; for when obtained by the Museum the image was completely black. Cleaning revealed the gilt surface, patched and dispersed as from intense heat. The nose has been disfigured from a blow and, most disturbing, the right hand has been knocked back so that the *dorje*-handle of the chopper or *dorje* now smashes into the open mouth of the boar's head, emerging from behind Vajravarahi's right ear, and the curved chopper blade or *dorje* has been broken off.[2] The goddess's girlish body and graceful dancing pose are counterbalanced by an angry face with open mouth, furrowed brows, and vertical third eye. The two unusual vertical flanges, hanging from her mouth and down her chin, do not seem to be "fangs" but may represent dripping blood from the beings she has devoured.

The dating of this piece is problematic; the absence of ornamentation and the naturalism of the modeling give it a timeless quality. It is close in style to a Vajravarahi in the Pan Asian collection, which is given a fourteenth-to-fifteenth-century date.[3] The youthful body and the gilt copper material are typically Nepalese; compare S14-16.

Previously published: Stanislaw Czuma, *Indian Art from the George P. Bickford Collection* (Cleveland: The Cleveland Museum of Art, 1975), no. 28.

1. The brackets must once have attached to a back-plate/nimbus. The only other such back-supported, "flying" *dakini* known to the authors is a large, seventeenth century (or later) Nepalo-Tibetan image in the Musée Guimet, see DDH, no. 149.

2. The boar's head is Vajravarahi's ("Diamond Sow") identifying characteristic. See hand position and boar's head in S34 and drawings, fig. 10A-B. Note also her appearance as the partner of Samvara, S21 and P11.

3. Pal, *Sensuous Immortals*, no. 109; compare also *Sino-Tibet*, pl. 35 for a similar type in a Chinese printed book, dated 1410.

S19

BODHISATTVA

Ivory, h. 5½″ (14.1 cm)
Nepal(?), date uncertain
Purchase 1973 Wallace M. Scudder Bequest Fund 73.130

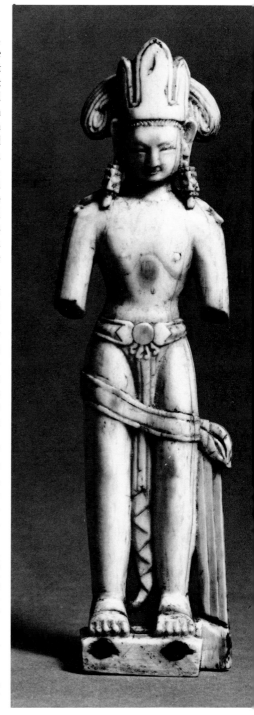

A problematic group of such images, all identical in pose and attire, are now known, made either of wood, or more rarely, ivory.[1] The components are: a rigid (as here) or very slight curved pose; the left hand on thigh at the sash, the right hand in gift-bestowing gesture at the right thigh (missing in Newark's ivory); a bare chest with a curved suggestion of breast line and raised nipples; a diagonal sash with a loop tie and a pleated drape down the left leg; a bevelled belt, with a central disk buckle, from which "hooked" flourishes and vertical pleats fall in ripples between the legs; faceted cube earrings with pendant bottoms, and a three-leaf, plain[2] crown with striated hair, gathered up in back to a top knot from which two fat side loops extend and two locks come down behind the ears ending in curls at the shoulders. The Newark Museum's ivory has a separate piece, attached with two iron pins, to form the front of the feet, and it once had arms socketed in. Brown stains cover the entire back;[3] traces of black pigment remain on the eyes, hair, crown and earrings. A small square recess is cut into the center back for consecration.

Ivory icons are rare, due probably to the expense of the material, but they have long been of importance across the Himalayas.[4] It is interesting that this particular bodhisattva form appears in ivory and wood, perhaps from the same workshop. The extraordinary faithfulness in copying the garments, earrings, hair and crown for this group suggests that an important original icon has been re-produced, probably as pious mementos. The numerous wood examples differ greatly in quality. The rigidity of the pose (in all the examples) is not typical of Newari carving from the Kathmandu Valley, but the individual elements of the form are derived from Nepal. The hair style recalls Indic and Nepalese images of both Hindu and Buddhist deities, and the pose and garments are seen on early Nepalese bodhisattvas.[5] One intriguing possibility is that this group is modeled after the famous sandalwood Avalokiteshvara in the Potala Palace which is believed to have been brought to Lhasa by Songtsen Gampo's Nepalese queen.[6] The date of these copies is difficult to determine, but the original prototype seems certainly to be in the style of the sixth to tenth centuries.

1. The other ivory example is in the Victoria and Albert Museum, London (no. I.M. 382-1914, 11″ h.), published by Stella Kramrisch, *Rupam*, no. 40 (1929), nos. 34-35. Published wood pieces include, Stella Kramrisch, *The Art of Nepal* (New York: The Asia Society, 1964), no. 73; Christie's sale catalogue (New York, December 1, 1982), lot 60; *LA-Tibet*, no. S14; Eskenazi, *Arte Himalayana* (Milano: Eskenazi, 1979), text by Roberto Vitali, no. 9 and no. 10.

2. The Los Angeles County Museum and Eskenazi figures (n. 1) have crowns with a standing buddha.

3. This discoloration is perhaps from association with other material.

4. See Pratapaditya Pal, *Elephants and Ivory in South Asia* (Los Angeles: Los Angeles County Museum of Art, 1981) for a general discussion of Asian ivory carving.

5. See Pal, *Art Nepal* I, pls. 11, 13, 22, 131, 142, 187, 188 and 191.

6. Ian Alsop has recently traced this bodhisattva form to the Potala image and will discuss it in "'phags-pa lo-ke-svara of the Potala," (forthcoming); the image can be seen, heavily covered in garments and jewelry, in Deng Ruiling et al., *Potala Palace*, pp. 70-71.

S20

VAJRAPANI PLAQUE

Cast copper, h. 2½" (6.4 cm)

Nepal, 15th century or earlier

Purchase 1936 Holton Collection[1] 36.347

This small plaque was probably cast in a mold. The flat, slightly recessed back has a small loop, allowing the plaque to be worn as an amulet or *tokde*.[2] Unlike most Tibetan *tokde*, however, this object is not worn and glossy from handling but corroded as from accidental burial. The squat body, round face and eyes, the pose as well as the type of metal, can be found in Nepalese work of the eighth to fifteenth centuries.[3] Although obscured by encrustations, the *vajra* in the raised right hand identifies the deity.

1. Carter D. Holton was an American missionary in Amdo, Northeastern Tibet, circa 1920-30, see Volume I, pp. 58-59.
2. Holton's notes say it is the type of object "excavated" in Northeastern Tibet and regarded as fallen from the sky in "thunder bolts." This is a common Tibetan explanation for the origin of *tokde;* see S13.
3. See von S., nos. 75C and 97G; also *LA Nepal,* nos. S9 and S11.

S21

SAMVARA AND VAJRAVARAHI

Gilt copper, cast in several pieces with hammered additions, jewel inlay, h. 17½" (44.5 cm)

Nepal, 16th century,

Purchase 1969 Museum Purchase Fund 69.31

This complex sculpture has been solid cast and fabricated in many parts, which are fitted together with rivets.[1] The copper is gilded on all surfaces. The headdresses and shoulders of the deity, Samvara, and his partner, Vajravarahi, show traces of orange paste from ritual worship; the plain oval base plate is not gilded. The front and two side faces of Samvara are stern, yet compassionate; the back face is shown with flaming eyebrows, eyes and mouth which give a fiercer expression; all four faces have a third eye. Each crown has a large, central jeweled leaf with smaller flanking leaves, skulls, and ropes of bone beads; the piled hair has a crossed *vajra* ornament in front, a ruby-set flaming finial, and a small skull and a crescent at the sides. The front pair of ears is adorned with jeweled disks, the back pair has holes to accommodate now missing earrings. Ropes of skull-and-bone ornaments festoon Samvara's arms, wrists, neck, chest, hips and ankles. Vajravarahi wears a crown similar to Samvara's, as well as disk earrings, and ropes of skulls and bones. While gazing raptly up at the deity, she wraps her legs about his hips and feeds him from a skull cup with her left hand while gesturing with a chopper in her right.

The *Sadhanamala* describes the procedure for worshiping Samvara, a form of Hevajra:

> The worshiper should think himself as Sam[v]ara with a string of skulls over his forehead and the crescent moon on

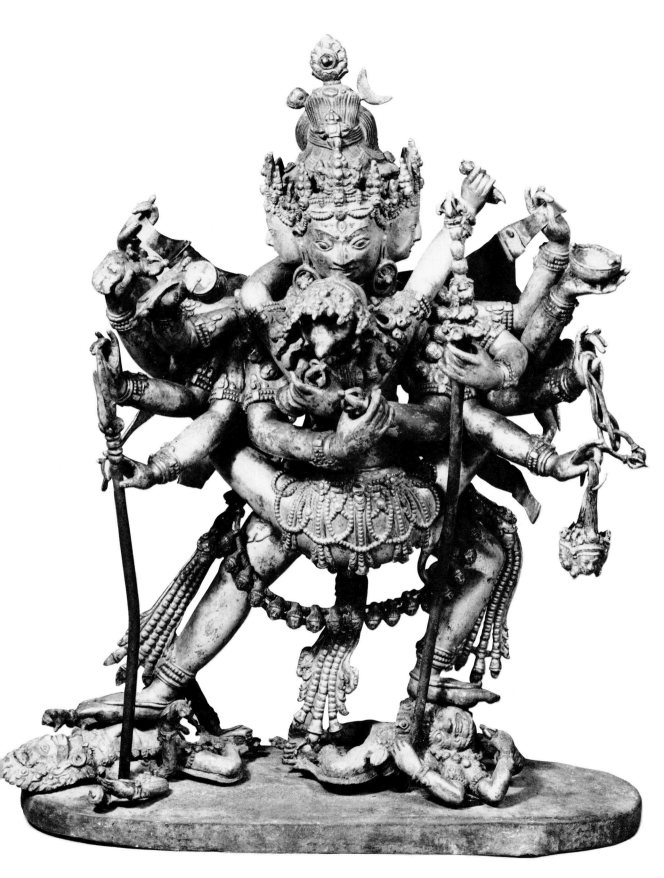

the top...He stands in the Ālidhā attitude and...tramples upon Bhairava and Kālarātri....

The form of Samvara with four faces and twelve arms is mentioned in the *Nispannayogavali:*

> With the two principal hands carrying the Vajra and Vajra-marked bell, he embraces his Śakti Vajravārāhī. With the second pair...he carries the elephant skin from which blood trickles down. In the remaining four right hands he holds the Damaru, the axe, the Kartri and the trident. The four left hands show the Vajra-marked Khatvānga, the skull cup full of blood, the Vajra-marked noose and the severed head of Brahmā....[2]

Fierce deity manifestations, such as Samvara, are visualizations from the "Supreme Yoga" *tantras,* formulated between the eighth and twelfth centuries in India and drawn upon diverse Hindu and Buddhist elements. From the tenth to the twelfth centuries the *tantras* passed from eastern and northwestern India into Tibet and Nepal.[3] The earliest surviving sculptural depictions of Samvara are from Kashmir and Bihar.[4] Painted images in the Pala style, dating from the twelfth to thirteenth centuries, have been found in Tibet and Central Asia.[5] Although the earlier existence of Nepalese images, both sculpted and painted, is assumed because of the twelfth-century Nepalese written evidence, known examples date from the fifteenth century on.[6] It is interesting that there is a rather extensive group of Nepalese gilt copper images of Samvara, dated from the sixteenth to eighteenth centuries. Was there perhaps a revival of a Samvara cult at this time, prompting commissions of such complex work—or are we dealing here merely with accidental survivals? A sixteenth-century date for the Newark image is plausible because of its close similarity to two inscribed images. However, the existence of not dissimilar Samvara sculptures, from as late as the eighteenth century, make the earlier date merely an informed guess.[7]

1. The god's body is in one basic section with some arms fitted on at joints (disguised by bone armlets). The goddess's body is cast in two sections, joined at the waist. All attributes are separately fashioned and attached with pegs, loops, or secured by the hands. The two legs have pegs which fasten down through the prostrate bodies and then into the base plate, secured with curved pins.

2. Bhattacharyya, pp. 160-62; the *Sadhanamala* was written in Nepal in 1163; the *Nispannayogavali* was written by Mahapandita Abhayakara Gupta, who lived at the time of Pala king Ramapala (1084-1130), in Bihar.

3. See p. 18, and Kalachakra, S5.

4. See von S., nos. 66D and 20F. For a related Pala image of Hevajra with partner, see AAI, fig. 18.14.

5. TP, pls. 11-12 and DDH, nos. 29-30.

6. *LA Nepal,* no. P13.

7. See von S., nos. 100D, 100E and 105B; and *LA Nepal,* no. S65.

S22

TEACHING BUDDHA

Cast gilt copper alloy, painted hair, h. 18½" (47.0 cm)
China, 15th century
Gift of Herman and Paul Jaehne 1941 41.1069

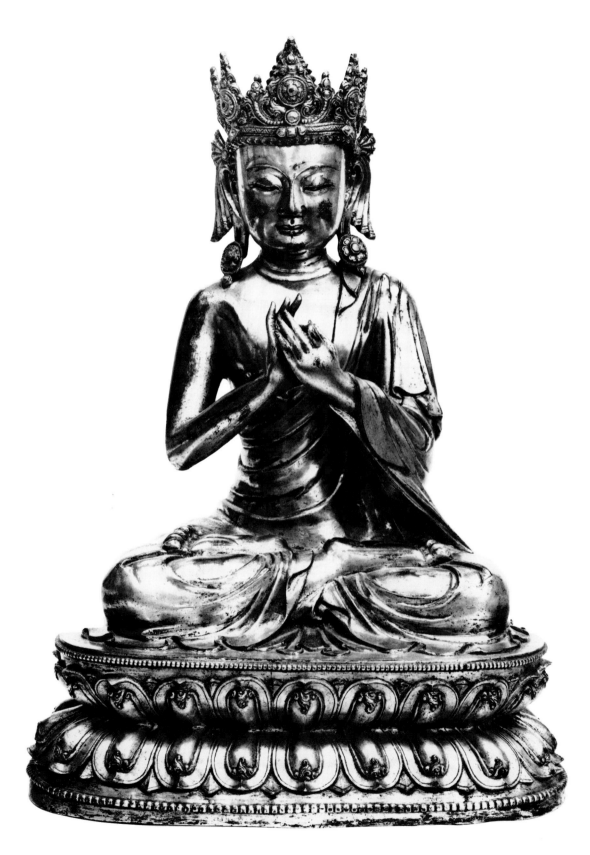

93

The superb casting, heavy weight, gilding, and decidedly Chinese face and drapery of this image, place it among the group of fifteenth-century sculptures made under imperial Ming auspices.[1] Like other casts, which exhibit a fully matured Chinese synthesis of imported Nepalo-Tibetan forms, this example has a square-jawed "moon" face, long slanted eyes, curved brows, "cupid's bow" lips and a prominent round chin; as well as smooth "boneless" arms and eloquent fingers, with double-line depressions to indicate nails. The precise folds of the drapery and the complex, double-lotus petal base, with beading in high relief, are also characteristic of fifteenth-century images, such as this.[2] The Newark Museum's example is missing its base plate (there are slashes on the edge where the tip of the metal was used to fasten the plate); the interior has been emptied to the neck but scraps of paper and yellow silk floss adhere to inner surfaces, which are completely covered in pitch-like material and red paint.

This image combines the usual attributes of Shakyamuni (plain robe, meditation pose, tight "snail" curls painted blue), with the teaching gesture of Manjushri or Dipamkara and the crown and earrings of a bodhisattva or Adi Buddha. The Chinese face and the downward-pointing sashes (which connect to the knotted ribbon tying the crown to the back of the head) behind each ear suggest a Xuande (1426-35) or later date.[3] Otherwise the image preserves the canon of style perfected in the Yongle period (1403-24). The existence of such images, with inscribed Chinese dates, provides a convenient basis of comparison to the many undated Sino-Tibetan and Tibetan sculptures attributable to the fifteenth-century period (S23-29).

1. For a discussion of sculpture with Yongle (1403-24) inscriptions, and the politico-religious milieu of China and Tibet, see pp. 23-24 and *Sino-Tibet*, pp. 72-99 and pls. 48-68.
2. For inscribed Yongle examples see von S., nos. 144E, F and 146F.
3. See examples with Xuande inscriptions, von S., nos. 147C, 148G, 149A and F.

S23

MAHAKALA

Cast gilt copper with traces of paint, h. 5" (12.7 cm)

China, 15th century(?)

Gift of Dr. Leonard Gorelick 1984 84.388

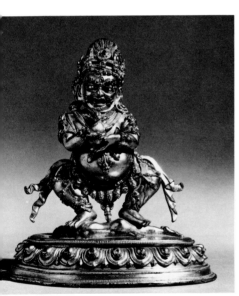

This small image is finely cast in one piece, the solid figure standing on a hollow, prostrate human figure and oval lotus base. The corpulent deity holds a chopper in his right hand (two fingers extending in *karana mudra*) and skull cup in his left. The hair, painted red,[1] rises flame-like and is caught by an encircling band; a five-skull tiara has a rosette disk (center) and flaming jewel finials (sides), and fastens to a sash around the back of the head with loops and flourishes behind each ear. Mahakala is adorned with rosette earrings, snakes (arms, wrists, ankles), tiger skin loin cloth, ropes of bone beads (chest, back, hips) and a long rope of severed heads; sashes flare out from the hips. His heavy body assumes a frontal, crouching, dance-like pose on the prone body; the base has a beautifully defined single row of lotus petals, with beading above and below.[2] The entire surface, except for the flaming hair, is gilded in a heavy deep gold. This two-armed form

of Mahakala is found in Nepalese and Tibetan, as well as Chinese examples, from the fourteenth to sixteenth centuries.[3] The quality of the casting and gilding here is closest to Chinese work. Because Newark's sculpture is comparable to Chinese images dated as early as 1292 and as late as the Xuande reign (1426-35), the fifteenth century date given here is tentative.[4]

1. Traces of red paint also remain in the brows, and black paint remains on the human figure.
2. The sealing plate is gone; scratches and nicks indicate its former existence and three small prongs cast onto the lower interior perhaps secured now missing contents.
3. Compare, for example, John Lowry, "Fifteenth Century Sketchbook (Preliminary Study)," *Essais*, fig. A12; *LA Tibet*, no. P10; and von S., nos. 145D, E, and 149B.
4. See a Vajrapani sculpture in the rock grotto at Fei-lai-Feng, Richard Edwards, "Pu-Tai-Maitreya and a Reintroduction to Hang Chou's Fei-Lai-Feng," *Ars Orientalis*, XIV (1984), fig. 41; and a Mahakala stone image, Heather Stoddard, "A Stone Sculpture of mGur mGon-po, Mahākāla of the Tent, dated 1292," *Oriental Art* (Autumn, 1985), pp. 260, 278-82; and for a Xuande example, see von S., no. 149B.

S24

BODHISATTVA

Cast gilt copper, h. 18" [with stand] (45.8 cm)
China(?), 15th century
Gift of C. Suydam Cutting 1950 50.146

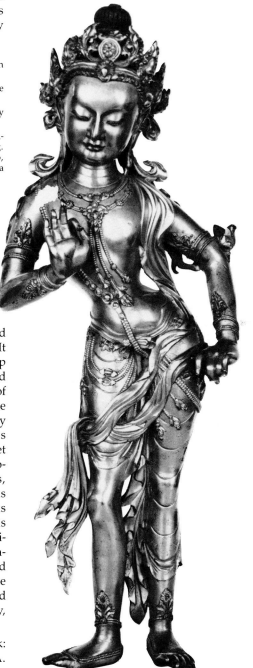

This image displays influences reflecting Nepalese, Tibetan and Chinese traditions and, therefore, has proved difficult to identify. It appears to be of Chinese manufacture; the heavy precise casting, deep gold gilding, and the obsessive attention to the intricacies of looped and swirled drapery, are more characteristic of Chinese than of Nepalese or Tibetan craftsmanship, yet the smooth sweetness of the face and the exaggerated and graceful sway of the body are peculiarly Nepalese.[1] The image appears to have been one of two bodhisattvas flanking a central figure;[2] vertical tabs cast on the soles of the feet would have been inset into a base perhaps large enough to accommodate three images. This might also explain the lack of attributes, although marks on the left arm indicate that there was once a lotus plant from the hand to shoulder. The entire top of the headdress is missing and has been replaced with a wooden top knot. The felicitous combination of Nepalese and Chinese influences can best be appreciated in the great Tibetan monument of the Gyantse Kumbum, consecrated in 1427 (see pages 23-24). The flanking figures to seated buddhas, and the rows of bodhisattvas on the wall paintings of the numerous chapels of the Kumbum, have the pinched waist and swaying pose of Newark's gilt image. Details of the crown, drapery, jewelry, and even the feet positions, are also similar.[3]

Previously published: Stella Kramrisch, *The Art of Nepal* (New York: The Asia Society, 1964), pl. 71; DDH, no. 220; and von S., no. 148A.

1. For a Chinese comparison see von S., no. 149F (note crown, bone ornaments and scarves). For a Nepalese comparison, see von S., no. 90F (note smooth face, torso and pose).
2. Compare P7.
3. Compare Tucci, *Indo-Tibetica*, vol. IV, figs. 184, 208, 209, 249, 250, 322; and Li Gotami Govinda, *Tibet in Pictures*, vol. I (Berkeley: Dharma Publishing, 1979), pp. 83, 86, 88, 89, 90, 93.

S25

VAJRASATTVA

Cast brass with copper, silver and jewel inlay, h. 17⅞″ (45.5 cm)
Western Tibet(?), 15th century
Purchase 1973 The Members' Fund and Membership Endowment Fund
73.131
See color plate 2

The image and triangular-shaped lotus base are hollow cast, all of a piece, in a golden brown brass with inlaid copper eyes, lips, finger-nails, and sections of body ornaments and dhoti. Silver and black (pitch?) complete the detailing of the eyes; turquoise and coral stones are set in the crown and body decoration. Two loops, cast on at the arms, once attached to a nimbus or encircling scarf. Chaplet marks remain on the knees, upper arms, and the back of the base. The base plate is lost and consecration contents have been removed. The deity holds his identifying symbols, the *vajra* and bell, in right and left hands, respectively; the bell is held in a manner variant to the usual hip position for Vajrasattva (compare S3). The wide and exaggerated eyes and brow, the highly schematic headdress (with finial missing) and the patched, unfinished state of the entire back of the image are qualities associated with Western Tibetan casting.[1] The tubular body, foliate crown, rosettes and scarves over the ears, as well as beaded body ornaments are legacies from earlier Indian forms which, via Kashmir, eastern India and Nepal, came into Tibet in the tenth to twelfth centuries. Whatever its exact provenance, this image is a synthesis of the major stylistic influences which formed the mature Tibetan school of sculpture and painting in the fifteenth century.[2]

Previously published: DDH, no. 168; von S., no. 38C.

1. Compare von S., nos. 34A, B, 35B-G, 36C-E, 37A, C-F, 38A, D-F, 39A-F and 40A, C-F. Compare, also, large clay images in Ladakh, Snellgrove and Skorupski, *Ladakh I,* figs. 17, 18, 88, 89.
2. See pp. 22-24.

S26

BOOK COVER

Wood with gold and painted details, 28″ × 10½″ × 1⅛″ (71.6 × 26.7 × 2.8 cm)

Tibet, 14th-15th centuries

Purchase 1977 Members' Contribution for Paris Trip 77.31

The painted and carved decorations on this book cover are among the best preserved of any that have appeared outside Tibet in recent years. The upper side (which is slightly convex) is rich with intricately worked detail. A central recessed rectangle features a buddha flanked by bodhisattvas, of whom Manjushri is identifiable at left, seated on throne bases with nimbuses. The whorling foliage background is thick with floral rosettes, horses, peacocks, fighting lions, unicorns, deer, monkeys and pheasants. The surrounding borders feature bands of beading, lotus petals, and scrolling leaves. The outside edge has a carved letter *Kha* (indicating the second volume) flanked by a leaf scroll; the other three edges are undecorated. The top and all four side surfaces are covered with gold leaf, and details of the buddhas, animals, and thrones are finely overpainted with red, green and yellow. The underside (which rested on the folios) has a delicately painted pattern of concentric circles (five horizontal rows of thirteen circles each) of black, green and yellow lines, each circle linked by black concave bands; the spaces between the circles are filled with diamond shapes, gold leafed. The background is red, the borders yellow.

The round, plant-like bodies of the buddhas, the densely articulated background, as well as the lively rendering of thrones and nimbuses are completely in the Nepalese idiom.[1] The size of the cover indicates that it was intended for use in Tibet (see P3 and 22); such large format volumes were never made in Nepal. Another Tibetan feature is the occurrence of frontal beasts to support the central throne; related animal supports are seen in Pala and Nepalese-style paintings in Tibet during the twelfth to fourteenth centuries.[2] The painted underside of linked circles may be a standard convention for book covers, for at least one other example has appeared recently.[3]

1. Compare S16 and 17 and *LA Nepal*, no. P7.
2. See TP, pls. 6, 10, 12, 17 and 18.
3. Compare the circle pattern on a cover sold in London in 1982, Sotheby's Sale Catalogue, 29-30 March 1982, lot 243.

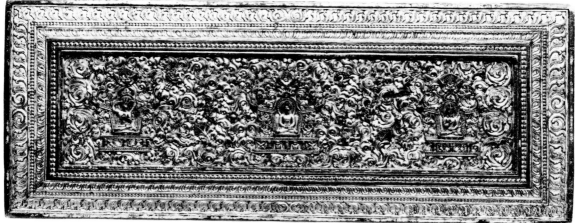

S26 Front

S26 Back

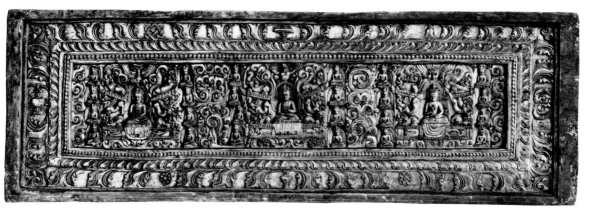

S27

S27

BOOK COVER

Wood with gold and painted details, 31½" × 10" × 1⅞" (80.0 × 25.0 × 4.8 cm)
Tibet, 15th century(?)
Purchase 1940 40.229

This large and heavy block of wood has a flat underside, completely carved with figures and ornamentation, and a slightly convex upper side carved with lozenges enclosing scrollwork and the eight Buddhist emblems.[1] The edge which faced out (when the book was stored in a monastery library shelf), has a carved design with a central stupa and the Tibetan letter *Ta* (indicating the ninth volume) at the left. The more heavily carved inner surface rested on the manuscript pages. The design of the latter involves a central recessed rectangle, which features three enthroned and crowned buddhas identical except for the hand positions. All have five-leaf crowns in front of high chignons with jeweled finials, curled earrings, broad square faces with long eyes, bracelets and various chest ornaments. As on the cover S26, the three thrones are decorated with diagonal-slanted beaded bars, *makaras* with foliate tails, and varied *garuda* "face of glory" apexes. The lions and griffins below the bars, the cloth throne drapes, and the frieze of birds and foliage beneath the thrones vary considerably from those of S26. Flanking the thrones here, are six vertical columns of four seated buddhas, each with an elliptical nimbus and lotus bases and with differing hand gestures, on a background of scrollwork. Surrounding the central rectangle are borders of beading, petals and more leafy scrollwork. In the broad outer border, the eight Buddhist emblems are set amidst leaves on all four sides. The carved areas are covered with gold and details of faces, hair and animals' paws/hoofs are overpainted in red and black; the plain outer borders are red.

The cover's crude, naive style contrasts with the sophistication of S26, which betrays strong Nepalese influence, whilst this shows Western Tibetan characteristics. Tucci published a group of book covers he obtained from Western Tibetan monasteries which are comparable in carving style and format.[2] The square faces, long eyes and crown/headdress style of S27 are close to those found on images attributed to Western Tibet.[3] The simplified rendering of buddhas and thrones is very close to two leaves from a ritual crown in the Los Angeles County Museum. In the same collection is a book cover with an upper lozenge design similar to Newark's example.[4]

1. The lozenge outlines are in deep relief, the scrolls and emblems very shallow but once set off with polychrome paint, now mostly gone.
2. Giuseppe Tucci, "Tibetan Book-Covers," *Art and Thought* (London: Coomaraswamy 70th birthday publication, 1947), pp. 63-68, pls. X-XIII.
3. Compare the face type on S25.
4. *LA Tibet*, nos. R2 (crown) and M5 (cover).

S28

VAJRADHARA

Cast gilt copper with inlaid turquoise, coral and lapis lazuli; traces of paint, h. 18¾" (47.6 cm)
Tibet, 15th century
Purchase 1970 The Members' Fund 70.5
See color plate 3

This beautifully modeled and gilded image has been cast in six parts: the hollow body is attached with clamps to the hollow triangular-form lotus base, which is missing the sealing plate and contents;[1] the separately cast lower arms, *vajra* and bell are assembled into a crossed position at the chest. It is this crossed hand position of "highest energy" which identifies the Vajradhara form of the Adi Buddha. Turquoise, coral and lapis stones are inlaid in the five-leaf crown, headdress finial, earrings and body ornaments; traces of polychrome remain on the face, and blue paint on the hair, which is gathered in a high chignon and falls in curling locks to the shoulders. The shoulder scarf and dhoti are decorated with incised floral patterns, and lotus "wheels" are incised on the soles of the feet. Many of the separate elements of this image can be traced to Nepalese and Chinese prototypes. The face, headdress and crown are of Nepalese derivation.[2] The festooned bead ornaments, scarf and floret-centered, lotus-petal base are found on fifteenth-century Chinese imperial sculptures.[3] Here they decorate a graceful, attenuated figure that is distinctly Tibetan; a style seen in a wide range of paintings and sculpture executed in Southern Tibet in the fifteenth century.[4] The crown, earrings, patterned shoulder drape and ornaments on the Amitayas painting P7, are especially close to this image.

1. However, two horizontal paper scrolls were found in the head area, one with the repeated printed image of Ushnishavijaya; the other with Tibetan mantras and notes for positioning in the head ("crown", "hair", "tongue"); together with silk sachets of powders and grains.
2. Compare von S., nos. 94D, 98A.
3. Compare von S., nos. 144A, D, 147A-C, D.
4. The Gyantse Kumbum is the most noteworthy site, see pp. 22-24; also Henss, *Tibet*, p. 161 and pl. 69, p. 168.

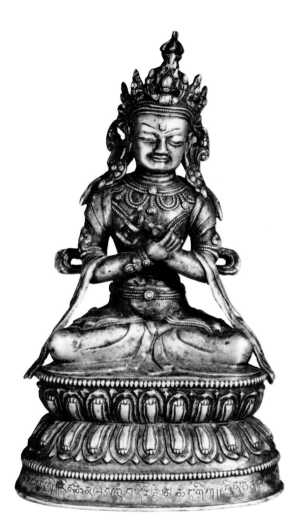

S29

VAJRADHARA

Cast brass with silver, copper and glass inlay, h. 8⅛" (20.7 cm)
Tibet, 15th-16th centuries
Gift of Dr. and Mrs. Wesley Halpert 1983 83.90

The figure and oval base are in one piece, cast in a golden brown brass with dark brown patina in areas that have not been cleaned. The *dorje* and bell, of the same metal, were made separately and placed in the hands. The long, narrow eyes are inlaid with copper and silver. The "third eye" is an awkwardly set broken chip of turquoise glass. The deity sits in meditation on a double lotus petal base, with beaded bands above and below. The incised inscription underneath, as well as the base decoration, continue around to the back. The base is sealed with a copper plate, incised with a double *dorje*. The garments include a dhoti with a fine, incised floral border and a shawl, which has cape-like folds over the shoulders. Beaded jewelry adorns the neck, chest, hips, arms, wrists and ankles. Coiled hair is pulled up to a high chignon with a *dorje* finial, and two locks come down behind the ears to each shoulder. The crown, with large center leaf and smaller leaves on each side, has florets at each ear and is tied with a band behind the head. The earrings are large rosette disks with jewel pendants.

The inscription reads: "Om-svasti. This image of Vajradhara fulfilling precious karma is constructed by the son of the donor Namgyal to return the kindness of his kind parents."

There is a group of similar sculptures, many with inscriptions and inlaid silver eyes, and all with square-jawed faces, shallow lotus petal bases, crowns and ornaments.[1] They may come from the same, as yet unidentified, workshop. They range in date from the fifteenth to sixteenth centuries determined by their likeness, with regard to costume and ornament, to inscribed Chinese images, as well as to certain larger scale sculpture from Southern Tibet.[2]

1. See von S., nos. 132C, 133A, C, F and G.
2. For Yongle and Xuande examples, see von S., nos. 144A-D, 147C-E and 148B-D, F, G. For Southern Tibet, see S28 n.4.

S30

LAMA GYAWA GOTSANGPA (1189-1258)

Cast brass with copper and silver inlay, h. 26" (66.0 cm)
Tibet, 15th-16th centuries(?)
Purchase 1969 The Members' Fund 69.32
See color plate 4

This large and expressive portrait is of a noted mystic, Lama Gyawa Gotsangpa, who lived in Western Tibet and was a disciple of the founder of the Drukpa branch of the Kagyupa school.[1] The hollow cast brass body has a golden tan patina; the eyes are inlaid copper with inlaid silver and black pitch(?). Copper is used for the lips and floral patterned vest brocade. The sun/moon emblem on the hat has an inlaid silver moon. The wide, staring eyes and prominent ears may be a convention for portraits of lamas, but the corpulent body seems idiosyncratic. The lama wears the stiff spreading hat (with loops for missing streamers) of the Kagyupa sect and the vest, skirt and pieced robe of all Tibetan lamas. He gives the argument gesture with his right hand; the left rests in his lap.[2] His patterned, spreading robes are riveted to the separately cast, double lotus petal base, formed from a copper alloy of different hue to that of the figure itself. The sealing plate at the bottom is missing, and all consecration contents are gone.

A double line of Tibetan is incised along the bottom front of the base:

> "Salutations to the image of the Jina [i.e., "the Victorious One," an epithet of the Buddha] Gotsangpa which liberates by seeing [i.e., the beholder is liberated by the mere sight of the image]. This inner support [i.e., used for personal meditation] belonging to Phagod Namkha Gyatso was made by the masters and students of Gotsang Drubdeh at the occasion of the miraculous birth of the cousin *Phyag sor rtse* [this is a curious personal name, it may be misspelled in the inscription] who was in the incarnation lineage of Bi-sho. Virtue and prosperity [for all]."

Gotsang Drubdeh is a hermitage near Hemis monastery, Ladakh, and consists of a cave, small temple and monks' quarters. Hemis is the foremost Drukpa establishment in Ladakh, founded by Tag Tsang Repa in the early sixteenth century and expanded under the patronage of Senge Namgyal (circa 1570-1642), the greatest of Ladakh's kings.[3] The hermitage is presumed to date from Gotsangpa's time in Ladakh. The quality of the metal, use of inlay, and the style of the broad face and figure of the lama are consistent with other images attributed to fifteenth-to-sixteenth-century Western Tibet and Ladakh.[4] We may be dealing here, however, with a conventional form for lamas and saints of the Kagyupa order, for several portraits of individuals venerated by this order are similar in style to Lama Gotsangpa.[5] A date range from the fifteenth to the sixteenth centuries is very tentative, pending discovery of the time period in which lived Phagod Namkha Gyatso and *Phyag sor rtse*, both named in the inscription.

1. Information courtesy of Dr. D. I. Lauf, Karma-Ling Institute of the Kagyupa Order, Tutzing, West Germany. Gotsangpa's travels in the Western Himalayas, and his mystic experiences are recorded in an illustrated manuscript biography, *rGyal ba rgod Ts'an pa mgon po rdo rjei rnam t'ar mt'on ba don ldan nor bui p'ren ba*, TPS, pp. 90-91, 158-59.

2. An attachment hole remains in the left hand for a now missing object.

3. Snellgrove and Skorupski, *Ladakh I*, pp. 126-30; an image of Gotsangpa is listed, but not illustrated, as being inside the cave, Snellgrove and Skorupski, *Ladakh II*, p. 76.

4. Compare S25.

5. Compare von S., nos. 135D, 139D; and the image of Tag Tsang Repa, Snellgrove and Skorupski, *Ladakh I*, fig. 131.

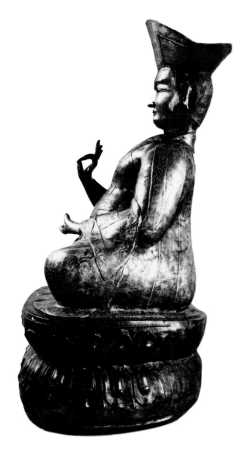

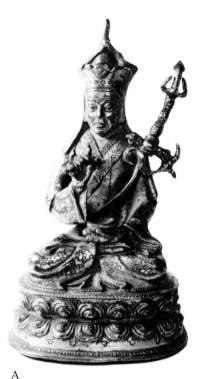

A

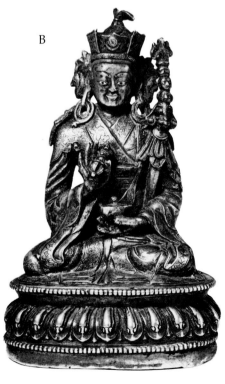

B

S31

PADMASAMBHAVA (in Tibet, circa 779)

A. Cast gilt copper, h. 6¾″ (17.2 cm)
Tibet, 15th-16th centuries(?)
Purchase 1948 Alice Getty Collection 48.5
B. Cast brass with painted details, h. 6¼″ (15.9 cm)
Tibet, 15th-16th centuries
Gift of Nasli and Alice Heeramaneck 1970 70.4

The great "Guru Rimpoche" is portrayed in both sculptures with the attire and implements which are his hallmarks: long-sleeved, multi-layered robe with wide lapels and cape-like shoulder lappets, mitre-hat with sun/moon emblem and feather finial, and the magic wand with its trident top over a skull, two heads, vase, *dorje* and sash. In addition, he holds the tantric implements of skull cup and *dorje*.

A has a triangular sealed base (cast in one piece with the image), with beaded edges and a double row of four-layered lotus petals, incised circles above and between each of the upper petals, and incised tri-lobes below and between each lower petal; all decorative work ends at the thighs, leaving the back of the base plain. B also has a triangular sealed base (cast in one piece with the image), beaded edges top and bottom, but a single row of downward-facing, "knobbed" lotus petals which completely encircle the base, as does the beading. The petals are on an increasingly inward slant so that the tips meet at center back. The metallic color of B is golden brown with reddish-brown patina in the recesses; the eyes and lips are naturalistically painted. The striated and blue painted hair forms a smooth roll at the nape and flows in long curls from under the hat, behind the ears and onto the shoulders.

The different depictions of the saint in these two images may reflect separate traditions, geographical areas and dates. A has a gaunt, elderly face and the hat incorporates a domed center with upstanding, scalloped-edged crowns front and back, plus smooth lappets which cover the ears and shoulders. The right hand, holding the *dorje*, gives the *karana* gesture and the skull cup is empty. B has a younger, broader face with the "knotted brows" of fierce manifestations. Pad-masambhava is here adorned like a bodhisattva, with spiral earrings, florets and sashes behind the ears. The open right-hand gesture with the *dorje* is that used by monks in rituals; the skull cup has "blood" contents and a knob (*dorje* finial broken off?). The robes differ slightly but both show floral incising. All details end at the sides on A, leaving a modeled but plain back; whilst the back of B is elaborately worked and incised with letters in Siddhi script on the robe around the hips, and with a plain rectangular cartouche above this.

Padmasambhava is revered especially by the Nyingmapa sect, but is venerated by all Tibetan and Himalayan Buddhists. Extant sculpture and paintings depicting this saint are very numerous from the fifteenth to the twentieth centuries.[1] Perhaps the earliest surviving representation is a wall painting at Alchi of circa late twelfth century to mid-thirteenth century.[2] B is a typical example of the many portrait images done in Tibet in the fifteenth to sixteenth centuries, in which incised textile patterning and the careful delineation of attributes are

featured.[3] A is executed in a more rustic idiom which may follow an earlier tradition, now difficult to identify.

1. See P17; also *LA Tibet*, no. S37; and Olschak, pp. 25, 83, 119 (icon no. 26).

2. Pratapaditya Pal and Lionel Fournier, *A Buddhist Paradise, The Murals of Alchi, Western Himalayas* (Hong Kong: Kumar, 1982), no. LS 20.

3. See *LA Tibet*, nos. S35, 37, 38; and von S., nos. 132B, 134F and 135D-F.

S32

MILAREPA (circa 1038-1122)

Cast brass with silver and jewel inlay, h. 4⅜" (11.2 cm)

Tibet, 15th-16th centuries

Purchase 1975 Sophronia Anderson Bequest Fund 75.94

See color plate 5

Small, and worn from rubbing, this pert image has a strong and attractive personality. The alert "royal ease" pose, graceful arm positions, and bright-eyed face have been skillfully modeled in a golden brass with silver inlay for the eyes. Incised floral and zig-zag patterns decorate the underskirt, shawl and meditation band; the antelope skin, which covers the top of the base, is incised to resemble "fur". The saint's hair hangs in thick locks down his back, falling under the shawl at center back and over the two shoulders. Coiled rings adorn his distended ear lobes. The skull cup, held in the left hand, has been cast bearing two brass balls and recesses hold five more balls, two of lapis lazuli, two of turquoise and a central ruby. The oval base has a single row of lotus petals of lavish, three-layered form with an under-row of petals between each. A lotus plant grows from under the center petal to support the right foot; a notched band encircles the base above and below the petals. The base plate is missing and most of the contents have been removed, but two paper rolls with mantras and two silk packets were found inside the neck and torso.[1]

Milarepa ("cotton-clad Mila") is a popular figure of veneration in Tibet. Revered as a great mystic and poet, especially by the Kagyupa sect, Milarepa exemplifies the way of the yogin in Tibetan Buddhist tradition.[2] There is no inscription to give a positive identification but the hand gesture to the right ear is Milarepa's characteristic sign.[3] The earrings, hair, meditation band, robes and antelope skin are commonly used for depicting yogins. Portrait sculptures were especially popular in the fifteenth to sixteenth centuries. The biography and songs of Milarepa are attributed to Tsang Nyon (1452-1507), and the resulting interest in his teachings may have prompted the popular production of his likeness at this time.[4]

Previously published: von S., no. 136C.

1. The larger roll of paper has a printed text, Sanskrit at the beginning followed by Tibetan; the words "secret relic" may mean this is a *terma* text. The smaller roll, too fragile to handle, shows handwritten Tibetan words at the outer edge; this was found in the innermost recess.

2. See Lobsang P. Lhalungpa, *The Life of Milarepa* (New York: E.P. Dutton, 1977); and Snellgrove, *Buddhist Himalaya*, pp. 198-202.

3. See Olschak, pp. 83 (left) and 85.

4. Lhalungpa, *Milarepa*, pp. XXVI-XXVII.

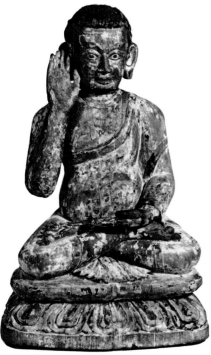

A

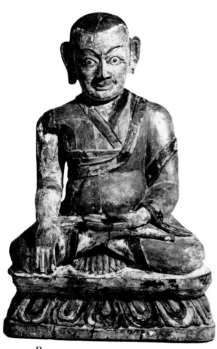

B

S33

TWO PORTRAITS

Carved and painted wood, h. (A) 15¾" (40.1 cm), (B) 15¼" (38.8 cm)
Tibet, 15th century or later
Purchase 1975 The Members' Fund 75.92-.93

These two portrait sculptures are from a larger set, probably depicting the full Kagyupa lineage. Each has been carved from single log sections of a pale, lightweight wood; the undersides (once filled and sealed) are hollowed out to the level of the images' laps. The wood has split into cracks along the grain, many of which have been secured with small, rectangular plugs. The figures sit on identical triangular bases, each with a single row of lotus petals fanning outward from a center petal to end evenly with the thighs; the backs are plain and vertical; the petals are painted with red, dark blue, turquoise, white and pale blue. The noses, staring eyes, "bow" mouths, ears, left hands, leg positions, feet and fanned pleats of the garment between the legs are similar for both images. Figure A gives the characteristic "listening/singing" gesture for Milarepa (see S32); he wears a white "cotton" robe with blue spots and red banded edgings; his skin is gold; his curly hair is blue and blue paint traces indicate that the hair originally flowed down his back and partly onto his shoulders. Figure B wears a red vest, skirt and shawl with maroon-banded edgings that are common to most Tibetan monks; he gives the "earth witness" gesture with his right hand; his smooth hair has a scalloped line around the brow and ears and is painted black. This figure could be Gampopa (1079-1153), the founder of the Kagyupa sect.[1]

The images are related in style to metal portraits of the fifteenth to sixteenth centuries.[2] They may best be compared to the large-scale, painted clay images popular in Tibetan monasteries. Such clay sculpture, of uncertain date, can be seen in Ladakh[3] but the "wide eyed, big ear" style may be geographically more diverse and better considered "Kagyupa type" than specific to any region.

1. Gampopa was the disciple of the yogin Milarepa, see Olschak, pp. 120-21, icon 33, which has the same hair and hand gestures, though the robes are slightly different.
2. See S30, 31 and 32.
3. Snellgrove and Skorupski, *Ladakh I*, fig. 131; *Ladakh II*, figs. 25, 41, 45, 48, 53 and 65 (material of the sculptures not always stated).

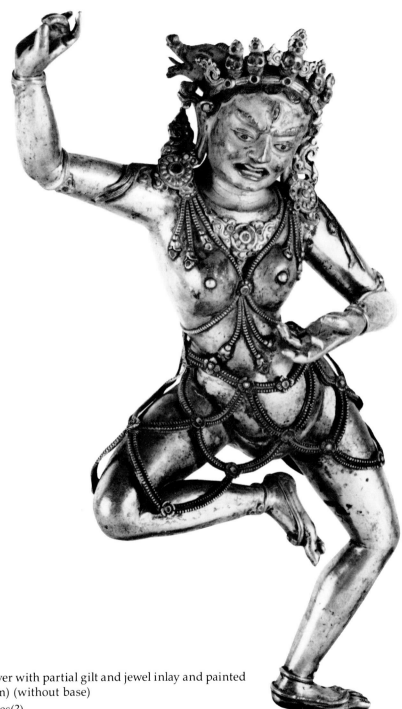

S34

VAJRAVARAHI

Cast and hammered silver with partial gilt and jewel inlay and painted
details, h. 12¾″ (32.4 cm) (without base)
Tibet, 15th-16th centuries(?)
Purchase 1970 Mary Livingston Griggs and Mary Griggs Burke Foundation Fund 70.3

This extraordinary solid silver image has been cast in one piece, with a rectangular lug for insertion into a base.[1] A girdle of bone ornaments which completely encircles the figure's hips and upper legs, and the lower section of hair in back, have been hammered from a separate sheet of silver and attached by hidden tabs at center back. Bands with trefoil ornaments at elbows, wrists, ankles and feet, a rosette and scroll necklace, rosette earrings, and a crown with sashes are lightly gilded and set with turquoise beads (most of which are missing, revealing a red wax setting material). The crown has five skulls with red-painted eye sockets, and gilt scroll flourishes once set with turquoises. The "bone" ornaments on Vajravarahi's chest, belly and hips are set with turquoises at juncture points. An eight-spoke wheel set with turquoise decorates the top of her head (behind the crown). The goddess's face and the boar's head, which is her identifying feature, are painted in cold gold with naturalistic polychrome features. The fierce mature face of this Vajravarahi contrasts with the more youthful appearance of the Nepalese example, S18. The antecedents of the ornaments can be seen in Nepalese versions of Vajravarahi, but there seem also to be links with Chinese and Mongolian ornamentation.[2] A comparison to dated Yongle and Xuande castings[3] in regard to ornamentation suggests this period, or slightly later, as the time of manufacture for this image. The face and body have a strong and energetic form, which seems "Tibetan", and it is likely that a Tibetan artist would have drawn on both Nepalese and Chinese traditions.

Previously published: DDH, no. 186; von S., no. 114B.

1. The lug is set into a modern wood stand. Note this construction in contrast to the back lugs on S18. A hollow recess for consecration items is indicated by a rectangular sealing plate, visible under the buttocks.
2. See S43, note especially the turquoise beads which are seen in "Mongolian" jewelry; note also the use of partial gilt on both these silver images.
3. See von. S., nos. 144A-D, F, G, 145F, 147D, E, 148B-D, F and G.

S35

PLAQUES FROM A BONE APRON

Carved bone with painted details, h. 6¾" (16.3 cm) (A-C), 2¼" (5.8 cm) (D-E)
Tibet, 16th century or later(?)
Purchase 1920 Shelton Collection[1] 20.438

The entire apron consists of seventy-one bones of varied shape and type, sewn to bone bead strings and suspended from a leather and cloth belt.[2] The five pieces shown in this detail are sewn to the cloth belt and represent three styles. A, B and C are in one style; they appear to have been carved at one time from similar pieces of ivory-toned bone and intended to occupy their present position at the center of the belt. B depicts a *heruka* deity and consort *yab-yum* with bone ornaments, choppers and cups, treading on two twisted human forms on a lotus base with flame background. Above, there is a seated crowned buddha in a niche with a scrolled background; below, a seated devotee(?) on a lotus base with a scroll leaf background. A and C feature *dakinis* holding choppers, bowls and skull-topped staffs on double lotus bases, with scrollwork top and bottom. The workmanship here is

somewhat stiff. D is a fragment, deeply carved, with an elaborate, vertical *dorje* on an oval lotus base with curling scroll background; red paint remains in recesses, and the bone is dark except for rubbed upper surfaces. The workmanship is quite assured. E is a fragment, also deeply carved, with a fierce griffin face and hands, and scrolls at the sides, under a curved horizontal bar with flaming jewel top. The bone is brown, with grimy recesses; the carving well done but not as fluid as on D.

1. Shelton notes: "From Lamasery, Batang".

2. See The Newark Museum, *Catalogue of the Tibetan Collection,* Vol. II (1950 edition), pp. 55-56, pl. XXXII for the complete apron. Numerous re-stringings and additions seem to have been made over the years in Tibet.

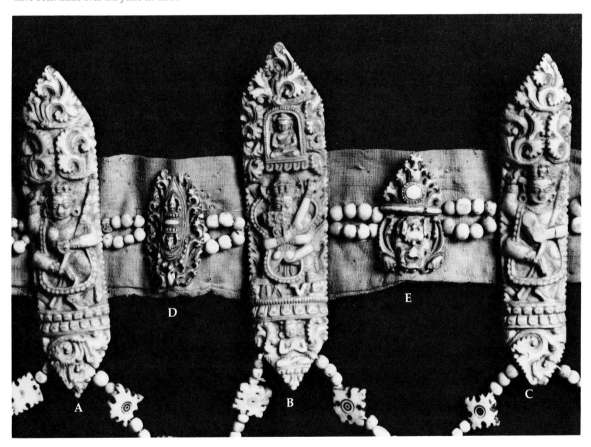

S36

TWO PLAQUES FROM A BONE APRON

Carved bone, h. 5⅛″ (13.1 cm) (A); 4½″ (11.5 cm) (B)

Tibet, 16th century or later(?)

Gift 1983 The Mei Ching Collection 83.266

The complete apron is considerably smaller than S35, and consists of five long plaques across the top (of which A and B are the two furthest right) with diagonal strings of bone beads and nine small diamond and cartouche-shaped bones carved with rosettes, figures and em-

blems. The whole is sewn to a fine piece of Chinese silk brocade.[1] A and B both depict a form of Mahakala, with a heavy body and both feet planted firmly on a corpse. Each holds a chopper and a skull cup at his waist and a *khatvanga* in the crook of his left arm, wears a five-piece crown, disc earrings, snake and bone bead ornaments, and has "flaming" hair and nimbus, bulging eyes, third eye, and leaf-scroll background. Slight differences in the style and finesse of carving, the color of the bone, and encrustations suggest that the two pieces were originally on different aprons. Both show wear on exposed surfaces from rubbing.

The bone carving in aprons S35 and 36 are clearly within the Nepalo-Tibetan repertoire, both as to the forms of deities and the style of decorative motifs. Although there was limited use of bone ornaments such as these in Nepalese rituals (both Hindu and Buddhist),[2] the large number worn by priests in Tibetan rituals points to a predominantly Tibetan usage. We are perhaps seeing a tradition begun as early as the thirteenth century, when Newari artisans skilled in wood, bone and ivory carving were commissioned by Tibetan monasteries to produce specialized ritual objects. The Newari artisans naturally used forms and styles known to themselves,[3] adapting work to the ritual uses dictated by the Tibetan religious authorities. The conservative nature of Nepalo-Tibetan art would tend to ensure that forms established in the thirteenth to sixteenth centuries were continued in these bone carvings. This conservatism makes dating of individual examples a complex task. A further difficulty is the lack of data on bone carving workshops in Tibet.

1. The apron now completes a set with bone armbands, neckband and headband, but these are late nineteenth to twentieth centuries in date.
2. See Slusser, *Nepal*, p. 366 and pls. 478-79, 556-57 and 592.
3. See Nepalese examples S18 and 21 and the Nepalo-Tibetan style of S23 and 26; for a discussion of Newari artists in Tibet, see pp. 20-21.

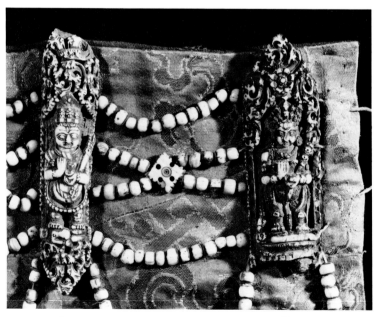

A B

S37

VAJRAPANI

Cast gilt copper with painted details, h. 8″ (20.3 cm)
Tibet, 17th century(?)
Gift of Doris Wiener 1969 69.30

The heavy body of the deity steps to the right and gestures menacingly, with a five-prong *vajra* held in his right hand and a snake in his left. He is adorned with snakes at ears, neck, wrists and ankles, and a long snake wraps from his neck to his groin. A beaded chain hangs from neck to belly and bands decorate his upper arms. A long scarf swirls behind his head, in front of his arms and behind his legs; an animal skin covers his loins with its head on the right knee and its two legs tied, along with a sash, between the legs. The god's fierce visage has fangs, "flaming" moustache, whiskers, a third eye and knotted brow. A bone bead-and-skull headdress ties with sashes at each ear, in front of raised and striated, red-painted hair. The back of the figure is fully modeled but details on the sashes are not given; a rectangular opening at the center back (once closed with a plaque) reveals consecration scrolls. The separately cast, hollow base is assembled from two sections which are joined between the upper and lower petal rows; the lotus petals and beaded upper edge continue only to the sides; the ridge at the lower edge is taken around to the back. The four snakes on which Vajrapani treads are fully three-dimensional. Two rectangular slits in the back upper surface would have received pegs for the missing nimbus. The base is sealed with a copper plate on which a small crossed *dorje* is incised. Deep gold gilding covers all surfaces except for the hair, the back and the bottom of the base; where not cleaned, there is a heavy, dark brown patina. The identity of this deity is problematic; the stance and arm positions are common to several wrathful forms and the *vajra* in the raised right arm is usual for many manifestations of Vajrapani.[1] The proliferation of snakes here, especially the one held noose-like in the left hand and the four underfoot, would indicate a particular form, as yet unidentified. The style seems to be a synthesis of pre-fifteenth century Nepalo-Tibetan types of fierce deities and the heavy, ornate forms seen in Yongle and related castings.[2] The precise yet simplified rendering of the adornments and lotus base are similar to those on seventeenth-to-eighteenth century Chinese and Tibetan images.[3]

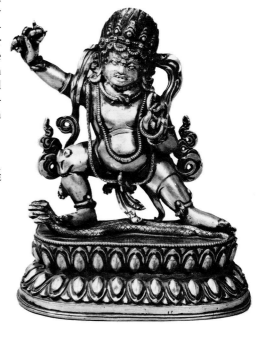

1. Compare stance, *mudras* and attributes for S13 and 20.
2. For Nepalo-Tibetan style in thirteenth-to-fourteenth-century China and Tibet, see pp. 20-22; for Yongle and other dated imperial Chinese castings, see von S., nos. 145A, D, E and 149B.
3. Compare von S., nos. 153C, D, 154A-C and 155A.

S38

JAMBHALA AND CONSORT

Cast gilt copper with painted details, h. 8½" (21.6 cm)
Tibet, 17th century(?)
Purchase 1920 Shelton Collection 20.456
See frontispiece

This animated and unusual cast depicts Jambhala clothed in a loose robe with sleeves flaring out like scarves, appliquéd boots and a turban fastened at the front with a plain band. He embraces his consort, who is dressed in a flowing robe with "cloud collar"[1] and seamed boots. Their robes fall open at the figures' chests revealing bare torsos. He gives the *karana* gesture with raised right hand and holds a mongoose spitting jewels in his lowered left hand; she reaches out around her partner, both hands in *karana*. Both faces are fierce, with third eyes and fanged mouths, showing traces of gold paint; his has black-painted, "flaming" brows and "whiskers" to the sides of the mouth and red paint on the hair. She wears a plain tiara band and a four-petaled flower decorates the top of her striated, blue-painted hair. The rectangular base has a beaded edge above a single row of petals, and below this a wide band of craggy rocks, often used as a setting for painted wrathful forms (see P32). The mongoose's jewels roll down Jambhala's knee; additional gems, singly or in three's, are placed about the beaded, lotus and rock levels of the base. The rock section, simplified, continues around the back of the base but the beading and lotus petals end at the sides; a metal loop, at the center back (level with the beading), was to receive the now-missing nimbus; the base is sealed with wood.

The style of this image is closely comparable to Chinese sculpture. The finesse in depicting flowing drapery, the fine casting and gilding, and the knobbed-petal type of lotus base can all be related to Ming sculptures.[2] The "Mongolian" garb, exaggerated poses and facial types, however, seem particularly Tibetan. The identification of the Newark image as the wealth-bestowing deity Jambhala seems unmistakable given the mongoose, but it is unclear exactly which form is intended. The flowing robes and boots are worn in the armored Vaishravana manifestation of the wealth-giving deity. The *yab-yum* pose is used for the "red, life-giving tantric" form: Mar Sogdrup, who clasps the consort, Norgyunma, in "royal ease posture."[3] The turban is used in Tibet to signify the garb of the *tsenpo*, and also appears on a few of the saints.[4] Any of these associations might be at work here for a special manifestation.

Previously published: Pal, *Art of Tibet*, pl. 74; DDH, no. 72.

1. For "cloud collar", see also S43.
2. Compare DDH, pp. 104-08, especially nos. 63 and 70.
3. See Olschak, pp. 176-77, icon no. 262 (wears boots and armor under robes), and icon no. 268 (Norgyunma is the Tibetan name for Vasudhara).
4. See turbans, flowing robes and "cloud collars" on portraits of Songtsen Gampo at the Jokhang and Potala, Henss, *Tibet*, figs. 15 and 31; see also Olschak, p. 32, for the turban (behind a tiara) on a form of Padmasambhava.

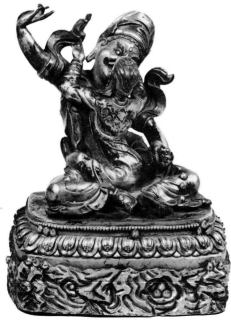

S39

LAMA

Lacquer with gold leaf and painted details, h. 21½" (54.5 cm)
China, 17th-18th centuries
Gift of Redfield Beckwith 1978 78.124

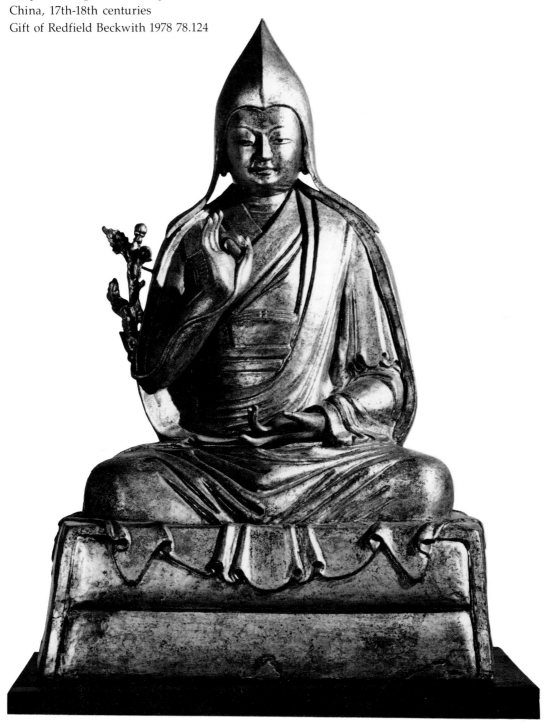

This is an unusual image in "dry" lacquer of the type of Gelugpa portrait sculpture familiar in Tibetan and Sino-Tibetan metal examples. The medium, even in China and Japan, is rare but appears to have been popular for fabricating Buddhist images in Yüan China in the thirteenth to fourteenth centuries. This example has been formed in one piece from cloth soaked in lacquer and clay (for the inner structure). Once hardened, it was covered with a blue/green, fine silk cloth impregnated with lacquer, and then given successive outer coats of black lacquer. Finally, a reddish-gold leaf was applied to the garments, hands and cushions, and a greenish-gold to the face. The face was further embellished with painted red lips and eye rims and black pupils. The figure is dressed in the pleated skirt and waist tie, vest, shawl and peaked cap with ear lappets common to all Gelugpa lamas. The garments, the hand gestures and the lotus plant extending from the right hand and upper arm to the right shoulder[1] are those used for Tsongkhapa, but lacking further attributes it is not possible to identify the portrait.[2] Old, clumsy repairs, and thick layers of plaster and orange varnish, especially on the base which had depressed and cracked from the weight of the figure, were removed at the Museum revealing the almost intact gilded surface on the exterior, and an emptied base. However, consecration contents remained inside the head: three silk sachets containing rolls of paper with printed Tibetan prayers,[3] large and small gray medicine balls and sandalwood dust. The extraordinary difficulty of the lacquer technique limits the production site to China,[4] but the form and consecration items are in the Tibetan tradition. This lacquer portrait was certainly modeled after a metal image; gilt copper and brass examples are ascribed to the seventeenth and eighteenth centuries.[5] The seat cushions under a cloth cover are commonly used for lama portraiture. Although bases of this style are used earlier for yogins, their frequent occurrence in realistic portraiture seem to date from the Gelugpa ascendency under the 5th Dalai Lama and to continue into the mid-twentieth century.[6]

1. The lotus is constructed of gold-leafed lacquer over a wire armature, the top section, now missing, might once have held an identifying attribute.

2. Compare P19 and S41; the single lotus and the gesture are close to that in Olschak, pp. 124-25, icon no. 46 for the 5th Dalai Lama.

3. The paper strips have red printed mantras designated "for head".

4. See Sherman E. Lee and Wai-Kam Ho, *Chinese Art Under the Mongols: The Yüan Dynasty (1279-1368) (Cleveland: The Cleveland Museum of Art, 1968), no. 19, for a discussion of the technique.*

5. See, for example, DDH, nos. 284-87.

6. See discussion of similar cushions and covers for S40.

S40

ATISHA (982-1054)

Assembled gilt copper, cast and hammered, with painted details, h. 7¾″ (19.7 cm)

Tibet, 17th-18th centuries

Purchase 1949 From the Baron von Stael-Holstein Collection 49.41

The hollow cast figure of Atisha is riveted to the separately cast base of two cushions covered with a textile, while hammered and applied lotus flowers sprout from the base along two sides of the saint, holding a chorten and basket.[1] The moon/sun/flame finial of the chorten is formed by a hollow frame filled with white opaque glass, translucent yellow glass, and a turquoise chip, respectively. The saint wears his characteristic "helmet" hat with concentric horizontal rings and a lappet that extends completely around the back like a cape. Uncharacteristically, he wears the skirt, vest and shawl of a Tibetan monk.[2] Fine scroll and floral incising decorates the borders of the hat lappet, shawl, vest and skirt, basket, seat, textile cover and cushions. The back of the figure, chorten and basket are fully modeled and detailed; the back of the seat and the leaves of the lotus plants are flat and painted red, and the seat base is sealed with a copper plate incised with a double *dorje*. The face of Atisha is realistically painted in cold gold, with red lips. The hands and feet have traces of cold gold.

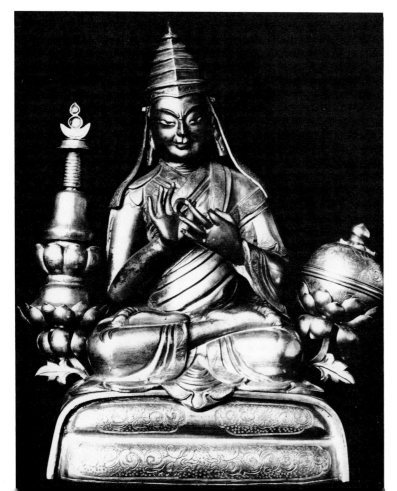

There seem to be no early portraits of Atisha, the great Indian monk, who traveled from Vikramashila Monastery in Bihar to Tibet in 1040, although paintings and images in the Kadampa tradition stemming from Atisha's disciples are known from the eleventh to thirteenth centuries, contemporary with the flourishing of this monastic order.[3] Atisha is shown twice in the lineage accompanying an early (fifteenth century?) portrait of Tsongkhapa obtained in Toling, Western Tibet, by Tucci but he is not differentiated, except by inscription, from the other monks.[4] A circa sixteenth-century fragmentary painting on wood of Atisha from Pokhang, in Southern Tibet, shows the saint with the same pose, hand gesture and garments as in Newark's sculpture, but lacks the stupa and basket attributes.[5] The use of a covered textile cushion seat in the Museum's example is Chinese inspired, although historical figures, donors and yogins are shown as subsidiary figures, seated on textiles and animal skins, as early as the eleventh-century paintings of Alchi.[6] Two (or more) Chinese brocade cushions, with a brocade or embroidered drape, were the standard seating (on a raised dais) for important monks in Tibet, and the numerous portraits in sculptures and paintings, executed during the seventeenth to eighteenth centuries, portray this with realism.[7] The workmanship on Newark's piece, especially the floral incising, delicate hammered lotus petals and use of glass, are suggestive of strong Chinese influence. The political importance of the Great 5th Dalai Lama (1617-82) gave renewed impetus to the Gelugpa lineage in which Atisha figures prominently. This may explain the proliferation of images such as these from the seventeenth century on.

1. The basket, *za-ma-tog* ("spiritual food"), is used to store ritual implements and is often depicted with Indian yogins. The lotus flowers, chorten and basket are assembled on pegs.
2. The usual garment for Atisha is "Indian": skirt, draped upper garment (around chest) and shawl, see Olschak, p. 121, icon no. 29; and Pal, *The Art of Tibet*, pl. 19.
3. See pp. 19-20.
4. TPS, pls. 8-12, pp. 339-46.
5. Ibid, fig. 79, p. 203; see also Henss, *Tibet*, p. 130 which shows a wall painting of uncertain date of Atisha in the Tara Lakhang at Nyetang Monastery, where he died.
6. Pratapaditya Pal and Lionel Fournier, *A Buddhist Paradise, The Murals of Alchi, Western Himalayas* (Hong Kong: Kumar, 1982), pls. D22, D23 and S17. For Sino-Tibetan examples see von S., no. 143E and TP, pls. 56 and 60.
7. See S39 and P15 and 16; and DDH, nos. 285-87.

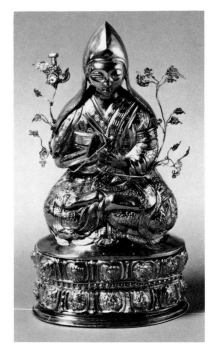

S41

TSONGKHAPA (1357-1419)

Hammered gold, h. (with base) 7¼" (18.5 cm)
China, 17th-18th centuries
Gift of Charles H. Colvin 1980 80.283
See color plate 6

It is exceedingly unusual to find extant gold images, although their existence is recognized in Tibet, China and the Himalayas. References to "gold" images are often surmised to be actually gilt copper or brass, but from the occasional silver (and gilt silver) image that is found (S34 and 43, for example) and the Tibetan penchant for gold adornment, we may conclude the certain existence of pure gold images and ritual implements.[1] It is the fragile nature of gold objects and the likelihood

of their being melted down that has made them so scarce. The image shown here is constructed of probably 16-karat gold sheets hammered and pieced together to form the hollow figure (modeled completely in the round). The rather thick ear lappets appear to be gilt copper; the filigree and wire lotus plants "growing" out of the hands up to the shoulders are 24-karat gold. When acquired by The Newark Museum the filigree was crumpled and the double lotus base was awkwardly attached directly to the skirts and shawl of the figure. Restoration separated the lotus band and figure and set them on a new, oval-shaped brass support; the filigree was also restored. The attire, hand pose and remains of a sword handle jutting from the right lotus plant all point to the identification as Tsongkhapa (see P19).[2] The ornate lotus base is similar to bases on seventeenth-and-eighteenth-century gilt brass and copper Chinese images. The child-like facial expression is also typical of these sculptures.[3] The filigree and fine incised cloud scroll on the garments strongly suggest Chinese goldsmith's work.

1. Numerous gold objects are in the Potala Palace, Lhasa, see Deng Ruiling et al., *Potala Palace*, pls. 16, 78-80 and 82-86.
2. Compare, also, Olschak, pp. 122-23, icon no. 41.
3. See von S., nos. 152A, B, E, 155F and 158F.

S42

AMITAYUS

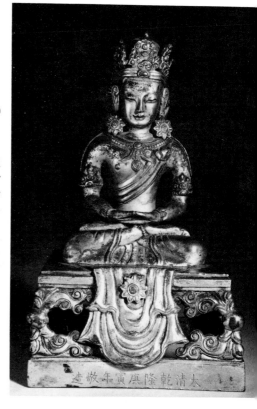

Cast and hammered gilt copper with painted details, h. 7½" (19.2 cm)

China, dated in accordance with 1770

Purchase 1909 George T. Rockwell Collection 9.1142

A great number of these sculptures were produced in the 1760s and 1770s, all bearing Qianlong inscriptions and fabricated in a similar way.[1] It is probable that these images were made with reusable piece molds.[2] Newark's example is created from separately cast or hammered elements: body, crown with sashes behind the ears, rosette earrings, hair locks to the shoulders, a drape complete with rosette hanging in front of the throne, the front and two sides of the throne and its flattened back. A vase, which once attached to a hole in the palm of the hands, is missing, as is a nimbus once attached through two rectangular slits at the top back of the throne. The copper has been gilded with a dark gold on all surfaces except the hair, the back of the throne and the inner surfaces of throne and crown. The underside of the body once held a plate which secured the consecration contents, now lost. Traces of blue paint are visible in the piled headdress, the hair locks and eyes; red paint traces are on the inner surfaces of the crown and on the mouth. There is a distinct similarity between these Qianlong pieces and Nepalese images, both in style and manner of fabrication. Compare S45, especially the *dorje*-like scrolling legs at the four corners of the throne, the front swathe of drapery and ornaments.[3] The nine-character Chinese inscription across the front of the base reads: "Respectfully made during the Keng-Yin year of the Qianlong reign of the great Qing dynasty."

1. See von S., no. 158B; Sotheby's Sale Catalogue (London: 26 November, 1984), lot nos. 63 and 65; A. Neven, *Lamaistic Art* (Brussels: Société Générale de Banque, 1975), no. 116.
2. See Neven, *Lamaistic Art*, p. 47; and von S., pp. 534-36.
3. See also Nepalese examples in von S., nos. 107C, D and 108B.

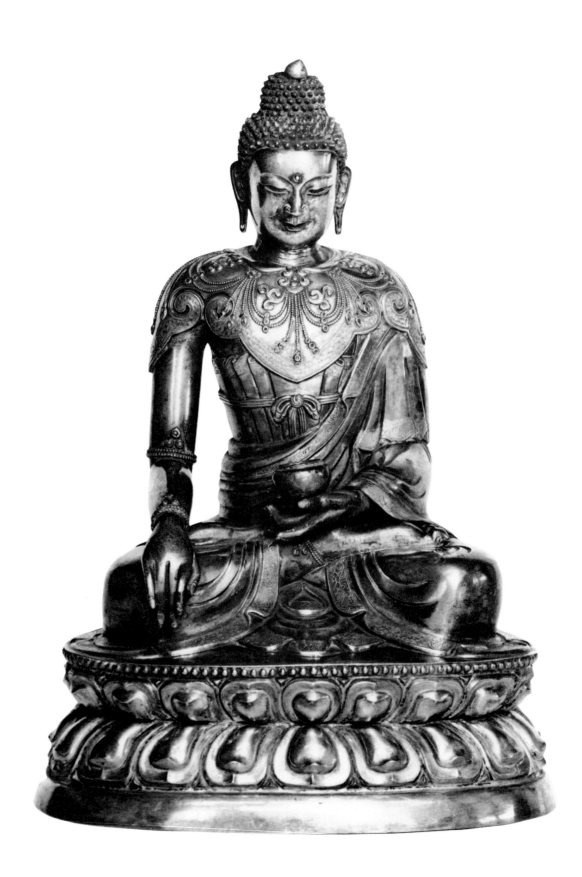

S43

BUDDHA

Hammered silver with partial gilt and jewel inlay and painted details, h. 12½" (31.8 cm)

Mongolia(?), 18th century(?)

Gift of Herman and Paul Jaehne 1941 41.1068

The working technique and decorative quality of this image suggest the product of a jewelry maker rather than a sculptor. The image has been fabricated from several, approximately 0.50 cm. thick silver sheets, carefully joined at the seams.[1] The small silver "alms bowl" attaches with a peg to the left hand. The double lotus petal base is edged with pearls; a recessed copper base plate, stamped with a double-*dorje* mark and a lotus flower center, is attached with four silver tabs. Thin gilding covers the entire base (except the top horizontal area), the "cloud collar" at the shoulders, the incised, floral-decorated shawl and underskirt, the sash tying the underskirt, and the jeweled ornaments on the right arm and ankle. The Buddha's "snail curl" hair is painted blue and has a gilded finial; traces of white paint remain in the eyes, mouth and fingernails; traces of gold paint remain on the face and neck. Small, finely polished stones of malachite and pale orange coral are set in round bezels on the beaded jewel "cloud collar", and the "three-jewel" ornaments on the right arm and wrist.

The date and exact provenance of this sculpture are uncertain. The quality of the silver and use of incising and thin gilt are similar to a ceremonial plate in Newark's collection which was purchased in Outer Mongolia.[2] The judicious insetting of the gems, their color and symmetry, are also associated with Mongolia and can be observed in a woman's silver eating set, with a Chinese signature, obtained in Labrang, Amdo, which is also in the collection.[3] A related group of images has been ascribed to Eastern Tibet, China or Mongolia, and dated from the eighteenth to nineteenth centuries. As in the Newark silver example, they are hammered and assembled with extraordinary skill, and characterized by base petals arranged centrifugally and bulging at their tips.[4] The identity of the deity is in question. The pose and hands are standard for Shakyamuni, as are the hair and basic elements of the robe. The "cloud collar" has cosmic significance and is part of both Tibetan and Chinese liturgical and royal custom, but its purpose here is unclear.[5]

1. Seams (horizontal and vertical) can be detected at the lower two sides of the body.

2. The Newark Museum, *Catalogue of the Tibetan Collection*, Vol. II (1950 edition), pp. 47-48, accession number 29.10.

3. Ibid. Vol. V (1971 edition), p. 8, accession number 36.446. Tibetans prefer rough, dark turquoise and coral stones; pale, round corals and malachite are found on Mongolian jewelry. Mongolian costume and jewelry was itself an eclectic mix of Tibetan and Chinese styles, especially during the seventeenth to twentieth centuries; see Martha Boyer, *Mongol Jewelry* (Copenhagen: National Museets Skrifter, 1952), figs. 82, 92 and pl. 2.

4. A. Neven, *Lamaistic Art* (Brussels: Société Générale de Banque, 1975), pp. 45-47, no. 111. See a similar centrifugal petal arrangement on a Nepalese example, S44.

5. See collar and jewels on gilt copper image of Songtsen Gampo, at the Jokhang, Lhasa, von S., p. 398; see also portrait image no. 140E. See The Newark Museum, *Catalogue of the Tibetan Collection*, Vol. IV (1961 edition), p. 40, and pl. XXIV, accession number 11.648, for a "cloud collar" used for a monk's dance costume.

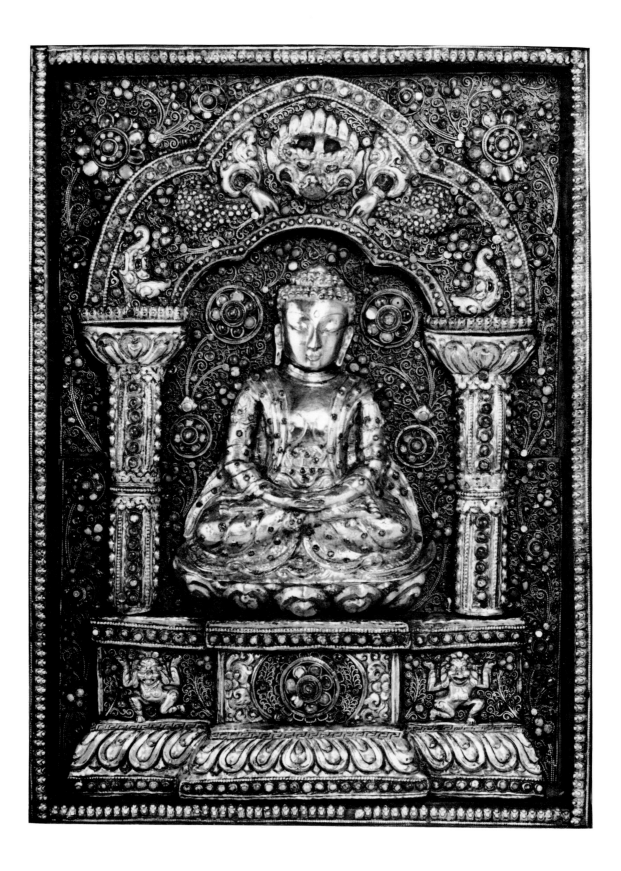

S44

BUDDHIST PLAQUE

Hammered gilt copper with filigree, and copper sheets on wood core, set with stones, h. 22⅜" (56.8 cm)

Nepal, 18th-19th centuries

Purchase 1978 The Members' Fund 78.126

Copper sheathing completely covers the wood core of this plaque. The deeply recessed center rectangle features a seated Buddha in robes, set with small rubies and emeralds, on a lotus base with his hands in meditation pose. The image is surrounded by a hammered and filigreed lobed arch with semi-precious stone inlay on elaborate, ruby-inlaid pillars. The arch has a *garuda* at the apex with lapis lazuli body and ruby eyes, flanked by snakes set with turquoise stones and *makaras* with ruby eyes. A gem-filled wheel and lions decorate the throne base. The background is covered with filigree flowers set with various stones (turquoise, coral, crystal, ruby and emerald). The outer rim has filigree "fans", each with a ruby center. The back and four sides are covered with copper sheeting; the sides stamped with a leaf chain, and the top bearing two lugs and a chain for hanging. Such ornate jewel and filigree work is a Newari art form dating from at least the eighteenth century. The work is an example of the penchant for decorating images with translucent stones, an idea that goes back at least to the ninth century in Nepal, and was not unknown earlier in India.[1] The abundance of jewels derives from the impulse in all Buddhist countries to honor and enrich images of Buddhist deities. In Nepal, inlay such as this is seen also in Hindu pieces.[2]

1. See von S., nos. 50F and 77C.
2. See Pal, *Nepal Gods Young*, pl. 83.

S45

ENTHRONED SUKHAVATI LOKESHVARA AND CONSORT

Gilt copper, cast in several pieces and assembled, h. 13" (33.0 cm)

Nepal, dated in accordance with 1818

Anonymous gift 1931 31.334

The four-headed, eight-armed god, the goddess on his knee, the lotus base, and the openwork, rectangular throne have been separately cast and attached together with copper tabs. The foliate nimbus, with seated Buddha Amitabha at the apex, was cast in one piece and fastened to the back of the throne by two tabs. A swathe of drapery, looped over the front of the throne, is riveted to it, as are the two swirls of drapery to the sides of the deity. All surfaces are gilded, except the separately cast *malla* in the upper right hand of the god, the flat back of the throne and much of the back of the nimbus. The deities are fully modeled and the back head of the god is beautifully formed. His main hands are in a preaching gesture; hers are in charity and argument. His other hands hold a lotus, bow and arrow, and a book, in addition to the *malla*. On the back of the pedestal is an inscription in Newari:

Om! Let there be prosperity! In the year 938 [of the Nepalese

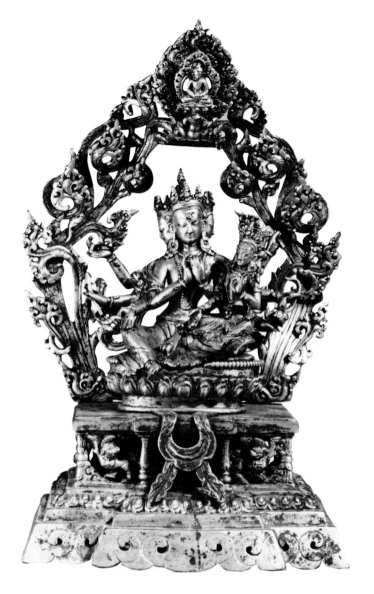

era, corresponding to A.D. 1818], [the month] Vāisākha, the light fortnight, the eleventh day, [in memory of] the heaven-gone Bhajumana Toradhara [or Tuladhara] and his wife who accompanied him by name Siddhi-Lakṣmī-Nikṣmasyā, an image of the thrice holy god Sukhāvatī-Lokeśvara was erected by the inheritors. Good Fortune![1]

There are a rather large number of similar Nepalese images extant of eighteenth to nineteenth century date, several inscribed.[2] Compare, as well, the same deities in painted form in a Nepalese *pata* dated in accordance with 1849, P 41.

Previously published: von S., no. 108A.

1. Translation by A. K. Coomaraswamy and W. Norman Brown with corrections by Ian Alsop. Alsop comments that the allusion to *sati* (wife sacrifice) here is unusual in a Buddhist context, and may mean only that she died at around the same time. If, however, Bhajumana was an important member of the Hindu Malla court, *sati* might have been required of his wife.
2. von S., nos. 107D-F and 108B, C, E; and A. Neven, *Lamaistic Art* (Brussels: Société Générale de Banque, 1975), nos. 76 and 78.

S46

FOUR PLAQUES OF SEATED BUDDHAS

Hammered gilt copper with painted details, h.(A-B) 5⅛″, (C-D) 6⅛″ (13.1, 15.5 cm)

Dagyab Monastery, Kham, Tibet, 19th century

Purchase 1920 Shelton Collection 20.426-.429

All four plaques are formed of deeply hammered copper sheets, depicting seated buddhas. A and B show the earth-witness *mudra* (with B having a vertical *dorje*), head and body halos of "flaming" scrolls, and an upturned lotus base. C has the teaching *mudra*, D the earth-witness *mudra*; both are set on "ruffled" lotus bases upon stepped and draped thrones, and both have complex nimbuses with *garuda* finials, *makaras,* riders on unicorns, lions and elephants. All four images have blue painted hair and traces of polychrome on the faces. Despite the slight differences in all four, they are reportedly from the decorative base of one image.[1] It is presumed there were originally more examples which formed some coherent iconographic grouping, such as two sets of the five buddhas. Plaques such as these are to be found decorating the bases of large reliquaries and images in temples and monasteries throughout Tibet.[2] The workmanship and material, and especially the style of the bases and nimbuses, suggest Newari craftsmen.[3] A history of the Dagyab region records their work on specific commissions at various times between 1676 and 1745,[4] and presumably this practice continued throughout the 19th century.

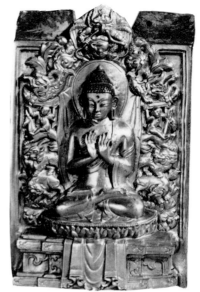

C

1. Shelton's 1920 notes list the four plaques as being "from frieze at base of idol" and "Chinese loot from burned monastery at Draya." Draya (Dagyab) is a region in Kham. Shelton probably was referring to the main monastery at Yemdum (Yenmdo), the "first city" of Dagyab, site of a monastic complex of about 5,000 monks prior to the Chinese destruction in 1909-12; information courtesy of Nima Dorjee.

2. See von S., p. 462 (top photo, background, and bottom photo).

3. Compare S45 and von S., nos. 107C, D and 108B, C.

4. See p. 26.

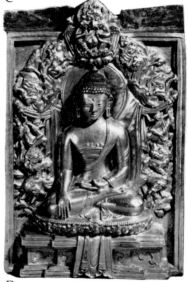

D

A

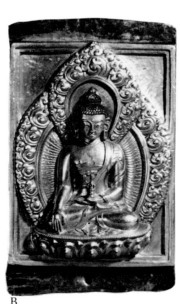

B

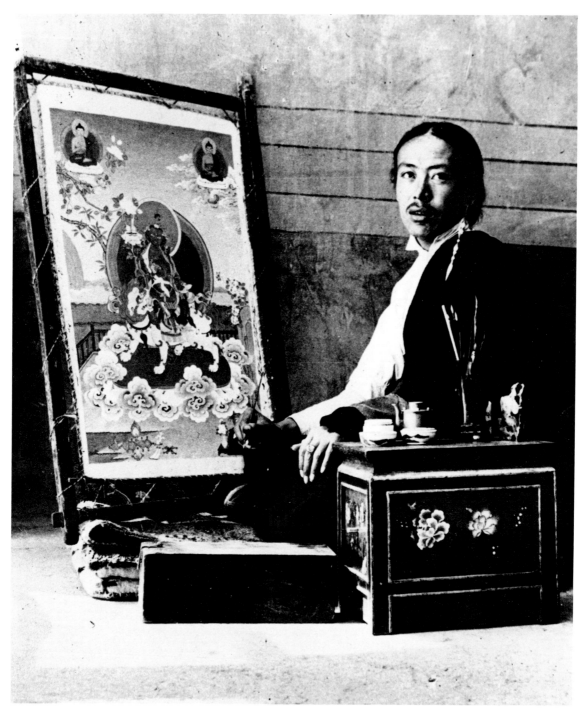

FIGURE 23

The artist, Tsering, completing a tanka at the Norbu Linga, Lhasa, 1937

Photograph: Cutting, The Newark Museum Archives (C6–C)

VIII. PAINTING: SURFACES, PIGMENTS MOUNTINGS AND CONSECRATION

Many of the steps involved in translating images of devotion into paintings parallel those for sculpture. The patron will solicit religious advice and then consult an artist or artists. An artist can be a monk, although a member of a lay professional painter family is more common. The making of a painting will entail the same spiritual preparation as for a sculpture (see pages 45-46). Sketchbooks will be consulted by the artist for the iconography, proportions and style of individual deities, or an existing painting or woodblock print might serve as a model (see P14, 15 and 18). The artist's sketchbooks may contain rough drafts as well as completely codified, proportional drawings, ready for transfer to the prepared surface (see figures 7–10). Stencils of the exact same size as the finished painting were commonly used. The stencils, pricked with holes closely following the drawn outlines, would incorporate all the main elements of a complete tanka (see figure 24) or wall painting, or merely certain repetitive decorative sections, as on architectural pieces. The antiquity of this practice is proven by the survival of both sketches and stencils, dating from perhaps the eighth to tenth centuries, at Dunhuang.[1]

In Tibet and adjacent areas painting is discovered on many different surfaces. As a finishing process for sculpture, painting and gilding have been discussed on pages 54-55. The pigments and binders for two and three-dimensional work are similar. The support (or surface) for the two-dimensional includes paper or its related forms, birch bark, palm leaf and wood; cloth, such as cotton, silk or linen; and walls of stone, earth or wood. These surfaces, as well as the pigments, binders, finishing techniques, consecration and worship practices applied to them are discussed separately. A method which creates flat "paintings" of colored sand or powder is part of the monastic ritual for certain mandalas, P39.

1. Paper and related forms (birch bark, palm leaf)

The earliest surviving Tibetan book folios with painted illustrations are made of paper. These are the *Prajnaparamita* manuscript pages found by Tucci in a ruined area at Toling, Western Tibet.[2] These illustrations are in the Kashmiri style also found in the wall paintings at Alchi (Ladakh), Tabo and Toling (Western Tibet), dating from the late tenth through eleventh centuries and, like these murals, depict deities which are visualizations of complex Mahayana liturgies. The Toling rectangular folios have large proportions (7½ by 26⅛ inches), a horizontal orientation, fine, ivory-toned, burnished paper, black ink script and polychrome-and-gold illustrations, which set the mode for Tibetan manuscripts over the next nine hundred years.

Tibetans were in contact with paper-producing civilizations from at least the seventh century. Paper technology had been invented and perfected by the Chinese in the first century A.D., and paper manuscripts were common in Central Asia by the third century. Thousands of paper scrolls, with writing, diagrams and paintings

FIGURE 24

Stencil

Thin, ivory toned paper, 29¾" × 22¾" (75.6 × 58.9 cm) Tibet, 19th century

Purchase 1983 C. Suydam Cutting Bequest Fund 83.443

A fine black line carefully delineates the central enthroned buddha, monk attendants, offerings below, and cloud-borne figures above in an idealized, landscape setting. Pin-pricks follow the lines to allow transferal to prepared cotton cloth. Notations in almost every space specify colors to be used.

1. *Silk Route*, pl. 74-75.
2. *LA Tibet*, no. M1

FIGURE 24

Detail

dating from the fifth to eleventh centuries, were discovered at Dunhuang.[3] It is remarkable, however, that the Tibetans chose paper so readily as the support for their scriptures, since two other materials with stronger roots in Indian Buddhist tradition also presented themselves: birch bark and palm leaf. Although the investigations of early manuscript materials are severely hampered by the paucity of surviving materials, some scholars believe that the most ancient Buddhist writing material was birch bark rather than palm *(talipot)* leaf. The latter was indigenous to Southern India, far from the heartland of Buddhist India, while the former was readily available across the Himalayas and was favored especially by the Kashmiris. Birch bark was known and used by the Tibetans, as is evident from the numerous folios found in the thirteenth-century chorten, S9-C, which are dated from the eighth to ninth centuries on the basis of orthographic peculiarities (figure 25). Birch bark was also used in Central Asia and the Karakoram region (Gilgit) from the first century A.D. on, and remained in use to modern times, when other mediums were unavailable. Greek scribes at the time of Alexander's conquests in India (late fourth century B.C.) record that bark and cotton cloth were the two supports in use for Indian written languages.[4] Seventh-to-eighth century birch bark manuscripts, recovered from Gilgit, are in a horizontal format (4¾ by 26 inches) with a handsome black script; decorated covers in wood were also found illustrated with painted deities in a Central Asian-Kashmiri style.[5]

Most of the earliest surviving Indian and Nepalese palm leaf manuscripts with illustrations have been found in Nepal. In Bihar and Bengal few Indian books survived the Islamic invasions. Some of the earliest extant palm leaf ones are dated by inscriptions mentioning Pala or Nepalese kings, who reigned in the period of circa 1000 to 1160.[6] Palm leaf continued to be used by Nepalese scribes (in company with paper) up to and during the eighteenth century. Both Indian and Nepalese palm leaf books follow a horizontal format, constricted by the very narrow and long proportions of the leaf itself (P1). That Tibetans recognized the palm leaf manuscript as the preeminent sacred form for a Buddhist text is proven by the depiction of deities and historical figures holding (or associated with) these small, thin, horizontal books. Yet when creating their own translations of the texts, the Tibetans used paper in a large, rectangular format. Palm leaf manuscripts bearing Tibetan script are exceedingly rare; a group which appears to be of comparatively recent age is housed in the library of the Potala, Lhasa.[7] Thus, the Tibetans could import blank palm leaf from India, as did the Nepalese, but the overwhelming number of surviving Tibetan books are on paper.

We may postulate that the Tibetans, confronted by original sacred texts written on birch bark and palm leaf from northwest and northeast India, respectively, yet knowledgeable about paper-making technology from China, chose to write their own translations on paper, as the

3. Roderick Whitfield, *The Art of Central Asia, the Stein Collection in the British Museum* (Japan, 1982).

4. Jeremiah P. Losty, *The Art of the Book in India* (London: The British Library, 1982), p. 5.

5. Ibid. no 1 (folios); *Silk Route*, p. 88 (covers).

6. Losty, *Book in India,* pp. 18-21, nos. 3, 4, 5, 6, 7, 9.

7. Ngapo Ngawang Jigmei et al., *Tibet*, pp. 88-89.

FIGURE 25

Folio

Birchbark with fragment of a
Prajnaparamita text in black ink, 10½"
× 6⅝" (26.7 × 16.9 cm)

Tibet, 8th-9th centuries; part of
contents of chorten S9-C.

Purchase 1981 W. Clark Symington
Bequest Fund 81.23

material of greatest flexibility and beauty of surface. The Tibetan penchant for color and ornamentation may have influenced this choice, since smooth white paper, which could be made in large sizes, provided a perfect surface for the embellishment of the script with illustrations in polychrome and gold. Interestingly enough, the Tibetans rejected the Chinese writing system just as they rejected the Chinese writing form—scrolls or folding books—for sacred literature, and instead used piled sheets of rectangular format, after the custom of India.

The technology of Tibetan papermaking is well documented. The simplicity of the method and its links to early Chinese processes lead us to suppose that paper manufacture has changed little since its earliest introduction into Tibet. Pulp is derived from boiling the inner bark of the Himalayan shrub, *Daphne cannabina* or *Daphne papyyracea* (also used for paper pulp in Nepal and apparently resistant to insect damage), although other vegetable matter is used in different areas of Tibet. After boiling, the pulp is beaten by hand and mixed with water. The resulting "stock" is poured into a flat mold, which is floated on water either in a vat or a stream. Then the mold, with its damp layer of pulp, is propped up diagonally (figure 26) until the layer dries and can be peeled off as a sheet of paper. The molds observed in use at Gyantse, Southern Tibet, in the middle decades of this century were wooden frames, approximately five feet by two feet in size, with a woven cotton center. A study of The Newark Museum's numerous drawings and manuscripts on paper, however, suggests that at an earlier period the molds were constructed of grass or bamboo, laced together with horsehair, similar to the "laid" mold of ancient China. Such molds are still in use in India. Laid molds leave a faint watermark of vertical or horizontal, parallel striations on the finished paper. These are clearly visible in the medium weight paper used for the texts (see figure 27) and drawings (see P2) found in chorten S9-C, and in the heavier weight paper used for the manuscripts in P3. A woven mold

FIGURE 26

Paper drying on a mold, Gyantse, Southern Tibet, 1935

Photograph: Cutting, The Newark Museum Archives (C5–C)

yields smooth paper, such as the thin stock used for the stencil, figure 24.[8] Successive pourings and dryings can produce laminated, cardboard-like layers, which is apparent in medium and thick Tibetan paper of the thirteenth century to the present.

A substantial amount of clay and other inorganic material has been found in Tibetan laminated papers; this could have been mixed into the pulp stock before pouring or coated on the successive layers.[9] Whether laminated or not, semi-dry sheets would be piled together and dried under pressure. Chain mesh indentations observable on the twelfth-to-thirteenth-century paper manuscript folios, P3 (but not on later folios), seem to have been made when the laminated sheets were dried under pressure between coarsely woven wool or hemp. Later, this method was abandoned in favor of smoother paper achieved with finer cloth-drying materials.

Ivory to buff colored paper of varied thicknesses would result from the steps described above. Additional treatment depended on the final use of the paper. Thin paper was suitable for woodblock printing or stenciling, while medium weight paper, for black ink script or drawings (P2), would be burnished and perhaps sized (see page 129), before it was cut and ready for use. Thick and fairly rigid paper, intended for gold and silver lettering and opaque polychrome and gold decoration would be dyed brown (P3) or painted black or blue-black (P3 and 22), and burnished. Tibetans must have been aware of the black and deep blue *sutra* scrolls of China, on which richly decorative gold and silver characters and deities were inscribed, when they first created the type of elaborate manuscript seen in P3. This type of folio, in which gold

FIGURE 27

Folio

Paper with Tibetan script in black ink, 8" × 6⅜" (20.3 × 16.2 cm)

Tibet, circa 1230; part of contents of chorten S9-C.

Purchase 1981 W. Clark Symington Bequest fund 81.23

8. See Dard Hunter, *Papermaking, the History and Technique of an Ancient Craft* (N.Y.: Dover Publication, 1978), pp. 111-14 and figs. 88-93, for the processes of papermaking in Tibet and adjacent regions; see pp. 77-94 for "laid" molds (a transferable covering of bamboo or grass strips sewn together and placed over the rigid mold frame, allowing wet paper to be removed from the mold immediately after dipping or pouring) and "wove" molds (woven cloth on a rigid frame).

9. Studies by Abraham Joel at the Courtauld Institute of Art and the Imperial College of Science and Technology, University of London, 1972-75.

and silver script on a dark ground is embellished with rectangular vignettes of deities in the manner of Indian palm leaf folios, continued to be produced into the twentieth century for fine editions of the *Kanjur*.

The work of making and finishing paper appears to be a lay craft. The script was written by monks. Final embellishment with illustrations or decorations were probably by the same lay artists responsible for wall and tanka paintings. Wood covers are used to protect the finished manuscripts and printed books; these are commonly carved, gilded and painted (see S26 and 27).

2. Cloth

Tibetan painted tankas are almost always on a cotton cloth support. This follows in the tradition of Nepalese *paubhas* (surviving examples date from as early as the twelfth century) and Indian *patas* (of which there are no documented surviving examples), which were constructed of cotton cloth and used as banners for processions, temple decoration and individual meditation. Silk (P29) and linen (P24) supports for Tibetan painting are known, but rare. Cotton examples in the collection vary considerably in the coarseness or fineness of the threads and weave, and in width from selvedge to selvedge. Cotton, as well as silk and linen, is imported, making the quality and size of the cloth dependent on availability. Tibetan artists would have routinely imported Indian or Chinese cloth, depending on geographical proximity.

The steps in preparing the fabric support, as observed among twentieth-century tanka painters are: a) Stretching the cloth on a wooden frame by means of a looping string, on all four sides; both a thin, tightly held inner bamboo frame and a thick, more loosely held outer hardwood frame could be utilized (see figure 23). b) Sizing the cloth with warm, animal-hide glue, on both sides, to yield a stiff, coated surface. c) Application of gesso *(dom):* a white earth pigment (chalk or kaolin) mixed with size. d) Moist and dry polishing, with a stone or shell, on both sides, to yield a surface that is hard, smooth and white. Because tankas are rolled when stored, it is important that the gesso ground adheres firmly to the cloth and is not allowed to become too thick or brittle.[10] The silk used in P29 has not been treated in this way, but the usual black, red or gold background cotton tankas would be (P30–32, 35).

Once the cloth is ready, the artist outlines the composition. This may be drawn directly onto the fabric or transferred from a prepared sketch by means of a stencil (figure 24). Prior sketches may have fully worked out proportions and details (figure 10), which are then enlarged to the scale of the cloth. In any event, the outline must be carefully positioned. Compasses, marking strings and chalk lines are used to divide the canvas into a grid with four, well defined borders. The outlines for the major and subsidiary figures are positioned on the grid, with smaller grids used to adjust the proportions and orientation of the head, body or limbs of each figure, as in figure 10. Various iconometric systems are used by Tibetan artists which give units of measurement for the body. For example, a buddha's face might be a measure of 12½ units, the neck 4, the chest 12½, the stomach 12½, the thigh 8 and the

10. Jackson, pp. 15-23.

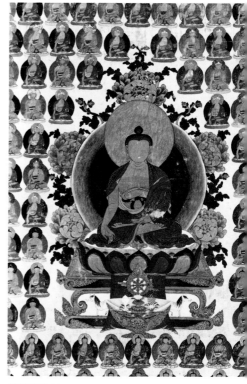

FIGURE 28

Unfinished tanka from a set depicting buddhas (detail)

Polychrome and gold on cotton cloth, (painted area) 29½″ × 21″ (74.9 × 53.3 cm) Kham, circa 1918-19

Purchase 1920 Shelton Collection 20.298

The thin, buff cotton of fine (probably machine) weave has been stretched on a frame and prepared on both sides. A central, enthroned buddha is surrounded by seventeen horizontal rows of buddhas, giving earth-witness and meditation gestures and seated on lotus bases. The incompleted upper half shows the picture in a half-realized state. The artist appears to have been working on filling in the blue hair of the small buddhas (completed only to the left half of eighth row from bottom) and the dark red outlining when interrupted. The throne, offerings and flowers are completely finished.

lotus seat 12. Reliance on iconometric systems can be traced back to Buton Rinchen Drub (1290-1364), the 8th Karmapa (1507-1554) and Menla Dongrub (flourished during the fifteenth century, see pages 22-24) among others, great scholars and/or artists who developed codified iconographies and styles for Tibetan art. The sketching and pouncing (see stencil, figure 24) is done with a charcoal stick, charcoal and ochre dust, respectively. These can be easily brushed off the surface while making corrections. Once the sketch is completed, it is redrawn with a brush and black ink. Also at this stage, notations for color areas are inscribed in black ink.[11] The strong firm outlines as well as the notations can be seen on tankas in areas where the overlying paint has been lost, as in P16 and 18. The canvas is now ready for painting (see figure 28).

3. Walls and related surfaces

No technical studies have been made on Tibetan wall paintings, but in artistic terms there is no doubt that the same artists worked on wall as on cloth paintings. Visual examination of murals *in situ* or through color photographs suggest that the pigments and binders are identical to those used on tankas. Certainly the iconographic and iconometric systems are similar, although walls demand works on a much larger scale, of course (the main deities would be life size or larger [figure 30], in contrast to the usual one- to two-feet-high scale of the central deity in a tanka). Walls in Tibet are either packed earth or stone. The main assembly halls of a monastery, the usual place for extensive, iconographic murals, are constructed mainly of dressed stone or rubble (see figure 29). Whatever the material, the wall would be covered inside and out with plaster to protect it from weathering. Interior walls, intended for painted designs, are further coated with the kind of white gesso used to prepare cotton cloth. After burnishing, the wall surface is ready to receive the preliminary charcoal sketch or transfer. The application of pigments would then proceed. Wooden beams, columns, window and door frames, doors and window shutters would be painted also, but usually only with decorative elements. The entire scheme for a chapel or hall would probably be planned by a group of religious advisers, patrons and artists, in order to achieve a ritual harmony between the sculpture and wall paintings, as well as the decorative work. Major, three-dimensional icons in clay or wood receive the same, fully polychromed surface as the walls (see figure 12).

There exists certain paintings on cotton cloth of as large a scale as wall paintings, and these were perhaps intended to be permanently attached to monastery walls. The use of painted cotton fabric for wall painting has been observed as a modern technique in Bhutan.[12] Paintings P12 and 40 are of a scale and type typically intended for wall paintings although they have cloth supports and are now free-hanging in the manner of tankas.

FIGURE 29

Ruined wall at a monastery in Chokhorgye, Southern Tibet, 1980. Note stone and rubble structure under painted gesso surface.

Photograph courtesy of Tenzin N. Tethong

11. Jackson, pp. 45-73.
12. Françoise Pommaret-Imaeda, "Auspicious Symbols and Luminous Colors - Art and Architecture," *Asian Culture*, no. 35 (Summer/Autumn, 1983), p. 30.

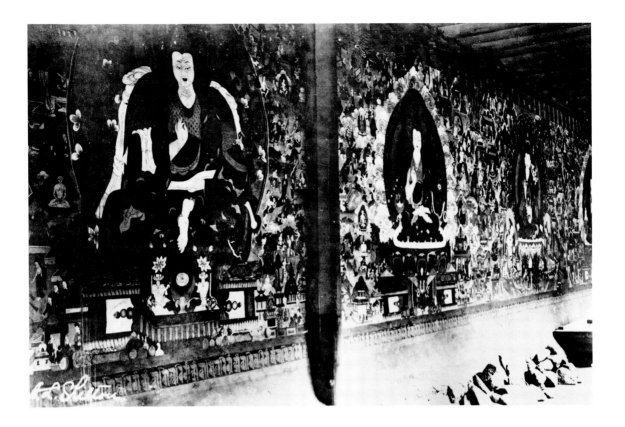

4. Pigments, including inks, dyes and gold[13]

The basic colors used in Tibetan painting are derived from minerals:

a) AZURITE BLUE *(ting; doting)* is from the copper carbonate which occurs in nature, and is found in several areas of Tibet.

b) MALACHITE GREEN *(pangma; do pang)* is a copper carbonate which also occurs in nature, usually in tandem with azurite. Both azurite and malachite ores require "wet grinding" with water in a stone mortar and pestle. The particles yield different intensities of color depending on the grinding. Very fine particles yield pale blues and greens; heavier, sand-like particles yield dark blues and greens. Lapis lazuli *(mu men)* was imported into Tibet for jewelry and medicinal use, but its rarity and expense precluded its use as a pigment. The similarity in color of lapis lazuli and dark azurite have led to confusion among non-Tibetan observers. Artificial, deep blue "ultramarine" was invented in Europe in 1830, and soon became available to Tibetan painters by way of British India. The presence of ultramarine in any Tibetan painting must be verified by chemical tests, thus visual judgments as to the occurrence of azurite verses ultramarine are not conclusive. Other artificial pigments were available in Tibet during the nineteenth and twentieth centuries; these include "emerald green," "Scheele's green," "Chinese green" and "Chinese blue," imported from India or China.

FIGURE 30

Lineage portraits along side wall of a ruined chapel, Batang, Eastern Tibet, circa 1908

Photograph: Shelton, The Newark Museum Archives (A5–S)

13. All of the information in this section has been adapted from Jackson, pp. 75-89, 111-15.

c) CINNABAR *(chog lama)* is derived from mercury-producing ore in a process long known to Chinese and Indian alchemists. The crystalline cinnabar which results from this controlled heating and cooling process was imported into Tibet from both China and India, and eventually Tibetans learned the technique of processing themselves. The crystalline cinnabar is crushed, rinsed with water and then ground to a fine powder, in a mortar, to yield an intense vermilion color.

d) MINIUM ORANGE *(litri)* is a lead tetraoxide imported from Nepal and China, where it was produced by heating lead to certain temperatures with certain additives. The smooth, intensely orange powder was ready for use without any additional preparation, although impure minium might require rinsing with water.

e) ORPIMENT YELLOW *(ba la)* is a trisulfide of arsenic which occurs naturally in Tibet, near mineral springs or silver deposits. Realgar *(dong rö)* is a red sulfide of arsenic which is found in related deposits. These pigments require dry grinding to reach the powdery state used for painting. Their poisonous nature necessitates great care.

f) YELLOW AND RED OCHRE *(ngang pa* and *tsag)* are forms of ferric oxide which yield a dark yellow and red, respectively. The yellow is used in Tibet as an undercoating for gold. The red is used by some painters but is more commonly employed for coating the exterior walls of buildings. They occur naturally in Tibet and require little grinding.

g) EARTH WHITE *(ka rag)* is obtained from various calcium compounds which, again, occur naturally in Tibet. Chalk (calcium carbonate) is soaked and ground to yield a pure white powder. Calcium compounds from animal bones and gypsum also are used to make white pigment. Synthetic lead and zinc whites were available to Tibetan painters from India and China by the beginning of the twentieth century.

h) CARBON BLACK *(nagtsa)* is obtained from soot and black ash, made by the controlled burning of wood or oil. The soot or ash is mixed with animal glue and various vegetable and mineral substances to yield ink. Imported Chinese ink, derived from soot, is used as well.

i) GOLD *(ser)*, in powdered form for "cold gold", is obtained from Newari merchants or produced by grinding gold leaf with an intermediate substance, such as glass or stone, to keep the soft gold from adhering to the mortar and pestle. Water is used to rinse out impurities. The gold is stored as a powder, or in "drops" of bound gold (the "drops" are also used by devotees to rub gold on an image or shrine). Powdered brass and copper are the common substitutes for gold.

j) SILVER *(ngul dul)* is obtained from ore, which like gold, is ground to a powder from sheets or leaf. Its tendency to tarnish restricts its use in painting. Both gold and silver powders are used in the script of sacred books (see P3 and 22). For this the binder is a roasted wheat solution.

All mineral pigments (except as noted) are mixed with a binder of size (animal hide glue).

Shading and details added over the basic opaque mineral colors are formed with dyes:

k) INDIGO BLUE *(rams)* is from plant material imported from India,

Nepal and China in slabs or chunks. These are ground with water, often with a small amount of size. The resulting paint is used for shading the outlining in preference to carbon black ink.

l) LAC RED (*gyatso*) is an insect resin, imported from India and China as crude insect scales or as dried cakes or pellets. The scales require cleaning, crushing and heating with water and medicinal leaves or salts. The gummy lac residue from this process is used for sealing wax and for cementing jewel stones (see page 55), while the liquid is used as a dye to highlight and redden details on paintings. Additional yellow, orange and red dyes are made from various native plant substances.

Washes of mineral pigments and water are employed for gradated colors and details. Indigo, lac, white, gold and black ink are used for outlining. The chief brushes for painting are constructed of animal hairs, tied to a pointed wooden stick, although Chinese-style brushes of bundles of hairs inserted into the hollow end of a wood or bamboo stick are also common.

5. Finishing

The important final step of "eye opening" (painting in the eye pupils) is regarded as part of the consecration and, for major wall paintings, clay and wood icons and tankas, would be executed on an auspicious day. Otherwise, final steps include burnishing and incising gold areas, such as brocade patterns or jewelry which require a shiny look, while faces and bodies remain matte. Burnishing tools are largely of stone and metal. The names of the deities or saints might be inscribed below each figure on the front of the painting. Often mantras are written behind each figure, on the back of the tanka. Inscriptions on the front are commonly done in gold; mantras on the back are commonly in red or black. These may be inscribed by a monk. After a final cleaning with dough or a cloth, paintings on fabric are cut from the stretcher and ready for mounting.

Tankas are traditionally sewn into cloth frames (figures 31 and 32). This appears to follow ancient Indian practice. Early tankas from Western and Southern Tibet, and Nepalese *paubhas*, are sewn onto relatively simple, straight or diagonally-shaped, dark blue cotton or silk mounts, usually only at top and bottom. If there are vertical sides, these are quite narrow. The top and bottoms are made rigid with wooden bars or dowels, and a hanging cord is attached to the top bar. Yellow and red decorative cording may be used on two or four sides of the mount, parallel to the edges of the painted tanka.

Invariably, eighteenth-to-twentieth-century tankas are sewn to a more complicated type of blue silk brocade mount, deep at the top and bottom, with narrow sides (representing the "celestial" realm) and thin, red and yellow stripes immediately adjacent to the painting (the radiant nimbus of the painting). Rectangular patches of a contrasting pattern or color might be sewn to the center of the bottom and, more rarely, the top blue brocade areas; these are called the "doors" or "windows" into the tanka. Again, decorative cording may be used to outline the inner and outer borders. Similar to early tankas, the conventional hanging method is a flat bar sewn into the top of the mount, along with a cord, and a round heavy dowel sewn into the

FIGURE 31

Typical mounting for eighteenth-to-twentieth-century tankas: "rainbow" bands, blue outer border, "door" or "window" below, bottom dowel, curtain covering and ribbons.

bottom to hold the tanka rigid and straight and to provide a smooth inner tube for rolling and storing. The bottom dowel may have elaborate metal or ivory ends. In addition, a thin, often patterned, silk covering is hung down over the tanka as a protection when it is not in use, and this is folded and draped as a decoration when the painting is viewed. Two flat ribbons of silk often hang loosely from the top edge down the sides of the mount, as a final flourish. All the work of mounting and attaching is done by sewing, never by glueing, and is executed by the painter or a specialized craftsman. The tradition of embellished silk mounts may greatly predate the eighteenth century, for some banners discovered at Dunhuang have similar brocaded additions.

6. Consecration

The *rabne* ceremony is performed to empower and honor completed paintings, in the same way as for sculpture. Sacred writings are inscribed, and special invocations made by the officiating monks. The hand and fingerprints or personal seals of holy teachers or officials may be affixed to the back (see P27 and 42), and prayers are offered to the deity represented in the painting. Loden Sherap Dagyab in *Tibetan Religious Art* recounts:

> During *rab-gnas* the grace and wisdom of the particular deity represented is invoked to the end that it will be infused into the work of art and the prayers being uttered in such a way that this grace, now transferred to the work of art, will

FIGURE 32

Mounted tanka displayed for a formal portrait of the king of Derge and his family, Kham, circa 1917.

Photograph: Shelton, The Newark Museum Archives (I49–S)

134

continue to exert its benign influence. The consecration ceremony is not reserved exclusively for performance on the completion of a new work but can be repeated thereafter as often as desired.

This ceremony of consecration may be on a simple or elaborate scale. It is carried out in accordance with the rites laid down and is a combination of meditation, incantation, and the recitation of prescribed mantras, together with the appropriate gestures and movements and the use of the correct ritual objects.[14]

7. Practices which can alter the appearance of paintings

Paintings on paper, cloth and walls can suffer from abrasions, dirt and soiling, fire, insect infestation and water. Such unintended ravages are mentioned, when discernible, in the entries. Certain intentional practices can also alter paintings. When installed in chapels and altars where butter lamps and incense are burning, the accumulated smoke and grease can coat and damage the works. The extent to which such accumulations can be safely removed varies, and the cleaning must always be done by a trained professional. Another harmful practice is rolling tankas for storage. Large areas of paint come loose from the cloth surfaces of tankas as they are rolled and unrolled. The color-selective nature of these losses suggests that certain pigments, such as white, are more unstable or adhere more poorly to the ground and thus loosen readily (see entries P16 and 18). Rolling can also, over time, cause vertical or horizontal creasing which will eventually crack and split. This problem is aggravated by the differential shrinkage of the painted cotton surface and the brocade mounts, which causes puckering and wrinkling.

14. Dagyab, p. 33.

A

B

P1

TWO FOLIOS FROM A *PRAJNAPARAMITA*

Ink and colors on palm leaf, (each) 21⅜″ × 2″ (55.2 × 5.1 cm)

Eastern India, late 11th-early 12th centuries

Purchase 1964 Jasper E. and Edward M. Crane Fund and Mrs. C. Suydam Cutting Endowment Fund 64.55 A,B From the Heeramaneck Collection

The long rectangular sheets of buff palm leaf have suffered considerable loss to both ends and to the upper and lower edges, with subsequent damage to the illustrations. Each leaf has five lines of well executed black *Kutila* script[1] in four columns, broken by vertical, red-patterned areas around the two string holes and by the centered, rectangular painting. On the reverse of each leaf, the five lines of script are broken into three columns by ruled black vertical lines. The painting on folio A depicts a seated, four-armed, white-bodied Avalokiteshvara, drawn in fine red outline with red soles to his feet and the palms of his hands. Red is also used to delineate bands at the wrists and on necklace, rosette earrings and leaf arm bands; a black line defines the brows, eyes, lips, the dhoti and the sash across the chest. Avalokiteshvara's hands are in *anjali mudra,* center; the subsidiary pair hold a white *malla,* left, and a lotus, right.[2] His black hair is dressed in a chignon with a jewel finial, and curls down the shoulders; the red crown has side sashes and three, yellow, upright leaves. A pale blue, oval halo, a red oval nimbus, a yellow, round back cushion and throne sides with a red linear pattern frame the figure against a blue background.

In folio B, an eight-armed, white-bodied figure is shown in *alidha* stance.[3] His body and ornaments are outlined in red; a black line is used for brows, pupils, third eye, three-segment crown, and for the

symbols held in each hand; which are (left to right); a *vajra,* arrow, (unidentifiable), goad, noose (at chest), bow and (unidentifiable). This protective deity wears short blue trousers and top; his black hair is dressed in two side buns and framed with a blue oval halo. The body is enclosed in a nimbus of dark red flames on a paler red background.

In both the script type and loose style of illustrations and margin decoration, the folios resemble manuscripts attributable to provincial ateliers in Eastern India of the eleventh and twelfth centuries.[4] The few surviving palm leaf manuscripts are all that remain of a complex Buddhist painting tradition in Eastern India at this time. Some complete or semi-complete manuscripts, most of which were preserved into the twentieth century in Nepal, have colophons mentioning kings or royal patrons of the Pala or related dynasties.[5] It is certain that similar illustrated palm leaf texts were carried into Tibet, as they were to Nepal, by returning pilgrims and visiting monks, thus helping to establish the Pala painting style in the Himalayas and Tibet (see pages 18-20). The *Prajnaparamita* was the most popular of the early Buddhist texts to commission in illustrated form.

1. *Kutila* ("crooked") script has a twist at the bottom of the vertical strokes; it was already an archaic script in the eleventh century; see Losty, *Book in India,* pp. 22-23.

2. This is the Sadakshari form of Avalokiteshvara, Bhattacharyya, pp. 125-27.

3. This may be some form of Vajrapani, see S37.

4. Compare Losty, *Book in India,* no. 10, note especially the linear style and stance of the top figure in the illustration on p. 34, in comparison to Newark's folio B; additional folios are illustrated in *Buddhism,* no. 81, pp. 67, 69.

5. See Losty, *Book in India,* pp. 24-28, 30-34, for a full discussion of these manuscripts; note the existence of Pala folios with Nepalese replacement covers.

P2

DRAWING OF AMITABHA

Ink on paper, 4¾" × 4⅛" (12.0 × 10.5 cm)

Tibet, radio-carbon dated to circa 1230

Purchase 1981 W. Clark Symington Bequest Fund 81.23C

The irregular rectangle of heavy buff paper (showing vertical, striated mold marks) is filled edge to edge with a carefully drawn, black line depiction of the deity as a bodhisattva, identified by the *dhyana mudra.*[1] He wears necklaces, sacred thread, dhoti with sashes between the legs and at the sides of the hips; anklets and bracelets, armbands with triangular appliqués similar to those on the tiered, helmet-like crown; heavy disc earrings, lotuses over the ears, florets and curved sashes behind the ears. His hair falls in two curling locks, fastened with lotus ornaments, down his shoulders. An elliptical halo and nimbus surround Amitabha's head and body; he sits on an oval cushion above downward-facing lotus petals against an oval back rest decorated with circles. The odd, triangular shapes, visible at shoulder level, are vestigial throne sides. This, and the accompanying drawing of Shakyamuni (now lost), were placed inside the chorten S9-C as part of the consecration. They were located against the inner wall of the chamber of the bell-shaped *anda,* facing each other from opposite sides (with packets of inscribed birchbark filling the space between). The barley seed contents of the chorten were radio-carbon dated to ± 1230 (see S9). The companion Shakyamuni drawing, of identical size, was

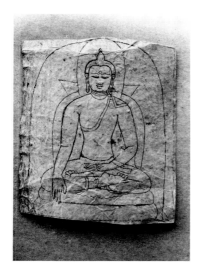

done by the same hand on the same type of paper, utilizing the system of elliptical halo, nimbus, cushion and triangular throne elements as here. Both drawings were inscribed on the reverse side in reddish-brown ink (partly embellished with yellow pigment); vertically, the seed syllables *Om ah hum* were positioned appropriately: *Om* behind the head, symbolic of the body; *ah* behind the throat, relating to speech; *hum* behind the heart, equated in Tibetan thought with the mind. The drawings had further inscriptions, giving the first stanza of the Buddhist Creed in Sanskrit and an excerpt from a *sutra* in Tibetan.[2] The Creed is commonly found carved in stone, and cast onto metal sculpture and clay tablets of the Pala period in India, and written as a consecration on early Tibetan paintings.[3] The drawings were thus made expressly for the consecration of chorten S9-C and, therefore, can be dated closely to 1230.

Robert T. Hatt, in his publication on this chorten, has given a concise summary of available comparative material, associating it with Atisha and the establishment of the Kadampa school of Tibetan Buddhism in the twelfth and thirteenth centuries.[4] However, Hatt was writing at a time when so-called "Kadampa" style paintings and drawings were associated with Western Tibet; Dr. Pal has more recently expanded the geographical range of these artworks to Central, Southern and Western Tibet, and into northwestern China.[5] As discussed in pages 19-20,

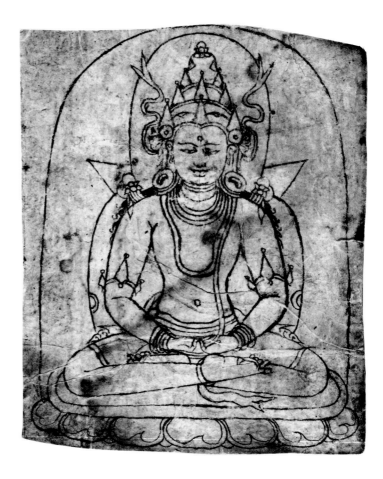

the "Kadampa" label is perhaps too narrow—despite the fact that Newark's drawing was found in a "Kadampa" chorten. In any event, the stylistic elements derive from Eastern India. The drawing of Amitabha exhibits several distinctive traits associated with the finest examples of the Pala style in Tibet: a helmet-like crown with triangular segments (seen also on the arms) and curving side-ribbons; large, spool-like earrings, and an oval back-cushion with triangular throne pieces.[6]

1. Amitabha is more commonly shown with an alms bowl in his lap but is known, as well, with empty hands in meditation (compare P4-A); the thumbs up version here is perhaps an earlier style than that with thumbs horizontal, see Robert T. Hatt, "A Thirteenth Century Tibetan Reliquary, an Iconographic and Physical Analysis," *Artibus Asiae*, XLII, 2/3 (1980), p. 198.

2. Hatt, "Tibetan Reliquary,", p. 207.

3. See p. 56, P7 and 16.

4. Hatt, "Tibetan Reliquary," pp. 198-206.

5. TP, pp. 29-59 and appendix.

6. Compare TP, pls. 7, 8 and 9; Lauf, *Sacred Art*, pl. 48; Neven, *Lamaistic Art* (Brussels: Société Générale de Banque, 1975), p. 19, fig. 1; and DDH, no. 102.

P3

ILLUSTRATED VOLUMES OF THE *PRAJNAPARAMITA*
(T. *Kanjur Sher Chin Bum*)

Ink, colors and gold on dyed paper, 25¼" × 8¼" (64.1 × 21.0 cm) (approximately)
Tibet, radio-carbon dated to circa 1195
Gift 1911 Crane Collection 11.721-.734
See color plate 7

The fourteen volumes contain from three hundred twenty-two to three hundred eighty-four folios, each; they are all missing their original covers and in some cases their original title pages. The paper is of a uniform type: a thick, pliable, layered paper with clay in-filling and horizontal striations and faint, chain mesh imprints remaining from the molding/drying process (see pages 127-28). Each folio has been dyed a deep brown and painted with a central, glossy black rectangle on both sides. The graceful and controlled *u chen* script is in either alternating gold and silver or completely in gold, seven or eight lines to each side. Two volumes (11.727, .733) have illustrated title pages (color plate 7) with cloth title flaps, attached at a later date, and one volume (11.734) has ten illustrated pages (A-C). It is not clear whether the other eleven volumes were once illustrated as well (several contain illustrated title pages of later date, see P22). The twelve illustrated folios are uniform in terms of format and style: figures are placed in reserved rectangles at the left and right margins; seated on pink lotus bases; enclosed in oval nimbuses and gold haloes, and supported by oval, scroll-decorated back cushions of varied colors with golden triangular throne elements each side. The figures are outlined either in red, black or gold. On all twelve folios the left-margin figure is a buddha seated frontally in meditation and dressed in red monastic robes, the body colors are gold, red, white, green or blue, and the hand gestures vary; these probably represent some grouping of buddhas.[1] The left-margin buddha in the colophon page of 11.734 (see

A

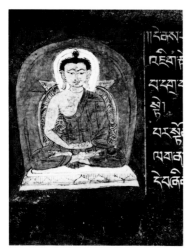

A-detail (left)

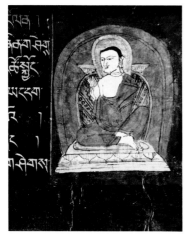

A-detail (right)

C, left) wears a golden, five-leaf crown rather than the smooth or curled monk's hair and *ushnisha;* the nimbus has three-cluster foliage added; a gold inscription under this figure reads, *"chöpag".*[2] In the right hand margin of nine folios are figures of monks (color plate 7 and A) in red robes, turned inward in a three-quarter view; the body colors are flesh, green, white, blue or gold in no discernible alignment with the corresponding buddha. The hand gestures vary and there are three variations of crossed-legged poses in which one foot is tucked in and the other is seen with sole and toes exposed. In two folios from 11.734, the right-margin figures can be identified as a seated Vajrasattva and the red bodied, "Goddess of the River Ganges" (B, right).[3]

In the right margin of the colophon page of 11.734 (C, right) a white-bodied bodhisattva is seated in three-quarter view; a gold inscription underneath (with dotted line connecting to the base so no mistake can be made as to the identification!) reads, *"Tag du ngu."*[4] To the right is the only standing figure among the illustrations, identified (also with dots) as *"Tsong pon";*[5] this white-bodied figure carries a gold-and-white umbrella and a lotus in right and left hands, respectively, and wears a gold crown and ornaments. The figure lacks a halo but is enclosed in a red nimbus. The inscription and position for this figure suggest a donor portrait but, if so, the bodhisattva garb is unusual.

Radio-carbon testing of sections of the paper from volume 11.734 has given a firm dating,[6] and the type of paper and illustrations is in keeping with the twelfth to thirteenth centuries period. Similar striated paper was found at Dunhuang, used for odd "doodles" with Tibetan inscriptions,[7] and as the support for the two drawings (P2) and a manuscript fragment (fig. 27) found inside chorten S9-C, which is radio-carbon dated to 1230. All aspects of the illustrations are consistent with Eastern Indian manuscript illustrations and with Pala-style painting found in or attributed to Western, Southern and Central Tibet, as well as Karakhoto and Dunhuang.[8] The odd, three-quarter view, crossed-legged position and short blouses which appear here are especially prevalent in subsidiary figures on Tibetan tankas and Karakhoto woodblock prints.[9] Although it is possible that this style persisted beyond the mid-thirteenth century, most later Tibetan painting shows an awareness of the Nepalese or Chinese stylistic elements introduced by the end of that century.

Newark's folios are in a pure Pala style, albeit a provincial version. It is interesting to note that in both the palm leaf folios, P1, and these *Kanjur* volumes, the calligraphy, done by monk scribes, is of superb quality while the illustrations, probably done by lay artists, are rather sketchy and uncertain. The volumes were obtained by Shelton "from

140

B

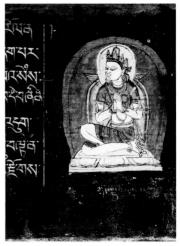

B-detail (right)

C

C-detail (left)

the widow of a former treasurer of the King of Tachienlu", either between 1904-8 when Shelton was stationed at this frontier town on the Sichuan-Kham border, or between 1908-10 when he was in Batang further to the west, where the King of Chala's (otherwise known as Tachienlu) family (and retainers?) were exiled.[10] The volumes, in their bulk and richness, are certainly fit for a royal or monastic library, liable to fall into foreign hands only under the sort of desperate conditions prevailing on the Sino-Tibetan border in 1904-10. In those folios added later, the illustrations (see P22) suggest associations with the Nyingmapa and Sakyapa orders, both of which had important centers in Kham. The volumes themselves have not yet yielded information on the location or circumstances of their original commission, or subsequent additions, but further study may reveal some answers.[11]

Previously published: DDH, no. 59.

1. The inscription under the buddha in folio 11.727 (color plate 7, top) reads *"Marme-dzed"*, the Tibetan name for Dipamkara, Buddha of the Past World Cycle.

2. In Sanskrit, *"dharma arya"*.

3. The Tibetan inscription under the figure reads, *"Gangeh Lhamo."*

4. This name, "always crying," is used for a bodhisattva who, weeping for the miseries of mundane existence, studied the *Prajnaparamita* to attain enlightenment.

5. The inscription reads, "A merchant," but this may refer to a previous life of the Buddha.

6. The radio-carbon age was determined as 790 years; the adjusted age range, accounting for statistical error, is 1040 to 1335 A.D. Testing by Alpha Analytic Inc., Coral Gables, Florida, 1985-86.

7. DDH, nos. 3-5.

8. See pp. 19-20, and P1, 2.

9. DDH, nos. 20, 23, 25 and 26; *Sino-Tibet*, pls. 16, 17, 20 and 22.

10. See Volume I, pp. 56-58.

11. The books will be included in the revised edition of Volume V, forthcoming.

C-detail (right)

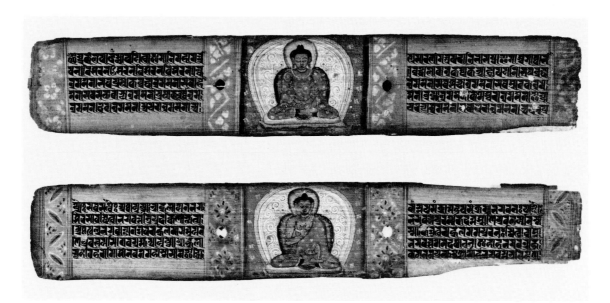

P4

TWO FOLIOS FROM A *PANCHARAKSHA* MANUSCRIPT

Ink and colors on palm leaf, (A) 12¾″ × 2¼″, (B) 12⅞″ × 2⅛″ (32.4 × 5.8, 32.6 × 5.4 cm)

Nepal, circa 1200

Purchase 1986 John J. O'Neill Bequest Fund 86.24 A,B

The two folios are from a manuscript of incantations to the five (*"pancha"*) spell goddesses and their five associated buddhas. The two seated buddhas depicted in these folios are the red-bodied Amitabha (A) and the green-bodied Amoghasiddhi (B). Each is seated on a pink lotus base and green cushion, with deep blue back cushions, against the golden, triangular sides of a throne. Red gems decorate the flanking sides and the two, leaf-form, upright finials. A fine red line covers the thrones' surface with foliate forms. The same line also delineates the swirling scrolls inside the wide, elliptical nimbus behind each figure; a deep yellow band with red radiating lines edges the nimbus. Amitabha (A) is shown in his characteristic *dhyana mudra* (compare P2) and wears a transparent red robe, with a white and yellow circle-and-flower pattern, covering both shoulders. His halo is green and the background is blue, sprinkled with white and yellow flowers. Amoghasiddhi (B) is shown in *abhaya mudra* and wears a red robe with a white rosette pattern which covers only the left shoulder. His halo is pink and the background is red with white and yellow flowers. Both buddhas are drawn with a thin but assertive black line which emphasizes their arched brows, prominent ears, neck rings and swelling shoulders. Shading modifies their faces and bodies, garments, halos, cushions and nimbuses.

Broad, vertical, margin bands flank the central illustrations, covering the string holes and marking the outer edges. On A, the inner set of bands is red with a white trellis and leaf pattern; the outer set is green with a white and yellow rosette pattern. On B, the inner bands are

green with a quatrefoil pattern in dark and light red, blue and white; the outer bands are red with a leaf and flower pattern in green, blue, pink and yellow. Five lines of black *Kutila* script (compare P1) fill the reserved blocks to each side of the illustrations. On the reverse of each folio, five lines of script occupy the length of the leaf, with reserve areas around the string holes and various notations in the margins.

Although the script and general composition of the folios parallels those on eastern Indian manuscripts of the eleventh to twelfth centuries, the squat and broadened forms of the buddhas and their nimbuses as well as the blithely patterned margin bands are very much in a Nepalese style. The wide, yellow-rimmed nimbus, pink lotus base and polychromed patterned margins are visible on an earlier Nepalese manuscript cover (circa 1100 to 1130), but the fully developed style is most evident on manuscripts of around 1180 to 1200.[1] Shading on the figures, nimbuses and margins and the flower-sprinkled backgrounds appear on three *Pancharaksha* folios attributed to the early thirteenth century in the Los Angeles County Museum. In the same collection is a slightly earlier group of five folios depicting seated buddhas and bodhisattvas, which share the Newark illustrations' scroll-filled nimbuses and gem-set thrones.[2] Elements of this Nepalese style can be identified in Chinese and Tibetan Buddhist art by the end of the thirteenth century.[3]

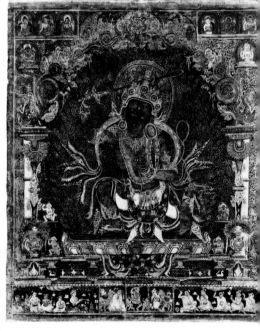

1. See *Buddhism*, no. 169, for the cover of circa 1100 to 1130, and nos. 171, 173 and 174 for manuscripts dated in the second half of the twelfth century; note also no. 159, a problematic eastern Indian or Nepalese manuscript, twelfth to thirteenth centuries.

2. *LA Nepal*, no. P6, *Pancharaksha* folios, and no. P5, five folios from a *Paramartha Namasangiti*.

3. See pp. 20-21.

P5

CHANDAMAHAROSHANA

Colors on cotton cloth, 28½″ × 23½″ (72.5 × 59.7 cm)
Nepal, late 14th-early 15th century
Purchase 1981 The Members' Fund 81.361
See color plate 8

The vigorous figure of Chandamaharoshana in *achalasana* is the focus of this painting. His body is seen in profile below the waist and frontally above. His three eyes and grimacing mouth sparkle and he brandishes a sword in his raised right hand and a *dorje*-ended noose in his "mesmerizing" left hand. He is adorned with a ruby-jeweled, five-leaf crown with additional tiers of smaller leaves and a *dorje* finial; rosettes, shells and scarves are at his ears. Further adornment includes mismatched disk-and-jeweled-leaf (right) and large oval disk (left) earrings; multiple necklaces, garlands of fine pearls and gems; bangles at wrists and elbow, and curving, festooned jewelry at ankles and feet. Several layers of brocade are worn around his hips, secured by a jeweled belt. A scarf swirling around his shoulders and matching pleated drapes at his hips and between his legs have floral rondels and scrolls of great complexity.

The oval halo of stylized golden flames encloses a dense pattern of lotus flowers in scrolled rondels; the large, oval, red-on-red scroll-

patterned nimbus has a leaf-shaped "flame" border, completely surrounding Chandamaharoshana and rising from a multi-colored lotus base. These, in turn, are enclosed in a *prabhamandala* composed of flame-pillars rising out of vases (adorned with twin fish and spilling forth a conch shell, foliage and gems) and supporting a *makara-scroll-kinnara-*snake-*kirtimukha* arched top.[1] The *prabhamandala* and Chandamaharoshana's lotus base stand on a throne plinth of many layers and textures, over which is draped a swathed brocade featuring several of the patterns of the deity's garments. Four small manifestations of Chandamaharoshana (colored white, yellow, red and green)[2] are placed to the bottom right and left of the main figure, inside the *prabhamandala* against a field filled with green and black scrolls. A similar, but blue and black, scroll pattern fills the outer field. In each of the two top corners are three buddhas[3] in rectangular enclosures, sharing a pink lotus base. Below these are a red, six-armed deity (left) and a white, four-armed Sadakshari Lokeshvara (right).

A band across the bottom depicts the initiation rituals.[4] At left are a priest in a crown similar to Chandamaharoshana's, the initiate in a red helmet and the family or temple members. Five figures involved in the initiation are on the right, dressed in gauze-like garments. Ritual vessels and emblems are arrayed on the green fields of these two segments. In the middle a dancing, sword-brandishing figure (the initiate as Chandamaharoshana?) and two attendants are flanked by a male figure attended by a jewel-carrying elephant, and a female figure attended by a jewel-carrying horse.[5] The damaged outer border has fine rosettes.

The cult of Chandamaharoshana (Achala, "immovable") is especially popular in Nepal. The style of the painting and the nature of the initiation scene tell us that this is a Nepalese work for home consumption.[6] Although Chandamaharoshana is a fierce divinity and is here given his standard weapons of sword and noose, the fangs, squinting eyes, crown of severed heads and snake ornament described for his *sadhana* are lacking as is the female partner usually shown.[7]

Special attention has been given here to the gorgeous princely adornments and surroundings. The complex *prabhamandala*-throne-nimbus assembly is featured in earlier Nepalese paintings, but the side supports constructed of vase-column-foliage appear to be a device dating from the fourteenth and fifteenth centuries.[8] A late-fourteenth-early-fifteenth-century date is proposed based on a close similarity to the few inscribed examples from this time period.[9]

1. For these symbols, see Volume I, pp. 71, 75-77.

2. See Christopher S. George, *The Candamahārosana Tantra, A Critical Edition and English Translation, Chapters I-VIII* (New Haven, Connecticut: American Oriental Society, 1974), p. 50.

3. These represent the five buddha families plus Shakyamuni.

4. See George, *Candamahārosana Tantra*, pp. 52-57, for a description of the rituals.

5. These are part of the "seven treasures of royalty", see Volume I, p. 72.

6. The priests and donors in the consecration are typically Nepalese, compare P11.

7. See Bhattacharyya, pp. 154-55. The form with female partner is seen, for instance, in two later paintings, Pratapaditya Pal, *The Arts of Nepal*, vol. 2, *Painting* (Leiden: E. J. Brill, 1978),nos. 109-10.

8. Compare *LA Nepal*, no. P9; Pal, *Nepal, Gods Young*, pls. 18 and 43; and TP, pls. 25-26.

9. Compare Pal, *Nepal, Gods Young*, pl. 43; *LA Nepal*, nos. P11 and 13; and John Lowry, "A Fifteenth Century Sketchbook," *Essais*, figs. A8-9, B1-7.

P6

CROWN

Painted and tooled gold on layered paper; each of five leaves: 7½" h. (19.1 cm)

Nepal, 15th century

Purchase 1978 Felix Fuld Bequest, John J. O'Neill Bequest and Louis Bamberger Bequest Funds 78.127
See color plate 9

The five separate leaves with lobed tops, straight bottoms and straight flaring sides have been cut from thick layered cardboard. The front surfaces are covered with gold foil, the back with a plain-weave, tan wool cloth. Each leaf features one of the five buddhas seated in embrace with his consort and enclosed in a bright red halo and nimbus, except for the right-most pair (Amitabha and consort) whose red bodies have a contrasting dark green halo and nimbus. The deities are outlined in a fine, black line and adorned with gold body ornaments and crowns in their piled black hair. The buddhas wear gold-patterned dhotis. The consorts wear contrasting scarves at their hips and offer the buddhas elixir from skull cups. The throne setting of each leaf is depicted entirely in densely tooled relief work on the gold foil; painted details are given only to the symbol (above) and the animal supports (below) for each buddha. The tooling includes double lotus bases above draped and patterned thrones and *prabhamandalas* of mythical animals, scrolls and umbrellas. Beneath each throne is a mantra; the top and sides of each leaf are banded in a leaf-like scroll. The small, painted, animal throne supports and the golden symbols at the apex of the *prabhamandala,* are each on a red background.

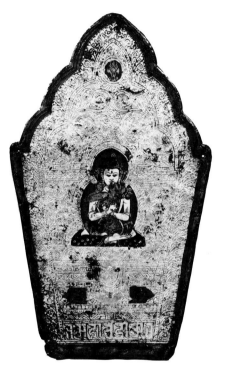

The buddhas and their corresponding supports and symbols are (left to right):

1. Yellow Ratnasambhava with flaming jewel in crossed hands, orange consort, flaming horse supports, flaming jewel symbol (black and white illustration).
2. White Vairochana with flaming wheels in hands, white consort, lion supports, flaming wheel symbols.

3. Blue Akshobhya with *dorje* in hands, blue consort, elephant supports, *dorje* symbol (color plate 9).
4. Green Amoghasiddhi with (? unclear) in hands, green consort, garuda supports, crossed *dorje* symbol.
5. Red Amitabha with lotus in hands, red consort, peacock supports, lotus symbol.

On the back of each leaf is a Sanskrit letter in gold within a gold circle, each symbolic of the respective buddha.

The buddha pentad, either shown as a symbol or depicted as deities, is the standard ornament for these crowns, which are used in Tibet for many tantric rituals.[1] Although for use in Tibet, this crown is clearly of Newari workmanship. Comparable dated and attributed paintings suggest a fifteenth century date for the crown.[2]

1. The Newark Museum, *Catalogue of the Tibetan Collection,* vol. IV (1961 edition), pl. XXV (left) and M. Brauen, *Heinrich Harrers Impression aus Tibet* (Innsbruck, 1974), p. 93, no. 54.
2. Compare *LA Nepal,* nos. D1, 2, P11, 12, 13 and 14.

P7

PARADISE OF AMITAYUS

Colors and gold on cotton cloth, 33⅝" × 29⅝" (85.4 × 75.7 cm)
Southern or Central Tibet, 15th century
Purchase 1976 Sophronia Anderson Bequest, Membership Endowment
and Charles W. Engelhard Bequest Funds 76.189
See color plate 10

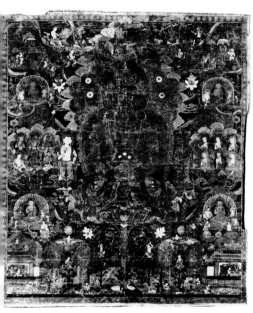

This many-layered paradise scene, expressed in lyrical color and
sensitive line, is similar to those found in the wall paintings of
Southern Tibet on monasteries and temples during the fifteenth
century. These paintings show a complex mingling of Indian,
Nepalese and Chinese elements. The varied styles have been brought
together here to form a beautifully realized ideal world. The central
deity, Amitayus, sits in meditation holding the golden vase of the
Elixir of Life. The lush flowers and dense green foliage, outlined
strongly in black, which spring from the vase are repeated throughout
the painting. Amitayus is adorned in gem-set, golden jewelry and
garments of finely patterned silk. His red body is depicted by
schematized, smooth flat forms with thin black outlining and, in some
areas, a second, pale red line "shadow"; the joined green halo-and-
nimbus is densely filled with black-and-gold-line lotus scroll pattern;
with a red banded edge and gold flames filled with red, green and
blue leaf-form gems. The scroll-edged, lotus petal base under
Amitayus is supported by a pink stalk, from the sides of which grow
leaves and tendrils encircling peacocks and sprouting white and
golden flowers. These curve up to the sides to hold, at left and right,
the multi-colored petal bases of two standing bodhisattvas. The two
figures are adorned in crowns, jewelry and patterned garments
similar to the central deity; at right, the green bodhisattva (Vish-
vapani?) holds in his "threatening" right hand a blue lotus plant,
which supports a *dorje* at his shoulder, and gives the *karana mudra* with
his left hand; at left, the white Avalokiteshvara holds in his blessing
right hand the stem of a golden lotus plant and gives the "mesmeriz-
ing" gesture with his left. Jewel-garlanded, thickly-leaved, flowering
plants and golden clouds surround the halo and upper nimbus of
Amitayus and the two-tiered, beribboned umbrella of patterned silks
with golden vase finial, which hangs above the deity.

As is characteristic of these fifteenth-century paradise tankas and wall
paintings, the background is filled with hierarchical groups of deities
and adoring figures. Here, the entire ground is painted a deep blue
with subtle black and gold lines in a swirling pattern, which can be
interpreted as both magical water and celestial settings. At the base of
the tanka is a golden flower and tree-filled landscape with a large,
central lake and two small ponds, all indicated in light blue with
golden wave patterns. Human figures swim in the ponds, ducks and
fish swim in the lake, and birds and crowned princely figures,
attended by heavenly beings, stroll on the golden shores. In addition
to the central lotus stalk, four smaller plants rise from the lake: two red
flowers holding adoring beings and two blue flowers bearing haloed
monks. At the left and right of this "golden land" are two tiered roof
pavilions, whose curtained interiors each enclose a bodhisattva seated

on cushions, entertained by dancers, musicians and gift-bearers. Above the gem-filled trees (left and right) are another two ponds in which humans swim, enclosed by fences similar to those around the pavilions.

Covering the rest of the blue background are dispersed groups of deities and attendants. Their cloud-and-flower settings are connected to Amitayus and to various golden flowers by curving rainbows. Four preaching buddhas in red robes of varied pattern, rainbow-striped nimbuses, worshiped by groups of monks, princes and divinities, occupy both the upper and lower sides. At the center sides are six monks (right) and six bodhisattvas (left). Enthroned golden buddhas in red mountainous settings, attended by umbrella-bearers and various royal, divine and holy figures, are ranged top left and right. Garlanded beings holding musical instruments, umbrellas and standards, hover near the clouds and flowers over Amitayus's head. Many decorative devices and small vignettes fill the remaining space with flowers, horizontally banded clouds, Buddhist emblems and divine figures on lotuses. Especially beguiling are naked "infant buddhas" seen through the transparent petals of closed lotus buds growing above the two pavilions. Golden rosettes, in a pale green scroll trellis, fill the four red borders.

A single line of Tibetan script is written in gold on the black band across the bottom,

> Buddhas repeatedly praised abode of Lord Amitabha, that it is the exceptionally superior of all heavenly abodes with its all perfect and pure existences. The fruits of deeds of accomplishment of this tanka are dedicated for the immediate rebirth of the famous master of painting and all the sentient beings existing under the sky into the best heavenly abode. With the warm and happy rememberance and desire to see Lord Amitabha and his disciples, I wish to be born in Dewachen [the Sukhavati paradise]—the great happy place. All the accumulated virtuous merits of the past, present, and future are dedicated for the furthering of the teachings of Lord Buddha.

The back of the tanka has a dedication in black Tibetan script, written in the form of a stupa in the center with vertical lines of red Sanskrit and black Tibetan mantras at the sides. The mantras are prayers for long life. The dedication reads:

> By the merit of making this tanka, I wish the sponsor and his family to have a long life and to increase their merit and be saved from demons and evil-minded people. Lord Buddha said that a person who does hard work gains patience and that patience is great enlightenment. Also Lord Buddha said that monks who hurt other people or beings or who try to harm another's life are not true monks. To the one who is as red as the *pema ragai* stone and has a smiling face with beautiful, water-colored hair flowing down from the right side of his head and who is holding a golden pot which is filled with *amrita* in his *samadhi mudra* to that deity, Amitayus, I am prostrating. You, the victor, please grant the gift of long life to everyone.[1]

Although this type of fifteenth-century paradise tanka has been

previously associated with Western Tibet, a more compelling comparison is to the fifteenth-century Kumbum at Gyantse, Southern Tibet. This mature Tibetan style, incorporating elements of India, Nepal and China, is seen in many Tibetan paintings and prints of the fifteenth century, from the "heartland" of Central and Southern Tibet to the "outlying" areas such as Western Tibet and even China.[2] One notes in these paintings and prints the frequent recurrence of motifs, such as: golden leaf scrolls in crowns, jewelry, nimbus edges and lotus petals (Nepalese influence); abstracted, flowing, two-dimensional body forms with fine black outlining of details, idealized and naturalized flowers and leaves with strong black outlining of masses of flowers and trees (Indian influence); celestial forms, like horizontal-bar or scroll-form clouds, rainbow nimbuses and patterning of garments (Chinese influence). All of these elements are to be found, in their finest manifestation, in the wall paintings at the Kumbum and the adjacent image hall at Gyantse.[3] The Paradise of Amitayus, although damaged, exhibits on a smaller scale the assured application of line and color which is the hallmark of this fifteenth-century school.

1. Translations by Nima Dorjee.
2. See pp. 23-24.
3. For Gyantse, see figure 1; Tucci, *Indo-Tibetica*, vol. IV, figs. 89-91, 93, 97, 122-32, 153, 173, 182-84, 203, 208-9, 215, 223-24, 245-50, 254-60, 288-98, 304 and 323; TP, pls. 20-21, and Henss, *Tibet*, pls. 61 and 63.

P8

TWO FOLIOS FROM A *GYALPO KACHEM* MANUSCRIPT

Ink, colors and gold on paper, 22⅛" × 6⅞" (56.2 × 17.6 cm)
Tibet, 15th century
Gift of Mr. and Mrs. Jack Zimmerman 1984 84.396 A,B

The two folios are from a group of illustrated manuscript pages, now dispersed to several collections, which have in turn been removed from the larger body of a text.[1] A preliminary investigation leads to the tentative identification of the manuscript as the *Gyalpo Kachem* ("Will and Testament of the King"), a *terma* text which, according to tradition, was written by Songtsen Gampo in the seventh century and found by Atisha in the eleventh century.[2]

The paper is buff colored, multi-layered and stained dark blue on both sides. The obverse of each illustrated folio is the beginning of a chapter with seven lines of carefully written gold script; the same script continues on the reverse, also in seven lines. Each folio is illustrated on both sides (a most unusual feature) with portraits (two each) of buddhas.[3] The drawing is in a fine black or red line: each buddha seated in meditation, with the upper body either turned inward or to the front. Skins are golden yellow and the hair black; the robes (skirt and shawl) are varied: red, gold or yellow. The oval haloes are green, blue or red; the circular nimbuses are blue or green. Each buddha sits on multiple lotus petals which completely fill the lower border; these vary in shape, direction and color (pale red or blue-gray). The plain, stylized, landscape backgrounds feature green fields, with and without white-capped conical mountains, and blue skies, with or without white, pale blue or pale red fluffy clouds. Beneath each buddha is an

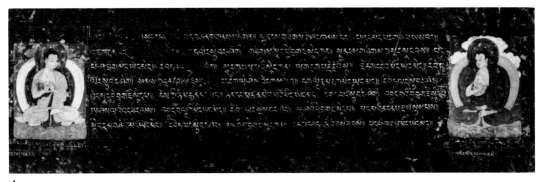

A

Obverse

B

A

Reverse

B

inscription in gold giving the name of the buddha, and above each buddha are faint silver mantras.

The sauve figures of the buddhas, the delicate line, and the rich palette of these folios suggest that they were done at the time of the mature Tibetan style in the fifteenth century. The figures and their framing clouds are comparable to periphery groups in the Paradise of Amitayus (P7), and to similar paradise scenes on the walls of the Gyantse Kumbum.[4] The extant folios have so far yielded no information as to provenance or date, but the sophistication of the calligraphy and illustrations indicate a monastery or atelier of importance.

1. Two are in the Los Angeles County Museum of Art, two in The Brooklyn Museum, the rest are in a private collection; all have double illustrations on both sides.

2. The *Gyalpo Kachem* may be one of the many sections of the large series of texts called the *Mani K'abum*. *Terma* are a type of text said to have been written at the time of the *tsenpos* (see pp. 14-17) and hidden for later discovery. These texts are especially important to the Nyingmapas, but many Tibetan Buddhists use them. Folio A describes the "Potala" paradise of Avalokiteshvara, and folio B includes a narrative on the death of Songtsen Gampo and his merging with Avalokiteshvara.

3. These may be from the group of 35 Buddhas of Confession or 1,000 Buddhas of the Golden Aeon which are discussed in other sections of the *Mani K'abum*.

4. See Tucci, *Indo-Tibetica,* vol. IV, figs. 153, 182, 203 and 278; compare also the elegant figures and fluffy cloud forms in wall paintings in other Tsang monuments, TPS, vol. I, figs. 22 and 44.

P9

PAINTED CARD DEPICTING "YUM CHEN"

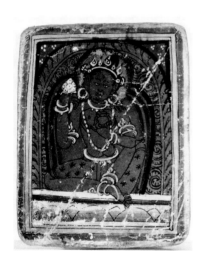

Ink and colors on paper, 4¼″ × 3⅜″ (10.9 × 8.6 cm)
Tibet, 15th-16th centuries
Gift of Mr. and Mrs. Jack Zimmerman 1984 84.394

The Tibetan inscription on the reverse of this card, in thirteen lines of black ink on a white ground, makes it clear that this is a *tsakali* ("miniature painting") for use in initiation ceremonies. The inscription first names the goddess as *Yum chen* ("great mother" i.e., Prajnaparamita) and later as *Lhamo* ("goddess"), and specifies that she is holding the lotus and the vase of life. The inscription further states that this card is for a *tsewang*, an initiation for long life, and that the card is the eighth in a series. The red-bodied goddess, outlined in black, sits in "royal ease" on a horizontal, white-and-green base over gradated, pink lotus petals; her red dhoti has a black star pattern and she wears a gold-and-red crown and ornaments. She has a blue-gray halo, shaded green back cushion, and flaming nimbus with scroll motifs. A green field, with yellow dot flowers, is visible at the upper left and right. The card is banded in yellow and red. Losses to the surface, especially along the diagonal crease, betray the fact that the buff paper has been cut down and reused from a larger manuscript, which originally had at least ten lines of black script on both sides. The painting has close affinities to Nepalese work of the fifteenth to sixteenth centuries, and may be by Newari artists for a Tibetan patron (an entire series would have been commissioned) or by a Tibetan artist, heavily influenced by Nepalese painting.[1]

1. Compare P5, 6 and 10; see also *LA Nepal*, nos. P12 (periphery figures), and 21; and *LA Tibet,* no. M4.

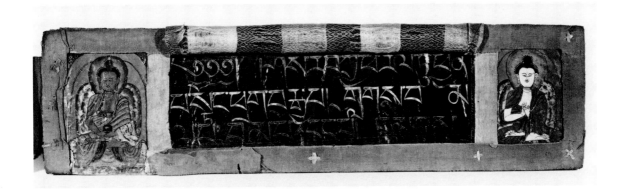

P10

TITLE FOLIO FROM A VOLUME OF THE *KANJUR*

Ink, colors and gold on paper with leather and fabric additions, 24" × 6¼" (61.0 × 15.9 cm)

Tibet, 15th-16th centuries

Purchase 1920 Shelton Collection 20.484

This is the title page from a volume of the *Kanjur,* part of a set of twenty-four books acquired by Shelton from the Jü Lama in Batang. Only two volumes in this set have illustrated title pages. The paper is layered (but thinner than that for the folios of P3), glossy, and tan in color with horizontal striations from the mold (see page 127). The central rectangle is painted a shiny black to set off the alternating lines of gold and silver script on both sides; the margins are ruled in red. The illustrations are painted on separate rectangles of similar paper (6¼" × 5") attached, along with the cotton-cloth-wrapped paper mats, by leather thongs to the folio of script. They depict a red buddha, left, and a white buddha, right, both seated in meditation on cushion bases with blue back cushions patterned with gold dots, and with red nimbuses. The buddha at left holds an alms bowl in his lap, wears a yellow shawl with green trim, a blue-green skirt whose pleats are visible at the stomach, a yellow lower robe with blue-gray trim, and has a blue-gray halo. The buddha at right gives the teaching gesture, wears a red shawl with green and gold trim, a red lower robe with blue-gray trim, and has a red halo with gold dots. Gold dots are sprinkled on the garments of both buddhas. The wiry black line delineating the figures, the heavy-jowled faces, the shading on the garments and cushions, and the odd "spikes" outlining the hair and *ushnisha,* appear to indicate a particular, perhaps provincial, atelier. Some comparisons can be made with Nepalese painting but the shading and strong linearity are more characteristic of Tibetan work.[1] The assemblage of illustrations and mats to the folio may have occurred at a later date.

1. Compare P9 and *LA Nepal,* no. P21.

P11

MANDALA OF SAMVARA

Colors on cotton cloth, 38¼" × 30" (97.2 × 76.2 cm)

Kathmandu, Nepal, dated in accordance with 1524-25

Purchase 1970 Mary Livingston Griggs and Mary Griggs Burke Foundation Fund 70.1

The intricate cosmic diagram[1] shows a dark blue Samvara embracing his red female partner, Vajravarahi, in the center of a series of concentric circles in which the gods of his entourage radiate in eight directions. The square citadel which surrounds these circles has elaborate portals that indicate the four directions by the colors (red— west, green—north, yellow—south, blue—east) bisecting the four protective goddesses in each corner. In the outer circle eight sprightly groups of divinities and animals represent the eight cemeteries, which symbolize the eight-fold task of dying for the ego in preparation for entering the center. Beyond the mandala proper, emblems and deities fill the remaining spaces while below, at the extreme right, are the patron and his family and on the extreme left, the consecration ceremony with priest and assistant.[2] A two-line inscription in Newari along the bottom is too damaged to be fully translated; however, several elements are legible. The date given is the "bright half of Pausa of the year 644." This is either the extreme end (late December) of 1524, or the first days of January, 1525. The words "śrī śrī" appear in the middle of the first line of the inscription, and probably preceded the name of the reigning king but, if so, the rest of his titles and name are now unreadable. In the second line are the names of several members of the donor's family, but unfortunately the caste name is no longer legible. The end of the inscription records the name of the Buddhist priest who performed the consecration ceremony, Gunasena Vajracarya of *Sikomagudi,* the present day *Cikammughah* of Kathmandu.[3]

The painting's colors are rich, reds and greens predominating, with details in bright yellow. Scroll tracery fills the background and becomes more emphatic in the flaming aureoles of the four ancillary forms of Samvara and Vajravarahi (yellow, red, white and green, respectively), in the four corners outside the mandala proper. Eight small *dakinis* in varied colors and eight rondels enclosing Buddhist emblems occupy the rest of the red scroll ground. A band of nine deities line up across the top, each enclosed in a trilobe arch supported by a vase-column-lotus, topped by garlanded stupas. Below, between the donor and consecration scenes, are three more protective deities in an arch-column-stupa setting flanked by red *dakinis,* in red flame aureoles. The small scale and severe paint losses of the central icon make it difficult to read, but it agrees in every aspect (except the left leg position of Vajravarahi) with the gilt copper image of Samvara, S21. A better preserved and almost identical mandala, which is dated in accordance with 1590, is in the Los Angeles County Museum of Art.[4]

1. For the symbolism of the mandala, see Volume I, p. 69.
2. Compare the donor portraits and consecration scene in P5; note the gold crown on the priest, here, at left, and the red helmets of the two figures, at right.
3. Translations and commentary by Ian Alsop.
4. *LA Nepal,* no. P19; compare also the earlier painting of Samvara and Vajravarahi, no. P13.

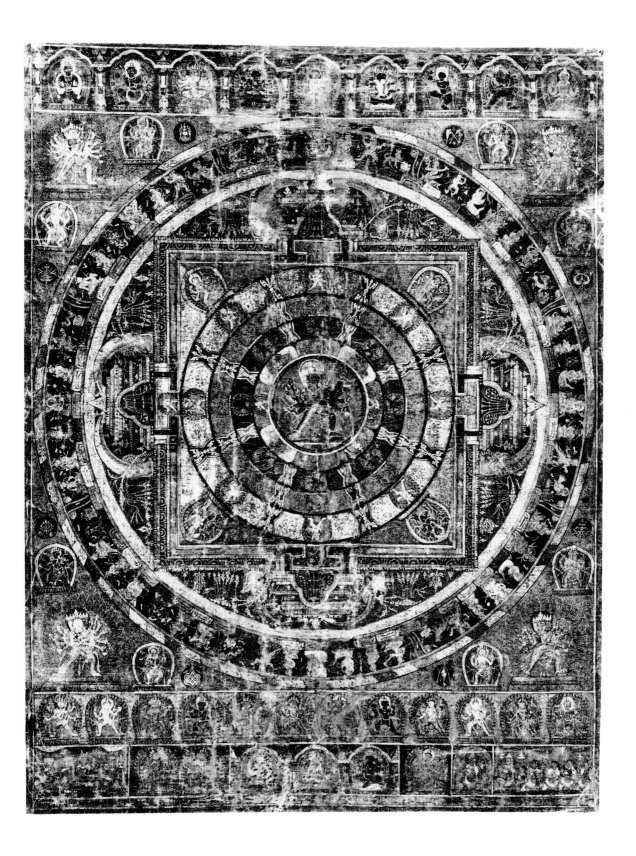

P12

PORTRAIT OF SONAM GYATSO (1617-1667)

Colors and gold on cotton cloth, 77¼" × 62¾" (196.2 × 159.3 cm)
Ngor Pal Evam Choden Monastery, Southern Tibet, circa 1667
Purchase 1979 Anonymous Fund 79.65
See color plate 11

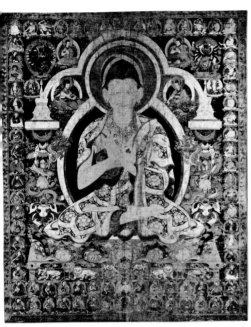

This over-lifesize portrait was painted with great skill and a rich application of pigments and gold. Unfortunately, some of the painted surface has been lost due to abrasion and folding, especially in a vertical area down the center.[1] Sonam Gyatso is portrayed in the manner established by the fourteenth century for Sakya (and other) patriarchs: the linear scrollwork in the red trilobed outer nimbus; the ornate gold scrolls and varied coloration of the lotus petal base; the four, lively, muscle-bulging lion throne supports; the lotus-topped columns rising out of vases flanking the throne, and the hierarchic placement of *mahasiddhas* and Sakya lineage figures in the four borders of the picture.[2] The use of Chinese elements is, however, a prominent feature of this painting. These include the playful dragon curling around the columns at left and right, the peony-like lotus flowers (gold on red), and the cloud and wave patterns (gold on gold[3]) on the central figure's robes. The decorative nature of these elements suggests that they were copied from actual Chinese brocades, fabrics known to have been in monastery treasuries and possessed and used by important lamas.

The calm, central figure dominates the painting by sheer size. His thin, pale, pink-fleshed, red-outlined face and body are schematically rendered, with crossed eyes, large pierced ears, large hands in teaching position, and feet in meditation position. He wears the Sakya red hat with domed top and gold-on-gold, cloud-pattern-edged lappets in a manner favored by several hierarchs at Ngor and Sakya, where the lappets are flipped up and cross at the top of the dome to create a helmet effect. His garments include a vest, a skirt held at the chest with a sash, and a shawl. This ornate adornment is set off by a plain, green halo and deep blue nimbus. He sits on a lotus base of green and blue petals with gold, pink and red centers and similarly colored secondary petals. This rests on a swastika-patterned plinth on a red support inset with gold appliqués and stones. Grinning out from under the plinth are lions of fantastic form. The center of the throne has a drape overhang of three brocades. To the left and right, are golden vases draped with green cloths out of which spring flaming gems, stalks and leaves and a single "peony" flower; around which curl brassy scaled dragons clutching flaming pearls and gazing up at the abbot. At the tops of the stalks are flowers and gold-on-gold chortens decorated with mantras and garlands.

To the sides of the abbot's head are much smaller portraits: on the left is a bearded lama holding a book and giving the gesture of argumentation. He wears a hat with lappets flying back, elaborate red and gold garments, and boots. On the right is a lama with an angular face holding a blue gem(?) and giving the gesture of gift-bestowing; he has a similar hat to the main figure, and rich red, orange and gold garments. Both have plain green halos and deep blue nimbuses and

are seated on polychrome lotus bases growing on leaf stems rising from behind the abbot. A red scrollwork nimbus encloses the abbot and the two lamas, bordered from chorten to chorten with a wide, gold-on-gold, wave-pattern band of trilobed form. A gold-on-gold band of the same pattern borders the abbot's halo and nimbuses of all three.

Beyond the throne and outer (trilobed) aura is an undifferentiated field of dark blue; on this are arranged seventy-six deities, *mahasiddhas* and saints of uniform size and settings. Each side is composed of vertical columns of fourteen *mahasiddhas* and saints. The horizontal row across the bottom contains ten saints, flanking Mahakala as Lord of the Tent, a blue figure holding a skull and thigh bone, and Lhamo. Above this is a second line of twelve saints, turning toward a central white Ushnishavijaya. The horizontal row across the top consists of eight *mahasiddhas* flanking a central flaming-jewel motif and four figures (much worn), which appear to be deities. The corner spaces to the left and right of the lobed aura have groups of figures of various sizes. On the left are Hevajra, Manjushri, and a seated lama; on the right are Samvara, Avalokiteshvara and Vajravarahi, and a seated lama.

The outer borders at top and sides are painted with gold cloud designs on red. The bottom border has three lines of fine gold script, badly worn, but it is possible to read the parts stating that this is "So-nam...Gyatso...the twentieth [abbot] of the monastery Pal Evam Choden." On the back there are mantras, inscribed in black ink, behind each figure and, in a chorten-like shape at center, a series of Sanskrit and Tibetan inscriptions—in black with some red areas—which celebrate the abbot as "Manjushri in human form" and discuss the auspiciousness of the three jewels.[4]

The extraordinary size of this work, one of a set depicting the Ngor abbots, suggests that it was originally installed permanently at Ngor (see page 130). The mixed, Nepalo-Chinese style is seen also in smaller scale in Sakya portrait sets, attributed to the sixteenth to seventeenth centuries.[5] Assuming that the portrait was done at the time of Sonam Gyatso's death in 1667 (or soon after),[6] the portrait proves the survival of this school of painting, under Sakya patronage, through the seventeenth century. The attention to richness of attire and the rigidly schematic organization have not, here, submerged the skilled and assured handling of line, color, and details in gold.

1. The losses have been aggravated by the vertical seam at the center, which attaches the two equal lengths of cloth.

2. Compare P5 and *LA Tibet,* nos. P13 and 15.

3. The gold-on-gold used here and elsewhere in the painting, has been achieved by covering the matt gold surface with a highly burnished gold overlay to delineate pattern and details.

4. Translations by Nima Dorjee and Amy Heller, with the kind assistance of Dezhung Rinpoche, Thartse Ken Rinpoche and Tsenshab Rinpoche.

5. *LA Tibet,* nos. P18 and 20, and TP, pls. 39-41.

6. Sonam Gyatso was born in 1617 in Narthang Paljorling, Gyantse, descended from a family in a high position in the court of Chogyal Phagpa (patron of the fifteenth-century Kumbum, see pp. 23-24); when he was 42 years of age he came to Ngor Pal Evam Choden monastery, where he remained as abbot until his death at 51 in 1667; he was the twentieth abbot; Khetsun Sangpo, *Biographical Dictionary of Tibet,* vol. XI (New Delhi, 1970); translation courtesy of Tsephal Taikhang. It would be customary to honor an abbot by adding his portrait to the lineage shortly after his death.

P13

SCENES FROM THE *BODHISATTVA AVADANAKALPALATA*

Colors and gold on cotton cloth, 30⅞″ × 21⅞″ (78.4 × 55.4 cm)
Tibet, 17th century
Purchase 1985 Helen and Carl Egner Memorial Endowment Fund 85.81
See color plate 12

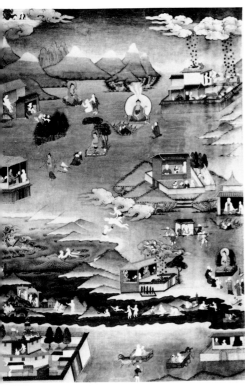

This tanka, now isolated, was from a set[1] depicting episodes from the one hundred eight stories in the *Chang Chub Sempeh Togju Pagsam Trishing* (S. *Bodhisattva Avadanakalpalata*), a collection of *Jataka* tales by Kshemendra.[2] These stories illustrate, through the adventures of Buddha and his disciples, the laws of karma and the importance of self-discipline. The Tibetan translation was done by the Lotsava of Shon (Dorje Gyaltsen) under the patronage of Phagpa Lama, at Sakya, in the mid-thirteenth century. It became incorporated into the *Tanjur* edition at the time of the 5th Dalai Lama in the seventeenth century.[3] A fine gold script identifies most of the vignettes here. Stories numbers 43, 45, 46, 47 and 48 are so labeled; story number 44 is illustrated here as well, although not identified as such.[4]

The scenes are executed with jewel-like juxtapositions of color, often with shaded gradations for the larger masses of buildings and rocks. These small scenes are dispersed across a landscape of soft green and tan, with snow-topped, blue-green mountains, rocky outcroppings, and a blue sea. As is true of the barren central Tibetan plateau, trees are located only in courtyards or near houses or in planted groves. The buildings are in a romanticized Tibetan style: brick-walled with tiled courtyards, tiled or gilt copper roofs, and wooden doors and windows. Clouds are used to transport heavenly beings and sacred objects. Among the diverse heavenly and earthly individuals depicted, there is a recurrence of men staring out of a door or window directly at the viewer; these represent the "Master" who is in reality the future Buddha. The secular male figures are dressed in white turbans and loose brocade robes. The female figures, whether princesses, queens or *nagas* are dressed as goddesses. All the buddha figures are golden and dressed in orange and red robes.

The scenes are,

Upper right (story 43): At the palace of King Ser dog, multi-colored gems drop from the clouds above. A monk transported in a cloud, hands a single gem to a man at the second story window. Large gems, a pair of tusks and parcels are stored in the first story and courtyard, where a blue-robed, "staring man" (King Ser dog, the future Buddha) and four other figures are to be seen. The rain of gems is the king's reward for his selfless gift of food to his people at a time of great drought.

Upper left (story 44): In a shrine-like building, a child is held in the lap of a queen; golden balls flow from his hands. In a smaller, front building the queen distributes the balls to two women and a man beside a group of trees. The child is Ser gyi lag from whose hands "20,000 silver coins miraculously fell each day." These were distributed to the needy. In the upper center, the kneeling Ser gyi lag is ordained

as a monk by the Buddha who sits on a rock pedestal.

Center left (story 45): A buddha walks towards a palace, inside of which are shown the episodes of Ajatashatru, in collaboration with the evil Devadatta, imprisoning his father King Bimbisara, who appeals for aid to the Buddha. To the lower left, sheltered by trees, a buddha sits on a mat holding a begging bowl; beside him the repentant Ajatashatru kneels having cast off his royal insignia, fan, whisk and boots.

Center right (story 46): A palace rests on a rocky promontory. Inside, and in the two courtyards, various groupings depict the marriage negotiations for the virtuous prince Chesheh, whose evil brother Chemasheh is the incarnation of Devadatta. In and around the upper level of the sea are scenes of the two brothers returning with treasures from a voyage. Their laden wooden boat breaks into pieces amidst clouds and storm waves; they swim to shore with a piece of the boat; on the shore Chemasheh puts out Chesheh's eyes with a stick, hoping to keep the riches for himself. The blind Chesheh wanders back to his betrothed who vows her love; because of their joint virtue, his eyesight is restored and they reclaim their place in the kingdom. Below the steps of the palace, four men carry a palanquin holding the queen and a man (Chesheh?). Further to the right, Chesheh, dressed in the garments of a Tibetan king, and his queen sit in a pavilion while, below, the evil Chemasheh is devoured in flames. The scene, upper center, in which Buddha is surrounded by a radiant nimbus may be from the beginning of story 46 when Devadatta, seeking to kill the Buddha, approaches disguised as a devotee but is swallowed up by the earth and hurled into hell.

Right, above the shore of the lower sea (story 47): The Buddha sits on a high plinth and preaches to four *nagarajas*; King Prasenajit, who wears a golden collar and is attended by servants, approaches and takes offense at the *nagaraja's* lack of deference to him. An umbrella, whisk, sword and boots (the insignia of the *nagarajas*?) lay on the ground. In the ensuing battle, the *nagas* brings a hailstorm onto King Prasenajit's palace which is changed to a rain of gems by the Buddha. Inside the palace, the Buddha receives the offering of the repentant king (left) and talks of the necessity of good karma.

At the lower center and the right (story 48): Prince Siddhartha, with a servant, is shown twice riding in a horse-drawn cart; he sees a poor beggar walking with a staff. Returning to his palace, he vows to seek the miraculous gem *chintamani* and put an end to all poverty. On the island to the left of the sea, he visits the shrines of *naga*-beings. To the right of this island, he is shown wading and swimming towards another island, where he is greeted by the king of the *nagas* and given the *chintamani*. Further to the right, his laden sailboat is shown twice. Siddhartha is tricked by a jealous god and loses the gem in the sea, but, while attempting to dry up the sea with a magic vase, has the gem returned to him by a goddess. At the bottom left, Siddhartha is shown on the rooftop worshiping an elaborate Buddhist standard surrounded by gems, having accomplished his vow.

In the sky, on the upper left, are clouds carrying the armored figure of Vaishravana and attendant. The entire painting has been sewn to fine red, gold and blue Chinese brocades, with a tie-dyed silk curtain and a bottom roller set with silver-damascened iron ends.

The style of this painting, and of the other narrative tankas executed possibly at the same atelier, remains problematic; they have traditionally been called "Karma Gadri" school.[5] There are elements which are in a purely indigenous style: the architectural details (compare P17, 23 and 43) and the misconceived notions of how sailboats and horsecarts function. The pastel color scheme and, especially, the sensitively drawn portraits of secular figures and beautifully rendered umbrellas, boots, etcetera, betray a knowledge of Indian Mughal painting. Indeed, it is quite logical that in depicting the previous lives of the Buddha, set in India, the artist would turn to Indian painting.[6] The turbans and coats are similar to the attire of individuals of lower social standing in Mughal miniatures of the sixteenth to seventeenth centuries.[7] The inspiration for the spacious setting of these narrative paintings may also have come from Mughal miniatures, which often feature a subtly graded, two-dimensional background. The clouds and exaggerated rock forms, derived from Chinese painting, were elements familiar to Tibetan artists since at least the fifteenth century. Tackling a new type of painting, perhaps following renewed interest in this subject when the *Avadanakalpalata* was incorporated into the *Tanjur* in the seventeenth century, the creator of this tanka has borrowed from India while retaining the conventions of landscape, sky and architecture well known to him. The manner of depicting this *Avadanakalpalata* seems to predate the quite different "authoritative" version established by the Nartang set of thirty-one woodblock prints, first produced in the mid-eighteenth century.[8]

1. There is a brief ink notation in Tibetan on the cotton backing, at top: "6th on the right," indicating the tanka's position for hanging within the now dispersed set.

2. For the Tibetan text of these stones, see D. T. Suzuki, ed., *The Tibetan Tripitaka*, Vols. 128-129, no. 5655 (Tokyo-Kyoto: Tibetan Tripitaka Research Institute, 1957). The Sanskrit titles and an extensive commentary on each of the 108 episodes is given in TPS, pp. 437-534.

3. TPS, pp. 437-40.

4. Ibid., pls. 113-14, pp. 485-89.

5. See TP, pls. 67-68, for two tankas which may be from the same atelier; for other series, see: *LA Tibet*, no. P28; Pal, *Art of Tibet*, pls. 16-17; Tibet House Museum, *Inaugural Exhibition Catalogue* (New Delhi, 1965), pls. 5, 11, 12 and 13; and Olschak, pp. 72-73 (the painting on the extreme right, bottom row, p. 72, has identical scenes with Newark's painting). Pal discusses in TP, pp. 131-32, the problems of defining the Karma Gadri school.

6. E. Gene Smith's introduction to *Kongtrul's Encyclopaedia*, pp. 49-50, mentions the noted artist, the 10th Karmapa (1604-1674), who was influenced by "Kashmiri" art; Smith also notes the fact that Mughal influence on Tibetan paintings in the seventeenth to eighteenth centuries requires further study.

7. See, for example, Stuart Cary Welch, *A Flower from Every Meadow* (New York: The Asia Society, 1973), pl. 62.

8. TPS, pp. 440-41 (fig. 121, and paintings based on the prints, pls. 100-30).

P14

SAKYA PANDITA (1182-1251)

Colors and gold on cotton cloth, 24½″ × 14″ (62.3 × 35.6 cm)
Tibet, 18th century(?)
Purchase 1969 Felix Fuld Bequest Fund 69.33 From the Heeramaneck Collection

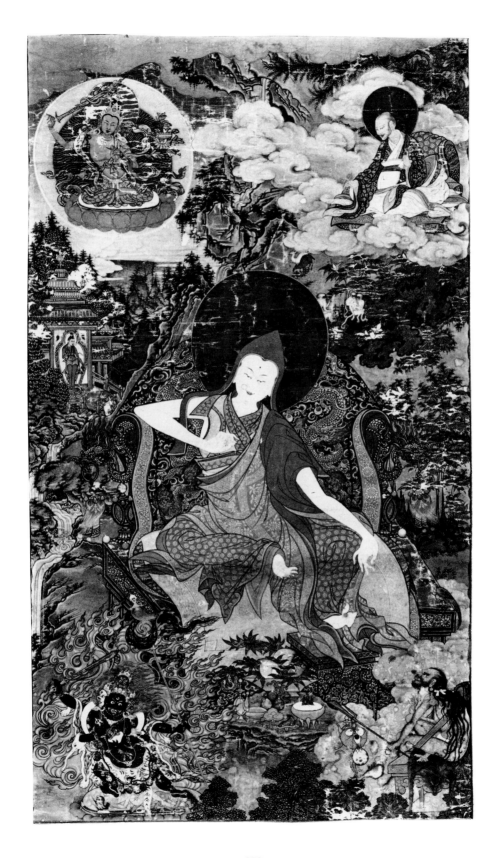

159

This composition is from a set depicting the previous incarnations of the Panchen lamas which exist in painted form, as well as in a woodblock edition of about 1737.[1] All of the details seen here, from the main figure and four subsidiary deities and yogins to the intricate, Chinese-style landscape, are included in the woodblock, but finely painted features such as the ornate brocades and the beautifully stippled, tree-and-rocks landscape, are the embellishments of the individual artist or atelier. Sakya Pandita (Kunga Gyaltsen) was the second Tibetan incarnation (the sixth, when counting Indian incarnations); an eminent scholar and translator whose nephew, Phagpa, was the first of the great Sakya hierarchs.[2] Together they traveled to Mongolia to begin the conversion of the Mongols to Buddhism.[3] In the paintings, Sakya Pandita is depicted with pink flesh, outlined in red, giving the gesture of argumentation, his legs in *lalitasana*; he is dressed in the red lappet hat and orange, red and yellow robes of the Sakya sect. The varied gold patterning of the garments and throne coverings is exquisitely done, even though the patterns do not conform to the folds of the cloth. The lacquered, gold and brown dragon throne, foot rest, and the craggy rock which holds offering vessels, gems and fruit are placed illogically in their setting—the confusion disguised by the swirling clouds which intersect the landscape elements and the four corner figures. Below Sakya Pandita is (left) Mahakala, and (right) the yogin, Harinanda, whom Sakya Pandita converted, marvelously drawn with matted locks, adept's staff, meditation band, and wolfskin-covered throne. Above are (left) Manjushri, and (right) Lama Dragpa Gyaltsen, who helped the saint in his conversions. In the background, are monkeys in a bamboo thicket with deer above; a colorful bird is on the right corner of the throne, and a waterfall at left, beneath receding mountains. The stiff red icon in the temple, at center left, and the odd, dark pink clouds at the top are awkward notes. The Chinese silk mounts are of fine, lotus patterned brocade.

Questions remain for the paintings associated with the woodblock set, such as: which are derived directly from the set (even printed from the blocks)?; are the paintings necessarily dated concurrently with or later than the woodblocks? Another painting of Sakya Pandita, in the Musée Guimet, follows the woodblock print more closely.[4] Newark's painting may be part of a set with others known in Western collections; certainly the other painting published by Tucci is from the same atelier. The dark pink clouds, brocade garments, stippled trees on a receding rock background, and animal vignettes as well as the brocade mount are the same.[5]

Previously published: TPS, pl. 87.

1. TPS, pp. 410-17, discusses the woodblock printed series attributed to Nartang monastery, near Shigatse. The first twelve woodcut portraits in the series (including Sakya Pandita), figs. 90-101, concluded with the twelfth incarnation, who died in 1737.

2. The list of incarnations (Sanskrit and Tibetan names) is given in TPS, pp. 412-13; see fig. 95, for the print of Sakya Pandita and pp. 413-14 for a translation of the accompanying inscription.

3. Shakabpa, *Tibet*, pp. 61-64; Sakya Pandita was invested with the right to rule over the "13 Myriarchies" by Prince Godan in 1247. The lama died in Lanzhou at 70 years of age. It is interesting that the woodblock and painting show nothing of the Mongol events of Sakya Pandita's life.

4. Musée Guimet no. MG 16502, published in J. Hackin et al., *Asiatic Mythology* (London: George G. Hassap & Co., 1932), p. 173, fig. 38.

5. TPS, pl. L; no dimensions given but the proportions are the same.

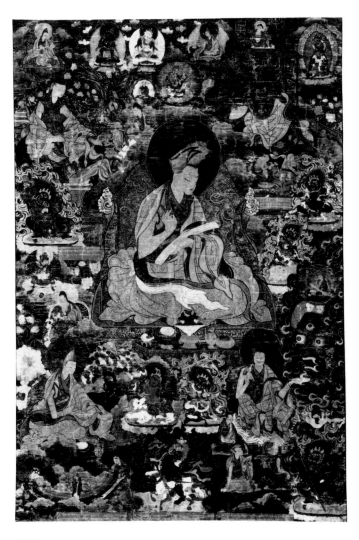

P15

PORTRAIT OF THE FIRST PANCHEN LAMA (1567-1662)
Surrounded by four other saints in the lineage and their entourages

Colors and gold on cotton cloth, 29" × 19¼" (73.6 × 49.0 cm)
Tibet, 18th-19th centuries
Gift of Dr. and Mrs. Eric Berger 1984 84.385

This painting[1] is an interesting assemblage from the lineage of the Panchen lama, better known in separate woodblock prints from a series printed at Nartang, circa 1737 (see P14). The dominant figure is the first Panchen lama, wearing a high-domed, yellow hat with multiple curved and pointed upturned lappets, and the traditional red, orange and yellow Gelugpa garments, all finely patterned in gold. He gestures in argument, holds a white book and sits on a draped golden throne. A red and gold table, in front of the throne, bears a conch, monk's bowl, dish of fruit, water vase and golden bowl. Immediately beneath and crowded together are small-scale depictions

of Vaishravana on his lion and an armored Begtse. Maitreya and two attendants in a "bubble" nimbus, Vajrasattva *yab-yum,* and the saint Sangye yeshe zhab are arrayed above the lama's head.[2]

Four other members of the lineage, smaller in scale, surround the central group. At the upper right is Bhavaviveka (the third Indian incarnation), shown dark-skinned, in a red peaked cap, holding prayer beads and with a "bag of treasures" at his side. Two Indian converts and two monks, on a tiled and balustraded terrace, and Mahakala complete the lower area for this group. Above and behind are a pavilion and garlanded trees, in which Nagarjuna sits; Samvara *yab-yum* is at the extreme upper right.[3] At upper left is Khugpa Lhatsi (Atisha's first disciple in Southern Tibet; incarnation number five) and his entourage. The saint wears a green, loose-necked blouse and a red lappet hat with forward-pointing peak; he holds a white book and gestures to four monks holding and reading additional books to the right. More books are stacked behind him and scrolls rest on the table below. Mahakala and a railing form the base of this vignette; Atisha, Vajradhara in clouds and peonies, and three small adepts meditating in caves in a rocky setting complete the upper left section.[4]

To the lower right is Yunton Dorje (1284-1365; incarnation number seven) wearing a red peaked cap with gold rings; he sits on a tiger skin, holds a *dorje*-topped dagger and a skull cup with contents curling to "conjure up" the enormous blue flaming head of Mahakala. Buton Rinpoche, in a bubble-like green nimbus, reading from a book on his lap and wearing a yellow hat, hovers above the fierce head. Above, and to the left of the dark flames is Yama Bhairava with his consort on a bull; to the extreme lower right is a table of skulls and entrails, above Mahakala, are three monks receiving his teaching.[5] To the lower left is Sonam Chökyi Lanpo (1439-1505; incarnation number nine) wearing Gelugpa robes and a peaked yellow lappet-less hat. He has oddly large arms; the right is thrust into his robes, the left gives the argumentation gesture. In front of his cushions, are a monk's bowl and golden water vase. In clouds and peonies above Sonam, are a red-hatted monk on cushions, attended by a small figure, and Vajradhara and consort; two queens(?) hold a rainbow-striped cloth on which a child stands in a green-hill-and-fluffy-cloud setting. Lhamo, is at center bottom.[6] Rectangular orange plaques, with gold Tibetan script, give the invocations for all five groups; they are placed along the bottom border and center sides.

The first Panchen lama, Bhavaviveka, Khugpa Lhatsi, Yunton Dorje, and Sonam Chökyi Lanpo are numbers 11, 3, 5, 7 and 9, respectively, in the lineage series (following the order of the woodblock set). The matching tanka depicting incarnations numbers 4, 6 (Sakya Pandita in the same pose as P14), 8 and 10, around the central figure of number twelve, who died in 1737, is in a private collection.[7] The artist who painted this pair obviously had access to the woodblock prints or paintings closely copied from them. The artist (or patron) felt it necessary to include every decorative detail for nothing which appears in the prints is missing here. The gold ornamenting the garments and thrones is quite fine, although the painstaking task of reproducing every aspect of the set has resulted in a crowded, static composition overall. Because of the wide availability of the print series, this tanka and its mate could have been done anywhere in Tibet after 1737.

1. This has been slightly trimmed on all sides and glued to a wood back; the silk mounts and sewn edges are gone.

2. The woodcut is given in TPS, fig. 100, a translation of the inscription on p. 414. Compare a painting which closely follows the woodcut, Gordon, *Iconography*, pl. opp. p. 107 (mistakenly called the 11th Panchen lama).

3. See TPS, fig. 92, and inscription p. 413. For tankas similar to the woodblock, see J. Hackin et al., *Asiatic Mythology* (London: George G. Hassap & Co., 1932), p. 172, fig. 36; and Chogyam Trungpa, Rinpoche, *Visual Dharma, The Buddhist Art of Tibet* (Cambridge, Massachusetts: Massachusetts Institute of Technology, 1975), pl. 27.

4. For the woodblock of this group, see TPS, fig. 94, and inscription p. 413.

5. For the woodblock, see TPS, fig. 96, and inscription p. 414. For paintings similar to the print, see Hackin, *Asiatic Mythology*, color pl. opp. p. 174, and TP, pl. 93.

6. For the woodblock, see TPS, fig. 98, and inscription p. 414. For a painting based on the woodblock, see Hackin, *Asiatic Mythology*, fig. 40, p. 174.

7. Sold at Sotheby's, New York, September 20, 1985, lot no. 161.

P16

PORTRAIT OF A DRUKPA KAGYUPA LAMA

Colors and gold on cotton cloth, 32 × 47⅜″ (81.3 × 120.3 cm)

Tibet, 18th century(?)

Bequest of Eleanor Olsen 1982 82.76

See color plate 13

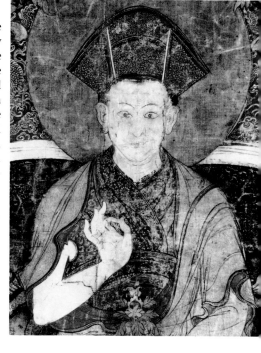

In this portrait, almost all the green pigment and much of the white and pale blue have been lost from abrasion, giving a faded and ghostly appearance to this once fine painting. The loss of white paint from the face and hands of the main figure reveals a sure draftsmanship[1] in the drawing of the wide, staring eyes, and a finely poised right hand giving the *vitarka mudra*. The figure wears the stiff, red domed hat with upright lappets which is the sign of the Drukpa Kagyu sect.[2] The orange and red vest, skirt, sash, shawl and brown outer robe (gathered around his lower body), all have thin, gold line designs derived from Chinese brocades. His left hand holds a blue scarf and a vase from which a lotus plant and flaming jewel emerge. A plain green halo surrounds his head. He sits on an elaborately carved and painted throne with Chinese brocade-covered cushions and drapes, jeweled finials, dragon heads holding bells at upper left and right, and two lively lions underneath. The scroll-legged offering table, of red and gold lacquer, holds two transparent vases of flowers, a flaming wheel, and a holy water vase around a blue monk's bowl on a gold stand, which holds flowers. Large, white, peony flowers and leaves decorate the top of the throne, with a flaming blue gem at center. To the sides of the throne are Chinese-style landscapes of rocks and streams; below is a pond filled with auspicious offerings, and above is a blue sky with fluffy clouds. Attendant figures include (above) three lamas of the Drukpa order, dressed similarly to the main figure, and (below) Samvara and Vajravarahi, flanked by Mahakala and Lhamo. There are tiny yogins in the clouds, and a sun and moon at the very top.

The painting now has a border of Chinese silk brocade, forming the orange and red bands next to the painting, and pale blue damask with an embroidered gold dragon (much damaged and pieced together from Chinese imperial robe material) outside. Because this border is glued on rather than sewn, it is evidently a non-Tibetan reassembly but presumably uses the mount original to the tanka. The Buddhist Creed and mantras are written on the reverse side of the painting.

The pose, rich brocades and ornate throne, as well as the small, framing, landscape scenes, all continue conventions first developed in the seventeenth century and earlier (see P12). Portraits of Kagyupa lamas are comparatively rare although metal images are known (see S30). So far, the subject of the portrait is unknown,[3] although an eighteenth century date is postulated for this tanka because of the similarity to portraits made widely available at this time through the Nartang woodblocks (see P14 and 15).

1. The paint loss also allows the "color key" symbols to be seen in some areas, see p. 130.
2. The hat is specific for the Drukpa order of the Kagyu sect.
3. Marceline de Montmollin, *Collection du Bhoutan* (Neuchatel, Switzerland: Musée d'Ethnographie, 1982), tanka no. 68.4.2, p. 105, has a similar figure at center: Kun-mkhyen Padma dKar-po (1527-1592); note the *mudra* and the Wheel of the Law below the figure.

P17

PARADISE OF PADMASAMBHAVA (in Tibet, circa 779)

Colors and gold on cotton cloth, 24¼" × 16¼" (61.6 × 41.3 cm)
Tibet, 18th-19th centuries
Purchase 1969 The Members' Fund 69.35 From the Heeramaneck Collection

Padmasambhava, in his characteristic hat, robes and emblems,[1] resides in his golden palace which, in turn, sits on the "copper-colored mountain."[2] The mountain, shown as an orange rock with caves and huts for ascetics, rises out of a swirling sea tossed with demons, animals, pavilions and jewels. On the shore below and to the sides of this sea is the land of the *rakshashas*,[3] who do various beastly deeds amidst a folk-style landscape of rocks, trees, hills, and Tibetan-style secular and religious architecture. On a bridge of golden light, two yogins cross from a chorten in the mountain to a chorten and temple on the shore (lower right). The architecture of Padmasambhava's palace is conceived as celestial (rather than Tibetan) and features golden roofs and garlanded walls, with Avalokiteshvara (and two attendants) and Amitabha in the upper stories; its entrances are attended by the guardians of the four quarters (South, East and North visible). The celestial quality is further conveyed by the pink and gold nimbus around the palace. Among the deities and saints gathered in the courtyard immediately surrounding Padmasambhava, are his two wives, his eight aspects, and figures associated with his legendary life.[4] Clouds and rainbow bands fill the sky above and around the palace, supporting various beings. Shakyamuni, and buddhas of the past and future, are in the flower-filled clouds at center top and celestial musicians, offering beings, as well as *dakinis* fill the rest of the upper area. Below are armored guardians and demonic and peaceful figures, many flying and dancing without benefit of cloud supports. The brocade mount is patterned with small dragon rondels on red and yellow (narrow bands), and dragon rectangles on dark blue.

1. See also S31.
2. For this "copper-colored mountain" form, see TPS, pls. 221-24, pp. 603-7.
3. The *rakshashas* represent the non-Buddhist forces overcome by Padmasambhava and at the same time the protectors of the palace, converted by and loyal to Padmasambhava.
4. See TPS, pp. 540-47, pls. 142-46, for the eight aspects; and pp. 87-88, for legends concerning Padmasambhava's life.

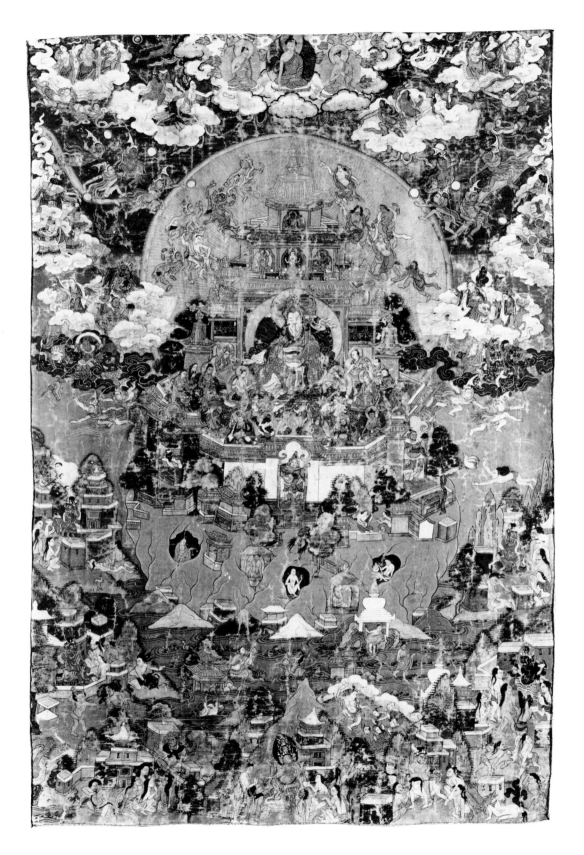

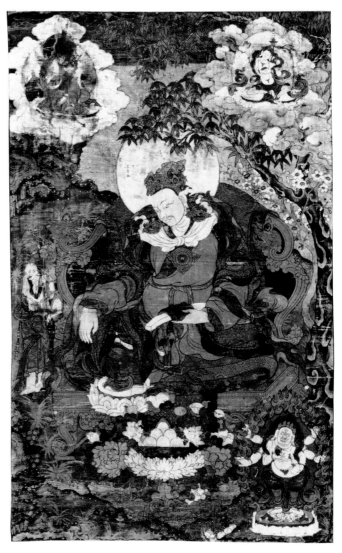

P18

A KING OF SHAMBALA

Colors and gold on cotton cloth, 26⅝″ × 16½″ (67.6 × 41.9 cm)
Tibet, 18th-19th centuries
Bequest of Elizabeth P. Martin 1976 76.320

The excellent quality of the original painting has been sadly reduced
by extensive, surface paint loss. Excepting the upper and center left,
where there is damage to the canvas, the losses reveal the underdraw-
ing. Where paint has adhered well, on the king's garments, the throne,
the bamboo tree and entwined blossoming tree on the right, the rich
gold patterning and sensitive line are still apparent. Where white or
highly whitened colors were used—on the face, hands, neck scarf and
book of the king, the body of Mahakala, bottom right, and the stream
and lower sky—the paint loss has been almost total. The richly garbed

king sits in royal ease on a golden dragon throne, in the three-quarter pose traditional for *arhats* and saints,[1] and holds a book in his left hand. The loose robes, scarves, golden pendant on his chest, floral earrings, crown (with a *garuda* at the front) and boots with curved toes are the typical attire for Tibetan royal portraits.[2] Various peony-like flowers grow from a stream at lower center to support an offering dish of gems, while lotus flowers form the base of the king's pendent foot. The king, throne and lotus pond are scaled to the tree, rock and plant filled landscape. Subordinate to the king are smaller figures of a monk with staff and a queen(?) offering a flaming jewel at left; a six-armed Mahakala at lower right; a saint at upper left, and *dakini*(?) at upper right. The painting has been removed from its mounting.

The golden crown-and-wheel pendant, worn by the king, is symbolic of the *Kalachakra Tantra* taught to the first bodhisattva-king of Shambala by the Buddha.[3] Shambala is a legendary Buddhist land in Inner (Central) Asia. The garments, pose, *garuda* crown, earrings, book in left hand and gesturing monk, are all to be found in the eighteenth-century Nartang woodblock of Manjushri-Kirti (Jampal Drag), a Shambala king who figures in the lineage of the Panchen lamas.[4] The subsidiary deities and the pavilion setting in the woodblock are, however, missing here, but the artist must have had access to some form of this printed portrait. It can be assumed, therefore, that this is the intended identification.

1. Compare P14 and 24.
2. See Deng Ruiling et al., *Potala Palace*, pl. 60; and Henss, *Tibet*, pl. 63.
3. See S5.
4. See TPS, p. 415, fig. 91, and inscription p. 413; for a painting which closely follows this woodcut, see J. Hackin et al., *Asiatic Mythology* (London: George G. Hassap & Co., 1932), p. 172, fig. 35. See P14 and 15 for other incarnations in this series; and TP, pl. 89 for a portrait of another Shambala king.

P19

SET OF TANKAS SHOWING THE LIFE OF TSONGKHAPA
(1357-1419)

Fifteen tankas: colors and gold on cotton cloth, each 26" × 19" (66.0 × 48.3 cm)
Tibet, 18th-19th centuries
Gift 1911 Crane Collection 11.695-.709
Illustrated: No. 13 of series 11.704

Upon each tanka the episodes unfold, beginning as a rule at the lower left, around the central figure of Tsongkhapa, who is depicted in accordance with the iconographical specifications: legs crossed in meditation on a lotus pedestal; dress of a Tibetan lama including the yellow cap with lappets; each hand holding the stem of a full-blown lotus blossom on which, at shoulder level, are the emblems of wisdom (sword at left, book at right).[1] The skin color is gold, the face youthful and rather stereotyped. The *mudras* vary with each of the fifteen figures and ritual articles are occasionally held, as for instance in the illustrated painting (no. 13), a book wrapped in white cloth. The lotus pedestals are imaginatively varied, as are the many-hued clouds which mystically separate the earthly scenes and glorify the heavens. The tankas are marked "Introductory," "Right I" to "Right VII," and "Left I"

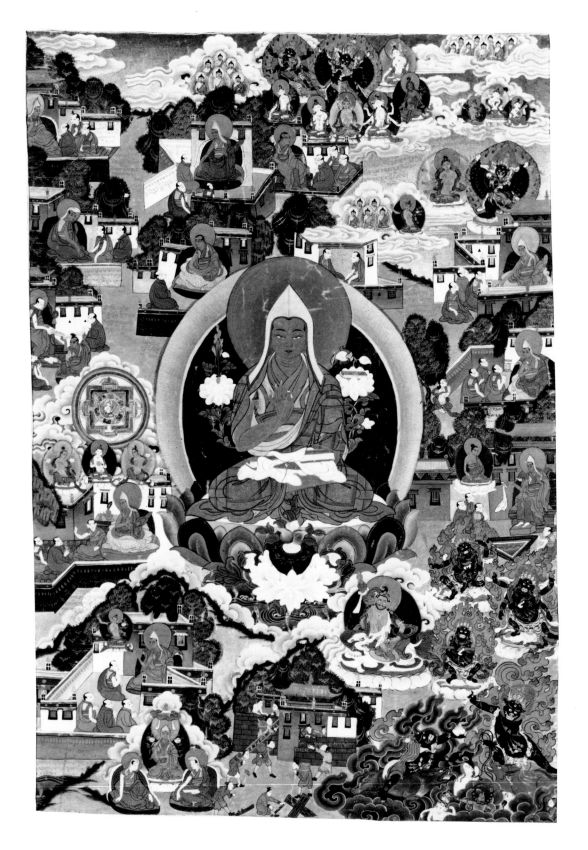

168

to "Left VII" (illustrated tanka is "Left V"). The introductory tanka (11.695) hangs in the center; its scenes alluding to the master's past incarnations. The other fourteen tankas deal with his Tibetan incarnation, including his miraculous conception, birth, youth and maturity. The two hundred and three scenes, each accompanied by a Tibetan inscription in gold, take place in an idealized Tibetan landscape, enriched by lush, gold-spangled foliage. The houses, temples, tents and vignettes are all in the Tibetan mode, as is the dress, except where foreigners enter the story. Of particular charm in tanka no. 13 is a scene of the building of Ganden Monastery (bottom center).

Woodblocks for this series were made to order at Tashilhunpo for Miwang Pholhaneh Sonam Topgyeh (1689-1747);[2] the designs were by the artist, Jamyang Shepa. In Newark's series, scenes and inscriptions are crisp and clear; the colors vivid, and the painting extraordinarily skillful. Newark's set appears to follow the woodblock prints quite closely.[3] The paintings are sewn to beautiful Chinese brocades of the requisite blue, red and gold, with silk gauze curtains and ribbons. A three-word mantra in black ink is on the back of each tanka, level with the central figure of Tsongkhapa.

1. As indicated by his emblems, Tsongkhapa is regarded as an embodiment of Manjushri. Named for the district in Amdo where he was born, Tsongkhapa founded the great monasteries of Ganden and Sera in Lhasa, and the Gelugpa, or "Virtuous Order."

2. This is the same patron as for other woodblock series done at Nartang, see TPS, p. 564. Pholhaneh was the defacto ruler of Tibet, between 1726 and 1747, see Volume I, pp. 20-21 and Shakabpa, *Tibet*, pp. 139-47. Newark possesses a silk document signed by Pholhaneh and dated 1740, which contains a decree giving authority to a particular ruler at Batang; this document was acquired by Shelton from the "Prince of Batang" (acc. no. 18.141).

3. See TPS, pp. 417-36, pls. 88-94 and M, and figs. 106-20; the woodcuts have the same arrangement of fifteen (one at center, plus seven on each side); tanka no. 13 corresponds to the woodcut in fig. 118, p. 523 (scenes no. 162-74). Because of this exact correspondence with the Tashilhunpo woodblocks and the established relationship between Pholhaneh and the ruler of Batang, it is probable that these tankas were painted at Tashilhunpo and sent to Kham. Shelton's notes give no particular source for the set of Tsongkhapa paintings.

P20

GELUGPA ASSEMBLY

Colors and gold on cotton cloth, 30″ × 21″ (76.2 × 53.3 cm)

Tibet, 18th-19th centuries

Purchase 1920 Shelton Collection 20.270

The main deities of the pantheon and the sources of the Gelugpa revelation are represented here in four groups (one in the "tree" and three in the sky). At the apex of the "tree" sits Tsongkhapa holding the alms bowl, his right hand in *vitarka mudra*. In his heart is Shakyamuni and in Shakyamuni's heart (scarcely visible) is Vajradhara. In the foliage sit lamas, deities and saints including the thirty-five buddhas of Confession and the eighteen *arhats*. Fierce *yi-dam* deities guard the top and *dharmapala* guard the base, below which the Guardians of the Four Directions (*lokapala*) alternate with lions and *makaras*. Blossoms and fruit burst forth from the foliage. The three, cloud-bordered groups in the upper area illustrate the three main streams of the doctrine, descending respectively from Maitreya, Manjushri and Vajradhara. On the left: Maitreya is the largest figure in this group of Indian and Tibetan saints who have transmitted his line of teaching; above this, Maitreya reigns in Tushita Heaven attended by Atisha and

Tsongkhapa, and Tsongkhapa and his two disciples descend in a cloud. On the right: Manjushri is the largest figure in this group of disciples; Nagarjuna and Atisha sit on either side of him; Amitabha Buddha reigns above in his western Paradise, attended by Avalokiteshvara and Vajrapani and Nagarjuna and two disciples descend in a cloud. At upper center: the tantric teachings of the Vajrayana descend in a direct line from Vajradhara through seven figures of Manjushri to Tsongkhapa; Vajradhara is attended by two, white-turbaned kings, probably Songtsen Gampo and Trisong Detsen. This group, unlike the other two, includes not only monks but ascetics, for the Vajrayana consists of yogic practices transmitted orally and telepathically from master to pupil. The two, small, rainbow-edged circles just above Tsongkhapa's head contain portraits of the eight transmitters. In the area below, the Wheel of the Law rises from a lotus blossom at the foot of the "tree." On the waters sacred emblems float, celestial beings dance, and Mount Meru, center of the universe, stands surrounded by the continents. On the land at the left, are the traditional emblems of royalty[1] and, at the right, two monks, differing in scale, make offerings.

The strength and unity of the composition is impressive despite its complex symbolism and extreme delicacy of detail. The miniature figures are rendered with great sensitivity, and the harmonious balance of the rainbow colors suggests the polyphony of an orchestra. This type of Assembly, with Tsongkhapa as the central figure, derived from eighteenth-century woodblocks carved at Tashilhunpo and were much imitated throughout Tibet.[2] The silk brocade mountings are similar to the Tsongkhapa biographical set and the Assembly painting brought out of Batang by Shelton in 1911 (P19 and 21).

1. See Volume I, p. 72.
2. TPS, pp. 408-09, discusses (but does not illustrate) the Tashilhunpo woodblocks; a tanka, pls. 83-84, derived from them is quite different from Newark's example. Olschak, p. 70, illustrates a painting which appears to be based on the same print as Newark's.

P21

GRADED WAY OF THE ASSEMBLY FIELD

Colors and gold on cotton cloth, 31" × 21" (78.7 × 53.3 cm)
Tibet, 18th-19th centuries
Gift 1911 Crane Collection 11.693

The evocation of this Assembly takes place at the beginning of every Vajrayana ritual. After the taking of refuge in the "Three Precious Ones," buddha, *dharma* and *sangha*, the vows are expanded to include lama or guru, *yi-dam* (whose meditational forms are an expression of the *dharma*) and *dakini* (who are transmitters of the *dharma*). The tantric disciple, while repeating the expanded formula, visualizes the vast assembly as resplendent beings, blazing with light, their rays penetrating in the ten directions (zenith, nadir and eight compass points).

Shakyamuni here occupies the center; in his heart is Vajradhara (*yab-yum*). The curving tiers of figures are contained in a vast lotus base, on a faceted lion throne. In descending order are various Gelugpa lamas (Tsongkhapa at the center), fierce *yi-dam*, buddhas of the Ten Directions, bodhisattvas, two rows of *arhats*, then *dakinis* and *dharmapala*.

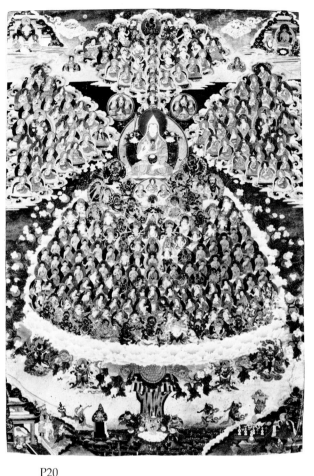

P20

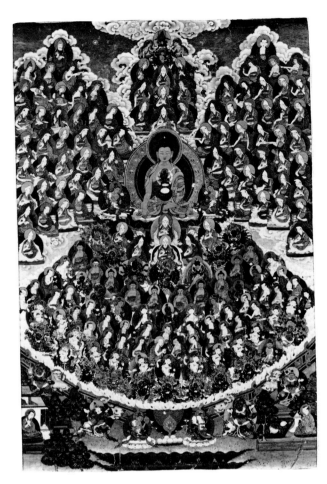

P21

Guardians of the Four Directions are placed in the garden below the throne. At the lower center, the Wheel of the Law stands between Brahma, who offers a wheel, and Indra who offers a conch. Monks make offerings amidst bejewelled trees. Maitreya (left) and Manjushri (right) sit on either side of the central figure of Shakyamuni. Asanga sits above the transmitters of Maitreya's teachings, on the left. Nagarjuna sits above the transmitters of Manjushri's doctrine, on the right; manuscripts and books symbolize both lines of teaching. In clouds at the center of the sky, are the transmitters of tantric practices: Vajradhara (*yab-yum*) through Manjushri, two *mahasiddhas*, and Tibetan lamas (Tsongkhapa, again, at the center).[1] This Assembly is mounted in the same silk brocades as the Tsongkhapa series P19, and, though of larger dimensions, seems to be part of this set. The static quality of the composition suggests a printed outline.[2]

1. This arrangement is quite similar to the three cloud groupings of P20.

2. See TPS, pp. 409-10, pl. 85, and p. 536, pl. 132, for two tankas with the same Assembly but differently arranged; see also Olschak, p. 71; Pratapaditya Pal and Hsien-ch'i Tseng, *Lamaist Art: The Aesthetics of Harmony* (Boston: Museum of Fine Arts, 1969), p. 39, pl. 17, with a Newari inscription dated in accordance with 1796 and stating that the commission and consecration was done at Tashilhunpo for a Newari merchant; and Getty, *Gods of Northern Buddhism*, frontispiece and pp. 160-62, this has a Newari inscription dated 1809.

P22

ILLUSTRATED VOLUMES OF THE *PRAJNAPARAMITA*
AND *COLLECTION OF MANTRAS*
(T. *Kanjur Sher Chin Bum* and *Kanjur Zungdu*)

Ink, colors and gold on dyed paper, approximately 25¼" × 8¼" (64.1 × 21.0 cm)

Tibet, 18th century(?)

Gift 1911 Crane Collection 11.734-.735

Twelve of the fourteen volumes discussed in P3, contain replacement title pages and initial folios which are in a completely different style of paper, script and illustration from the earlier body of the manuscripts. The paper is thin, with irregular horizontal striations, and has been dyed dark gray. A central rectangle has been painted a glossy black to serve as a ground for the one to six lines of silver and gold script. The title pages, to which cloth tabs are sewn, have been reinforced by gluing on tissue-like strips of blue paper for borders. The reverse sides of the title page folios are plain. Margins are ruled with a thick red line. The illustrations on right and left, set in reserved rectangles, are in the bright polychrome style of seventeenth-to-nineteenth-century tanka paintings, simplified, of course, to suit the miniature format. The settings are green meadows and blue skies, sometimes with little mountains at the horizon. Typical of these illustrated folios is a title page, A, with two Sakya lamas in red hats, and red and orange robes; one seated on a lotus base with a halo and nimbus (left), and one on cushions with a halo (right); both have draped throne plinths and orange inscriptions (11.734).

A fifteenth volume, *Collection of Mantras, Part I* (11.735), obtained by Shelton, "from a pawnbroker in Tachienlu," is entirely in this later style and includes an unusual, laminated and recessed title page, B, and four interior folios with illustrations, C. It is obviously by the same artist or atelier as the replacement pages of the twelve *Praj-*

A-detail (right)

A

C

172

B

naparamita volumes. The title page, B, has two portraits of Padmasambhava flanking the center recess of raised gold script; three buddhas, two monks and eight *arhats* fill the top thirteen recesses; additional *arhats* fill the bottom thirteen recesses, and the four guardian kings are at the center sides. On an unnumbered page, C, in small rectangular reserves, upper left and right, are portraits of two monks wearing pointed red hats with gold trim, seated on thrones.

The appearance of portraits of monks from varied lineages on these replacement and later folios is interesting. A complete reading of the manuscripts, forthcoming for Volume V, will hopefully yield an explanation of the provenance of both the twelfth-century books (P3), and the later replacement folios and complete *Collection of Mantras*.

P23

THE PARADISE OF GREEN TARA

Colors and gold on cotton cloth, 24¼" × 21" (87.0 × 53.3 cm)

Tibet, 18th century

Purchase 1969 Felix Fuld Bequest Fund 69.36 From the Heeramaneck Collection

The green form of the savioress is seated in royal ease on a lotus base, gesturing in *varada mudra* and holding the stems of lotus plants which bloom at her shoulders in blue and pink flowers and buds. She is adorned with golden-patterned silks of red, orange and blue, and golden jewelry; her black piled headdress has flowers, gems and gold. A red halo, blue and orange nimbus, backed by peonies and lotuses, set off her head and body. The palace of golden and orange roofs, patterned walls and tiled floors, follows the Tibetan convention for sacred or royal architecture.[1] The gold, peaceful goddess, Marici, and the blue, fierce goddess, Ekajata, are seated just below Tara, at left and right. Pink-fleshed celestial musicians, dancers and attendants celebrate the deity within the tiled courtyard, in the pale clouds above and in the lotus pond garden at lower left. From a similar pond, also surrounded by a tent wall, in the center of the courtyard, grows a lotus to support Tara's pendent foot. Fine, golden garlands festoon the beautiful green and blue trees outside the palace as well as the exterior walls of the courtyard. Two carefully painted individuals, a bareheaded monk and a red brocade-robed man, meditate in caves at lower right. Behind them wander a pair of elephants. The painting is sewn into fine Chinese silk brocades.

The high quality of the drawing and jewel-like color are similar to that of Sakya Pandita (P14); indeed the odd, dark pink clouds, used as a

compositional device in both paintings, suggest they are products of the same atelier and date. It is also interesting to see, in the eighteenth century, the retention of "Paradise" devices such as nymphs in walled pools which appear in earlier vignettes, such as in the fifteenth-century Paradise of Amitayas, P7. Although this style of painting is especially characteristic of the eighteenth century, it continued well into the nineteenth century, as attested by a similar example published by Tucci.[2]

1. Compare P43, and the various palaces in P13.
2. TPS, p. 539, pl. 136, which includes the portrait of a lama who died in 1854; compare, also, pp. 538-39, pl. 135, in which a similar palace and landscape setting (including elephants) is depicted.

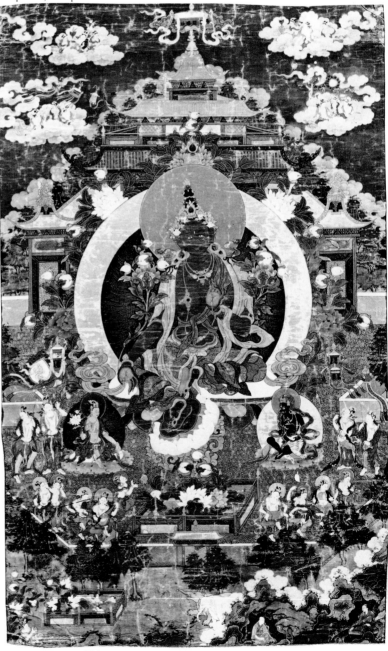

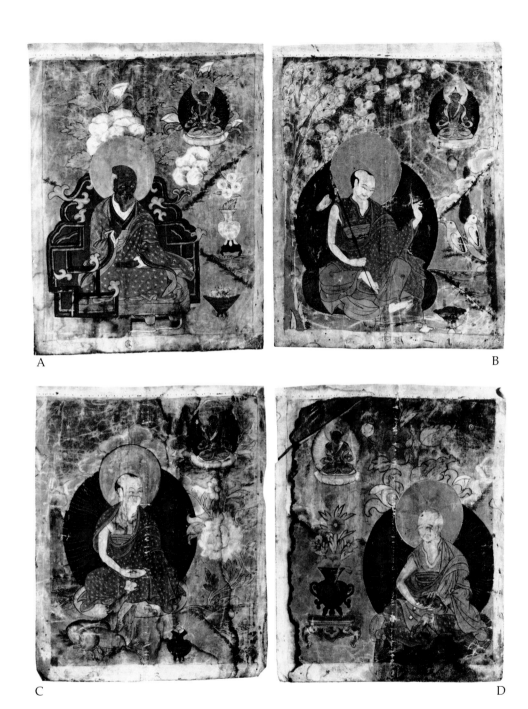

A

B

C

D

P24

SET OF BANNERS DEPICTING ARHATS

Colors and gold on linen cloth, each approximately 11½″ × 9½″ (29.2 × 24.1 cm)
Tibet, 19th century
Anonymous Gift 1982 82.225

When acquired, the set of small painted cloths and vertical, chevron-patterned panels were sewn to a horizontal blue, yellow and red striped cotton cloth, to form a complete length of almost sixteen feet. The eighteen paintings depict Shakyamuni Buddha at the center, flanked (left) by nine *arhats* and (right) by six *arhats* and the protectors, Dharmatala and Hvashang. All the *arhat* paintings are in the same style on vertically joined lengths of cloth,[1] most with a black ink lettering ("numbering") system at the center bottom reserved margin, and charcoal *Devinagari* identification of each figure. All are in a landscape setting of pale green hills and pale blue sky with an image of Amitayus at an upper corner.

The four illustrated banners show:

A. The dark-skinned (purple), elderly *arhat*, Bhadra, is seated on a fretwork throne and cushions, with pale green halo, dressed in red, blue and white robes; blue curved-toe boots are seen below, a vase of leaves is at lower right, with a stream and a pink vase of flowers at center right.

B. The white-skinned *arhat*, Vajriputra, in purple, brown and red robes, is seated on a cushion with a blue nimbus and an orange halo; he holds a yak tail staff; a dish of food(?) is at the lower right; a stream and two white birds are center right, and a flowering tree is on the left.

C. The white-skinned *arhat*, Chudapantaka, in pale blue, orange and red robes, is seated on a cushion with a blue nimbus and a pink halo; two deer and a vase of gems are below; a stream and peony are at the right.

D. The gray-skinned, elderly *arhat*, Bakula, in green, red and orange robes, holds a mongoose spitting gems and sits on a cushion. He has a blue nimbus and an orange halo; a table and vase of flowers is at his left, and a peony above.

These paintings are in a late, simplified style of Tibetan painting, yet they retain the Chinese-inspired, three-quarter pose, throne or cushion seat, and landscape settings established as early as the thirteenth century for *arhat* portraits.[2] These conventions, in turn, influenced many other forms of religious portraiture in Tibet, see P14, 15 and 18. Their arrangement, on a horizontal banner, may be a later, misunderstood use of these paintings whose four plain borders seem to call for four-sided mounts—although there are no stitching holes. The order is incorrect, although soiling and wear indicate that the set was hung and used in this form in a temple or altar. The group should consist of the central Shakyamuni, flanked by sixteen *arhats* (eight each side), and ending with the two added figures of Dharmatala and Hvashang, accompanied by the four guardian kings. *Arhat* Ajita is missing here.

1. The cloth is unusual—very finely woven in narrow lengths, some with a lozenge pattern weave.

2. Chinese *arhat* portraits, in landscape settings, are known from the twelfth century and were widely produced under Mongol patronage in the thirteenth to fourteenth centuries, at which time the paintings would have been introduced to Tibet. Tucci discusses the possible, pre-eleventh century introduction of *arhats*, TPS, pp. 555-70; see also Pratapaditya Pal and Hsien-ch'i Tseng, *Lamaist Art: The Aesthetics of Harmony* (Boston: Museum of Fine Arts, 1969), pls. 23, 24A-B, 25, 26 (opp. p. 24) and 28.

P25

MANDALA OF THE FIERCE AND TRANQUIL DEITIES

Colors and gold on cotton cloth, 28½″ × 19″ (72.4 × 48.3 cm)

Tibet, 18th-19th centuries

Purchase 1969 The Members' Fund 69.34 From the Heeramaneck Collection

See color plate 16

The painting shows visions that confront the individual in the Bardo, the stage between death and rebirth. We learn from the *Bardo Todol*, that during the forty-nine days in the Bardo, each seed thought in the individual's consciousness revives. During the second stage called the Chönyid Bardo, the devotee sees visions first of the peaceful deities, then of the wrathful ones. The devotee who is spiritually prepared recognizes these fearsome ones as manifestations of the beneficent buddhas. The spiritually unprepared soul is frightened; as the ever-more terrifying visions overwhelm him, he sinks into rebirth in one of the six realms.

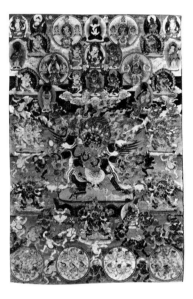

The tranquil (upper) and fierce (center and lower) deities are, in this painting, combined in a single vision although in other examples, two separate compositions are used.[1] The fierce deities are here given prominence with Chemchog Heruka, the winged, wrathful form of Samantabhadra, and his consort in the center; his hands hold the bell and *dorje* and the trident, mirror, noose, and skull cup. The Adibuddha Samantabhadra and consort, in peaceful forms, are placed in the center at the topmost point of the painting. Also in the peaceful region, are the five buddhas *(yab-yum)*, four accompanied by bodhisattvas and guardians: Vairochana (below Samantabhadra); Akshobhya (lower circle at left); Ratnasambhava (upper circle at left); Amitabha (upper circle at right); and Amoghasiddhi (lower circle at right). The six *loka-buddhas* are interspersed in the upper section, holding the appropriate implement for the six regions ("*lokas*").[2] Filling the rest of the space are the five knowledge-holding deities *(yab-yum)* in dancing form, wearing tiger-skin loin cloths, and the fierce door keepers of the four directions. Vajrasattva is at the upper right, and Sadakshari at the upper left.

Surrounding the central fierce Chemchog Heruka are the five *heruka* buddhas *(yab-yum)*, with the wrathful forms of the five buddhas above: Ratnaheruka (upper left), Vajraheruka (lower left), Padmaheruka (upper right), Karmaheruka (lower right) and Buddhaheruka (below center). Various animal and bird-headed or fierce beings dance about in the rock and hill landscape. In the lower zone, within four circles, are the twenty-eight animal-headed gate keepers. Green Tara is on the right and fierce offerings on the left of the central lotus base. A caption in red Tibetan script is given for each deity or group of deities. A Chinese silk mount is sewn to the painting.

Previously published: Gordon, *Iconography*, pp. 97-101 (then in collection of Dr. Davenport West).

1. Compare TPS, pls. 151-52, pp. 548-51, and Snellgrove, *Buddhist Himalaya*, pp. 228-34. Dr. D. I. Lauf of the Karma-Ling Institute, Tutzing, West Germany, has identified this painting as specifically the teaching of the Terton Karma Lingpa of the Nyingmapa tradition.

2. See also P40.

P26

LHAMO

Colors and gold on cotton cloth, 35" × 24¾" (88.9 × 62.8 cm)
Tibet, 18th-19th centuries
Gift of Dr. and Mrs. Eric Berger 1984 84.383

The fierce blue figure of Lhamo, astride her white mule, dominates this energetic painting.[1] She wears a crown of five skulls topped by a crescent and peacock feather finial, golden earrings, bracelets, anklets and a brown brocade robe, open in front and swirling at sleeve ends and hem, to reveal golden lining and red brocade trim. She grips a tiny human body in her rolled tongue, carries a *dorje*-mounted and silk-festooned club and skull cup of blood. Her other fierce accoutrements include flaming hair, human skin, a snake, and skull adornments on chest and belly; flames and smoke springing forth from her robe and green sash provide a fearsome aura. Her mule is attired in snake bridle, human and tiger skin blankets, and a skull pendant around his neck. A staff, tied to a skin bag with a snake and dice, is attached to the skin blanket. Lhamo's six acolytes, fierce-headed, sagging-breasted, blue, red and gold-skinned creatures, dance amidst her flames and ride their animal mounts at the four corners. All of these visualizations fly over a sea of blood, from which emerge craggy green rocks with trees and bushes, and a jewel offering. A skull, with a heart and blood, is the central tantric offering below Lhamo. In the upper area, a pale blue sky shades to dark blue, with pastel clouds and, at the center, a tiny blue buddha in a rainbow. The tanka is mounted in faded and damaged plain silks of the usual red, yellow and blue.

Lhamo is the chief protectoress of the Gelugpas, introduced into this school by the 1st Panchen Lama,[2] and consequently sponsored by the 5th Dalai Lama in the mid-seventeenth century. When Lhamo's cult was first brought to Tibet, its already complex mix of Hindu and Buddhist aspects became further enriched by assimilation with indigenous protectoresses.[3] Her fiercesome aspect is emphasized in the liturgy of the Gelugpas for Lhamo:

> ...in her right hand she brandishes a club, surmounted by a *dorje*, over the brains of those who have broken their promise; in the left, on a level with her heart, she holds a skull-cup full of blood and of substances used in exorcism. Her wide mouth, gnashing its sharp teeth, gnaws a corpse; her joyous yelps resemble roaring thunder. She has three red, round eyes, gleaming like lightning. Her yellowish hair stands on end, eyelashes and beard blaze like the fire which flames up at the end of cosmic aeons...she wears...a diadem made out of five skulls, a scarf of 15 freshly-severed heads, dripping blood.[4]

1. Much of the original opaque blue of Lhamo's body has flaked off, taking with it the delicate white chains of bone ornaments once covering her body; some of the white on the mule has come away, revealing underdrawing and color notations.

2. See P15, note appearance of Lhamo at the center bottom.

3. See TPS, pp. 590-91.

4. From the *dPal ldan dmag zor rgyal moi gdams skor*, TPS, pp. 591-92; compare pls. Y, 200, 202-04, for similar paintings.

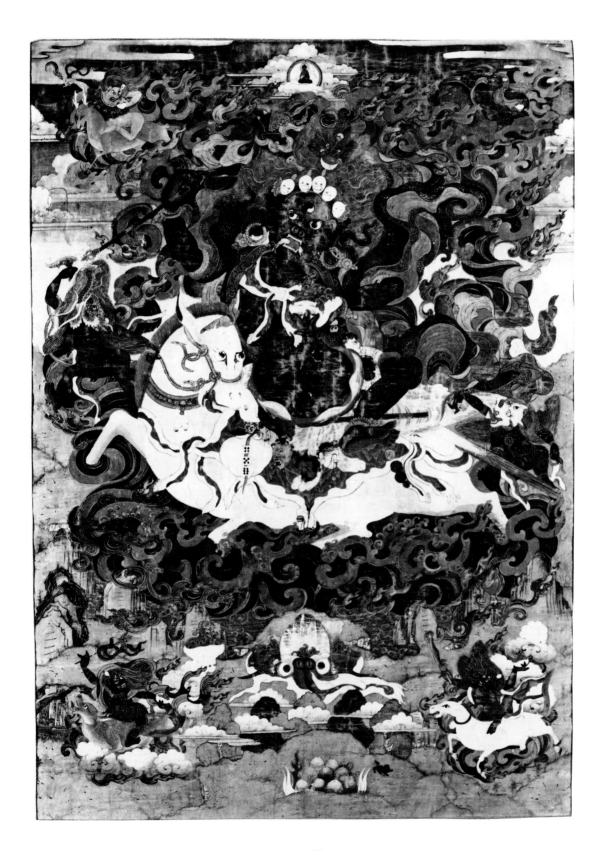

P27

TWO PROTECTORS: MAHAKALA AS "LORD OF THE TENT" AND BEGTSE

Colors and gold on cotton cloth, each: 30″ × 20″ (73.5 × 49.0 cm)
Tibet, 18th-19th centuries
Purchase 1920 Shelton Collection 20.265, .268
See color plates 14-15

The energetic drawing and strong coloring of these two paintings show the skill and power of comparatively late work. In both, the central fierce deity is given a vivid and dramatically modeled face and body, juxtaposed with elegant ornamentation. Above the flames and smoke of the deities and their fearsome entourages, are pastel skies filled with deities and saints.

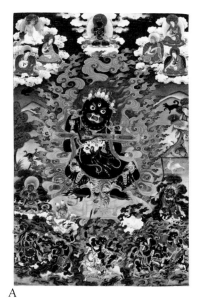

A

In A, Mahakala *(Gonpo)* as "Lord of the Tent" *(Gurgon)*[1] is depicted with a deep blue body, adorned with a garland of severed heads, a snake, a tiger skin, gold and bone ornaments and brocade scarves. A fanged and gaping mouth, flaming whiskers, brows and hair, a third eye, and a *dorje*-topped skull crown, are the main elements of Mahakala's expressive head. His two hands hold a chopper and skull while balancing a gem-set magic club across his arms; he treads on a pale-blue-skinned human figure laying on a lotus base. Orange, red and gold flames encircle the body and fierce offerings spill out of two skulls at the base. To the lower left, is the blue-skinned Ekajata goddess dressed in a leopard skin, holding a vase of elixir and seated on a lotus base. Directly below is Lhamo on her mule. To the right of Mahakala's lotus base, is a blue-skinned demonic form dressed in robes and a garland of heads, with a sword and skull cup, treading on a human being. Flanking Lhamo are four more ferocious manifestations, Mahakala's "ministers", brandishing diverse weapons. All the fierce forms are enveloped in smoke and flames. The beautiful landscape, in the middle ground, shows Mahakala's cemetery with a vulture devouring a body; a jackal (at right) and a she-demon (at left), while the black bird and black dog of his retinue appear at the left and right, respectively.[2] In the sky above, in pale pastel clouds, is Vajradhara on a pink lotus with three saints at each side from the Sakyapa lineage, bearing their attributes and seated on cushions.

This two-armed form of Mahakala, with his distinctive, squatting pose on a supine human form and the magic club across both his arms, is freqently seen in Tibetan sculpture and painting. Several tankas with clear Sakyapa associations have been known for some time.[3] A recently published stone image of Mahakala of the Tent, inscribed with a date in accordance with 1292, gives firm evidence of the early establishment of this form in Tibet.[4] The stone image and the Sakyapa tankas feature Ekajata and Lhamo in Mahakala's entourage, as in Newark's painting. All the Sakya tankas contain members of the lineage and the stone inscription mentions Phagpa, the great Sakyapa political figure. This sure sectarian link is continued in Newark's example.

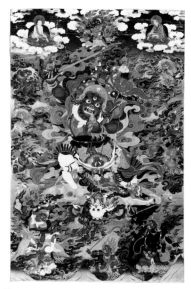

B

In B, Begtse[5] is red-bodied, with a third eye and fangs, and wears a golden helmet with a banner, flags and a skull. The chain mail cuirass *(beg-tse:* "hidden shirt of mail") is his definitive emblem, worn with a

severed-head garland and a "frog-demon" front attachment. He steps to his right, with elaborate *makara* boots, onto a horse and a human, and brandishes a scorpion-handled sword, right, while holding a human heart to his mouth and clasping a bow-and-arrow and lance (with severed head and scarf), left. Orange, red and gold flames envelop the deity, who is supported by a lotus base before which is a skull cup of ferocious offerings. Begtse's "sister" appears at the lower right of the painting, with blue body and red face, riding a man-eating black bear, and wielding a sword and *phurpa*. At the lower left, "the red master of life," attired in a manner similar to Begtse, rides a blue wolf and spears a human with his lance. The other beings who surround the central deity are (upper center) Yama, Lord of Death, in *yab-yum* pose with his consort, and the eight red acolytes known as the "eight butchers who wield swords," enveloped in smoke, each brandishing sword, knife, skull cup, or human heart. Begtse's cemetery setting and lake of blood are shown in the middle and foreground. Two saints are in pale clouds at the top corners.[6]

Both paintings are sewn into handsome Chinese brocade mounts, and there are a pair of hand prints on the back, part of the consecration ritual. Obtained by Shelton in Kham, the paintings may have been executed locally, under the auspices of monasteries at Batang or Derge, or brought in from Central Tibet. In either case, the complexity of the paintings, the richness of pigments and the gold used for details indicate they were lavish commissions.

1. See Nebesky-Wojkowitz, *Oracles and Demons*, pp. 49-51, for descriptions of the black (or blue-black) "Lord of the Tent" forms of Mahakala.

2. Ibid., pp. 50-51, describes the entourage and cemetery setting in a slightly altered form.

3. TP, pls. 27-28, and *LA Tibet*, no. P10.

4. Heather Stoddard, "A Stone Sculpture of mGur mGon-po, Mahākāla of the Tent, dated 1292," *Oriental Art* (Autumn, 1985), pp. 260, 278-82. See pp. 20-22, for a discussion of the Nepalo-Tibetan context of this work.

5. Nebesky-Wojkowitz, *Oracles and Demons*, pp. 88-93, gives a complete description of the form of Begtse, his entourage and setting, as depicted here. Recent research into the biography of the 3rd Dalai Lama (1543-1588) and two eleventh-century *tantras*, has proven that Begtse was not introduced from Mongolia in the sixteenth century but has long been in the Tibetan liturgy and, in fact, shows pre-Buddhist aspects; Amy Heller, "Early Textural Sources for the Cult of Beg-ce," *Proceedings of the 1985 Seminar of the International Association of Tibetan Studies*, Munich, forthcoming.

6. The helmeted manifestation of Begtse (in contrast to P28-C) is the Sakyapa form of the deity; the identity of the two figures here, especially in view of the obvious relationship with the painting of Mahakala and its Sakyapa lineage, is problematic. The bare-headed figure could be any one of many Sakyapa hierarchs; the yellow-hatted lama may be the 2nd Dalai Lama, who transmitted the Begtse liturgy to Sakyapa students.

P28

SET OF FOUR PROTECTORS

Colors and gold on cotton cloth, each: 11⅞" × 16⅞" (30.2 × 42.9 cm)
Tibet, 18th century(?)

Gift of Mr. and Mrs. Jackson Burke 1974 74.35-.38

Although these tankas have suffered losses and soiling, they still exhibit the exuberant vitality and meticulous detailing of the finest wrathful paintings.

A. Lhamo and her entourage, in a form almost identical to P26, dance and ride their mounts amidst smoky flames over a sea of blood.

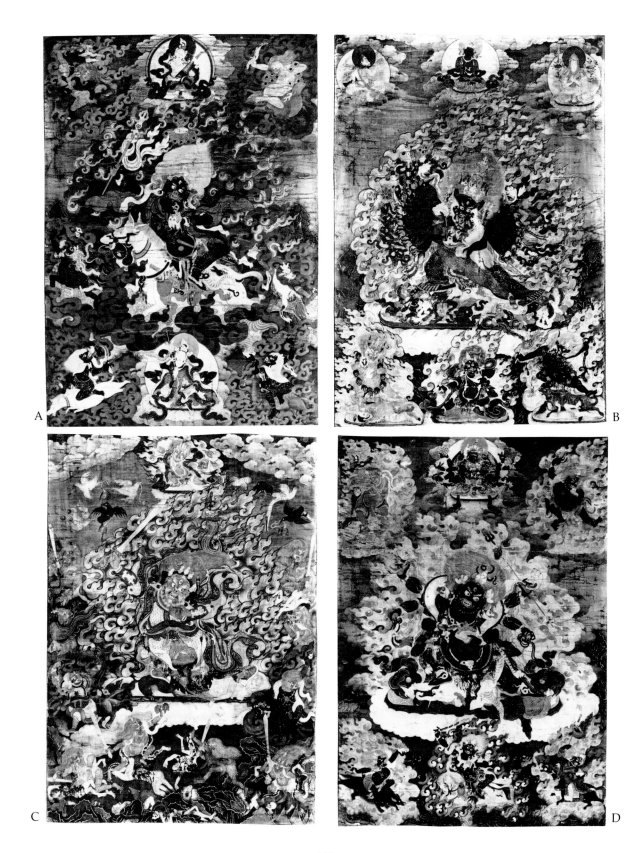

A

B

C

D

In this visualization, the goddess Sarasvati plays her lute in the pastel sky at center top and a god of wealth, in the garb of the ancient kings, sits with gems and staff in similar clouds at bottom center.

B. The Vajrabhairava form of Yamantaka, the black/blue bull-headed conqueror of death, strides in *yab-yum* with his green consort who feeds him from a blood-filled skull. The god has nine heads, thirty-four arms holding various weapons, and sixteen feet, which tread on birds, animals and humans, on a pink lotus pedestal surrounded by flames. In the cloud-filled sky above, Vajradhara is flanked by a *mahasiddha* on a tiger skin (left) and Tsongkhapa (right), each with radiant nimbuses. Below, in the rocky landscape, are the red and black forms of Yama flanking blue Mahakala, each encircled in flames.

C. Begtse, the red-bodied protector, in a form similar to P27-B, holds a scorpion-handled sword and eats a heart. He is dressed in his distinctive chain mesh armor, brocade robes and boots. Begtse's bronze hair is shown loose, and he wears a skull crown and golden earrings.[1] A bear(?) skin and severed heads hang down his stomach, a lance and a bow-and-arrow are held in the crook of his left arm, and he treads on a human and an animal who lie on the pink lotus base. Orange and gold flames envelop his body. To the right of the lotus base, Begtse's "sister," with blue body and fierce red face, rides a bear and brandishes a knife and *phurpa*. To the left of the base, an armored "red officer" rides a wolf, holding a staff and noose. The eight "butchers who wield swords" perform ghastly deeds in the rocks and the smoke at bottom and sides; all are red-bodied, golden-haired and wear bone ornaments and various skins. In the blue, cloudy sky, vultures carry entrails and the red, horse-headed Hayagriva is in flames at the center.

D. Mahakala, one of the main protector deities of Tibet, is here in a six-arm form,[2] holding trident, noose, skull cup, chopper, drum and an elephant skin. His dark blue body is adorned with golden jewels, a tiger skin, severed heads, snakes and a skull crown; he pins an elephant-headed demon to the pink lotus base, and is surrounded by red and gold flames. In the rocky landscape below, Lhamo is flanked by two of Mahakala's blue-bodied "ministers," one riding a bear and brandishing a skull cup and chopper (left), and one riding a horse and holding a lance and skull cup (right). Above, in the cloud-filled sky, are two more "ministers" dancing on bodies and circled by flames, the red demon on the left holding a drum and skull cup, and the blue on the right holding a drum and noose. At the center top, is Guhyasamaja in *yab-yum;* god and consort both blue, six-armed and dressed as bodhisattvas, with radiant nimbus and halo.

All four tankas have fine brocade mounts but, when restored in Japan, the mounts were adhered with glue to the paintings rather than sewn. The set may have originally been part of a group of eight protectors, which would include Vaishravana, Yama, Sita-Brahma and Hayagriva.[3] The Gelugpa forms of the Begtse and Mahakala paintings, indicate that this set was commissioned under the auspices of that school.

1. This is the usual Gelugpa form of Begtse, in contrast to the helmeted Sakyapa form in P27-B.
2. This is the form especially venerated by the Gelugpas.
3. Nebesky-Wojkowitz, *Oracles and Demons*, p. 23.

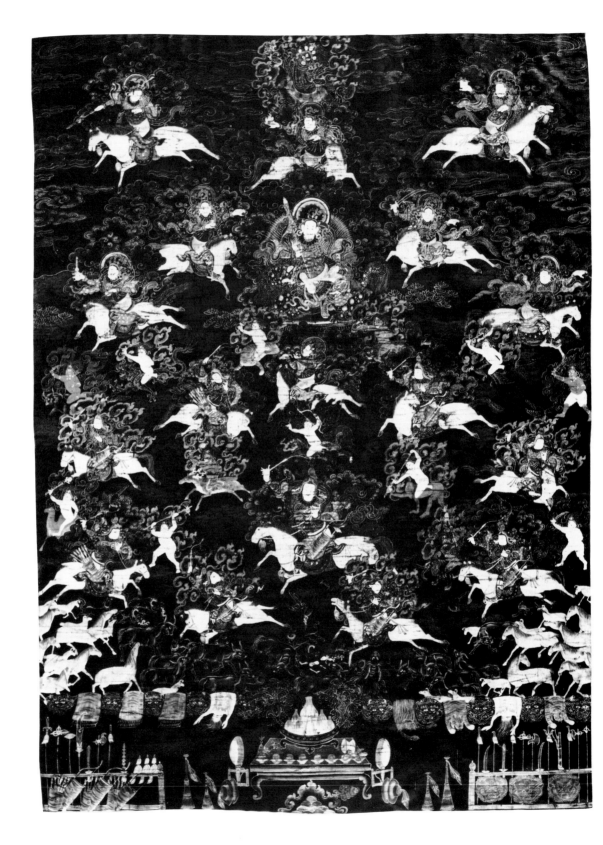

P29

VAISHRAVANA AND THE NINE DRALHA BROTHERS

Colors and gold on black satin, 31⅜″ × 23⅛″ (79.7 × 58.8 cm)
Tibet, 18th-19th centuries
Purchase 1972 The Members' Fund 72.159

"The Great Yellow Vaishravana," a form of the god of wealth, is shown here as a warrior figure and guardian of the North. He sits in the upper center on a fantastic spotted lion, wearing fine robes over his armor, holding a banner of victory and the "treasure-producing" mongoose. He has a halo and a radiant nimbus. Surrounding him are eight similarly attired warriors, on ghostly white horses; each holds a mongoose and a weapon or ritual object. As guardians of one of the eight directions (South, Southwest, West, etcetera), these attendants to Vaishravana are known as the "Eight Masters of the Horses" (T. *Tadag Gyed*).[1] In the lower section of the painting, eight more warriors race on horses around a central ninth rider. These are the nine *dralha* brothers.[2] Their copiously detailed equipment includes red-tasseled helmets, tiger skin cases for bows-and-arrows, and whips (each followed by a falcon); miniature tigers and lions sit on their shoulders. Demonic figures whirl amongst the brothers, either on foot or on various animal and human mounts. Herds of animals, common to Tibet, move in from both lower sides toward a central pile of bones and entrails. Below these is a "clothes line" of gargoyle heads, alternating with skins of tigers, humans and an ape(?)[3] Auspicious offerings, musical instruments and weapons are arrayed at the bottom. Vajrapani is situated at the very top of the painting, serving as spiritual mentor to the scene. Paintings on dyed black silk are rare, and this tanka is an especially effective sample of Tibetan black background demonic visualizations. The transparent colors used in the painting give the swirling figures an eerie quality. They, and their enveloping flame and cloud aureoles, appear to vaporize into the dense black environment. The satin painting is sewn to a dark gold silk mount.

1. See Nebesky-Wojkowitz, *Oracles and Demons* pp. 68-69, for Vaishravana and the "eight masters"; also TPS, pp. 571-78, and pls. S and 173-77. Tucci's thesis that the warrior-wealth god manifestation was a mix of Indic and Central Asian traditions, is borne out by a painting recovered from Karakhoto (see pp. 19-20), which shows Vaishravana and the "eight masters," in a Chinese-Central Asian style while a Vajrapani, at the center top, is completely in the Indic Pala style, see DDH, no. 31.
2. See Nebesky-Wojkowitz, *Oracles and Demons*, pp. 328-29, for the nine *dralha* brothers; this is the numerical group, within the broader category of *dralha* ("enemy-god") indigenous deities, who most resemble Vaishravana and his eight companions.
3. A Yeti?

P30

GURU DRAGPOCHE

Colors and gold on black painted cotton cloth, 31″ × 25″ (78.4 × 64.0 cm)
Tibet, 18th-19th centuries
Gift 1911 Crane Collection 11.718

This emanation of Padmasambhava is shown as a translucent, red-winged divinity with three heads (white, red and green), six arms and

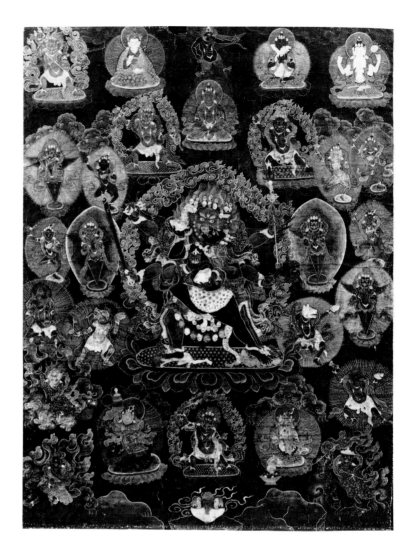

four legs.[1] Charged with fiery energy, he clasps his consort in *yab-yum* pose as they crush human beings on a lotus base. She is black, has a boar's head in her hair and holds a skull cup. Both have the third eye and wear skull crowns. His primary hands hold a chopper and skull cup; his remaining hands hold a sword, *dorje*, ritual wand and scorpion with an eye in each of its seven claws. He wears silk scarves, armor, elephant and tiger hides, garlands of skulls and a human head; she wears a leopard-skin lower garment. They are encircled in flames. Twenty-seven deities loom out of the cloudy black ground around the central figures, some overlapping one another; they are all seated or dancing on lotus bases, except for the "sky-dancing" forms of *garuda*, the animal-headed cloud fairies and the animal-mounted kings. *Garuda* stands at the upper center between Padmasambhava and Samantabhadra. Amitayus sits below *garuda*, and Avalokiteshvara is at the upper right. The four *phurpa*, winged forms whose bodies end in triangular blades, can be interpreted as emanations of Padmasambhava as well as personifications of the implement *phurpa* (see S12). The four, animal-headed protectors and the four, flame-encircled

fierce protectors, all wearing tiger-skin loin cloths, and the five *dakinis*, are part of the retinue of beings who guide the disciple. Closer to the earthly realm, represented by dark rocks and a fierce offering, are Vaishravana on a lion (see P29) and the "Bearer of Life" with a golden vase, plus three robed fierce protector kings riding a lion, mule and horse, respectively.

The rich, transparent coloration, the golden radiances around the figures and the black ground, unite to produce an effect of luminous beings in a world of midnight darkness. The eccentric positioning and odd number of beings impart an air of spontaneity in this painting. There are paint losses along the top and bottom edges; stitching holes indicate sewing of a replacement mount, now missing.

1. This form of Padmasambhava was identified by Dr. D. I. Lauf of the Karma-Ling Institute, Tutzing, West Germany, who cites it as a special version according to the Terton Padma Lingpa (1450-1521) of the Nyingmapa order. A slightly different emanation, and the Nyingmapa initiation ritual involving the deity, are described in Huntington, *The Phur-pa*, pp. 66-68, fig. 70.

P31

SETAB

Black line with added colors and gold on orange painted cotton cloth; 42" × 31" (106.7 × 78.7 cm)

Kham, 18th-19th centuries

Purchase 1920 Shelton Collection 20.292

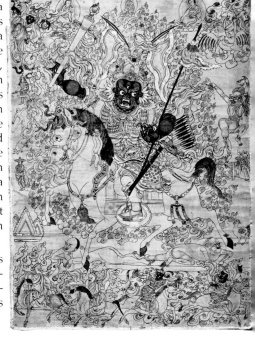

The ferocious red dharmapala, Setab, enveloped in flames and riding a horse, brandishes a jeweled club in his right hand and a snare in his left; over his flowing robes he wears elaborate, laminar armor and a helmet surmounted by banners; *garuda* and *makara* heads decorate the shoulders, stomach and brow sections. A lance, with a banner top, rests in the crook of Setab's left arm; a quiver, bow case of leopard skin and sword hang from his belt. The deep red of his face and arms has been modeled to describe the bulging muscles. His horse treads on two nude figures, male and female. A fierce nude female dances at the upper right, waving a heart and a scalp. In the upper corners and below, are Setab's six emanations: five of whom ride horses while the sixth rides a cockerel. At the sides are the messengers of each emanation: a snake, an armed giant, a monkey, a mongoose and a monk, on the left, and a magician, on the right. Three monks sit on lotus thrones at the top. A cock and *torma* offering at right and left sides, respectively, complete the painting. Stitching holes remain from the lost mount.

Setab, whose names means "armor," is an indigenous protector who is linked in iconography and character with Begtse (see P27-B and P28-C), and perhaps springs from similar origins.[1] In this exuberant, folk-style painting, the exclusive modeling of the protector's body gives him particular power.

1. Nebesky-Wojkowitz, *Oracles and Demons*, pp. 149-53.

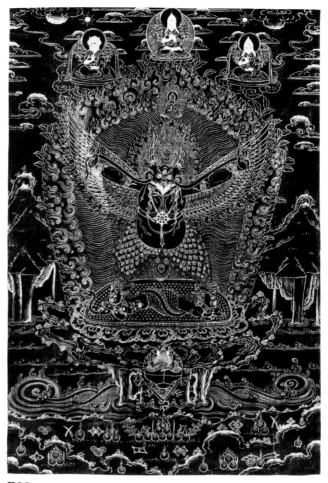

P32

VAJRAPANI AS GARUDA

Gold line and slight color on black painted cotton cloth, 19″ × 12¾″ (48.3 × 32.4 cm)

Tibet, 19th century

Purchase 1949 49.408

Garuda, the wrathful, semi-human bird, with an aura of flames, treads on serpent divinities and holds a serpent in his mouth and claws. Serpents entwine his horns, arms and torso. Each of his feathers ends in a half-*dorje*. On his head is a wish-granting jewel, and a wheel is suspended at his chest. Above sits Akshobhya Buddha. In the cloud-filled sky, Tsongkhapa appears between the Qianlong Emperor (left) and Lalitavajra (right).[1] *Garuda's* lotus pedestal sits on rocks, which rise from swirling waters. A tantric offering of the Five Sense Organs stands in the foreground, amid scattered jewels and wealth emblems. The presence here of Vajrapani's spiritual father Akshobhya and of their emblem, the *dorje*, indicates that this *garuda* is an emanation of Vajrapani; in order to protect the *nagas* from the *garudas*, Vajrapani sometimes assumes a *garuda* form. This horned form of the mythic bird

can, however, also be interpreted as the *khyung* of Bon tradition.[2] This small painting is entirely executed in gold line and shading, with slight touches of red and black to delineate details on the matte, black-painted cloth. It is sewn to a simple, plain, red, yellow and blue silk mount.

1. For Tsongkhapa, see P19; the Chinese Qianlong Emperor (1736-1795) is similarly portrayed in a painting in the Potala, Deng Ruiling et al., *Potala Palace*, fig. 34, p. 44; Lalitavajra-Rolpa Dorje, (1717-1786), a religious advisor to the emperor, is commonly shown with the same symbols as Tsongkhapa and Qianlong, see Olschak, icon no. 53, pp. 124-25.
2. See Nebesky-Wojkowitz, *Oracles and Demons*, pp. 256-58.

P33

PEHAR

Colors and gold on cotton cloth, 17¼″ × 12¼″ (43.8 × 30.8 cm)
Tibet, 19th century
Gift of Dr. Schuyler V. R. Cammann 1964 64.34

This unusual form of Pehar is finely painted on a small format tanka. The wrathful protector has a white body with an odd lumpy stomach. The central white face has an enormous nose, third eye, ears and mouth, while the blue and red side faces have more normal proportions for fierce features. Of the six hands, one pair draws a bow and arrow and the others, in turn, hold a crossed-*dorje* wand, sword, staff and curved-blade knife. Pehar wears a stiff brimmed red hat topped with a scarf-wrapped skull and *dorje*, silk scarves, a tiger skin and golden ornaments. He rides a ferocious gray lion, with a green mane and tail, and is enveloped in orange and gold flames. This depiction follows in all its main forms the Gelugpa text for this deity's mandala.[1]

Four emanations, each in flames, are placed at the four corners, dressed in similar stiff hats, patterned robes and boots. Shin Cha Chan at upper left ("south") is blue-skinned, carries an axe and rides a horse; Drala Kyechigbu at upper right ("west") is red-skinned, carries a sword and rides a mule; Monbu putra and Gyachan at lower left ("east") and right ("center") are blue-skinned, each carry *dorje* and alarm staff, noose and curved knife, and ride a lion and elephant respectively. A lama, wearing the red hat of the Kagyupas and holding a skull cup, is seated in a radiant nimbus at upper center. An offering of weapons, skulls and entrails is at lower center. An idealized landscape and cloudy sky forms the background. Pin holes and silk thread remain from the original silk mount, now lost, but a painted border of white, red and yellow stripes surrounds the painting. The four emanations conform to the Gelugpa texts,[2] giving Pehar of the "north" the central position because of his importance. The presence of the red-hatted lama indicates, however, that this is a Kagyupa tanka.

1. See Nebesky-Wojkowitz, *Oracles and Demons*, pp. 94-108, for a general discussion of Pehar's antecedents and places of residence; for this particular emanation, see pp. 110-11. Pehar, a protective deity with mixed indigenous and Indian antecedents, was associated with Samye monastery as a guardian in connection with Padmasambhava and, from the seventeenth century on, with Nechung, the seat of the Gelugpa state oracle, outside Lhasa. Pehar is the chief of a group of five "king-demons", the other four of whom can be described as emanations of Pehar (see also P34); see John F. Avedon, *In Exile from the Land of Snows* (New York: Knopf, 1984), pp. 191-217, for the traditional Tibetan account of Pehar and his role in the oracle system.
2. Nebesky-Wojkowitz, *Oracles and Demons*, pp. 108-11.

P34

AN EMANATION OF PEHAR

Colors and gold on cotton cloth, 32″ × 24¾″ (81.2 × 63.9 cm)
"Yarragong" monastery, Kham, Tibet, 19th century
Gift 1911 Crane Collection 11.719

An exuberant, provincial rendering of the Gyachan emanation ("king of the mind") of Pehar[1] dominates this tanka. The coarse cotton cloth has a polished gesso ground. The purple-skinned protector, with third eye, fangs and flaming hair, wears a large, stiff brimmed, diamond finialed and curtained hat,[2] brandishes a noose and knife, and wears a black robe with green boots. He rides a white elephant, who wears a jewel on his head, and tramples a black-skinned man and a pink-skinned man on a lotus base. Flames and smoke surround Pehar. Below are four attendants: an armored archer; a club-wielding, robed spirit; a dancer in black hat with *phurpa* and prayer beads, and a monk, with staff and begging bowl, wearing the same stiff hat. The side borders are ruled and show pin holes from the lost mounting. The coarse cloth, limited color palette and crude drawing all point to a local production. Several other tankas of this type were obtained by Shelton at the "Yarragong" monastery and included in the 1911 Crane gift, and thus they may constitute a provincial school.

1. Nebesky-Wojkowitz, *Oracles and Demons*, pp. 108-09, see also P33.
2. This is the characteristic, stiffened, parasol-like hat of Pehar and other protectors.

P33

P34

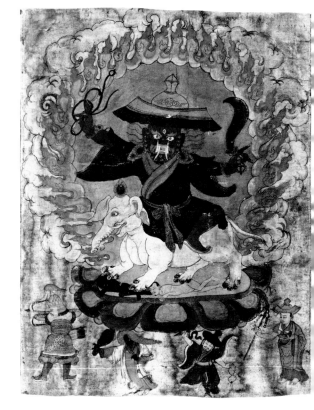

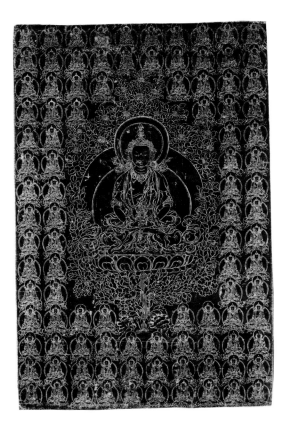

P35

AMITAYUS

Gold and slight color on red painted cotton cloth, 27¼″ × 18⅛″ (69.2 × 49.1 cm)

Tibet, 19th century

Gift of Mr. and Mrs. Jack Zimmerman 1984 84.393

The painting is entirely worked in fine gold line on a matte red ground,[1] with lightly brushed black to indicate the hair. The subject is Amitayus, holding on his lap the vase of the water of life from which grows a multi-petaled lotus flower; he is adorned in bodhisattva robes, scarves, jewelry and headdress; encircled by a double-halo and a double-nimbus. His lotus petal base grows from a stalk which emerges from a small water-and-rock area, that also supports luxurious peony and lotus flowering plants below, beside, and above the deity. This large, central image is surrounded by one hundred smaller, identical icons (only slightly simplified as to jewelry, garments, halo and nimbus; and lacking the lotus stalk and floral growths), arranged in fifteen horizontal rows, overlapping slightly vertically. On the reverse are mantras in red and brown inks, positioned behind each icon. Stitching holes on all four borders (marked with ruled gold line), indicate that the tanka was once sewn to silks for hanging.

1. This form is called *tsaltang* ("red painting"); linear paintings, in gold on red, where the central figure is surrounded by multiple emanations, are a popular format, compare TPS, pls. 178-80, 182-84.

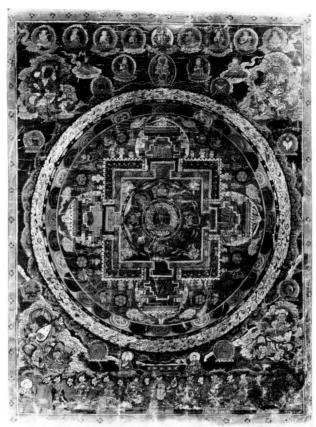

P36

MANDALA OF AMITAYUS BUDDHA

Ink, colors and gold on cotton cloth, 30¾″ × 23″ (78.1 × 58.4 cm)
Obtained in Amdo, Tibet 19th century
Purchase 1936 Holton Collection 36.520A

The Buddha of Infinite Life appears in the center and in each petal of
an eight-petaled lotus. The square citadel has four gateways, sur-
mounted by the Wheel of the Law between antelopes and flanked by
three vases each, one bearing a tree of life and two bearing banners.
The gates and walls follow the usual pattern, while celestial beings
and umbrellas fill the rest of this space. The four outer circles are of
lotus petals, *dorjes*, flames and smoke. Surrounding the mandala are
the Eight Glorious Emblems and the Guardian Kings of the Four
Quarters. Buddhas and monks are above; protector gods and a monk
on a plinth are below.[1] A red color scheme and deeper patterning
prevail inside the circle, recalling Nepalese mandalas (see P11). The
outlines are swiftly sketched in with all the vigor and vivacity of folk
art. Although the dark landscape and arrangement of figures outside
the circle are in the style of later Tibetan paintings, the earlier
Nepalese convention of rosettes along the borders are here retained.[2]

1. The position suggests this figure may be involved with the donation or consecration of
the painting.
2. See TP, pls. 81-82, and TPS, pls. 219-20, for Tibetan mandalas of similar mixed style.

P37

MANDALA OF VASUDHARA

Gold line on blue painted paper, 34" square (86.4 cm)
Obtained in Outer Mongolia, 19th century
Gift of Mrs. Frank L. Babbott 1954 54.359

The drawing is in red-gold, the inscriptions in yellow-gold, on a dark blue painted (or dyed) paper sheet. The Goddess of Abundance is surrounded by her eight emanations, one in each petal of the lotus mandala. Each divinity holds her right hand in gift bestowing, offering a jewel, and her left in argumentation holding a spike of grain. The heart of each goddess is inscribed with her complete mantra in Tibetan letters, which revolve in a circle around her *bija* (seed syllable) mantra. Within the outer circles of flames and *dorjes*, the Sanskrit alphabet written in Tibetan is repeated three times and then, at the bottom, the artist or donor asks a blessing on the work. Vasudhara's mantra is "*Om Vasudharini svaha Vam*" (homage to the goddess Vasudhara Vam); *vam* is the *bija* mantra which brings the deity into manifestation. Each of the eight emanations of Vasudhara has a different name and *bija* mantra. Before each deity is an offering surmounted by a vase of life. This mandala was probably intended to be used, folded, as a charm inside an image.[1] The paper support and square format are inappropriate for a tanka.

1. Chongla Rato and Nima Dorjee identified the mantras and suggested the intended use for this mandala.

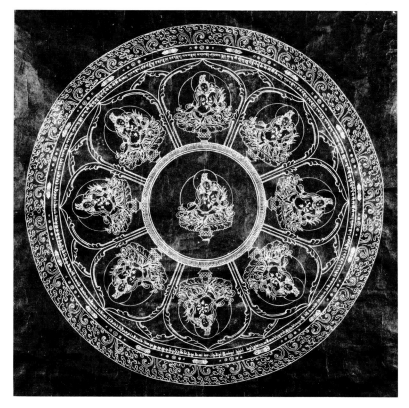

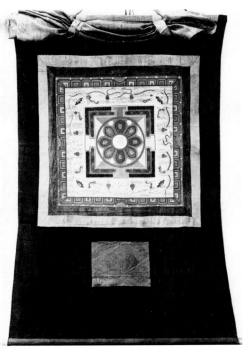

P38

BIJA MANDALA (OR *YANTRA*) OF AMITABHA BUDDHA

Colors and gold on cotton cloth, 18″ square (44.1 cm)

Obtained in Eastern Tibet, 19th century

Purchase 1920 Shelton Collection 20.274

The eight-petaled lotus has the letter *Hrih* (Amitabha's *bija* mantra or seed syllable) in the center and *Phu* in each petal; the lotus is within a square citadel with the usual T-shaped gates and festooned walls.[1] Surrounding the square is foaming, bright blue water in which pairs of jewel-bearing serpents swim, the pairs at the sides turn their heads away from each other, those at top and bottom face each other.[2] A parasol between scepters is at each corner, and on all four sides are twin "paradise trees" in vases. Outside the water area multi-colored panels are hung from posts, the center panel of each side sagging.[3] The term *yantra* is sometimes applied to mandalas featuring the *bija* (essence) of the deity instead of his image or emblem. *Yantra* is also a general term for any instrument of worship. The devotee enters the mandala, chants the *bija* mantra and imagines the god as springing from the luminous seed syllable within his own heart. Thus, he identifies with and becomes the *nirmanakaya* of Amitabha. There is a Chinese mount of plain, blue-black silk with an inset showing a golden *dorje*; red and gold silk bands are adjacent to the painting.

Previously published: Schuyler V.R. Cammann, "Suggested Origin of the Tibetan Mandala Paintings," *The Art Quarterly*, Spring, 1950, pp. 107-17, fig. 6.

1. Gold lines sketch dancing figures on the inner walls and geometric patterns on the intermediary wall. See the same festooned walls in P36.

2. Dr. Cammann believed that the waters in this mandala are the "Four Seas" of ancient Chinese mythology, see "Suggested Origin..."; Dr. D. I. Lauf of the Karma-Ling Institute, Tutzing, West Germany, has suggested that this is the mandala of the Eight *Nagas*, with *Hrih* standing for Simhanada-Avalokiteshvara as a descendant of Amitabha.

3. These seem to represent tent walls; the walls are obviously derived from those surrounding paradise ponds, or pools, as in P7 and 23.

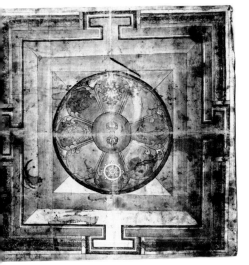

P39

MANDALA OF AKSHOBHYA

Colors on unsized cotton cloth, 36″ square (91.4 cm)

Obtained in Eastern Tibet, 19th century

Purchase 1920 Shelton Collection 20.303

In the green center of the eight-petaled lotus is a blue *dorje* symbolizing Akshobhya. The petals (red, yellow, green and blue), which point to the four cardinal points, contain the emblems of the other four buddha families: an alms bowl on a red lotus (Amitabha); a green sword (Amoghasiddhi); a white Wheel of the Law (Vairochana); and a yellow wish-granting jewel (Ratnasambhava). The lotus is contained within a square citadel, divided by diagonal lines into four triangles of color corresponding to the Buddha emblems and symbolizing the four directions. This is the basic fivefold mandala. The outer blue walls have faint, gold line festoons similar to those in P36 and 11. The cloth is

quite rough and the slightly ragged edges show no signs of mounting stitches. A large gash and numerous stains suggest it was used for rituals. Mandalas constructed of colored grain or powders are commonly made for rituals in Tibet, see figure 33; at the completion of the ritual, the mandalas are destroyed. It is possible that this cloth served as the base outline for such a grain/powder construction, or was itself the mandala and was for some reason not burned at the conclusion of the ritual. In any event, the painting is undoubtedly a local product.

P40

THE WHEEL OF EXISTENCE

Colors on cotton cloth, 43" × 34" (109.2 × 86.4 cm)
Northeastern or Eastern Tibet(?), 18th to early 19th century
Purchase 1936 36.535
See cover

Tibetan *Sipeh Korlo* ("Wheel of Worldly States of Existence") paintings, which depict the most basic life-views of Buddhist teachings,[1] are placed in obvious and accessible locations, to be viewed and absorbed by laymen and monks alike. Most of these paintings were executed directly onto walls, but this example's cloth structure allowed its removal from an unknown location sometime prior to 1936.[2]

The basic scheme is a wheel clasped by the Lord of Death, Yama or Shinje, here shown as an immense, bear-like creature whose matte brown body with oddly modeled musculature bursts from the picture frame. He has sharp claws and fangs, three bulging eyes, a bulbous nose, flame-like brows and mouth whiskers, and wears jeweled ornaments on ankles, wrists and ears, as well as a tiger-skin loin cloth and lotus rosette crown with swirling scarves. The wheel symbolizes the endless cycle of rebirth: at the hub of the wheel are the three basic causes or "poisons" leading to rebirth, the snake (aversion) is coiled around the pig (delusion) and clutched by the pigeon (greed). The six conditions of rebirth are depicted in the body of the wheel. Beginning at the top and moving clockwise, they are the realms of the gods, titans, *pretas*, hell dwellers, animals and humans. The gods, who are born from lotus blossoms and enjoy heavenly delights, are actually only supermen, for delusion still binds them to the wheel. They dwell in Indra's paradise until their merit has been used up, when they will descend to a lower world. The titans were expelled from paradise because of pride. They are separated from the gods by a great wishing tree whose roots are in the titan's realm and whose fruits are in paradise. Motivated by jealousy and lust for power, they fight vainly for the fruits of this tree. Indra, on his elephant, leads the gods against the titans' attacks. The third realm is inhabited by tortured spirits called *pretas* (T. *yidag*), who have been guilty of greed in past lives. They have huge bellies, hair-like gullets and pin-point mouths. Their hunger and thirst is insatiable, for what food and drink they are able to swallow turns into lacerating knives and fire. The lowest realm, and the only one connecting directly to the hub, consists of eight hot and eight cold hells. In the center, Yama appears as judge of the dead, holding a mirror which reflects all good and evil deeds and is inscribed with Amitabha's seed syllable *Hrih*. (As a wrathful aspect of

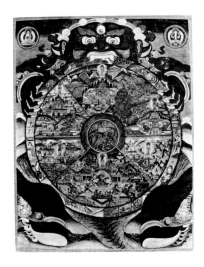

Avalokiteshvara, Yama is Amitabha's emanation.) Animal-headed assistants administer punishments suited to the transgressions, and each sufferer submits until his sins have been expiated, when he is reborn in a higher realm. At the lower left, the animals live in a world of uncontrolled instincts, fear and persecution. The human realm shows a typical Tibetan valley, dominated by a monastery. Women bring tea and *chang* to a plowman, a child is born, men ride horseback and engage in an archery contest; beside a chorten, at the right, a lama rattles a drum and blows a thigh bone trumpet, while vultures dispose of a corpse. A *loka* buddha, actually Avalokiteshvara in his buddha form, stands in each realm. To the gods he brings a lute whose sounds arouse beings from self-complacency; to the titans a sword of wisdom and armor for the spiritual battle; to the *pretas* a vessel containing spiritual food and drink; to the hells a purifying flame; to the animals a book; and to the humans an alms bowl and a pilgrim's staff.

The outer rim of the wheel shows the causal nexus or the twelve interdependent causes of rebirth. Beginning at the upper left and proceeding clockwise:

1. A blind woman illustrates delusion.
2. A potter illustrates the form-creating activity. As a potter shapes his pots so we shape our karma.
3. A monkey plucking fruit symbolizes consciousness.
4. Two individuals rowing a boat represent personality.
5. An empty house represents the senses.
6. A man and woman embracing symbolizes contact.
7. An arrow entering a man's eye represents feeling.
8. A man being served tea and fine foods symbolizes desire.
9. A person grasping vessels filled with nature's bounty symbolizes clinging to worldly objects.
10. A pregnant woman symbolizes the process of becoming.
11. A newborn child symbolizes birth.
12. A corpse being carried to a cemetary symbolizes death.

Outside the wheel, in the upper corners, are Shakyamuni, who taught men how to be free, and Avalokiteshvara who helps them to become free.

The style of this and most other Wheels of Existence is that of folk painting, using landscape and architecture drawn from the local Tibetan scene. Neither the lyrical landscape of India nor the monumental scenery of China figures here. The pleated door curtains behind the man drinking tea or the canopy above the birth scene are typical Tibetan touches. Odd biblical elements, however, can be seen in the embracing and arrow vignettes.[3] The wheel and Yama are set in an extremely simplified landscape of thin, gradated, blue-gray for mountains; deep blue and white swirls for the lake (at Yama's feet), and pale blue gradating to bright blue at the top for sky, with a few fluffs of clouds behind the mountain peaks. The artist has used thin, diluted colors in contrast to the rich pigments used on fine tankas.

1. See Volume I, pp. 29-30.

2. See p. 130; for an example on a wall, see Lauf, *Tibetan Sacred Art*, pl. 59; for another example on cloth, see DDH no. 259.

3. The "embrace" and "arrow" vignettes on the wheel rim suggest fairly sophisticated, European-style prototypes. This painting left Tibet in the 1930s (or earlier), a time when the most likely biblical influence would have been in Amdo and Kham, where Christian missionaries were allowed by the Chinese authorities; see Volume I, pp. 54-60.

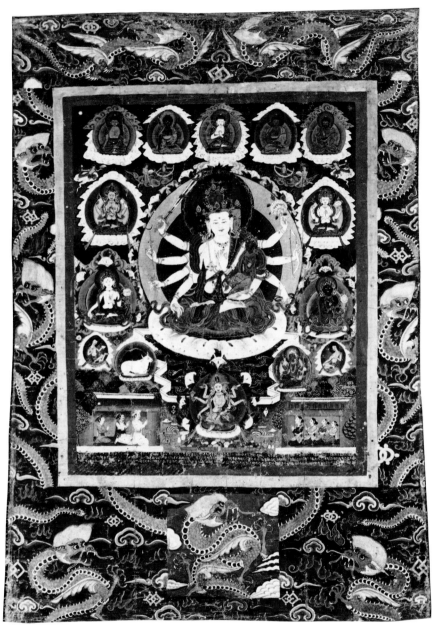

P41

SUKHAVATI LOKESHVARA

Colors and gold on cotton cloth, 44⅞″ × 30¼″ (113.8 × 76.8 cm)
Nepal, dated in accordance with 1849
Gift of Dr. and Mrs. Wesley Halpert in Honor of Eleanor Olson 1980
80.272

The ten-armed, four-headed,[1] white-skinned deity sits in meditation
with a smaller, red female figure on his lap, held with one left arm.
Both are dressed in multi-colored, patterned garments and golden,

bejeweled adornments; his arms hold a sword, arrow and *vajra* (right); lotus, bow, noose and book (left); and his two main hands are placed in teaching gesture at his chest. He sits on a pink lotus base, which floats on a blue lake enclosed in zig-zag white walls. The halo is green, with a black and gold-patterned border, and the nimbus blue, with a yellow border and radiating gold lines; pink lotus blossoms surround the nimbus. In the background of stylized landscape and sky, are the pentad of buddhas across the top, and below them two other forms of Lokeshvara. To the lower left and right of the main icon, are white and green Taras. Flanking the blue lake, are yogins on tiger skins holding skull cups, a white bull[2] and a red Tara. Directly below and in front of the lake, are a yellow, six-armed Mahamayuri[3] and offerings. In two pavilions, at the lower left and right, are the donor's family (women at right, men at left), mentioned individually in the three-line inscription of yellow Newari script on a black background:

> Salutations to Sukhavati Lokesvara. On Tuesday, the first of the bright half of the month of..., Pūrva Phālguni naksatra [one of the twenty-seven lunar "mansions"], Dhruva yoga, in the sign of Saggitarius..., in the year 969 [approximately A.D., 1849], on this day [this work] was finished. When Citrahāra [painter caste]...Sim of the great city of..., his wife, Siva Laksmi, his son, Ciki..., his 2nd son, Chatra Raya, his daughter, Teja Laksmi, his 2nd daughter...Laksmi, and his third daughter, Laksmi, were all gathered together [and consulting among themselves], a pious spirit arose [in them] and in the name of [his] father, Kasau Sim, and [his] mother, Hekasulini Fepu, [this] image of Sri sri sri Svakhâvati [sic—Sukhâvati] Lokesvara was made and offered. By the merit of this act may the devotee's family wealth and offspring all increase![4]

An interesting aspect of this work is the painted imitation brocade border, in the style of Tibetan tankas: narrow red and yellow bands, then wide, blue-gray panels with multi-colored dragons, clouds, flames and auspicious emblems, and a rectangular panel painted at the center bottom with the dragon design on a red ground. The painted cotton has been sewn onto rust-colored cotton cloth borders.

The form of Sukhavati Lokeshvara and his partner are similar to the dated 1817 sculpture of Sukhavati Lokeshvara, S45. The donor's family are shown in the manner typical of Newari work, a tradition seen in earlier paintings (see P5 and 11). The lively, and somewhat strange, character of the painted "brocade" mount suggests that the artist was not copying an actual fabric but working from sketches or other painted copies.[5] The selection of an untypical border is obviously the result of Tibetan influence, and reflects the desire to beautify and enrich the donor's offering.

1. Note the device of showing the red head at rear, by placing it above the three others; the two side heads are yellow (left) and blue (right).

2. An overt reference to the Shivaite association of Sukhavati Lokeshvara in Nepal.

3. A tantric form of Manjushri.

4. Some parts, such as the name of the city are, unfortunately, illegible; the name of the mother is very unusual; translation and commentary by Ian Alsop.

5. Compare sketches of Chinese dragons in a sketchbook, dated 1652-53, done in Lhasa by a Newari, Vajracharya, *LA Nepal*, no. D9 (also shown in TP, fig. 7). For a similar painting, see Doris Wiener Gallery, *Thangka Art* (New York, 1974), pl. D.

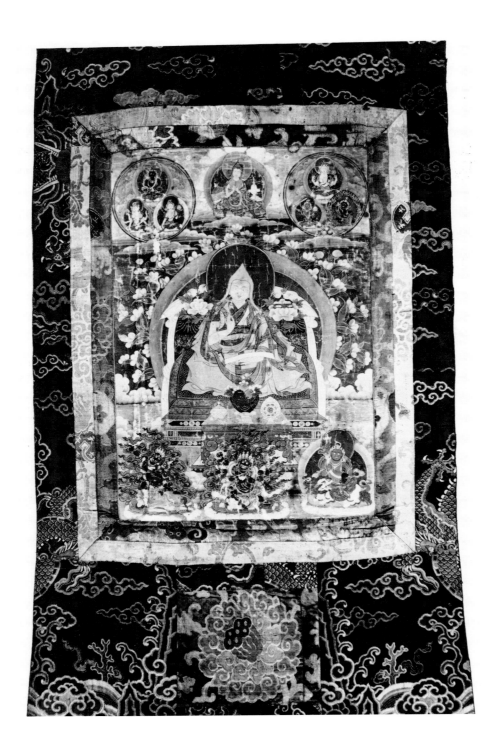

P42

THE 10th(?) DALAI LAMA TSULTRIM GYATSO (1816-37)

Colors and gold on cotton cloth, 23¼″ × 16½″ (59.1 × 41.9 cm)
Lhasa, Tibet, circa 1870
Purchase 1920 Shelton Collection 20.264

The subject is portrayed in the manner prescribed for all Gelugpa lamas from the fifteenth and sixteenth centuries on: frontal pose, yellow hat with lappets, and red-and-yellow monk's garments.[1] The additional outer robe, arranged loosely around the body, and the rich, gold patterning of the brocades, are appropriate for higher lamas.[2] The lama's pink face and body are finely delineated in red, and he holds the symbols associated with Tsongkhapa, founder of the Gelugpa order: sword and book on lotus flowers at shoulder level, the stems held in his hands. The gesture of argumentation, and the book on the lap, are used for Gelugpa hierarchs and for the Dalai Lamas. The lama sits on multiple brocade cushions upon a jeweled blue throne; brocades and a white scarf cover the throne back. A plain red halo surrounds his head and a red nimbus, with radiating gold lines, surrounds the throne. The gold and red table holds a begging bowl of gems and flowers, a covered dish and a flaming wheel, the specific attribute of the Dalai Lama.[3] Below (and in front of) the table and throne are the protectors, Yama (left), Mahakala (center) and Jambhala (right), with their appropriate flames or nimbuses. Above, center, Atisha is flanked by rainbow disks, enclosing three deities each: Amitayus, Ushnishavijaya and Tara (left); Avalokiteshvara, Manjushri and Vajrapani (right). The rather perfunctory background consists of a plain, dark blue sky and flowers around the nimbus of the main figure, a pale blue sky and flowers around the upper deities, and a green ground, blue pond and fluffy clouds in the lower areas. The painting is sewn to handsome Chinese brocades of dragon and lotus patterns.

This portrait has previously been considered to be that of the 7th Dalai Lama, but various symbols and characteristics, such as the youthful face, are not appropriate.[4] The painting is now believed to be of the 10th Dalai Lama, who never assumed political power and, thus, is not shown actually holding the wheel, emblem of the Dalai Lama's temporal status.[5] The hand prints, seal and inscriptions on the back are of the 12th Dalai Lama, Trinley Gyatso (1856-75),[6] and the "Chief Incarnate Lama of Kundeling Monastery." If the 10th Dalai Lama is indeed depicted, this is a rare portrait. A possible reason for its existence in Batang, Kham (where Shelton obtained it), is that the 10th Dalai Lama, otherwise unremarkable in comparison to the 5th , 7th or 13th, came from Kham and would be especially revered there. There seems to be no question that the tanka was painted and consecrated in Lhasa, the residence of the Dalai Lamas and of the Kundeling Lama, but perhaps under the commission of a family in Kham.

1. See P19. Perhaps the earliest portrait in this form, is one identified as the 5th Dalai Lama, TPS, pls. 80 and J.

2. Compare P14 and 15.

3. See portrait of the 5th Dalai Lama, TPS, pl. 80.

4. Note the presence of books and attendants in the *tsa-tsa*, fig. 22E, of the 7th Dalai Lama.

5. Tsepon Shakabpa, in examining the tanka, suggested the 10th Dalai Lama attribution because the wheel is not in his hands but on the table; the tenth incarnation lived only to the age of 21, always in poor health; Shakabpa, *Tibet*, pp. 174-76.

6. The handprints are of adult size, and thus were made toward the end of the 12th Dalai Lama's life.

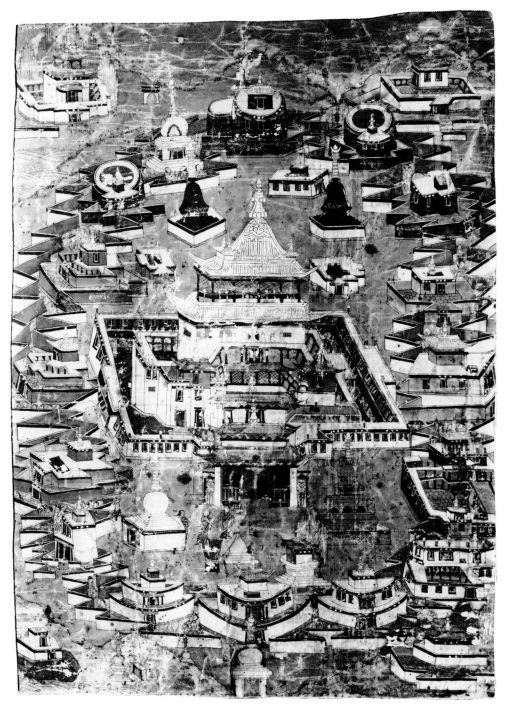

P43

SAMYE MONASTERY

Colors and gold on cotton cloth, 21″ × 15″ (53.3 × 38.1 cm)
Tibet, 19th century(?)
Purchase 1920 Shelton Collection 20.271

This famous site is the location of the first Buddhist monastery in Tibet, midway between Lhasa and the Yarlung Valley, founded by King Trisong Detsen in 775.[1] The probable abandonment of the site, after the fall of the dynasty in the mid-ninth century, and its neglect (if not willful destruction) for some one hundred years,[2] then the later centuries of refurbishing and rebuilding, have made it difficult to determine the historicity of the nineteenth- and twentieth-century complex as described, painted and photographed.[3] According to Tibetan records, Samye was built on the model of the great Indian monastery of Odantapuri in Bihar (itself completely destroyed in 1193, so the accuracy of this cannot be tested). The records also say that Samye, like many other temple and monastery complexes, symbolizes the Buddhist universe in its mandala plan and that the three stories of the central building were intended to be in three styles: Tibetan, Indian and Chinese.[4]

Newark's painting, which was obtained in Kham by Shelton, is impossible to date with any certainty. It has the look of a pilgrim's memento, and perhaps this was a favorite icon/souvenir to bring home from a pilgrimage to this most illustrious place. One can imagine a pious, and probably wealthy, Khampa merchant or lama having this as a remembrance from a trip to Central and Southern Tibet. The interesting combination of the idealized temple-as-mandala, and the realistic folk treatment of the building as it would have been viewed (in the usual Tibetan combination of aerial and spatial perspective), along with the vignettes of earnest secular pilgrims and monks, convey a sense of lively invention. The central building is wholly Tibetan: whitewashed, thick, sloping walls with colorful, painted, wood-trimmed windows, flat roofs and doorways which repeat the sloping effect of the walls; tiled and paved courtyards and balconies; columned interior arcades; golden roof pavilions and finials. The surrounding chortens, chapels and out-buildings are all labeled, and the whole complex is surrounded by a wonderful, zig-zag wall which follows the usual Tibetan convention for depicting walls.[5] It is this feature which is odd, since Samye was surrounded by a famous circular wall, originally topped by rows of chortens. Some of this circular wall remains today and is clearly visible in photographs of around 1950.[6] A wall painting at Samye, of uncertain date, and most other known portable paintings, show the circular wall.[7] The plan of Samye, included in a wall painting in the Kumbum of Jonang, in Southern Tibet, defines the monastic complex with a zig-zag wall and small, curved-wall side buildings in a way quite similar to Newark's tanka.[8] It is unclear why this variant manner of depiction exists in these two instances.

1. See p. 16 and Volume I, pp. 16 and 32.

2. See p. 17 and Volume I, pp. 16, 17 and 33.

3. See Henss, *Tibet*, pp. 117-28. Much still remains of the site, according to recent visitors, but the golden roofs of the main temple and all chortens are gone.

4. Snellgrove and Richardson, *Cultural History*, p. 78; and Shakabpa, *Tibet*, p. 37, who refers to Tucci, "Symbolism of the Temples of Bsam-yas," *East and West*, VI-4 (Rome, 1956).

5. Compare P17 and 19.

6. Henss, *Tibet*, pp. 122 and 125.

7. For the wall painting, see Ngapo Ngawang Jigmei et al., *Tibet*, pp. 248-49; for other paintings, see Henss, *Tibet*, pls. 40-41.

8. The Samye plan is on a wall in the eighth chapel, first story, which is believed to date from the time of Taranatha's restoration in 1621; see Tucci, TPS, pp. 190-93, fig. 55.

Abbreviations used for words frequently cited in the footnotes

AAI	Susan L. Huntington, *The Art of Ancient India.*
Bhattacharyya	Benoytosh Bhattacharyya, *The Indian Buddhist Iconography.*
Buddhism	W. Zwalf, *Buddhism, Art and Faith.*
Dagyab	Loden Sherap Dagyab, *Tibetan Religious Art.*
DDH	Gilles Béguin, *Dieux et démons de l'Himâlaya.*
Essais	Ariane MacDonald et al., *Essais sur l'Art du Tibet.*
Jackson	David P. and Janice A. Jackson, *Tibetan Thangka Painting, Methods and Materials.*
Kongtrul's Encyclopaedia	Lokesh Chandra, editor, *Kongtrul's Encyclopaedia of Indo-Tibetan Culture.*
LA Nepal	Pratapaditya Pal, *Art of Nepal,* a catalogue of the Los Angeles County Museum of Art collection.
LA Tibet	Pratapaditya Pal, *Art of Tibet,* a catalogue of the Los Angeles County Museum of Art collection.
Olschak	Blanche Christine Olschak and Geshé Thupten Wangyal, *Mystic Art of Ancient Tibet.*
Silk Route	Deborah E. Klimburg-Salter et al., *The Silk Route and the Diamond Path.*
Sino-Tibet	Heather Karmay, *Early Sino-Tibetan Art.*
TP	Pratapaditya Pal, *Tibetan Paintings.*
TPS	Giuseppe Tucci, *Tibetan Painted Scrolls.*
von S.	Ulrich von Schroeder, *Indo-Tibetan Bronzes.*
Wen Wu	*Wen Wu (Cultural Relics),* no. 9, 1985.

SELECTED BIBLIOGRAPHY

Béguin, Gilles. *Dieux et démons de l'Himâlaya.* Paris: Editions des musées nationaux, 1977.

Bhattacharyya, Benoytosh. *The Indian Buddhist Iconography.* Calcutta: Firma K. L. Mukhopadhyay, 1968.

Chandra, Lokesh, editor. *Kongtrul's Encyclopaedia of Indo-Tibetan Culture.* Parts 1-3. With an introduction by E. Gene Smith. New Delhi: International Academy of Indian Culture, 1970.

Dagyab, Loden Sherap. *Tibetan Religious Art.* Wiesbaden: Otto Harrassowitz, 1977.

Deng Ruiling et al. *The Potala Palace.* Hong Kong: Joint Publishing Co., 1982.

Getty, Alice. *The Gods of Northern Buddhism.* London: Oxford University Press, 1914.

Gordon, Antoinette K. *The Iconography of Tibetan Lamaism.* New York: Columbia University Press, 1939.

Henss, Michael. *Tibet, Die Kulturdenkmäler.* Zurich: Atlantis Verlag, 1981.

Huntington, John C. *The Phur-pa, Tibetan Ritual Daggers.* Ascona: Artibus Asiae Publishers, 1975.

Huntington, Susan L. *The Art of Ancient India.* With contributions by John C. Huntington. New York: Weatherhill, 1985.

Jackson, David P. and Janice A. *Tibetan Thangka Painting, Methods and Materials.* London: Serindia Publications, 1984.

Karmay, Heather. *Early Sino-Tibetan Art.* Warminster: Aris and Phillips, 1975.

Klimberg-Salter, Deborah E. et al. *The Silk Route and the Diamond Path.* Los Angeles: UCLA Art Council, 1982.

Lauf, Detlef Ingo. *Tibetan Sacred Art, the Heritage of Tantra.* Berkeley: Shambala, 1976.

Losty, Jeremiah P. *The Art of the Book of India.* London: The British Library, 1982.

MacDonald, Ariane et al. *Essais sur L'Art du Tibet.* Paris: J. Maisonneuve, 1977.

Nebesky-Wojkowitz, René de. *Oracles and Demons of Tibet.* The Hague: Mouton & Co., 1956.

Ngapo Ngawang Jigmei et al. *Tibet.* New York: McGraw-Hill Book Company, 1981.

Oddy, W. A., and W. Zwalf. *Aspects of Tibetan Metallurgy.* Occasional Paper No. 15. London: The British Museum, 1981.

Olschak, Blanche Christine, and Geshé Thupten Wangyal. *Mystic Art of Ancient Tibet.* New York: McGraw-Hill Book Company, 1973.

Pal, Pratapaditya. *Art of Nepal.* A catalogue of the Los Angeles County Museum of Art collection. Los Angeles: Los Angeles County Museum of Art, 1985.

_____. *The Art of Tibet*. New York: The Asia Society, 1969.

_____. *Art of Tibet*. A catalogue of the Los Angeles County Museum of Art collection. Los Angeles: Los Angeles County Museum of Art, 1983.

_____. *The Arts of Nepal, Part I, Sculpture*. Leiden: E. J. Brill, 1974.

_____. *Bronzes of Kashmir*. New York: Hacker Art Books, 1975.

_____. *Nepal, Where the Gods are Young*. New York: The Asia Society, 1975.

_____. *The Sensuous Immortals, A Selection of Sculptures from the Pan-Asian Collection*. Los Angeles: Los Angeles County Museum of Art, 1978.

_____. *Tibetan Paintings*. London: Ravi Kumar/Sotheby Publications, 1984.

Richardson, Hugh. *A Corpus of Early Tibetan Inscriptions*. London: Royal Asiatic Society, 1985.

Schroeder, Ulrich von. *Indo-Tibetan Bronzes*. Hong Kong: Visual Dharma Publications, 1981.

Shakabpa, Tsepon W.D. *Tibet, A Political History*. New Haven: Yale University Press, 1967.

Slusser, Mary Shepherd. *Nepal Mandala, A Cultural Study of the Kathmandu Valley*. 2 volumes. Princeton: Princeton University Press, 1982.

Snellgrove, David L. *Buddhist Himalaya*. New York: Philosophical Library, 1957.

_____, editor. *The Image of the Buddha*. Paris: UNESCO, 1978.

_____, and Hugh Richardson. *The Cultural History of Tibet*. New York: Frederick A. Praeger, 1968.

_____, and Tadeusz Skorupski. *The Cultural Heritage of Ladakh*. 2 volumes. Warminster: Aris and Phillips, 1977, 1980.

Stein, R. A. *Tibetan Civilization*. London: Faber and Faber, 1972.

Tucci, Giuseppe. *Indo-Tibetica*. 4 volumes. Rome: Reale Accademia d'Italia, 1932-41.

_____. *Tibetan Painted Scrolls*. 3 volumes. Rome: La Libreria dello Stato, 1949.

_____. *Transhimalaya*. Translated by James Hogarth. Geneva: Nagel Publishers, 1973.

Wen Wu (Cultural Relics). A special issue on archeology in Tibet (in Chinese). No. 9, 1985.

Zwalf, W., editor. *Buddhism, Art and Faith*. London: The British Museum, 1985.

TABLE OF PHONETICIZED AND
TRANSLITERATED SANSKRIT AND
TIBETAN WORDS

Note: Sanskrit/Indic (S) and Tibetan (T) words appear in the catalogue in phonetic form. This alphabetical table gives the transliterated spellings in instances where these differ from the phonetic form. The Wylie system is used for transliterated Tibetan.

S. *abhanga* = *ābhaṅga*
S. *abhishekha* = *abhiṣekha*
S. Achala = Acala
S. *achalasana* = *acalāsana*
S. Adibuddha = Ādibuddha
S. Ajatashatru = Ajātaśatru
S. Akshobhya = Akṣobhya
S. *alidha* = *ālīḍha*
S. Amaravati = Amarāvatī
S. Amitabha = Amitābha
S. Amitayus = Amitāyus
S. *amrita* = *amṛta*
S. *anda* = *aṇḍa*
S. *anjali* = *añjali*
S. *ankusha* = *aṅkuśa*
S. Arapachana = Arapacana
S. *ardhaparyanka* = *ardhaparyaṅka*
S. Asanga = Asaṅga
S. Atisha = Atīśa
S. *Avadanakalpalata* = *Avadānakalpalatā*
T. *ba la* = *ba bla*
S. Bagh = Bāgh
S. Bamiyan = Bāmiyān
S. *bana* = *bāṇa*
T. *Bardo Todol* = *Bar do thos grol*
T. Batang = 'Ba thang
T. Beri = Bal ris
S. *bhadrasana* = *bhadrāsana*
S. Bharhut = Bhārhut
S. Bhavaviveka = Bhāvaviveka
S. *bhumisparsha* = *bhūmisparśa*
S. *bija* = *bīja*
S. Bimbisara = Bimbisāra
S. Bodhgaya = Bodh Gayā
S. Brahma = Brahmā
T. Buton Rinpoche = Bu ston rin po che
T. Buton Rinchen Drub = Bu ston rin chen grub
S. *chakra* = *cakra*
S. Chakrasamvara = Cakrasamvara

T. Chamdo = Chab mdo
S. *chamara* = *cāmara*
T. Champa = Byams pa
T. Chana Dorje = Phyag na rdo rje
S. Chandamaharoshana = Caṇḍamahāroṣaṇa
T. *Chang Chub Sempeh Togju Pagsam Trishing* = *Byang chub sems dpa'i rtogs brjod dpag bsam 'khri shing*
T. Chenrezig = sPyan ras gzigs
T. Chemasheh = Bya ma shes
T. Chesheh = Bya shes
T. *chinlap* = *byin rlaps*
S. *chintamani* = *cintāmaṇi*
T. *chog chin* = *chos sbyin*
T. *chog lama* = *cog la ma*
T. Chogyal Phagpa = Chos rgyal phags pa
T. Chokhorgye = Chos 'khor rgyal
T. *chökor* = *chos 'khor*
T. *chokyi korlo* = *chos kyi 'khor lo*
T. Chönyid Bardo = Chos nyid bar do
T. *chöpag* = *chos 'phags*
T. *chorten* = *mchod rten*
T. Chöying Gyatso = Chos dbyings rgya mtsho
T. *chöyon* = *mchod yon*
S. Chudapantaka = Cūḍapanthaka
T. *da* = *mda'*
T. Dagyab = 'Brag yab
S. *dakini* = *ḍākinī*
S. *damaru* = *ḍamaru*
T. Demchog = bDem mchog
T. Derge = sDe dge
S. *Devanagari* = *Devanāgarī*
S. *dharmachakra* = *dharmacakra*
S. *dharmakaya* = *dharmakāya*
S. *dharmapala* = *dharmapāla*
S. *dhyana* = *dhyāna*
S. *dhyanasana* = *dhyānāsana*
S. Dipamkara = Dipaṃkara
T. *dom* = *'dom*
T. Donyo Drupa = Don yod grub pa
T. *do pang* = *mdo spang*
T. *doring* = *rdo ring*
T. *dorje* = *rdo rje*
T. Dorje Chang = rDo rje 'chang
T. Dorje Gyaltsen = rDo rje rgyal mtshan

T. *dorje kyildrung* = *rdo rje skyil krung*
T. Dorje Pagmo = rDo rje phag mo
T. Dorje Phurpa = rDo rje phur pa
T. Dorje Sempa = rDo rje sems dpa'
T. *doting* = *mdo mthing*
T. *drachompa* = *dgra bcom pa*
T. Dragpa Gyaltsen = Grags pa rgyal mtshan
T. Drakmar Keru = Brag dmar ke ru
T. Drala Kyechigbu = dGra lha skyes gcig bu
T. *dralha* = *dgra lha*
T. Drepung = 'Bras spungs
T. Drigung = 'Bri gung
T. Drogmi = Brog mi
T. Drolma Jangu = sGrol ma 'jang gu
T. Drolma Karpo = sGrol ma dkar po
T. Drukpa = 'Brug pa
S. *dvarapala* = *dvārapāla*
T. Dzambhala = Dsam bha la
T. *dzong* = *rdzong*
T. *dzopu* = *mdzod spu*
T. *dzubmo* = *mdzub mo*
S. Ekajata = Ekajaṭā
T. Gampopa = sGam po pa
T. Ganden = dGa' ldan
S. Gandhara = Gandhāra
S. Ganesha = Gaṇeśa
T. Gangeh Lhamo = Gaṅ gha'i lha mo
T. *gartub* = *gar stabs*
S. *garuda* = *garuḍa*
T. Gegtar Ched = bGegs thar byed
T. Gelugpa = dGe lugs pa
S. *ghanta* = *ghaṇṭā*
T. *gonkhang* = *mgon khang*
T. Gonpo = mGon po
T. Gotsang Drubdeh = rGod tsang sgrub sde
S. Guhyasamaja = Guhyasamāja
T. Gurgon = Gur mgon
T. *Gyalpo Kachem* = *rGyal po'i bka' chems*
T. *gyalpo rolpa* = *rgyal po'i rol pa*
T. *gyaltsen* = *rgyal mtshan*
T. Gyachan = brGya byin
T. Gyantse = rGyal rtse
T. *gyatso* = *rgya mtsho*
T. Gyawa Gotsangpa = rGyal ba rgod tsang pa

206

S. *harmika* = *harmikā*

S. Hayagriva = Hayagrīva

T. Jampal = 'Jam dpal

T. Jampal Drag = 'Jam dpal grags

T. Jamyang Shepa = 'Jam dbyangs bzhad pa

S. *Jataka* = *Jātaka*

T. *jigme* = *jigs med*

T. *jigten kyong* = *'jig rten skyong*

S. *jnanasattva* = *jñānasattva*

T. Jowo Rinpoche = Jo bo rin po che

T. Kadampa = bKa' gdams pa

T. *kadro* = *mkha' 'gro*

T. Kagyupa = bKa' brgyud pa

S. Kalachakra = Kālacakra

S. *kalasha* = *kalaśa*

T. *Kanjur* = *bKa' 'gyur*

T. *Kanjur Sher Chin Bum* = *bKa' 'gyur sher phyin 'bum*

T. *Kanjur Zungdu* = *bKa' 'gyur gzungs bsdus*

S. *kapala* = *kapāla*

S. *karana* = *karaṇa*

T. Karma Gadri = Karma sgar bris

S. *kartri* = *kartrī*

S. *kartrika* = *kartrikā*

S. *kaya* = *kāya*

S. *khadga* = *khaḍga*

T. Kham = Khams

T. *kharsil* = *mkhar gsil*

T. *khatvamga tsesum* = *kha tvam ga rtse gsum*

S. *khatvanga* = *khaṭvāṅga*

T. Khugpa Lhatsi = Khug pa lhas tsi

T. Khyenri = mKhyen ris

S. *kila* = *kīla*

S. *kinnara* = *kiṁnara*

S. *kirtimukha* = *kīrttimukha*

T. *konchog sum* = *dkon mchog gsum*

T. Kontrul = Kong sprul

S. Kshemendra = Kṣemendra

T. *kudra* = *sku 'dra*

T. Kumbum = sKu 'bum

T. Kundeling = Kun bde gling

T. Kunga Gyaltsen = Kun dga' rgyal mtshan

T. Kuntu Zangpo = Kun tu bzang po

T. *kuten* = *sku rten*

S. *Kutila* = *Kuṭila*

S. Lakshmi = Lakṣmī

S. *lalitasana* = *lalitāsana*

T. Lalitavajra Rolpa Dorje = Lalita vajra rol pa'i rdo rje

T. *lhazo* = *lha bzo*

T. Lhodrak = Lho brag

T. *litri* = *li khri*

S. Lokanatha = Lokanātha

S. *lokapala* = *lokapāla*

S. Lokeshvara = Lokeśvara

S. Mahakala = Mahākāla

S. Mahamayuri = Mahāmāyūrī

S. Mahapandita Abhayakara Gupta = Mahāpaṇḍita Abhayākara Gupta

S. *maharajalilasana* = *mahārājalīlāsana*

S. *mahasiddha* = *mahāsiddha*

S. Mahavira Jina = Mahāvīra Jina

S. Mahayana = Mahāyāna

S. *malla* = *mālā*

T. *Mani K'abum* = *Ma ṇi bka' 'bum*

T. Manjushri = Mañjuśrī

S. *Mantrayana* = *Mantrayāna*

S. Marici = Mārīcī

T. Marme-dzed = Mar me mdzad

T. Mar Sogdrup = dMar srog sgrub

T. Menla Dhondup = sMan bla don grub

T. Menri = sMan bris

T. Menri sarma = sMan bris gsar ma

T. *metsa* = *me btsa'*

T. Mikyopa = Mi bskyod pa

T. Milarepa = Mi la ras pa

T. Miwang Pholhaneh Sonam Topgyeh = Mi dbang pho lha nas bsod nams stobs rgyas

T. Miyowa = Mi gyo ba

T. *miyoweh zug* = *mi gyo ba'i bzugs*

S. *mudra* = *mudrā*

S. *naga* = *nāga*

S. Nagarjuna = Nāgārjuna

S. *nagaraja* = *nāgarāja*

T. *nagtang* = *nag thang*

T. *nagtsa* = *snag tsha*

T. *namchag* = *gnam lcags*

T. Namgyal = rNam rgyal

T. Nartang = Nar thang

T. Nechung = gNas chung

T. *ngayab* = *rnga yab*

T. Ngor Pal Evam Choden = Ngor dpal e vam chos ldan

T. *ngul dul* = *dngul dul*

S. *nirmanakaya* = *nirmāṇakāya*

S. *Nispannayogavali* = *Niṣpannayogāvalī*

T. Norgyunma = Nor rgyun ma

T. Nyetang = Nye thang

T. Nyingmapa = rNying ma pa

S. *Om ah hum* = *Oṁ āḥ hūṁ*

T. Öpagme = 'Od dpag med

S. Odantapuri = Odantapurī

T. Palkhor Chöde Kumbum = dPal 'khor chos sde sku 'bum

S. Padmapani = Padmapāṇi

S. *padmasana* = *padmāsana*

T. Padma Wangyal = Padma dbang rgyal

S. Pala = Pāla

T. Palden Lhamo = dPal ldan lha mo

T. Pal Duki Korlo = dPal dus kyi 'kor lo

T. Pal Sangwa Dupa = dPal gsang ba 'dus pa

S. *pancha* = *pañca*

S. *Pancharaksha* = *Pañcarakṣā*

T. *pangma* = *spang ma*

S. *pasha* = *pāśa*

S. *pata* = *paṭa*

S. *patra* = *pātra*

T. *pecha* = *dpe cha*

T. Pema Chungneh = Padma 'byung gnas

T. Phagod Namkha Gyatso = Pha rgod nam mkha rgya mtsho

T. Phagpa = 'Phags pa

T. Phamo Drupa = Phag mo gru pa

S. *prabhamandala* = *prabhāmaṇḍala*

S. *prajna* = *prajñā*

S. *prajnalinganabhinaya* = *prajñālinganābhinaya*

S. Prajnaparamita = Prajñāpāramitā

T. *rabne* = *rab gnas*

S. *rakshasha* = *rakṣāśa*

T. *raltri* = *ral gri*

T. Rinchen Chungden = Rin chen 'byung ldan

T. Rinchen Zangpo = Rin chen bzang po

T. Rongpuk = Rong phu

S. Sadakshari = Sadakṣarī

S. *Sadhanamala* = *Sādhanamālā*

T. Sakyapa = Sa skya pa

T. Sakya Pandita = Sa skya Paṇḍita

S. *samadhi* = *samādhi*

S. *sambhogakaya* = *saṁbhogakāya*

T. *samden* = *bsam gtan*

T. Samye = bSam yas

T. *sanon* = *sa gnon*

S. Sanchi = Sañcī

S. *sangha* = *saṅgha*

T. Sangye yeshe zhab = Sangs rgyas ye shes zhabs

S. Sarasvati = Sarasvatī

S. *sati* = *satī*

T. Senge Namgyal = Seng ge rnam rgyal

T. *ser* = *gser*

T. Ser dog = gSer mdog

T. Ser gyi lag = gSer gyi lag

T. *sertang = gser thang*

T. Setab = bSe khrab

S. Shakyamuni = Śākyamuni

T. Shakya Tupa = Shā kya thub pa

S. *shankha = śaṅkha*

S. *shara = śara*

T. Sherab ki Parol tu Chinpa = Śes rab kyi pha rol tu phyin pa

T. Shigatse = gZhis ka rtse

T. Shin Cha Chan = Shin bya can

T. Shinje = gShin rje

T. Shinje Shed = gShin rje gshed

S. Shiva = Śiva

S. Shri Devi = Śrī Devī

S. Shyamatara = Śyāmatārā

S. Siddhartha = Siddhārtha

S. Simhanada Avalokiteshvara = Siṁhanāda Avalokiteśvara

T. *Sipeh Korlo = Srid pa'i khor lo*

S. Sitatara = Sitatārā

T. *sog shing = srog shing*

T. Sonam Chökyi Lanpo = bSod nams chos kyi glang po

T. Sonam Gyatso = bSod nams rgya mtsho

T. Songtsen Gampo = Srong btsan sgam po

S. Sukhavati Lokeshvara = Sukhāvatī Lokeśvara

S. *sutra = sūtra*

T. Tabo = Ta pho

T. Tadag Gyed = rTa bdag brgyad

T. *Tag du Ngu = rTag tu ngu*

T. Tag Tsang Repa = sTag tshang ras pa

T. *talmo jar = thal mo sbyar*

T. *Tanjur = bsTan 'gyur*

T. *tanka = thang ka*

S. Tara = Tārā

T. Taranatha = Tāranātha

S. *tarjani = tarjanī*

T. *ten = rten*

T. *tenkhang = rten khang*

T. *terma = gter ma*

T. Terton Karma Lingpa = gTer ston karma gling pa

T. Terton Padma Lingpa = gTer ston padma gling pa

T. *ting = mthing*

T. *tingedzin = ting nge 'dzin*

T. *todpa = thod pa*

T. *tokde = thog rdeu*

T. *tokpa = rtog pa*

T. Toling = mTho lding

T. *torma = gtor ma*

T. *trengwa = phreng ba*

S. *tribhanga = tribhaṅga*

T. Tride Tsugtsen = Khri lde gtsug btsan

T. *triguk = gri gug*

T. Trinley Gyatso = 'Phrin las rgya mtsho

S. *Tripitaka = Tripiṭaka*

T. Trisong Detsen = Khri srong lde btsan

S. *trishula = triśūla*

T. *tsag = btsag*

T. *tsak par = gtsag par*

T. *tsaltang = mtshal thang*

T. Tsang = gTsang

T. Tsang Nyon = gTsang snyon

T. *tsenpo = btsan po*

T. Tsepagme = Tshe dpag med

T. *tsewang = tshe dbang*

T. *Tsong pon = Tshong dpon*

T. Tsuglakhang = gTsug lag khang

T. *tsugtor = gtsug tor*

T. Tsultrim Gyatso = Tshul khrims rgya mtsho

T. *tulku = sprul sku*

S. Tushita = Tuṣita

T. U = dBus

T. *u chen = dbu chen*

S. *urna = ūrṇā*

S. *ushnisha = uṣṇīṣa*

S. Ushnishavijaya = Uṣṇīṣavijayā

S. Vairochana = Vairocana

S. Vaishravana = Vaiśravaṇa

S. *Vajracharya = Vajrācāryya*

S. *vajrahumkara = vajrahūṁkara*

S. Vajrakila = Vajrakīla

S. Vajrapani = Vajrapāṇi

S. *vajraparyanka = vajraparyaṅkā*

S. Vajravarahi = Vajravārāhī

S. Vajrayana = Vajrayāna

S. Vasudhara = Vāsudhārā

S. Vighnantaka = Vighnāntaka

S. Vighnantaka = Vighnāntaka

S. Vikramashila = Vikramaśīla

S. Vishvapani = Viśvapāṇi

T. Yarlung = Yar klungs

T. *yehpeh kyang = gyas pa'i rkyang*

T. *yehrol = gyas rol*

T. Yeshe Ö = Yeshes 'Od

T. *yizhin norbu = yid bzhin nor bu*

T. *yidag = yi dvags*

T. *yonpeh kyang = gyon pa'i rkyang*

T. Yunton Dorje = gYun ston rdo rje

T. *zangpo dugdang = bzang po'i 'dug stangs*

T. *zhag = zhags*